Books are to be returned on or before
the last date below.

KT-239-088

057587

THE HENLEY COLLEGE LIBRARY

THE HENLEY COLLEGE LIBRARY

Masterpiece
a work that is excellent,
or the best example of a creator's work

British
an adjective referring to the countries that make
up the United Kingdom or British Isles, and its peoples

Design
the conception and planning of an
optimum solution to a particular problem

"Have nothing in your houses that you do not know to be useful or believe to be beautiful."

William Morris

"Perhaps believing in good design is like believing in God, it makes you an optimist."

Sir Terence Conran

Published in 2012 by Goodman Fiell
An imprint of the Carlton Publishing Group
20 Mortimer Street
London W1T 3JW

www.carltonbooks.co.uk

Text © 2012 Charlotte & Peter Fiell
Design © 2012 Goodman Fiell

All rights reserved. This book is sold subject to the condition that it may not be reproduced, stored in a retrieval system or transmitted in any form or by any means, electronic, mechanical, photocopying, recording or otherwise without the publisher's prior consent.

A CIP catalogue record for this book is available from the British Library

Printed in Hong Kong

ISBN 978 1 84796 035 1

Masterpieces of
British
Design

Charlotte & Peter Fiell
Foreword by **Sir Terence Conran**

GOODMAN
FIELL

Contents

Foreword,
by Sir Terence Conran

This book is published at an important moment in time as it is vital to convince Government and manufacturers that intelligent design and engineering can help our country to employ people to make things that the world wants. After all, we are universally credited with being the most creative nation in the world; we should play to our strengths and help resolve our greatest problem – the unemployment, especially of young people, our greatest disgrace.

We certainly have the design talent, but this talent needs manufacturers to succeed. A designer has to work closely with a factory understanding its machinery and the skills of its workforce for excellent results to be achieved. He or she also needs to be involved in the marketing and presentation of the products they have designed and understand the needs and wants of the consumers.

Intelligent design – as this book admirably demonstrates – is desired the world over, and Britain has a long history of producing products that have helped shape the world of industrial design. When I first started my career we were called "industrial artists", which confused people's view of design. One of the reasons I founded the Design Museum was to try to clarify and extol the importance of intelligent industrial design to Government, industry and consumers. It started as the Boilerhouse in the Victoria and Albert Museum which was, and still is, a magnificent museum of the Decorative Arts which are, of course, important as a component of design. Pattern may cheer up a badly designed tea service but it is only superficial and won't stop the drips from the teapot.

Government and taxpayer have invested heavily over the years in educating designers in some of the best design schools in the world, and it is particularly important at this time that this investment should reap returns. It certainly has done so for Apple with Jonathan Ive, their designer educated at Northumbria University. Even more important is for us all to realise that intelligent design adds to the quality and enjoyment of our lives. So let's use it and bring about a second design-led industrial revolution and in the process make people proud of making good things and reduce unemployment at the same time.

Sir Terence Conran
24 July 2012

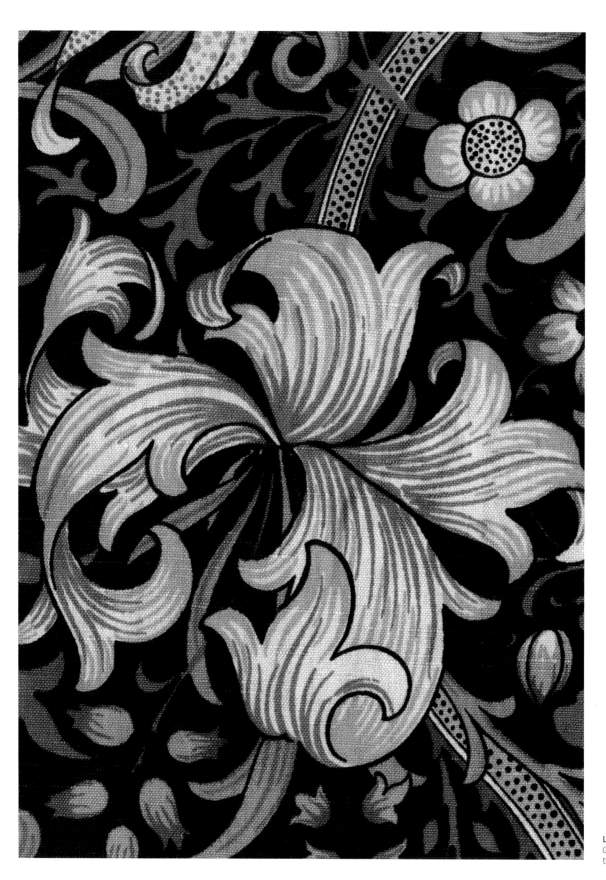

Left: John Henry Dearle,
Golden Lily Major printed cotton
textile for Morris & Co., 1897

Introduction

This book celebrates British design achievements from the Industrial Revolution to the present day, using just over 100 of the most important designs to illustrate some of the landmarks of those 300 years. Each masterpiece has been selected not just for its inherent excellence, but because of the story it can tell about the wider history of British design. We hope that by taking this selective – and by necessity slightly subjective route – we can not only show the breadth and variety of ideas emanating from the nation's greatest designers, but also identify some common threads that unite their work, so that the true characteristics of British design are revealed.

From the beautiful sweeping lines of the *Spitfire* to the seductive curves of the Jaguar *E-Type*, the practical clarity of the *Routemaster*'s functional design, to the craft sensibility of a William Morris textile, in the end British design masterfully embodies a purposeful beauty that sets it apart and reflects the perfect balance between form and function.

What is it that makes British design so British?

A seafaring island nation, Britain has always looked beyond its shores and assimilated foreign influences into its own cultural canon. At the same time, her people have looked inwards and developed a resourceful inventiveness and a powerful sense of self-reliance. Both characteristics are reflected in how British designers and engineers have approached problem-solving, which is essentially what design is all about.

Every design starts with an idea, a belief that there is a better solution to be found, whether through evolutionary honing or revolutionary thinking. British designers and engineers seem to have a special gift for taking a pragmatic approach in pursuit of this goal of "the better thing", and for the skilful balance of form with function.

British design has a certain gentle refinement, an understated elegance (perhaps a reflection of the traditional idea of British character) which is based on the understanding that true quality is about a beautiful object's intrinsic values and how these relate to its user, rather than just its surface treatment or its technological reasoning. It is this down-to-earth mindfulness that sets British design apart, and gives it such an engaging emotional appeal.

The English Tradition, The Analysis of Beauty and The Classical Ideal

The distinctive qualities of British design were born out of the Industrial Revolution in the eighteenth century, and the Arts & Crafts Movement of the nineteenth century. This balance between engineering and craft has probably shaped British design more than anything else. Even before the engines of industrial change began to roll in the early 1700s, there was a definably English way of making things. In the words of the eminent design historian John Gloag, "From the time when the crude chests of the thirteenth and fourteenth centuries were decorated with roundels of chip carving… an unmistakable affinity of purpose is apparent, disclosing that deep affectionate sympathy for materials, that sense of apt selection and gay orderliness in the forms of embellishment, which are inseparable ingredients of the English tradition of design." [1]

In the sixteenth century, the English Reformation brought in its wake what became known as a "protestant ethic" that would inform the development of a more thoughtful approach to design and manufacture in Britain over the coming centuries. In the Georgian period, when the Grand Tour had become a *de rigueur* rite of passage for many young gentlemen, an understanding of design was seen as an important part of their education and this was reflected in the classically inspired yet functional proportions of contemporary furniture. Although different foreign influences – Dutch and French, Chinese and Indian – became fashionable within the decorative arts during this era, they were only ever permitted a fleeting modishness and were never really allowed to disrupt the graceful proportions or purposeful function of a design.

The artist William Hogarth's book *The Analysis of Beauty* (1753), now remembered mainly for its espousal of the elegant serpentine line, was essentially an early treatise on aesthetic theory that was "written with a view of fixing the fluctuating ideas of taste". In this influential book, one of the first to consider the emergence of consumer products, Hogarth laid down immutable principles for the attainment of timeless beauty. Importantly these included, in relation to design practice, the notions of "fitness", which he described as "the first fundamental law in nature with regard to beauty"; "simplicity", that "serves to prevent perplexity in forms of elegance"; and "proportion", which he defined as "a just symmetry and harmony of parts with respect to the whole". It was however Hogarth's overriding call for appropriateness of form, within both art and industry, that was to be of lasting influence. It could be argued that Josiah Wedgwood was the first to put Hogarth's theory into practice, in his pursuit of the classical ideal and his implementation of a systemized method of mass-production. His *Queen's Ware* range of cream-coloured ceramics, with its simple classical forms, certainly accorded entirely with Hogarth's notions of good taste. Critically, Wedgwood had the cultural wherewithal to employ some of the best artists and craftsmen of the day to create designs for industrial production, most notably John Flaxman.

Similarly, the Coalbrookdale foundry – established by Abraham Darby, one of the founding fathers of the Industrial Revolution – soon progressed from manufacturing purely functional cooking pots and cauldrons to producing cast-iron seat furniture, fire surrounds, doorstops and more, which had a classically-inspired elegance as well as a functional purpose.

Sadly however, not all British manufacturers were so

Above: William Hogarth, *The Analysis of Beauty – Plate I* engraving, 1753 – featuring classical sculptures as exemplars of beauty, illustrating his belief that the serpentine line was the essence of beauty.

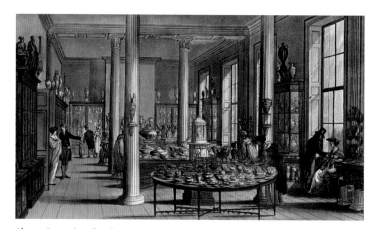

Above: Engraving showing the interior of the Wedgwood & Byerley showroom in York Street, St. James's Square, London, published in R. Ackermann's *Repository of Arts* in 1809

enlightened. The year after Hogarth's treatise was published saw another, more official attempt to unite the arts with industry: the aim of the Society for the Encouragement of Arts, Manufactures and Commerce, founded in 1754 by the artist and social activist William Shipley, was "to embolden enterprise, to enlarge science, to refine art, to improve manufacture and to extend our commerce". Shipley also reputedly suggested that badly designed objects should be seen as physically repugnant. But despite his best intentions and those of his Society of Arts, which offered not just awards but also monetary prizes, few British manufacturers heeded the call for design reform over the next century.

The Gothic Revival and the High Victorian Style

By the mid-nineteenth century Britain had become the most powerful nation on earth, thanks to her extensive empire and her impressive manufacturing capability. Being the first country to become industrialized, however, meant learning through mistakes, as true of the design and manufacture of consumer goods as of anything else. The vast majority of manufacturers saw the machine as a means to create goods more cheaply and more quickly, and so improve profit margins. They didn't realize that rather than being used merely to mimic handicraft, industrialized production methods could be used to make better quality products. Shoddy "fancy goods", often superficially copying luxury items and lavishly decorated with superfluous ornament to hide the defects of poor production, became the mainstay of most British manufacturers. This sorry state of affairs was plain for all to see in many of the 100,000 designs on display at "The Great Exhibition of the Works of Industry of all Nations", the Great Exhibition of 1851, an event organized by the Society of Arts as a celebration of modern technology and international design.

Housed in Joseph Paxton's remarkable prefabricated iron and glass building, which became known as the Crystal Palace, this event revealed not only the impressive ability of industry to create all manner of wondrous inventions but also the Victorians' insatiable appetite for ornament. The plethora of revival styles that quickly passed in and out of fashion during this period reflected not only the *nouveau richesse* of a country gorging on its newfound economic wealth, but also a manufacturing industry hard at work promoting "stylish" fads and creating a voracious market for them among all classes of consumer.

Even before the Great Exhibition there had been stirrings of design reform; A. W. N. Pugin's *True Principles of Pointed or Christian Architecture* (1841) called for an integrity in design and architecture based on fitness for purpose, truth to materials, and revealed construction – ultimately, a moral honesty. In 1849, Henry Cole – a leading member of the Royal Society of Arts and the driving force behind the Great Exhibition – had noted that "Design has a twofold relation, having in the first place, a strict reference to utility in the thing designed; and, secondarily, to the beautifying or ornamenting that utility." [2]

Significantly, a year after the Great Exhibition the Government decided to establish the Museum of Manufactures at Marlborough House in Pall Mall, using £5,000 from the profits of the exhibition to acquire some of the objects that had been on show there. The main aim of the museum was to help improve the standards of art and design education in Britain, especially in relation to industrial production. A committee that included Pugin was set up to select suitably instructive objects for display, and Henry Cole was appointed the first General Superintendent of the museum's Department of Practical Art. Cole also set up a display of poorly designed objects that was entitled "Decorations on False Principles", which became known as the "Chamber of Horrors". Featuring some truly ugly and heavily ornamented objects produced by a variety of British manufacturers, the object of this display was twofold: on the one hand, it was intended to shame manufacturers into producing better designed "art manufactures"; while on the other it was meant to educate the public about the difference between good and bad design.

The exhibits at Marlborough House became the nucleus of the collection that would in 1857 form the South Kensington Museum, later renamed the Victoria and Albert Museum. The Government School of Design, which had previously been established at Somerset House in 1837, was also transferred to this new museum in South Kensington and renamed the Art Training School – later becoming the Royal College of Art – which meant that the museum's design study collection became an absolutely crucial element of design teaching in Britain. However, as the design historian and cultural commentator Stephen Bayley has written, "Cole and his fellows did not realize that the emerging world meant that the market was likely to dominate taste and that it was no longer possible for a small elite, no matter how well-intentioned, to set up universal standards."[3]

Design Reform & The Arts & Crafts Movement

Four years after the South Kensington Museum had been established, the young William Morris, inspired by the socially and artistically reforming ideas of John Ruskin and the Romantic escapism of the Pre-Raphaelite Brotherhood, attempted to reform design in a very different way with the founding of the company Morris, Marshall, Faulkner & Co.

This new venture was motivated by a social mission to replace "useless toil" with "useful work". Morris's goal was as much to restore the joy of labour to the working man through pride in his handicraft, as it was to create beautiful, meaningful, artistic manufactures that would give pleasure to their users. Having earlier dedicated himself to "a life of art", Morris attempted a revolutionary, typically hands-on approach to design and manufacture; its aim was to tackle the social problems and human cost resulting from rapid industrialization by, for the most part, rejecting the industrial process and its dehumanizing reliance on the division of labour. Putting reforming theory into practice, Morris fostered a new Arts & Crafts aesthetic, which centred on well-crafted designs that promoted the virtues of simplicity, utility, beauty, symbolism and quality.

Through his work, Morris attempted to define a national design identity by looking at age-old vernacular precedents and evolving honed forms from them. But there was a fundamental paradox in Morris's approach: he wanted to bring good design to the masses while improving the lives of working men and women, but because of his rejection of mechanization in favour of handicraft, his furniture, textiles, glassware and ceramics were necessarily expensive to produce and as a result he was prevented from fulfilling his social cause. All too often he instead found himself "ministering to the swinish luxury of the rich" in order just to keep "The Firm" going.

Despite this, Morris's contribution to the development of British design cannot be overstated; he inculcated a craft ideal and a social conscience into the national design psyche, while at the same time his work powerfully expressed a distinctive Britishness that was based on a timeless and graceful practicality. Crucially, Morris also demonstrated the morality of producing objects of quality, while his use of design as a democratic tool for social change had a fundamental impact on the origins of the later Modern Movement.

Also during this period, English architect Owen Jones had a significant impact on design practice with the publication in 1856 of his *Grammar of Ornament*, a comprehensive design sourcebook which put forward 37 "general principles in the arrangement of form and colour in architecture and the decorative arts". It was however Charles Locke Eastlake's *Hints on Household Taste*, published in 1868, that was to have perhaps an even greater influence on public taste both in Britain and in America. As an accessibly written handbook on interior decoration, it derided the concept of fashionable novelties and instead encouraged the "discrimination between good and bad design in those articles of daily use which we are accustomed to see around us". Eastlake argued that some of the worst examples of bad design were often to be found in expensive articles of luxury, and that it was often the simplest items in a home, such as a plainly constructed bedroom washstand, that were actually the best designed. It was this linking of quality with utility that was to help change taste and therefore demand in Britain, and that would help to spur a new proto-modernity in design the following decade.

During the 1870s a new wind of reform swept through British design thanks to the opening up of Japan. Designers such as Christopher Dresser and Edward William Godwin created Anglo-Japanese designs that had what might be described as a convincing pre-modernity, with their pared down geometric forms. In 1873 Dresser published an influential book, *The Principles of Decorative Design*, which explored the relationship that exists between form and function and which was intended to aid "the art-education of those who seek a knowledge of ornament as applied to our industrial manufactures". He argued that beauty had a commercial value and as such was an important element of design, stating "We may even say that art can lend to an object a value greater than that of the material of which it consists, even when the object be formed of precious matter, as of rare marble, scarce woods, or silver or gold. This being the case, it follows that the workman who can endow his production with those qualities or beauties which give value to his works, must be more useful to his employer than the man who produces objects devoid of such beauty, and his time must be of higher value than that of his less skilful companion."

Dresser is often regarded as the first professional industrial designer because he worked as a consultant for many leading manufacturers, while his "designer signature" was even emblazoned on some of his wares. Unlike Morris however, Dresser did not distrust the machine but fully embraced it, realizing that a new, more rational approach to design needed to be adopted that would harness its mass-manufacturing

Right: Charles Rennie
Mackintosh, high-backed chair
for the Argyle Street
Tea Rooms, 1897

Below: James Dixon & Sons
photograph showing a variety
of teapots designed by
Christopher Dresser, 1879

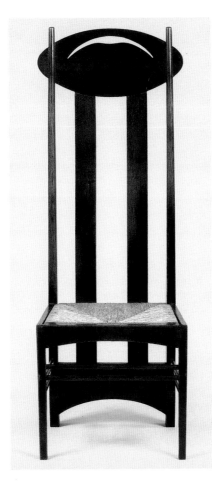

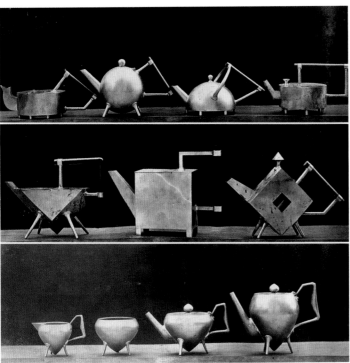

potential in order to create beautiful, useful and at the same time affordable objects for the many, rather than for the few. Dresser certainly practised what he preached, his designs demonstrating a formal and functional rationalism that was new and eminently suited to the demands of industrial mass-production.

From the 1880s to the outbreak of the First World War, British design was dominated by the second phase of the Arts & Crafts Movement, which had taken on board Morris's handicraft aesthetic but was more ambivalent towards industrial production. Like Dresser, many of the designers associated with the movement used pared down forms, but based on British vernacularism rather than Eastern archetypes. They also used a modicum of mechanization in the manufacture of their designs. The furniture of Charles Rennie Mackintosh and Charles Voysey, John Dearle's textiles and Archibald Knox's metalware for Liberty, all typified the look of this *fin-de-siècle* "New Art" movement, which was as inspired by forms found in the natural world as it was by age-old folk motifs. Arts & Crafts designs during the slightly later Edwardian period were characterized by an ever-greater simplification of form, yet they still retained a definable craft sensibility – plain and honestly constructed wares for the British home.

The outbreak of the First World War in 1914 however catapulted Britain out of its cosy Arts-and-Crafts idyll and into the modern world, bringing with it enormous social change, especially with regard to the class system. The "War to End All Wars" completely changed the social demographic of the population that had been the very fabric of the old order, and at the war's cessation in 1918 Britain was an entirely different place. As on the Continent, there was a general feeling that Modernism needed to be embraced, but victory had come at a heavy cost both financially and in human terms, with a generation of men lost. The ensuing postwar economic stagnation saw British design and manufacturing in almost complete stasis, but the introduction of the *Austin Seven* motorcar in 1922 reflected a new postwar social order, being Britain's first affordable car for the everyman.

The 1920s also saw the introduction of a number of notable forward-thinking designs, from Edward McKnight Kauffer's Art Deco-inspired posters for London Transport to Eric Gill's *Gill Sans* typeface. British designers followed the progressive development of the Modern Movement in Europe, but at this time France was still seen by the British as the major driving force behind Modernism – it was only later,

in the 1930s, that greater awareness grew of the Weimar Bauhaus. Although founded in 1919, it wasn't until the early 1930s – and later, when many members of the Bauhaus relocated to London at the outbreak of the Second World War – that the school began to garner recognition for its influence. It was in the 1930s that British designers began to wholeheartedly embrace the Modernist aesthetic that was sweeping across Europe.

Social Idealism & Wartime Utility

The effects of New York's Wall Street Crash in October 1929 rippled outward like a financial tsunami, and by the early 1930s Britain was once again in the grip of an economic depression, with unemployment rising to 20 percent in 1933. In Britain, the decade began with a coalition National Government being formed by Ramsey MacDonald in the face of an economic crisis, and it was to end with the formation of another coalition government in the face of a looming military crisis. The intervening so-called "devil's decade", however, was also the period that saw the steady rise of Modernism within design practice, and the development of the industrialized "Machine Age" not just in Europe and America, but also in Britain. During this difficult and financially straitened period, a spirit of social idealism blossomed that was strongly reflected in the clean, modern lines of designs that embraced a new industrial functionalism, from George Carwardine's innovative 1933 *Anglepoise* lamp to Wells Coates's iconic Ekco *AD 65* radio (1934), which was made of gleaming Bakelite and was the three-dimensional realization of Coates's belief that "the social characteristics of the age determine its art". Similarly, Henry Beck's diagrammatic redesign of the London Underground map (1933) revealed a modern objectivity in graphic design, as did Edward Young's clean, unfussy book covers for Penguin paperbacks (1935). The threat of a looming war also focused attention on the necessity of developing state-of-the-art military hardware, leading to Reginald J. Mitchell's ingenious design of the sublimely beautiful *Supermarine Spitfire*, which took its first flight in 1936.

The 1930s saw an influx into Britain of leading Modern Movement architects and designers fleeing Nazi Germany, most notably Marcel Breuer and Walter Gropius, and this also helped to galvanize acceptance of the modern design cause. The tubular steel furniture produced by PEL, for example, was not only an acceptance of Bauhaus-style functionalism but also a rejection of the craft ideal that had been so central to the development of British design during the early years of the twentieth century. This same seemingly strident Modernist stance was also reflected in the bold geometric forms of Keith Murray's ceramics for Wedgwood and Enid Marx's hardwearing moquette textiles for London Transport. Yet at their core, these designs were born from a craft tradition and were thereby a gentler and more human-centric expression of modernism. The influence of Scandinavian Modernism on British designers during the 1930s was also felt, most notably through the work of the Finnish architect Alvar Aalto, whose revolutionary moulded plywood furniture was imported and retailed by Finmar Ltd. Crucially, this type of soft-edged, organic design did not have any worryingly Teutonic connotations, and the direct influence of this approach to design is clearly seen in Gerald Summers's remarkable plywood lounge chair of 1933–34. It could even be said that British design during the Thirties was essentially "Scandinavianized", while at the same time retaining a distinctive and purposeful, national, craft-derived resonance.

The decade also saw the practice of design become increasingly professionalized with, for example, the foundation of the Industrial Design Partnership by Milner Gray and Misha Black in 1934, as a forerunner to the Design Research Unit. The Government too was mindful of the importance of good design in relation to industrial production, and was highly active during this period in its promotion of arts allied to industry. It even instigated a series of committees focusing on the subject, which ultimately led to the establishment in 1933 of the Council for Art and Industry (the forerunner to the postwar Council of Industrial Design), which was chaired by Frank Pick. In 1938 the Royal Society of Arts introduced a new distinction: Royal Designer for Industry (RDI), bestowed on (among others) Charles Voysey and Eric Gill for their services to the design industry. The role of design in relation to consumer goods, and its potential impact on society, was becoming more widely understood, with Harold Macmillan writing in his 1938 book *The Middle Way*: "There is a clear relationship between purchasing power in the hands of the people and the demand for consumers' goods and the level of employment among workers engaged in producing those goods." There was a general feeling in Government and among design practitioners that Modernism would allow the design of a new, better, more equitable world – the problem was that the British consumer often had other ideas.

By the late 1930s Britain had – thanks to its excellent

Below: PEL Ltd advertisement
for tubular steel nesting chairs,
Punch, 1953 – this Modernist
chair had previously been
introduced in the 1930s

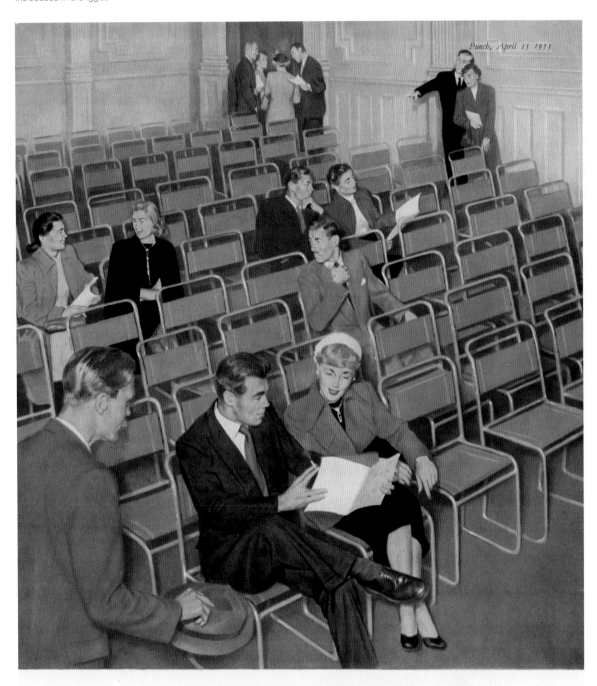

Punch, April 15 1953

It is good to know that when Pel nesting chairs furnish a hall they will go on looking good — come plays, come whist drives, come dances, come lectures — for years and years again. They are comfortable to sit upon, and easy to stack away. The first cost is small and upkeep costs are negligible because they are so well made. Illustrated catalogue on request.

PEL tubular steel nesting chairs

MADE BY PEL LTD · OLDBURY · BIRMINGHAM · A (TI) COMPANY · LONDON SHOWROOMS · 15 HENRIETTA PLACE W.1

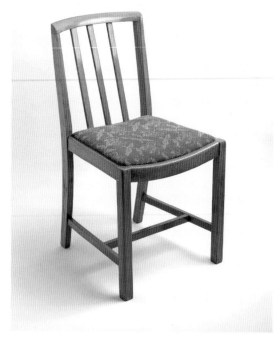

Above: Cover of *Design 46: A Survey of British Industrial Design as Displayed in the "Britain Can Make It"* Exhibition, 1946

Above: Utility Furniture Advisory Committee, *Model No. 3a* dining chair for Board of Trade Utility Furniture scheme, 1942

system of design education and the Government's tireless promotion of good design as a tool for positive change – a strong professional body of highly talented designers and engineers. They could be, and were, mobilized at the outbreak of the Second World War in 1939 to overcome the many design challenges that faced the nation, from the development of advanced military hardware to the creation of hard-hitting public information posters. During the war, all design and manufacturing activity was by necessity focused on the production of military materiel and the war effort. Because raw materials were in such short supply, the Government also had to introduce strict rationing, and eventually brought in the Utility Scheme for the design of clothing and furniture in 1941 and 1942 respectively. It was actually not until 1951, well after the cessation of hostilities, that the Utility Scheme for furniture was completely lifted. These standardized "home front" furniture pieces, designed by people like Gordon Russell and produced under the auspices of the Utility Scheme, though not particularly masterful, were solidly enough constructed and highly serviceable – blandly utilitarian Arts-&-Crafts-meets-Modernism hybrids that reflected the wartime socialism of the day.

Postwar Design & The Festival of Britain

The end of the Second World War heralded the beginning of a new chapter in British history and its story of design. Like other nations, Britain needed to help her industries adapt quickly from military production to peacetime manufacture, so that she could begin exporting goods and generating foreign revenue to supplement her seriously depleted national coffers. This was a major challenge because of the scarcity of available raw materials, but British ingenuity was employed to dramatic effect through innovative designs like Ernest Race's *BA* chair of 1945, which made use of re-smelted aluminium aircraft scrap in its construction. This design along with around 4,000 others was later included in the 1946 "Britain Can Make It" exhibition at the Victoria and Albert Museum. Critics dubbed this showcase of export-led products the "Britain Can't Have It" exhibition, because strict rationing was still in place and the goods on show were available only to foreign markets. Nevertheless, the majority of the exhibits accorded with the generally accepted criteria of "good design" and reflected the telling sentiment expressed

by Enid Marx in a survey of the exhibition: "William Morris, horrified at the prevailing ugliness, revolted against the machine. How much better if, instead, he had revolted against its misuse and directed his delight in good craftsmanship toward improving machine-made mass production." [4]

The idea for the exhibition had originally come from the President of the Board of Trade, Sir Stafford Cripps, who had from its inception insisted that the objects on show be limited to manufactured goods rather than handmade craft items. He said, "The primary object of the 'Britain Can Make It' exhibition is to prove that industrial design is by no means an impracticable and idealistic matter. Industrial design has, in fact, the most intimate connection with the comfort and happiness of our daily life. Good design can provide us in our homes and working-places with pleasant articles which combine good construction and fitness for their purpose with convenience in use and attractiveness in shape and colour." [5]

Importantly, the exhibition had a two-pronged agenda: the first and most obvious was to establish foreign markets for well-designed British products; the second was an educative remit, which was conveyed through the Design Research Unit's section entitled "What Industrial Design Means". This display attempted to demonstrate to the British public the entire stage-by-stage process of designing an object for industrial production, by tracing the development of an egg-cup, from initial concept to finished product. It ended with a speech bubble emerging from the eggcup with the words: "So you see designing me, Is as tricky as can be: A thousand other problems lie, In every object you may buy".

A similar light-hearted approach to design education was taken five years later in 1951 at the Festival of Britain, which was rather tellingly described by the historian David Thomson as "a national folk-festival in modern idiom". [6] Marking the centenary of the Great Exhibition, the Festival was, like its Victorian predecessor, a popular and well-received celebration of national accomplishment in the fields of science, technology, industrial design, architecture and the arts. Patriotic to its core and exuding a sense of national confidence, the yearlong Festival was a much-needed morale boosting "tonic for the nation", as well as a catalyst for modern design. After coming through two battering world wars and a prolonged interwar recession, Britain was now ready to look forward optimistically to a brighter and more modern future. This was most emphatically demonstrated at the Festival's centrepiece, the South Bank Exhibition

overlooking the River Thames. Here was the newly built Royal Festival Hall, the futuristic Dome of Discovery and a host of pavilions, as well as the soaring Skylon sculpture which appeared to float above the ground and became an enigmatic symbol of the event.

During the Festival, the South Bank Exhibition attracted nearly eight and a half million visitors, many of whom visited the Design Review display designed by Neville Conder and Patience Clifford. The organizers of the Festival felt that the earlier Great Exhibition had failed in its central mission, as it didn't lead to any noticeable improvement in the standards of industrial design and consequently industrial manufacture. Determined that history should not be allowed to repeat itself, they instead took a far more selective approach to what was shown in the Festival's Design Review section. As Gordon Russell, by now Director of the Council of Industrial Design, wrote, "An avowed aim of the Festival of Britain is to show a high standard of industrial design. How shall we define this? I would say that a well-designed industrial product would be made to serve a particular and useful purpose. It would be designed so that it could be made economically, of good and suitable materials, by normal machine processes and sold through normal trade channels... It should give pleasure in use. Design... is recognized as an integral part of quality, which can no longer be thought of as good workmanship and good material only. In fact, good design should be regarded as one of the consumer's guarantees of quality." [7]

The Festival's Design Review section had displays dedicated to furniture, lighting, domestic appliances, tableware, home electronics, travel goods, Festival souvenirs, packaging, dress fabrics, fashion accessories, footwear, toys, farm equipment, machinery, laboratory equipment, motorcars, bicycles, commercial vehicles, trains, aeroplanes, ships and communications equipment. All of these reflected the CoID's desire for well-made, well-designed products that embodied a forward-looking, practical utility. It was however Ernest Race's *Antelope* chair, designed for the outdoor terraces of the South Bank Exhibition, that perhaps most memorably communicated the Festival's contemporary "new look" spirit, with its looping steel rod construction and its curious atom-like ball feet.

Significantly, a new generation of designers, many of whom had either recently graduated from the Royal College of Art or were still studying there, were emboldened not only by the designs they saw on show at the Festival but also by the underlying message about the importance of good design. After the

overwhelming success of the Festival and over the following few years a distinctive, contemporary style of design grew strongly in popularity, and young designers such as Lucienne Day, Robin Day, David Mellor, Robert Welch, Terence Conran and Robert Heritage all produced work that expressed this new and modern mid-century aesthetic, itself a reflection of the growing confidence felt in Britain, especially with the coronation in 1953 heralding the dawn of a new Elizabethan Age. In 1957, the Prime Minister, Harold Macmillan, made an optimistic speech to a Conservative rally in which he stated: "most of our people have never had it so good". It was certainly true that the grim years of austerity and utility had been replaced by a consumer-led society of growth and employment, of bright textiles and modern furnishings, of televisions and modern labour-saving appliances.

Pop Design & Youth Culture

If the winds of change had fluttered the patriotic bunting at the Festival of Britain in the early Fifties, by the beginning of the 1960s they had become a powerful gust as Soho's fledgling advertising industry grew in stature and professionalism, and Britain's burgeoning music and fashion scene underwent a demographic shift toward a more youthful audience. This generational displacement of power and influence soon saw London becoming the epicentre of the Swinging Sixties. As the design historian Fiona MacCarthy put it: "There was an obvious feeling of the new day dawning and a sudden, reckless, very general enthusiasm, even among erstwhile caretakers of purism, for the fashionable, ephemeral and zany... The style of the times was, at its most apparent, a rather knock-out style of ostentatious verve and jollity."[8]

This new Pop *Zeitgeist* in Britain was crucially fuelled by the introduction in 1962 of the Sunday Times's "colour supplement", the first of its kind. In its quest for new and exciting content to fill its pages each and every week, along with other lifestyle journals it helped to promote a stylistic pluralism in design that seemed to reject the dominance of good taste and state-promoted "good design" in favour of bold and eye-catching consumer products. By the early 1960s two-thirds of British households owned a television, which also helped to accelerate a surge in consumption. The British public had simply become bored with sensible rationalism; they no longer wanted or required "definitive" design solutions. Driven by the

tastes of a younger demographic, consumers now desired a steady stream of the type of inexpensive and expendable product that suited more casual lifestyles. The opening in 1964 of Terence Conran's first Habitat store on Fulham Road in London, with its warehouse-like retail space packed and stacked with affordable flat-pack furniture and a bazaar-like array of constantly changing cookware and accessories, was a concrete expression of this spirit. It could reasonably be argued that Conran and his fashionable emporium did more to bring modern design into people's everyday lives than the previous decades of worthy "good design" promotion had ever done.

The Design Centre in Haymarket, established in 1956, continued to display the best of British design and innovation, while the Duke of Edinburgh Prize for Elegant Design (later becoming known as the Prince Philip Designers Prize), founded in 1959, also became highly instrumental in promoting British design excellence during the 1960s. At the same time the head of the Design Council, Paul Reilly, acknowledged in an article entitled "The Challenge of Pop" that "We are shifting perhaps from attachment to permanent, universal values to acceptance that a design may be valid at a given time for a given purpose ... All that means is that a product must be good of its kind for the set of circumstances for which it has been designed. For example, in this age of accelerating technology to refuse to take notice of the transitory or to reject the ephemeral per se is to ignore a fact of life." [9] This acceptance of the inevitable was no more emphatically demonstrated than when Peter Murdoch's paper furniture won a Design Council Award in 1968.

But during the 1960s British designers, unlike, say, their French or Italian peers, for the most part created work that had a distinct residual trace of good design in its DNA, whether it was Kenneth Grange's *Insta-matic 33* camera, or Robin Day's ubiquitous *Polyprop* chair, or Robert Welch's *Alveston* tea set. What made these products stand out from earlier British designs was the extraordinary sophistication of both form and function – a sublime marriage of exquisite engineering with refined aesthetics. The design that captured the seismic lifestyle changes in Britain better than any other was probably Alec Issigonis's small yet perfectly formed *Mini*, a truly "classless" car whose diminutive boxy form and fun, zippy handling stylishly and fashionably expressed the youthful, liberal spirit of Swinging London. During this era of unprecedented social change, the work of British designers mirrored the shift from a Government-sponsored

Right: cover of *Design in the Festival*, 1951

Below: Habitat catalogue for 1977–78 – bringing good design into the lives of the British public

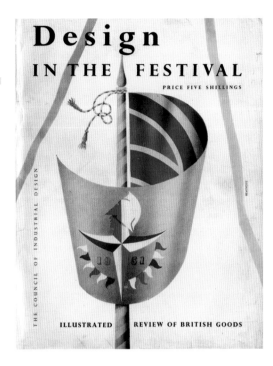

"form-follows-function" doctrine to a more open interpretation of good design, which reflected the desires of a voracious consumer-led society that was becoming increasingly design-literate.

High Tech, Creative Salvage & A New Internationalism

The heady bubble of Pop was dramatically burst by the Oil Crisis of 1973 and the ensuing economic downturn. In its wake a new rationalism swept across the landscape of international design practice. In Britain, this was manifested in the emergence of the High-Tech style with its industrial-chic aesthetic; Rodney Kinsman's *Omkstak* chair and Fred Scott's *Supporto* task chair became ubiquitous icons of this new and starkly neo-modernist look. Collier-Campbell's *Bauhaus* textile for Liberty also reflected a reassessment of the Modern Movement's contribution, being itself a colourful reinterpretation of an original Bauhaus tapestry. However, these were notable highlights in British design during the early 1970s, and for the most part blandness was the hallmark of the design mainstream as manufacturers cut their research and development budgets and opted to produce safe, conservative products in the face of an uncertain and constraining economic climate.

Paradoxically, during the 1970s there was also a return to craft-design, which was the antithesis of not only the High-Tech style, but also the "have-it-today-and-sling-it-tomorrow" consumerist ethos of the previous decade. Craft revivalists such as John Makepeace attempted to preserve the British craft tradition that had undergone such a battering from modern industrial production. At the same time, the popularity of craft-design during the 1970s was a reflection of a new eco-awareness. This was the heyday of Habitat, with the company opening its flagship store on the King's Road in 1973 and Terence Conran publishing *The House Book* in 1974; yet by the late 1970s a new and virulent rebellion against the status quo, with its flat-pack furniture, fluffy duvets and chicken-bricks, was gathering pace in the form of Punk fashion and music – and also in design, as dramatically demonstrated by Jamie Reid's anarchic 1977 cover for the Sex Pistols' *God Save the Queen* single. The deep economic recession of the 1970s and its high unemployment rates had created a generation of disenfranchised youth that was deeply sceptical of the Establishment; like any self-respecting teenager, it rebelled

against imposed constraints and attempted to find its own unique form of expression.

In the wake of Punk, the 1980s saw the emergence of the Creative Salvage movement, which had a similarly rough-and-ready aesthetic and anti-mainstream agenda. Designers such as Tom Dixon, Ron Arad and Mark Brazier-Jones began creating designs from *objets trouvés*, found objects, roughly welded together. This hands-on approach gave these young designers a practical understanding of materials and processes that would, crucially, have a huge bearing on their later, more mature and refined work, such as Arad's *Big Easy* chair from 1988. The Thatcherite revolution would also impact on how design developed in Britain during the Eighties. Not only was Margaret Thatcher Britain's first female prime minister, she was also acutely aware of the link between design and industry, and it was under her political watch that the London Institute (later to become University of Arts London) was created in 1988, bringing together Central Saint Martins College of Art and Design,

Camberwell College of Arts, Chelsea College of Art, London College of Printing (later to become London College of Communication), and London College of Fashion as specialized centres of excellence within the different areas of art and design. Another defining moment for the development of British design was the opening of the Boilerhouse Project exhibition space at the Victoria and Albert Museum in 1981, under the directorship of Stephen Bayley and operated independently by the Conran Foundation. It ultimately led to the establishment of the Design Museum in Butler's Wharf in 1989 – the world's first museum devoted entirely to the promotion and examination of design.

Although Margaret Thatcher had promoted British design and innovation abroad and the importance of design education, she also administered a steady decline of the country's unionized manufacturing base in favour of a "cleaner" service-sector economy. To some extent this led to a new internationalism in British design, as designers were forced to find overseas clients to manufacture their products.

Below: Jonathan Ive (and the Apple Design Team), *iPhone* for Apple, 2007

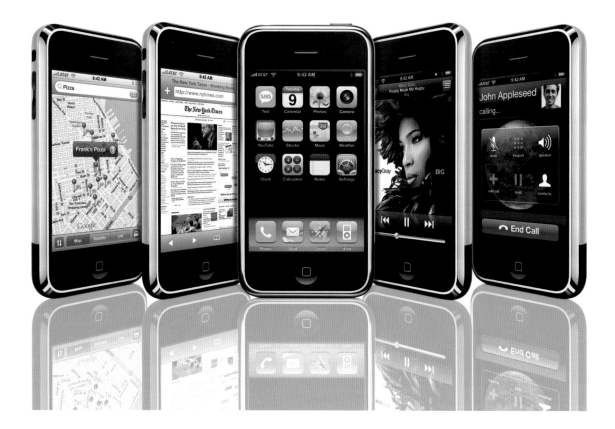

Indeed, the 1990s saw the emergence of a new generation of highly skilled British designers who, although located in London, were working for companies based all over the world. These design superstars, including Ron Arad, Ross Lovegrove, Tom Dixon, Sam Hecht and Jasper Morrison, were hugely influential in solidifying the pre-eminence of British design on the world stage. Another British designer who showed that British design and engineering ingenuity were still flourishing was James Dyson, whose vacuum cleaners went on to become world-beating products. Importantly, Jonathan Ive, although working in America, was able to bring a uniquely British design sensibility to the products he helped develop for Apple – another milestone in the internationalization of British design.

The "Cool Britannia" phenomenon of the late 1990s certainly helped to focus world attention on Britain's renewed creative energy, whether it was Brit Pop music, YBA art installations or cutting-edge design. Tony Blair's newly elected Labour government latched on to this trend for all things British, and added to the hype by courting the highest-profile protagonists from the various fields of creative endeavour. Meanwhile the previous government had elected to mark the millennium with the building of a Richard Rogers-designed exhibition space in Greenwich, but it was left to the new government to decide what went into the Millennium Dome. Regrettably, their good intentions led to a PR disaster: the exhibits were, as the social historian Ed Glinert was inclined to note later, "the epitome of dumbed-down Blair-era vacuousness"[10].

Nevertheless, British design continued to grow in stature during the "noughties" and beyond. British designers set a pace that the world strove to match,

embracing state-of-the-art technologies and imaginatively applying them to the creation of products that showed a distinctive British refinement. Ross Lovegrove's super-formed aluminium *Muon* loudspeakers, Jasper Morrison's gas-assisted injection-moulded *Air-Chair*, Tom Dixon's vacuum-metalized *Copper Shade* light, Thomas Heatherwick's rotationally moulded *Spun* chair - all of these echo certain long-held British design traits: superb engineering precision, innovative use of materials, mindful logical elegance and graceful gestural lines; and all, ultimately, hark back to William Hogarth's serpentine "Line of Beauty".

Today, British design education is generally regarded as the best in the world, and its renowned centres of excellence continue to equip graduates from all around the globe with the creative and technical skills needed to compete at the highest level. As British design continues to expand its international foothold through both practice and education, so the importance of its inherent attributes – purposefulness, beauty and quality – becomes evermore apparent. It is British designers' innate understanding that good design is essentially about providing people with practical, honest, affordable, durable and attractive things, which has long guided its most celebrated practitioners, from Josiah Wedgwood and William Morris to Robin Day and James Dyson. Throughout its illustrious history, British design has uniquely wrought the perfect balance between craft and industry, and it is the ability of the nation's designers to find the precise sweet spot between these opposing themes that has made British design ultimately so great – as so exquisitely demonstrated by the selection of masterpieces in the coming pages.

Footnotes

1. Gloag, J., *The English Tradition in Design*, p.8
2. Heskett, J., *Industrial Design*, p.20
3. Bayley, S. (ed.), *The Conran Directory of Design*, p.24
4. *Design 46 – A Survey of Industrial Design as Displayed in the "Britain Can Make It" Exhibition Organized by the British Council of Industrial Design*, p.87
5. Ibid. p.5
6. Thomson, D., *England in the Twentieth Century*, p.229
7. *Design in the Festival: Illustrated Review of British Goods*, The Council of Industrial Design, London, p.11
8. MacCarthy, F., *British Design since 1880: A Visual History*, p.143
9. *Architectural Review*, Issue 142, October 1967, p.255–59
10. Glinert, E., *The London Compendium*, p.427

Overleaf: *Supermarine Spitfire Mk IXB MH434*, flown by Mark Hanna in 1998 – perhaps the most famous of all *Spitfires* still flying today.

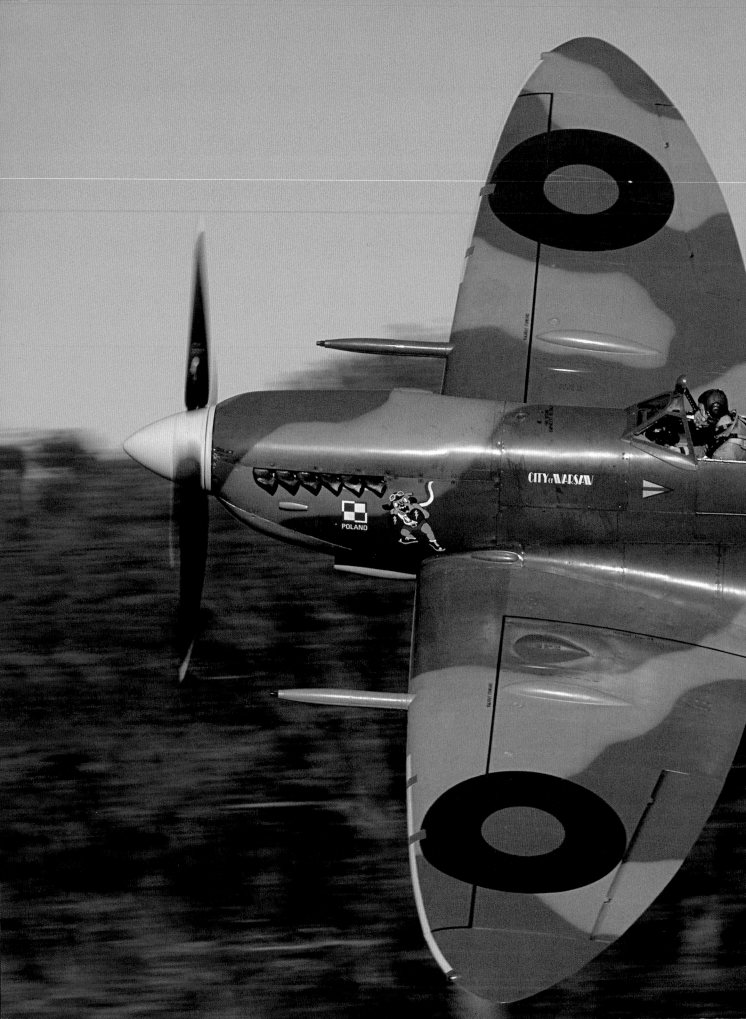

Abraham Darby (c.1678–1717)
Cast iron cooking pot, c.1710s

Common Pot.
Wine measure.
$\frac{1}{4}$ $\frac{1}{2}$ $\frac{3}{4}$ 1 $1\frac{1}{4}$ $1\frac{1}{2}$ $1\frac{3}{4}$ galls. each.

Negro Pot, with long legs.
Wine measure.
$\frac{1}{4}$ $\frac{1}{2}$ $\frac{3}{4}$ 1 $1\frac{1}{4}$ $1\frac{1}{2}$ $1\frac{3}{4}$ galls. each.

Oval Pot.
Wine measure.

per gallon.
2 to 4 galls., rising $\frac{1}{2}$ gall.,
4 to 10 ,, ,, 1 ,,
10 to 20 ,, ,, 2 ,,
20 to 80 ,, ,, 5 ,,
 or per cwt.

per gallon.
2 to 4 galls., rising $\frac{1}{2}$ gall.,
4 to 10 ,, ,, 1 ,,
10 to 20 ,, ,, 2 ,,
20 to 80 ,, ,, 5 ,,
 or per cwt.

per gallon.
2 to 4 galls., rising $\frac{1}{2}$ gall.,
4 to 10 ,, ,, 1 ,,
10 to 20 ,, ,, 2 ,,
 or per cwt.

Above: Coalbrookdale cast iron cooking pots from Coalbrookdale Company Catalogue, 1875

The origins of the Industrial Revolution are perhaps much earlier than most people suppose, in a small town in Shropshire. For it was here in Coalbrookdale that Abraham Darby pioneered the use of coke to fuel blast furnaces in the smelting of iron ore, thereby revolutionizing the production of iron. In 1707 Darby patented a method of casting iron cooking pots whereby re-usable patterns were used to make sand-moulds, into which the molten iron was poured and then cast. This meant that the cooking pots could be mass-produced at a relatively low cost, and since most cooking in the early eighteenth century was performed over open fires, there was huge demand for them. In fact, they became the staple product of the Coalbrookdale Company and were exported throughout the world.

Darby also patented his method of producing the first marketable pig iron from a coke-fired furnace. Coke-fired iron was of a much higher grade than charcoal-fired iron, as it was smelted at higher temperatures and therefore had far fewer impurities. Crucially, the superior quality of Darby's iron meant that it could be cast into thin sheets and so could compete with brass in the manufacture of all kinds of wares, including, of course, the humble cooking pot.

As the earliest and most successful products manufactured by the Coalbrookdale foundry, these pot-bellied cast-iron vessels are generally regarded as the earliest British designs to be industrially mass-produced, and as such are important artifacts of Britain's proud industrial heritage. The foundry went on to produce the first iron rails for railways, the first iron boat and the first steam-locomotive, as well as the components for the famous cast-iron bridge designed by Thomas Pritchard not far from Coalbrookdale. Spanning the River Severn, the Iron Bridge erected by Darby's grandson Abraham Darby III between 1777 and 1779, was the very first of its kind in the world.

Throughout the eighteenth and nineteenth centuries, Coalbrookdale remained a major centre of iron production, fuelling the progress of British industry and consequentially British design. As the birthplace of the Industrial Revolution, Coalbrookdale is now a World Heritage Site, while the utilitarian black cauldrons produced there can be seen to be where the story of modern industrial design in Britain really began, over three hundred years ago.

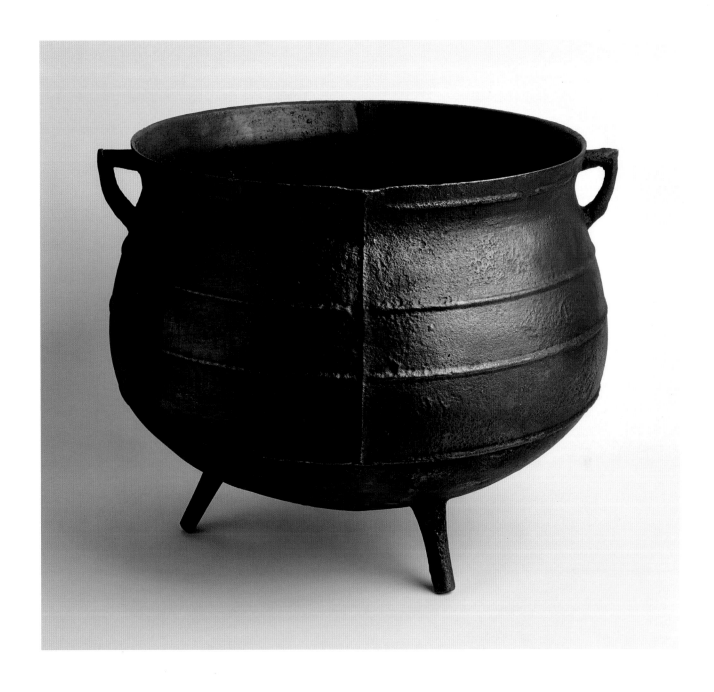

Josiah Wedgwood (1730–1795)
Queen's Ware (Creamware), 1765

Acclaimed as the "Father of English Potters" and one of the great pioneers of the Industrial Revolution, Josiah Wedgwood was the youngest of 12 children, whose family had been potters since the seventeenth century. After the death of his father the young Josiah spent some years working for the family pottery and at the end of a five-year apprenticeship with the well-established potter Thomas Whieldon, the two went into partnership. During this early period of his career, Wedgwood began to make a precise record of his various experiments in ceramics manufacturing, which included a successful formula for a distinctive green glaze.

In 1759 he established his own small factory at the Ivy House Works in Burslem, rented from a relative. There he produced high-quality cream-coloured earthenware, which he later noted was "quite new in appearance, covered in a rich and brilliant glaze". This "creamware" had the added benefit of being able to withstand sudden changes of temperature and, just as important, was relatively easy to manufacture and so reasonably priced.

After Queen Charlotte, wife of George III, specially ordered a tea and coffee service of this warm cream-coloured earthenware, Wedgwood used this royal patronage as an excuse to re-brand it *Queen's Ware* in 1765. Ever the canny businessman, Wedgwood also proudly styled himself "Potter to Her Majesty", which brought considerable cachet to his simple yet functional wares. As C. L. Brightwell later noted in *Heroes of the Laboratory and the Workshop*, "This illustrious patronage rendered the beautiful novelty so popular, that orders flowed in upon its successful inventor faster than he could execute them".

Attractive and well-finished, *Queen's Ware* was also an extremely versatile range of ceramics that could either be left plain or decorated with incised, transfer-printed or hand-painted patterns and motifs. Its innate durability and practicability ensured that it became the standard domestic pottery not only in Britain but around the world. Because it could survive abrupt alterations in temperature, *Queen's Ware* was especially suited to the new vogue of tea drinking, which itself substantially increased the demand for pottery during this period. At the same time, the simple yet refined forms of *Queen's Ware* not only made it

Above: engraving of Etruria published by William MacKenzie, showing the main Wedgwood factory, opened in Stoke-on-Trent in 1769

eminently suitable for large-scale mass-production, but also meant that it was utterly in tune with the emerging Neo-Classical style and as such extremely fashionable. In order to meet growing demand for *Queen's Ware* and his other ceramic ranges, in 1764 Wedgwood moved his potteries to the larger Brick House Works in Burslem, whose canal-side location offered a safer and cheaper means of transport to market than pack-horses or carts. It was here that he also famously pioneered efficient modern manufacturing processes – including the logical division of labour, better training of the workforce and the rationalization of production methods – as well as instigating new and innovative marketing techniques. Hugely influential, the Wedgwood factory was a veritable powerhouse of British innovation and invention during the eighteenth century (and indeed throughout the nineteenth and twentieth centuries), its beautiful yet simple *Queen's Ware* forming the firm's commercial bedrock. It was this design's astonishing commercial success that allowed other more ornamental wares to be researched and developed, including Wedgwood's well-known and highly successful cameo-like *Jasperware*.

Josiah Wedgwood (1730–1795)
Queen's Ware (Creamware), 1765
(Example shown: dinner-service, c.1790)
Glazed ceramic
Josiah Wedgwood & Sons Ltd, Burslem, Stoke-on-Trent, England

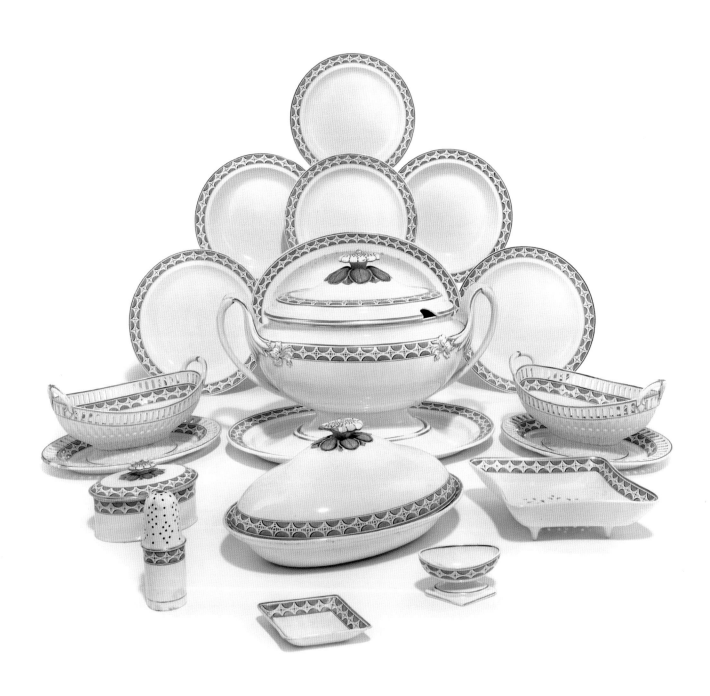

Sir Humphrey Davy (1778–1829)
Mining lamp, 1815

One of the great heroes of British design innovation, Sir Humphrey Davy was apprenticed at the age of seventeen to an apothecary in Penzance with a view to pursuing a career in medicine. He found, however, that he preferred undertaking chemical experiments in his makeshift laboratory at home, and this hands-on research into, among other things, nitrous oxide (laughing gas), eventually led to his appointment as chemical superintendent of the Pneumatic Institution in Bristol, which was set up to study the medical effects of recently discovered gases.

It was at the institution that he began to look into the therapeutic nature of various gases, especially compositions of nitrogen. This interest in analytical chemistry led him not only to discover and name sodium and potassium, but also to identify the elemental nature of both chlorine and iodine.

It was, however, his design of the famous "safety lamp" that was ultimately to be of greatest benefit to society. One of the most daunting hazards of mining was the possibility of a fire-damp explosion, which often led to catastrophic loss of life. The explosion would be caused by naturally-occurring underground pockets of volatile methane that were ignited by the naked flames of candles and other types of lanterns used by miners to illuminate the tunnels. In 1812, there was a major explosion at the Felling Colliery near Sunderland which caused the deaths of 92 miners, and it was this devastating incident that led to the formation of the Society for the Prevention of Accidents in Coal Mines, whose members asked Davy to direct his expert attention to this pressing subject.

Davy's research led him to find that "gauze of wire, whose meshes were only one twenty-second of an inch in diameter stopped the flame, and prevented the explosion. The candle or lamp being wrapped in such gauze, and all access to the external air prevented, except through the meshes, the lamp may be safely introduced into a gallery filled with fire-damp." His lamp comprised a wick connected to an oil reservoir, which was then sheathed in a double-layered metal gauze chimney that not only confined the flame, but also conducted the heat of the flame away from the light source.

Davy did not patent his invention but allowed it to be copied by various manufacturers, thereby forgoing a rich profit; however, as he noted later, "My sole object was to serve the cause of humanity; and I am amply rewarded by the reflection that I have been enabled to do so." Certainly, the social value of the Davy lamp was widely acknowledged and led to Davy being knighted in 1818, elected president of the Royal Society in 1820 and awarded the Royal Society's Royal Medal in 1826.

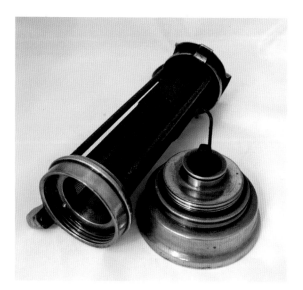
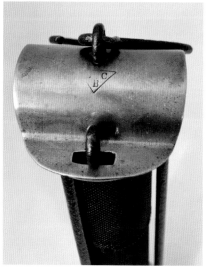

Far left and left: Details of Joseph Cooke of Birmingham mining lamp.

Humphrey Davy (1778–1829)
Mining lamp, 1815
Metal, metal gauze, cotton wick
Various manufacturers (example shown here produced by Joseph
Cooke of Birmingham)

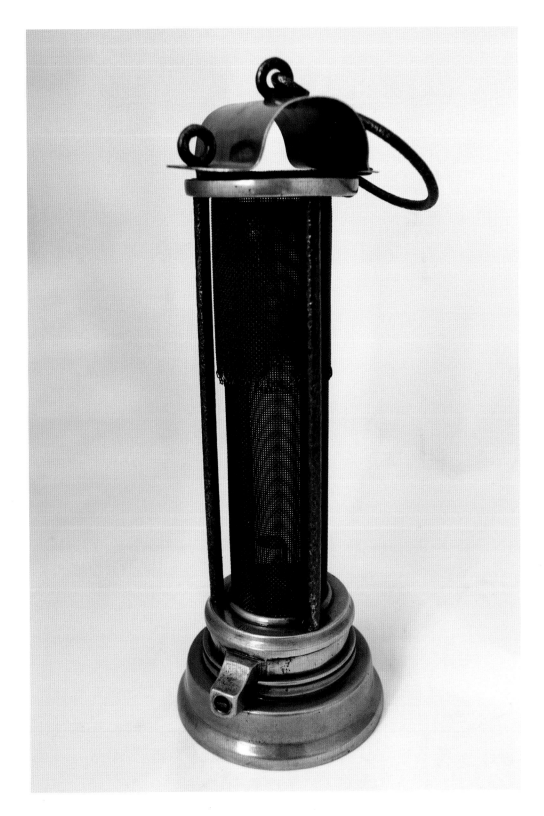

George Stephenson (1781–1848)
Rocket locomotive engine, 1829

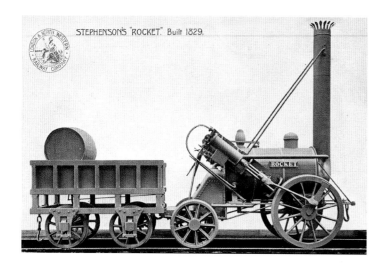

STEPHENSON'S "ROCKET". Built 1829.

Left: early postcard of Stephenson's *Rocket* locomotive, c.1900 – showing its cylinder pistons that drove the wheels and also its tender (coal-car)

The *Rocket* locomotive was one of the great landmarks of the Industrial Revolution. Its design heralded the railway age, and in so doing changed the way people lived throughout the world.

George Stephenson, who was the designer of this groundbreaking invention, was lucky enough to get a rare early insight into cutting-edge steam-engine technology, because his mechanic father operated one of the new steam engines designed to pump water out of coalmines, the *Newcomen*. It was a formative experience for George that was furthered when as a 19-year-old, he was himself put in charge of one of these revolutionary new water-pumping engines. This experience eventually led to his appointment in 1812 as "enginewright" at the Killingworth High Pit colliery.

The following year he visited the nearby Middleton colliery to view John Blenkinsop's "steam boiler on wheels", a device for hauling heavy coal-laden trucks out of the mine. It was after seeing this early engine that Stephenson developed the *Blucher*, his first steam-powered locomotive, in 1814. This design was not particularly successful until Stephenson added a funnel for the waste steam, which helped to double the engine's power.

His next effort was the *Killingworth* engine, an improvement on the last, which had the additional benefit of an innovative sprocket and chain-drive. Stephenson spent the succeeding years refining his engine design until in 1821 he was commissioned to manufacture a proper steam locomotive for the newly constructed Stockton to Darlington line. The result, the *Active* as it was known, pulled the world's first public passenger train on 27 September 1825. It later became known as the *Locomotion* and could carry up to 450 passengers at a speed of 15 miles an hour. Stephenson was subsequently given the job of surveying and constructing a new railway line from Liverpool to Manchester, and as completion approached in 1829 the famous Rainhill Trials were held at Rainhill, Lancashire (now Merseyside) to decide whether it would be better to use stationary steam engines or locomotives to pull the trains.

The competition's first prize of £500 was awarded to Stephenson for his design of a new and improved locomotive engine – the legendary *Rocket* – which managed to attain a top speed of 36mph along a two-mile stretch of track and back. This new and pioneering design featured single-drive wheels on both sides which were coupled to a steam cylinder on either side of the firebox. When the Liverpool-to-Manchester line eventually opened in September 1830, eight *Rockets* were put into service, having been built at Stephenson's works in Newcastle. Almost immediately, the *Rocket* came to embody the exciting progress of the Industrial Revolution, which witnessed the dramatic transition from horse power to steam power. As the world's first modern steam train, the *Rocket* also brought widespread fame to its inventor, who is still fittingly remembered as "The Father of the Railways".

George Stephenson (1781–1848)
Rocket locomotive engine, 1829
(This image shows the incomplete remains of the original *Rocket* without its tender)
Iron, wood, various other materials
Messrs. R. Stephenson and Co., Newcastle-upon-Tyne, England

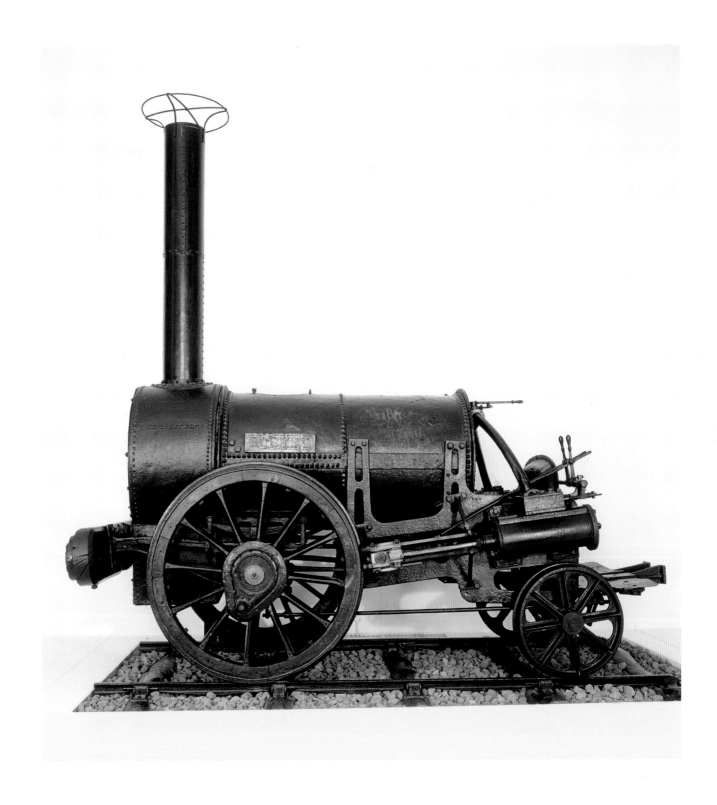

Edwin Budding (1795–1846)
Model No. 3157 lawn mower, 1830

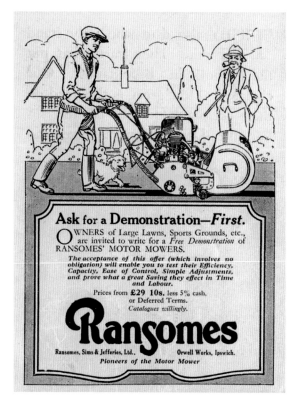

Ask for a Demonstration—*First.*

OWNERS of Large Lawns, Sports Grounds, etc., are invited to write for a *Free Demonstration* of RANSOMES' MOTOR MOWERS.

The acceptance of this offer (which involves no obligation) will enable you to test their *Efficiency, Capacity, Ease of Control, Simple Adjustments,* and prove what a great *Saving* they effect in *Time* and *Labour.*

Prices from **£29 10s.** less 5% cash, or Deferred Terms.
Catalogues willingly.

Ransomes

Ransomes, Sims & Jefferies, Ltd., Orwell Works, Ipswich.
Pioneers of the Motor Mower

Above: Ransomes advertisement showing an evolution of Budding's "motor mower", 1932

Edwin Beard Budding's grass-mowing machine – with the help of an innovative system of gears which allowed the blades on the cutting cylinder to rotate 12 times faster than the large rear roller – did the work of six men. Budding introduced to the world the perfect, English, carpet-like, green lawn.

An engineer from Stroud in Gloucestershire, Budding caused his neighbours so much concern with his strange contraption that he was reputedly forced to test it at night so no one could see what he was up to. His concept for the basic mechanical principle behind the lawn mower came from a visit to a local cloth mill, where he saw a bench-mounted, rotating cutting cylinder being used to trim the irregular pile from woollen textiles in order to give their surface a smooth finish after weaving. Budding realized that he could adapt this concept to cut grass by mounting the rotating bladed reel in a wheeled frame, in such a way that the cutting edge of the blades would be close enough to the lawn surface to cut the grass to a required length.

Budding's lawn mower was constructed of cast iron and had spur gears connecting the main roller to the cutting blades. In 1830, he went into partnership with John Ferrabee, who funded development and paid for this new invention to be patented, in return for the rights to manufacture it. The machine's production was subsequently licensed to other companies, most notably, J. R. & A. Ransomes of Ipswich, who put this landmark grass-cutting machine into production in 1832.

The resulting *Model No. 3157* lawn mower was a two-man mower: in order to operate it one man was needed to pull it from the front, while another pushed it from behind. It was originally intended for cutting the grass of sports grounds, large gardens and public parks, with Regent's Park Zoological Garden in London being an early client. Certainly, it was a better-performing and more time-efficient alternative to the scythes that had been used up till then.

Budding's lawn mower was advertised with the message "Gentlemen will find my machine an amusing & a healthy exercise, plus do the work of 6 men". Over the following decades, the *Model No. 3157* served as the essential blueprint for subsequent variants that became increasingly lighter and easier to use. Importantly, like so many great British inventions, Budding's lawn mower was based on a proprietary engineering concept that would eventually become a successful game-changing product.

THE HENLEY COLLEGE LIBRARY

Edwin Budding (1795–1846)
Model No. 3157 lawn mower, 1830
Painted cast iron
J.R. & A. Ransomes, Ipswich, Suffolk, England

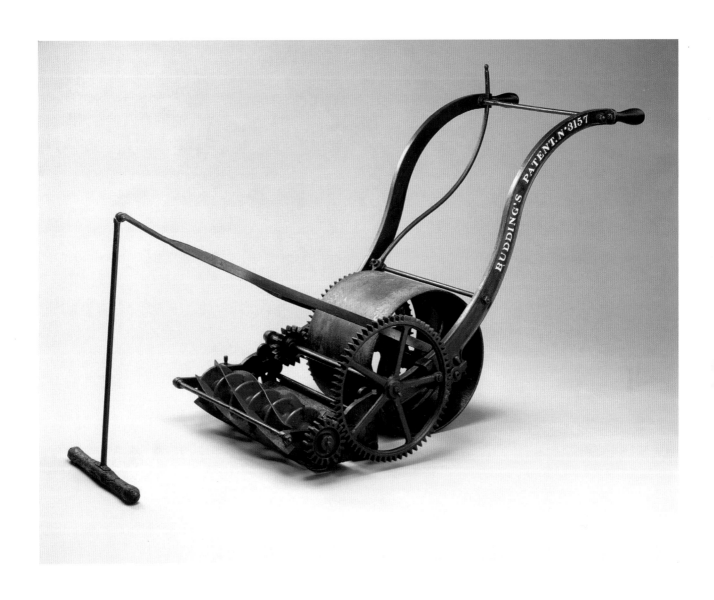

Augustus Welby Northmore Pugin (1812–1852)
Waste Not, Want Not bread plate, 1849

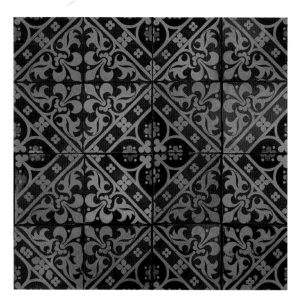

Above: encaustic tiles designed by A. W. N. Pugin for Minton & Co., 1847–50

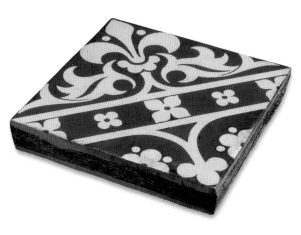

Above: encaustic tile designed by A. W. N. Pugin for Minton & Co., 1847–50 – showing sectional view of tile

A. W. N. Pugin was the first great design reformer of the nineteenth century. His deeply held religious convictions profoundly influenced his approach to architecture and design; he consistently rallied against the falsehood of superfluous ornament, and in his seminal treatise, *True Principles of Pointed or Christian Architecture* (1841), wrote that in the design of buildings, "the smallest of detail should have a meaning or serve a purpose".

He applied this sentiment equally to the design of objects, including his famous *Waste Not, Want Not* bread plate which he designed for Minton in 1849. Exhibited at the Birmingham Design Exhibition the same year, this was by far the most important domestic ware created for Minton by Pugin using the encaustic process. The encaustic technique had been used in medieval times to make floor tiles, and involved using inlays of different coloured clays, rather than surface glazes, to create patterns on the tiles.

This revived manufacturing process was, of course, "fit for purpose" when applied to the design of a bread plate, because unlike a surface-coated glaze, the encaustic pattern was an inherent part of the ceramic body and was therefore not affected by knife cuts caused by the slicing of bread. The motto – "Waste Not, Want Not" – running around its edge was also a suitably meaningful form of decoration given the intended function of the design.

Minton produced a basic three-colour earthenware version of this famed design and also a superior six-clay model, as well as, somewhat surprisingly, a glazed majolica variant. Although today the *Waste Not, Want Not* plate is seen as a seminal Gothic Revival design, it was dismissed by some critics at the time of its introduction, with one declaring: "The bread plate is made on the encaustic tile principle, very dark and massive in colouring, and disagreeably associating with the bread. The design might well do for a pavement, but it is rude and coarse, and unfit for an object immediately close to the eye on the table."

Certainly the motto that encircles this magnificent example of nineteenth century "art manufactures" embodies the very essence of nineteenth century design reform, and as such the genus of the moral philosophy that underpinned the Modern Movement.

Augustus Welby Northmore Pugin (1812–1852)
Waste Not, Want Not bread plate, 1849
Encaustic earthenware
Minton & Co., Stoke-on-Trent, England

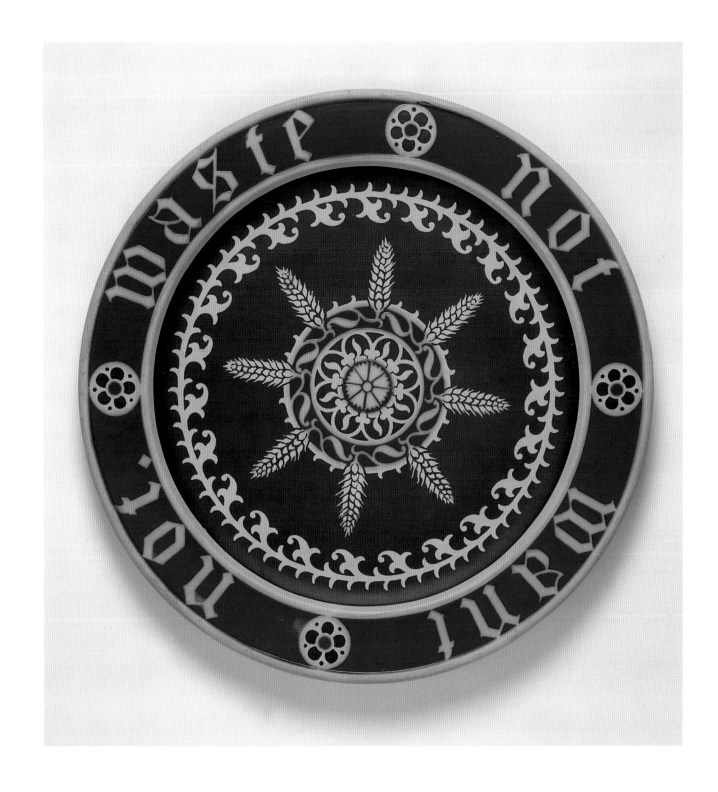

Augustus Welby Northmore Pugin (1812–1852)
Table for Horsted Place, Sussex, 1852–53

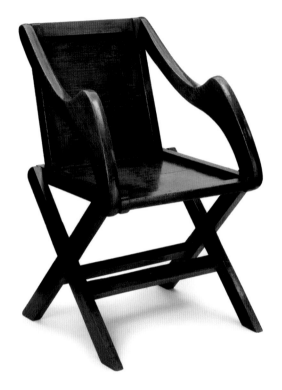

Above: *Glastonbury* oak chair designed by A. W. N. Pugin, 1839–41 – showing similar "revealed construction"

A. W. N. Pugin was by far the most prominent, influential and outspoken Gothic Revivalist of the nineteenth century, responsible for innumerable sumptuously detailed buildings, as well as their exquisitely complex interiors and finely executed fittings.

Like his architect father, Augustus Charles Pugin, he also designed an amazing array of furniture in the Gothic style, but the younger Pugin's work had a far greater sense of muscularity and functional purpose in that it was a three-dimensional realization of his religiously inspired, design-reforming zeal.

Pugin advanced two important and memorable principles for architecture – which applied equally well to the design of objects – in his influential 1841 book, *True Principles of Pointed or Christian Architecture*: "1st, that there should be no features about a building which are not necessary for convenience, construction, or 'propriety'; 2nd, that all ornament should consist of enrichment of the essential construction of a building". This essentially meant that you could ornament construction, but you should not construct ornament.

The table he designed for Horsted Place in Sussex in the mid-1800s beautifully epitomizes this dictum, with its X-shaped supports, fine, detailed chamfered decoration, and carefully bevelled edges. The house for which this design was specially created had been commissioned from the architect George Myers by one Francis Barchard Esq, but Pugin was responsible for much of its furniture and interior detailing. With its central stretcher echoing the form of a Gothic ogee arch, the table's design has a strong architectural quality.

The work was executed by the London-based manufacturer John Webb, who also made the furniture for Pugin's most important commission, the Palace of Westminster. In this and other similarly designed tables, also featuring robust revealed constructions, and exuding a sense of honesty and simplicity, Pugin's designs contrasted dramatically with the overly ornamented work of his High Victorian contemporaries. Throughout his career he sought what he described as the "True Thing", by which he meant a moral integrity in design and architecture that was informed by practical function, and which possessed an inherent beauty derived from such an approach. As an early and important design reformer, his achievement was immense and his influence was felt widely among successive generations of architects and designers.

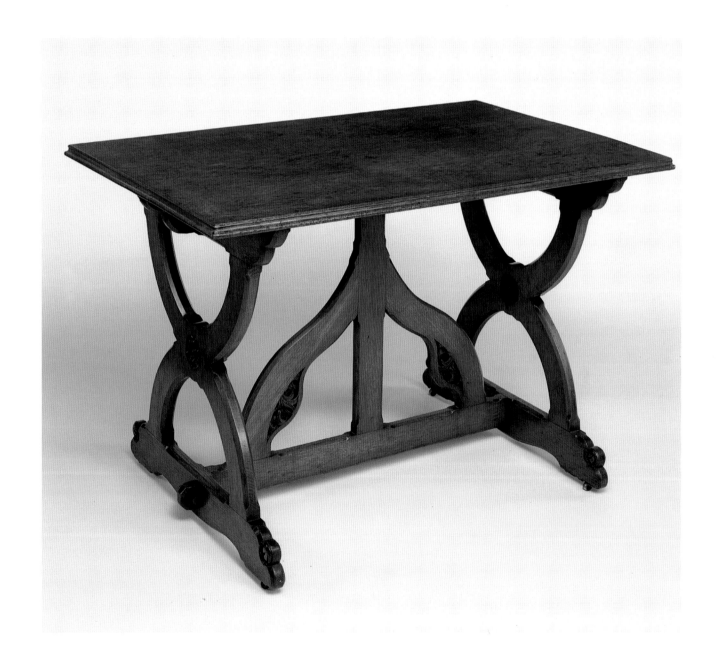

Philip Webb (1831–1915) (attributed)
Sussex armchair, c.1860

For many years the design of the *Sussex* chair was attributed to William Morris, but in all likelihood it would have been designed by Philip Webb, who was responsible for other furniture designs manufactured by Morris, Marshall, Faulkner & Co. (later Morris & Co.) including an adjustable chair that became the blueprint for the type of armchair known as a "Morris chair".

The firm's *Sussex* rush-seated chairs were an extremely popular range. They included not only this design and its variations, with their distinctive turned spindles, but also the *Rossetti* armchair, designed by the Pre-Raphaelite painter Dante Gabriel Rossetti; and another very similar vernacular-style chair with a cross-shaped back, also designed by a painter aligned to the Pre-Raphaelites: Ford Madox Brown. He reputedly discovered its antique archetype in an antiques shop in Sussex. In the same way, the *Sussex* chair was inspired by an earlier vernacular model that had been functionally honed over the decades, and in this light it is possible to see how the design is a modern evolution and adaptation of a successful historical paradigm.

The Sussex chair came with either a stained or an ebonized finish, the latter utterly in keeping with the fashionable Aesthetic Movement style of the 1870s and 1880s. Another, presumably slightly later, variant had exactly the same construction, but with differently shaped, graduated-ball spindles which were more in keeping with the rustic country look of the Edwardian Arts & Crafts style.

The *Sussex* rush-seated range, which included a side chair, an armchair, a corner seat and a three-seater settee, remained in continuous production right up until Morris & Co. closed its doors in 1940. Its success spawned a host of copies by other manufacturers, most notably Heal's. Importantly, the *Sussex* chair – the side chair and armchair retailing for seven shillings and nine shillings respectively in around 1912 – was one of the more competitively priced designs produced by "The Firm", and as such fulfilled one of its central goals, as defined by Dante Gabriel Rossetti in 1861: to "give really good taste at the price as far as possible of ordinary furniture".

It could indeed be argued that the success of this lower cost vernacular-style furniture, which William Morris described in 1882 as "good citizen's furniture" and "necessary work-a-day furniture which should be, of course, well made and well proportioned" led to the birth of the Arts & Crafts Movement and its more accessible rustic "cottage"-style furnishings.

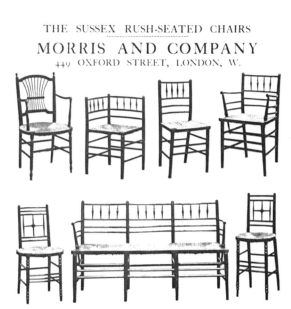

Left: page from Morris & Co. catalogue showing range of *Sussex* rush-seated chairs

Philip Webb (1831–1915) (attributed)
Sussex armchair, c.1860
Ebonized wood, woven rush
Morris, Marshall, Faulkner & Co. London, England
(later became Morris & Co.)

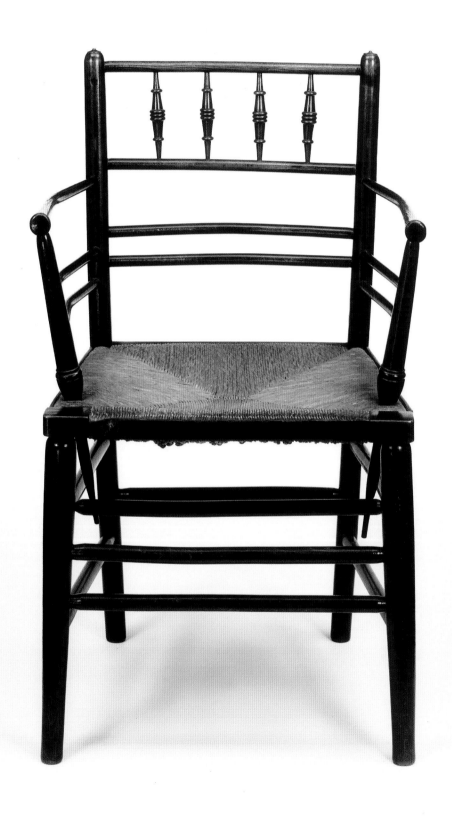

William Morris (1834–1896)
Fruit wallpaper, 1865–66

Of all the many textile and wallpaper patterns designed by William Morris over his long, illustrious and highly prolific career, the classic British wall-covering *Fruit* is by far the best known, despite also being one of his earliest wallpaper designs.

Morris had drawn *Trellis* – the birds themselves were drawn by Philip Webb, who was a better draftsman than Morris – in 1862. This was followed by *Daisy* in 1864, which was a reinterpretation of an earlier historic crewel-work textile. These two papers were by any standard highly accomplished patterns, but they possessed a slightly naïve quality when compared to his next design, *Fruit*, which revealed a truly masterful understanding of balanced composition and visual rhythm, with its repeating pattern of stylized branches of lemons, oranges and pomegranates.

What is important about *Fruit* is that its closed, patterned design conveys a strong sense of organic growth through the density of its scrolling foliage, an attribute that would eventually become a key feature of the highly stylized Art Nouveau work of the succeeding generation of textile and wallpaper designers. It is also distinguished by its muted, yet richly toned colourways, set on a background canvas of dark green, dull blue or warm cream; and unlike the majority of wallpapers produced in the popular High Victorian "French" style during the latter half of the nineteenth century, there is no florid three-dimensional realism, nor does it use brash colours, but instead it has a strong sense of flatness, thereby being "truthful to materials".

Morris had initially intended to manufacture *Trellis*, *Daisy* and *Fruit* using zinc plates, but he found the process too time-consuming and laborious to execute himself, and so instead turned to a firm of block-cutters, Barrett of Bethnal Green, to carve the printing blocks in the traditional manner, out of pearwood. This choice of printing block gives *Fruit*, which is sometimes also referred to as "Pomegranate", a strong sense of hand-craftsmanship.

The Islington-based firm of Jeffrey & Co. produced the original *Fruit* wallpaper at its factory in Essex Road, but in 1925 manufacture was transferred to Arthur Sanderson & Sons. Since then, *Fruit* has been in virtually continuous manufacture using both hand and mechanized methods of production, and remains one of the best loved British home furnishing patterns of all time, both as a wallpaper and as a textile.

Left: original design for *Fruit* wallpaper designed by William Morris, 1862

William Morris (1834–1896)
Fruit wallpaper, 1865–66
Block-printed paper
Jeffrey & Co., Islington, London, England for Morris, Marshall,
Faulkner & Co., London, England (later became Morris & Co.)
(from 1925 produced by Arthur Sanderson & Sons, Uxbridge,
London, England)

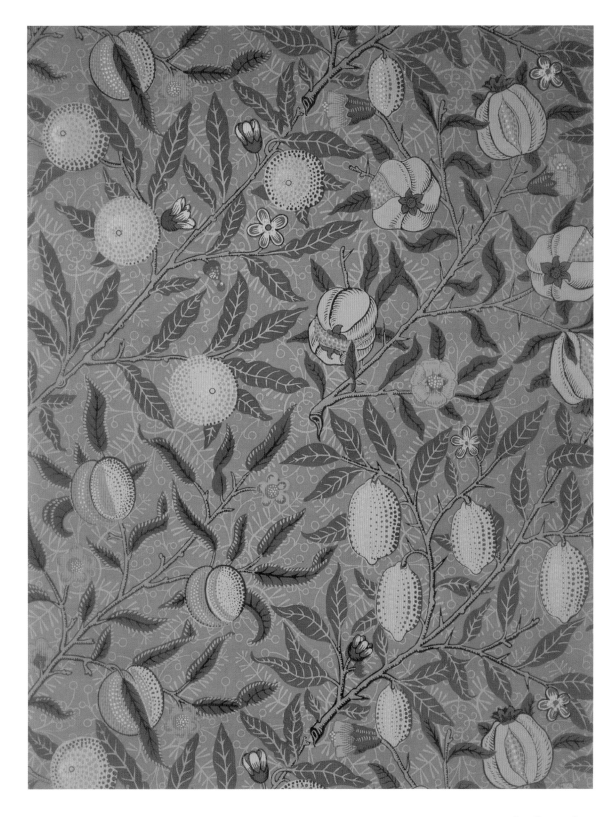

Edward William Godwin (1833–1886)
Sideboard, c.1867

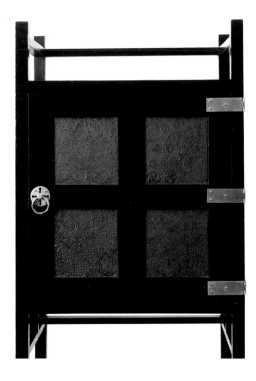

Left: detail of sideboard, c.1867, showing "embossed leather" Japanese paper door panels

The reason designers associated with the Aesthetic Movement looked to the East for inspiration was essentially due to the opening up of Japan in the third quarter of the nineteenth century, which meant that for the first time they were exposed to a completely new decorative and design culture that had evolved over centuries in a quite different way to the cultures of the West.

The stripped-down, formal vocabulary of traditional Japanese architecture and design prompted a new and captivating elementalism in design, which was not only highly refined in terms of aesthetics and function, but ideal for applying to products intended for mass-production – essentially the simpler the product, the easier it was to manufacture.

Like Christopher Dresser and Thomas Jeckyll, Edward William Godwin was a leading proponent of the Anglo-Japanese style during the 1860s and 1870s. His work could be considered proto-Modern, in that it often displayed a strong pared-down quality. However, the Japanese-inspired furnishings designed by Godwin were far from simple constructionally, and were in fact made by highly skilled craftsmen. Among the many Japanese-inspired furniture designs drawn up by Godwin, by far the most progressive was the ebonized sideboard manufactured by William Watt & Co.

The initial version of this case piece was designed for the dining room of Godwin's own home in London, and was executed in deal – an inexpensive but not particularly high-quality wood – in 1867. Other examples were later produced, including the ebonized mahogany variant shown here, made some time between 1867 and 1870, which originally belonged to the architect Frederick Jameson.

With its dramatic grid-like construction of strong vertical and horizontal elements inspired by Japanese screens, this stylish sideboard was also highly functional; it had cupboards, shelves and drawers in which to store china and cutlery, while between the cupboards was an integrated rack to display large plates. With its clean-looking and relatively unadorned surfaces, it was also a very practical and hygienic piece and must have seemed startlingly modern when it first appeared. Known as one of the most magnificent *tour-de-force* of progressive nineteenth century reforming design, Godwin's sideboard presaged the stripped down geometric functionalism that emerged decades later with the Modern Movement.

Edward William Godwin (1833–1886)
Sideboard, c.1867
Ebonized mahogany, silver-plated brass, "embossed leather" paper
William Watt & Co., London, England

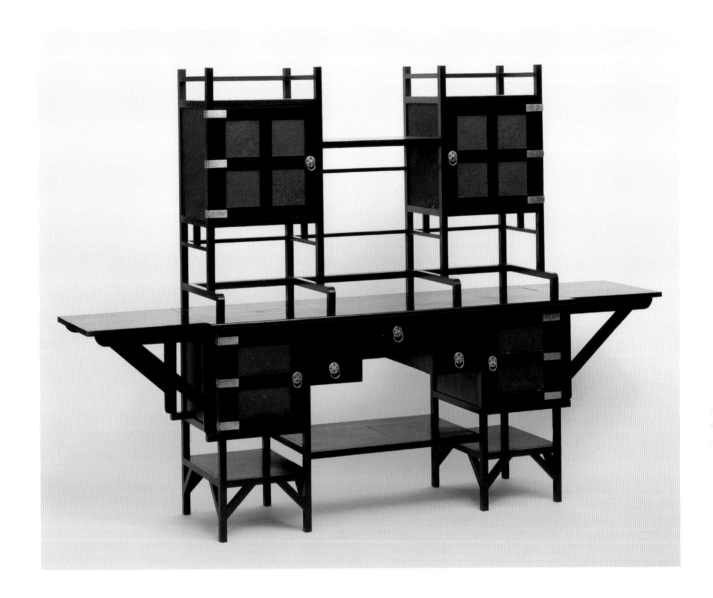

Thomas Jeckyll (1827–1881)
Model No. 880 andirons, 1876

The English architect Thomas Jeckyll was one of the leading proponents of the Aesthetic Movement during the 1870s and 1880s. He is especially well known for those of his designs which were inspired by the traditional arts of Japan.

Jeckyll started his career as an architect in his home town of Norwich. In 1859 he began to produce several Anglo-Japanese metalwork designs for the local foundry of Barnard, Bishop & Barnard, including fire surrounds, stove fronts, grates, chairs, tables and door furniture. One of the most notable is his beautifully detailed design for an andiron, which takes the form of a highly stylized sunflower. This was one of the most popular motifs of the Aesthetic Movement, being a symbol of dedicated love and purity of thought.

Jeckyll had previously incorporated this exact motif into his design for the ornate cast-iron and wrought-iron railings which encircled his Japanese Pavilion at the Philadelphia Centennial Exhibition of 1876. This two-storey building, designed by Jeckyll and made by Barnard, Bishop & Barnard, received widespread praise for its originality and exacting execution. The sunflower motif is found repeatedly, in a more abstracted form, in his many designs for fire surrounds.

He was also responsible for designing the famous Peacock Room for F.R. Leyland's London residence (1876) – the perfect three-dimensional realization of the Aesthetic Movement's doctrine of "art for art's sake". Jeckyll's original design for this room, commissioned by Leyland to display his collection of blue and white Chinese porcelain, was controversially – and exceedingly richly – embellished by the artist James Abbott McNeill Whistler without the patron's full consent, following which Jeckyll succumbed to a mental illness from which he never recovered.

Despite an impressive body of work that not only exemplified the rich decorative vocabulary of the Aesthetic Movement, but also received international critical acclaim, Thomas Jeckyll's contribution to nineteenth-century British design was all but forgotten over the succeeding decades; it has only been relatively recently that his reforming design work, at the same time beautiful and useful, is being properly reassessed and reappraised.

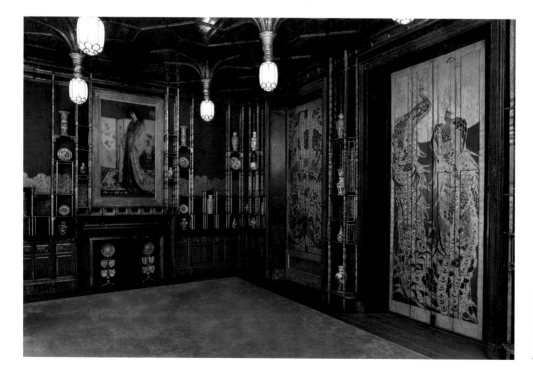

Left: the Peacock Room (now in the Freer Gallery of Art, Washington DC) – originally designed by Thomas Jeckyll and subsequently embellished by James Abbott McNeill Whistler

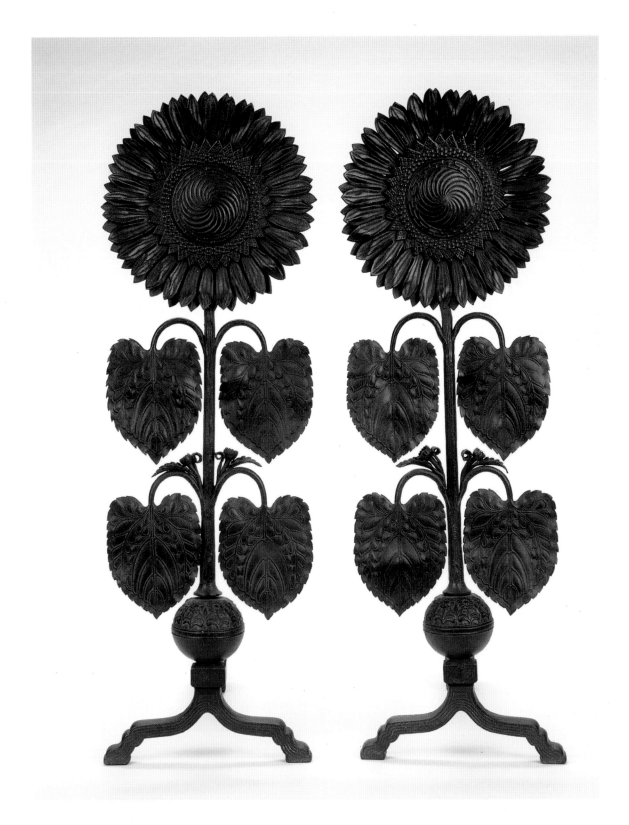

Christopher Dresser (1834–1904)
Model No. 2274 teapot, 1879

Christopher Dresser's designs for industry reveal the profound influence of Japanese form, especially in the silver-plated metalware he created for Hukin & Heath and for James Dixon & Sons. For James Dixon, he designed a variety of geometric teapots that were stripped of all superfluous ornament, and startlingly modern in appearance.

Regarded as "the father of industrial design", Dresser published *The Principles of Decorative Design* in 1873, in which he explored the relationship between geometric form and ergonomic function, and related it to the design of tableware. Four years later he visited Japan, becoming the first Western designer officially to travel there specifically to study its arts and manufactures. Japanese culture was utterly revelatory to Dresser, who relished the way Japanese craftsmen were able to give even the most humble of utilitarian objects an exquisitely beautiful form. Dresser's lozenge-shaped *Model No. 2274* teapot designed for James Dixon & Sons was by far the most radical of his works. Interestingly, this strikingly original electroplated teapot was stamped with a facsimile signature – an extremely early example of a "designer label"

being used to give the object additional cachet (though presumably also intended to verify its authenticity). Described as "English Japanese" in James Dixon's costing book of 1879, this design seems to embody, in its elemental geometric form, the influence of Japanese art – and yet it is totally unlike an actual Japanese teapot. It was generally thought until recently that Dresser's range of geometric teapots only existed as prototypes or as rarefied special orders, and no one really knows for sure how many were actually made. What is known is that the more unconventional designs such as the *Model No. 2274* must have been less popular than Dresser's more traditionally-shaped teapots simply because far fewer of them are known to exist today. Despite its rarity, however, the proto-Modern *Model No. 2274* must be regarded as not only the most revolutionary British silverware design of the nineteenth century, but also one of the most significant. With its bold geometry and stripped down aestheticism, it predicted the formal vocabulary of the Modern Movement, the flowering of which occurred nearly thirty years later with the founding of the Deutscher Werkbund.

Below: Silver plated tea service designed by Christopher Dresser for James Dixon & Sons, c.1880

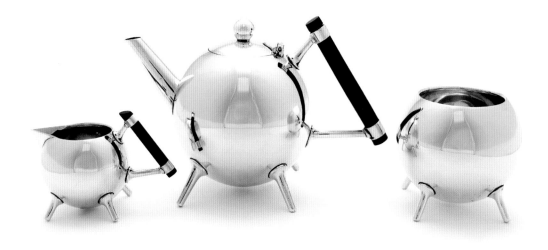

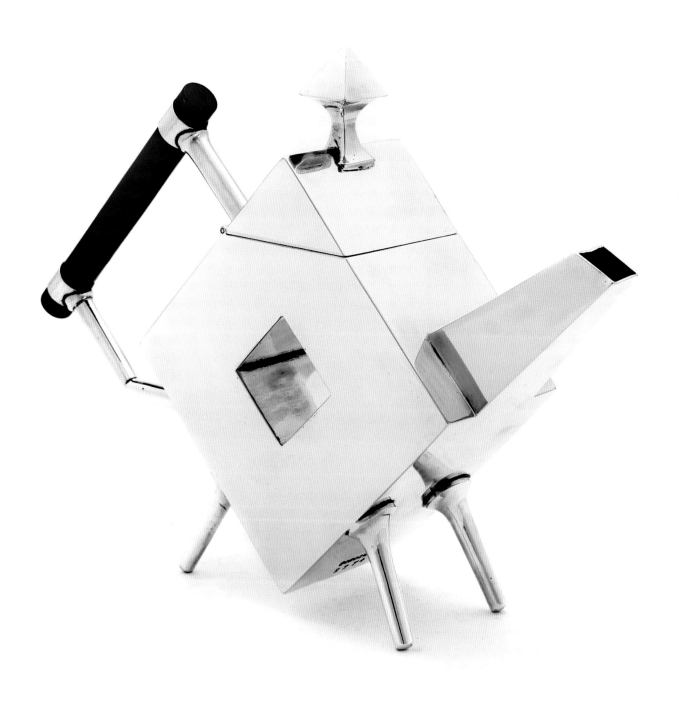

William Arthur Smith Benson (1854–1924)
Tea set, c.1885

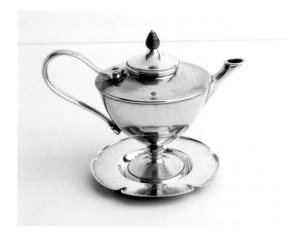

Left: *Model No. 693*
"Aladdin's Lamp" teapot
with matching saucer,
designed and manufactured
by W. A. S. Benson

Unlike his fellow members of the Arts & Crafts Movement, William Arthur Smith Benson wholeheartedly embraced mechanization and the majority of his metalwork designs were intended for machine production. He approached manufacturing from the perspective of an engineer rather than that of a handcraftsman, and ensured that his products were logically designed so that they were suited to standardized industrial production.

After studying classics and philosophy at Oxford, in 1878 Benson became articled to the rising young architect, Basil Champneys. A chance meeting with the artist Edward Burne-Jones led to an introduction to William Morris, and with their encouragement Benson decided to abandon architecture in order to feed his passion for designing and making objects.

In 1880 he set up his own workshop in Fulham to produce simply designed furniture pieces that were then retailed through Morris & Co. A year later, Benson recruited two highly skilled metalworkers, John Lovegrove and C.S. Scott, who were able to translate Benson's progressive ideas for metalware designs into exquisite products, often using an attractive combination of copper and brass. In reconciling art manufactures with rational mechanized methods, Benson was an important and early proponent of modern design. His pioneering efforts drew the highest praise from the German design reformer and critic, Herman Muthesius, who thought that Benson's manufacture of artistic wares should serve as a future model for German industrial production. Despite Benson's designs being industrially produced, however, they did not have an overt machine aesthetic. His high-quality wares can best be described as "crafted by machine", and with their warm metallic glow and sinuous and unfurling forms they became an essential element of fashionable Arts & Crafts interiors during the *fin-de-siècle* years – especially those created by Morris & Co.

One of his most popular and aesthetically pleasing designs was this exquisitely proportioned tea service with its small "genie lamp" teapot. Like many of Benson's designs, the warmly glowing individual pieces were made up of standardized components, which were then joined together in different combinations to create different types of objects; for example, an element found on a teapot might well also have been used to construct a lamp or inkwell. This type of mix-and-match assembly enabled Benson to produce literally hundreds of different patterns at his large purpose-built factory, the Eyot Metal Works in Hammersmith, which were then sold in his fashionable showroom in New Bond Street.

Although Benson's great success spawned many copies, these never matched the quality or stylistic aplomb of his metalwares. Significantly, designs like this tea set demonstrated succinctly that manufacturing quality did not have to be compromised by mechanization, and in fact when harnessed correctly the machine could be used to create high-quality yet relatively inexpensive wares that were not only practical but also very beautiful.

William Arthur Smith Benson (1854–1924)
Tea set, c.1885 (*Model No. 693* teapot, *Model No. 479* sugar bowl,
Model No. 652 milk jug)
Brass, copper, ebony
W. A. S. Benson & Co., London. England

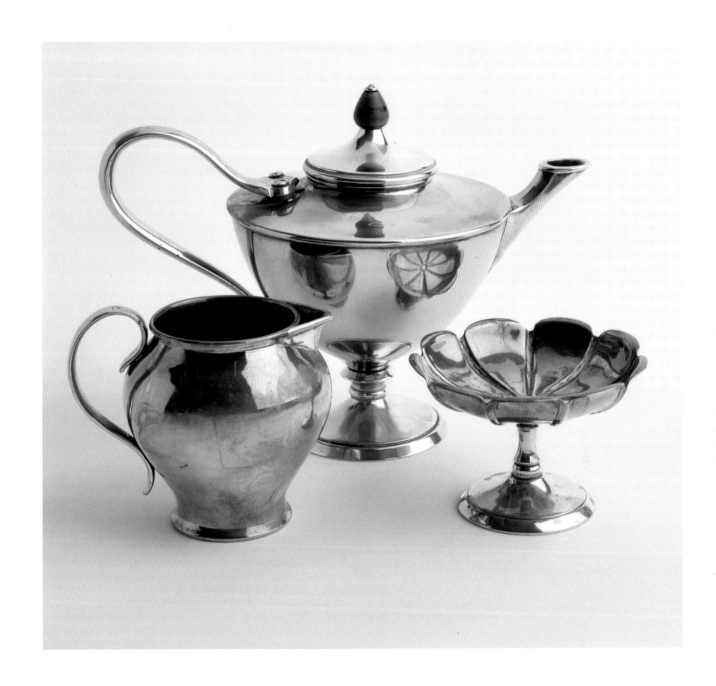

Charles Voysey (1857–1941)
Swan chair, 1883–85

Above: Haydee Ward-Higgs
seated on the *Swan* chair, c.1908

The most influential British architect and designer
of his generation, Charles Voysey created buildings,
furniture, textiles and metalware with a strong and
emotionally engaging quality that was a direct result
of his upbringing within a deeply religious family.

His father had been a highly controversial Anglican
clergyman who was eventually accused of heresy for
effectively starting a new religion when he established
the Theist Church in 1880. Dubbed "the Religion of
Common Sense", theism embraced the theory of
evolution and accepted science, and as such was an
essentially humanist theology. Throughout his life's
work Voysey reflected this philosophy through his
deployment of organic forms inspired by nature,
or folk-influenced motifs.

After studying with the architect John Pollard
Seddon, and later working in the architectural offices
of Henry Saxon Snell and George Devey, Voysey
established his own practice in 1882. As well as
undertaking building commissions, Voysey turned his
hand to the decorative arts, with the *Swan* chair being
his earliest recorded furniture design. The name
comes from the shape of this elegant armchair's back,
which takes the form of two stylized swans.

The original design drawing for this armchair has
survived and is thought to date from between 1883 and
1885. It is now in the collection of the Royal Institute of
British Architects. However, it would appear that a
number of slightly varying versions were produced,
including the example shown here, which was executed
in 1898 as a desk chair for the Bayswater home of the
successful solicitor William Ward-Higgs and his
fashionable wife Haydee. Originally, this version of
the chair had an upholstered seat and back-rail, which
would have provided much-needed additional comfort.

With its gently undulating lines which flowed in
accord with the human body, the anthropometric
Swan chair was an exceedingly progressive design that
not only predicted the sculptural sensuality of the Art
Nouveau style, but was also an extremely early example
of ergonomically informed design.

A *tour-de-force* of late-nineteenth century design,
the *Swan* chair has an essential, pared-down quality
that exemplifies the reforming ideals of the British
Arts & Crafts Movement: truth to materials, revealed
construction and fitness for purpose – the moral
philosophical basis upon which the Modern Movement
would subsequently be built.

Charles Voysey (1857–1941)
Swan chair, 1883–85 (example shown executed 1898)
Oak
No maker recorded, England

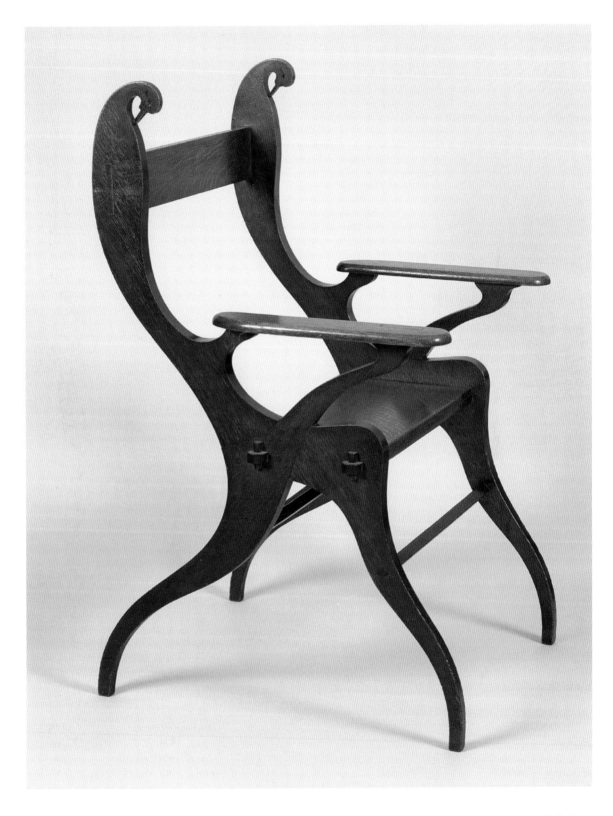

John Kemp Starley (1854–1901)
Rover bicycle, 1885

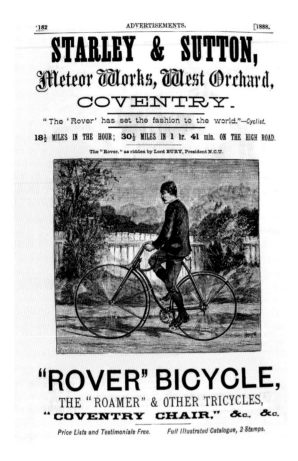

182 ADVERTISEMENTS. [1888.

STARLEY & SUTTON,
Meteor Works, West Orchard,
COVENTRY.

"The 'Rover' has set the fashion to the world."—*Cyclist.*

18¼ MILES IN THE HOUR; 30½ MILES IN 1 hr. 41 min. ON THE HIGH ROAD.

The "Rover," as ridden by Lord BURY, President N.C.U.

"ROVER" BICYCLE,
THE "ROAMER" & OTHER TRICYCLES,
"COVENTRY CHAIR," &c. &c.

Price Lists and Testimonials Free. Full Illustrated Catalogue, 2 Stamps.

Above: Starley & Sutton advertisement for the *Rover* bicycle, 1888

The bicycle is without question the most efficient means ever devised of converting human energy into propulsion, and the origins of this elegantly efficient mode of transport can be traced back to Jean Theson's rider-propelled four-wheeled machine patented in 1645. However, the development of the first modern bicycle can be attributed to the English inventor and industrialist, John Kemp Starley. In 1872 he moved from his native Walthamstow to Coventry to work with his uncle, the inventor James Starley, who is often referred to as the "Father of the Bicycle Industry". James Starley had the previous year co-invented with William Hillman the patented *Ariel* (1871) high wheeler, which had a large front wheel and a small back wheel and was nicknamed the "penny-farthing" after the smallest and largest copper coins used in England at the time. Having spent several years fabricating bicycles at his uncle's factory, John Kemp Starley eventually joined forces with a local cycling enthusiast, William Sutton, and together they established their own Coventry-based bicycle-manufacturing business in around 1877–78.

Here they produced penny-farthings and "ordinary" bicycles, which from 1883 were sold under the Rover brand. The firm's breakthrough, however, came in 1885 when Starley invented and patented a new kind of "safety" bicycle, which was a rear-wheel-drive, chain-driven design that had two wheels of similar size. This new cycle was considerably more stable than the earlier high-wheeler models because the seat was closer to the ground, while its steerable handlebars made it more manoeuvrable and therefore much safer to ride, not to mention quicker. As an advertisement for the *Rover* safety bicycle in *The Graphic* (1885) noted, it was "safer than any tricycle, faster and easier than any bicycle ever made. Fitted with handles to turn for convenience in storing or shipping. Far and away the best hill-climber in the market." Produced at Starley & Sutton's Meteor Works in West Orchard, Coventry, this revolutionary new bicycle, despite its solid rubber tyres, was also considerably lighter in weight than previous models and as *Cyclist* magazine noted "set the fashion to the world". Not only was it a huge commercial success in Britain, it was also widely exported across the globe. As the first truly modern bicycle, Starley's *Rover* safety bicycle became the blueprint for many subsequent models and as a veritable masterpiece of British inventiveness and engineering, it continues to provide the basic constructional format for the majority of bicycles produced today.

John Kemp Starley (1854–1901)
Rover bicycle, 1885
Enamelled tubular metal, metal springs, metal, leather,
solid rubber
Starley & Sutton Co., Coventry, England

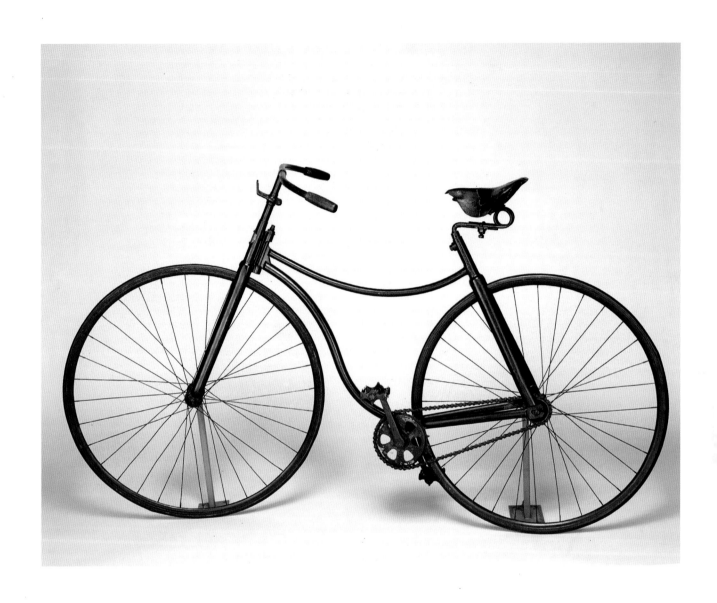

Arthur Silver (1853–1896) (attributed)
Hera furnishing textile, 1887

Left: alternative colourway of the *Hera* textile

Although it was Liberty & Co.'s company policy not to name the designers working for the firm, it is known that it commissioned many of the leading designers of the day to design Arts and Craft-style textiles and wallpapers, including Lindsay Butterfield, Charles Voysey, Sidney Mawson, Arthur Wilcock and Jessie M. King. It is also known from an extant workbook that Silver Studio, established by Arthur Silver in 1880 and based in leafy Brook Green in west London, undertook many such designs for Liberty's, including, it is generally thought, the department store's most famous textile design, *Hera*.

The attribution of *Hera* to Arthur Silver is made on stylistic grounds; many designs known to have been executed by Silver have a very similar graphic quality and visual rhythm. Certainly, only the most talented of textile designers could have been responsible for this masterful repeating pattern, with its beautiful sprays of peacock plumes.

The peacock feather was one of the most important leitmotifs of the Aesthetic Movement, and was used extensively within the decorative arts during the 1870s and 1880s when the style was at its fashionable height. This famous Liberty print is named after Hera (also known as Juno), Greek goddess of love and marriage, and wife of Zeus. According to Greek mythology, Hera had the most beautiful large eyes, which was the reason iridescent peacock feathers with their own "eyes" were symbols of her beauty and immortality. The goddess was often depicted in Hellenistic imagery on a wagon pulled by these exotic and sacred birds.

Initially devised as a printed cotton furnishing fabric, *Hera* was produced by Liberty in a variety of different colour combinations over the years. It was a hugely influential pattern in that it predicted the swirling organicism of the *fin-de-siècle* Art Nouveau style — which in Italy, tellingly, became known as the *Stile Liberty*. The company also produced at least two other textiles with similar sprays of peacock feathers that were less tightly patterned. Today, the *Hera* pattern has become completely synonymous with the Liberty brand and continues to have an enduring appeal, thanks to its overtones of oriental exoticism and its perfectly balanced composition.

Arthur Silver (1853–1896) (attributed)
Hera furnishing textile, 1887
Printed cotton
Liberty & Co. Ltd, London, England

William Arthur Smith Benson (1854–1924)
Table light, c.1890s

William Arthur Smith Benson was the greatest lighting designer of the British Arts & Crafts Movement. However, unlike other designers affiliated with this reforming "New Art" crusade, he embraced, rather than rejected, the use of machinery to produce his beautiful brass and copper designs. He designed literally thousands of chandeliers, wall lights and table lights, which were manufactured in his Fulham metalworking workshop and later in his own well-equipped factory in Hammersmith. Often using a combination of brass and copper, "Mr Brass Benson" – as he was nicknamed by his friend and colleague William Morris – produced lights that accentuated the glowing warmth of these metals through the use of unornamented surfaces and sinuous forms that were reminiscent of unfurling fronds. One of the most exquisite examples of this was his table light from around the 1890s. It has a whiplash-like stem arising from a beautifully executed copper leaf, from which is suspended a delicate shade of iridescent glass. Forms found in the natural world similarly inspired the bell-shaped opalescent Vaseline glass shade. This table light, more than any other of Benson's metalware designs, exemplifies the sensual organicism of the continental Art Nouveau style. Benson offered his designs for sale through his own Bond Street showroom, and much of his work, probably including this lamp, was exhibited in Samuel Bing's influential Paris gallery, the Maison de l'Art Nouveau. As with many of Benson's lighting designs, the glass shade on this model was made by the well-known London glassmaker, James Powell & Sons, later to become known as Whitefriars Glass Works. As early as 1835, James Powell was experimenting with uranium salts as a colorant, which produced a slightly radioactive glass with a very particular yellow-greenish tint and it was this that gave the illuminated glass a distinctive type of otherworldly glow. This type of glass also had a somewhat greasy-looking appearance – hence the name Vaseline glass. With its radiant milky-hued shade, and warmly glowing combination of brass and copper, this electrified table light must have seemed a completely wondrous thing when it was first introduced to a public that had grown up with flickering candlelight and gas-lamps. Even by today's standards this design retains a very precious quality that is testament to Benson's skill both as visionary designer and as progressive manufacturer.

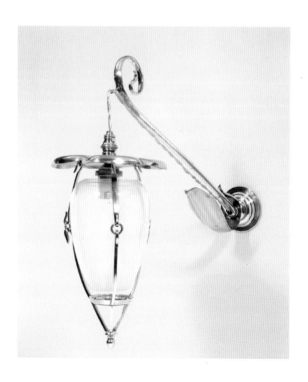

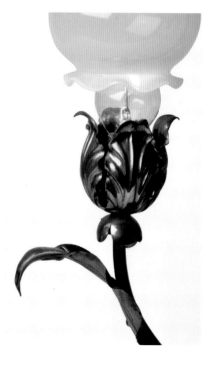

Far left: wall light designed and manufactured by W. A. S. Benson, c.1902

Left: detail showing tulip-shaped bulb holder

William Arthur Smith Benson (1854–1924)
Table light, c.1890s
Brass, copper, Vaseline glass
W.A.S Benson & Co., London, England (shade manufactured
by James Powell & Sons, London, England)

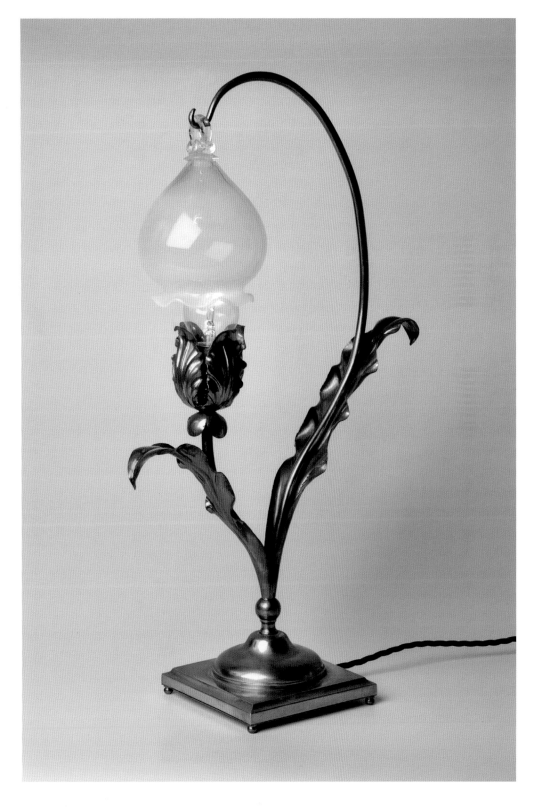

John Henry Dearle (1860–1932)
Golden Lily furnishing textile, 1897

The British textile designer John Henry Dearle was responsible for many of the classic textiles and wallpapers manufactured and retailed by Morris & Co. which are generally, though incorrectly, assumed to be the work of William Morris himself. Morris's towering reputation as an outspoken public figure, famous decorator, renowned poet, firebrand socialist and successful entrepreneur might have overshadowed the design accomplishments of J. H. Dearle throughout the younger man's career, but that does not detract from the quality of Dearle's work, which was extraordinarily accomplished.

His career began in 1878 as an 18-year-old assistant in the Oxford Street showroom of Morris & Co. His artistic talents were soon spotted by Morris, who took him under his wing and gave him training in tapestry weaving. In 1887 he created his first tapestry design and by 1890 he had become the chief textile and wallpaper designer for "The Firm". His earliest patterns were stylistically very similar to those of Morris and even for an expert eye it is difficult to

attribute them, unless it is known which of the two created a specific design. However, by the 1890s Dearle's work had matured, with a greater sense of swirling floral stylization and a distinctive graphic quality which reflected his interest in traditional Turkish and Middle Eastern patterns.

Dearle's *Golden Lily* pattern – one of the best-known "Morris" designs of all – was used for both textiles and wallpapers, and revealed his genius for creating complicated, intertwined, repeating patterns that were harmoniously balanced both in the overall composition and in their choice of attractive colour combinations. During the Victorian era floriography, or the "Language of Flowers", whereby symbolic meanings were attached to particular flowers, was a popular pastime, and certainly many of the original purchasers of this textile would have known that the majestic lily was a symbol of beauty. After Morris's death in 1896, Dearle was promoted to art director of Morris & Co. Under his guidance, until his death in 1932, the company continued to flourish well into the twentieth century.

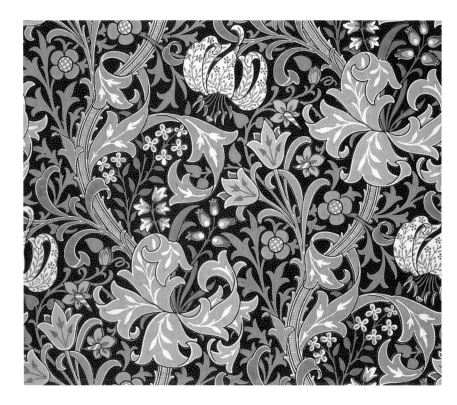

Left: *Golden Lily* wallpaper designed by J. H. Dearle for Morris & Co., 1897

John Henry Dearle (1860–1932)
Golden Lily furnishing textile, 1897
Printed cotton
Morris & Co., London, England

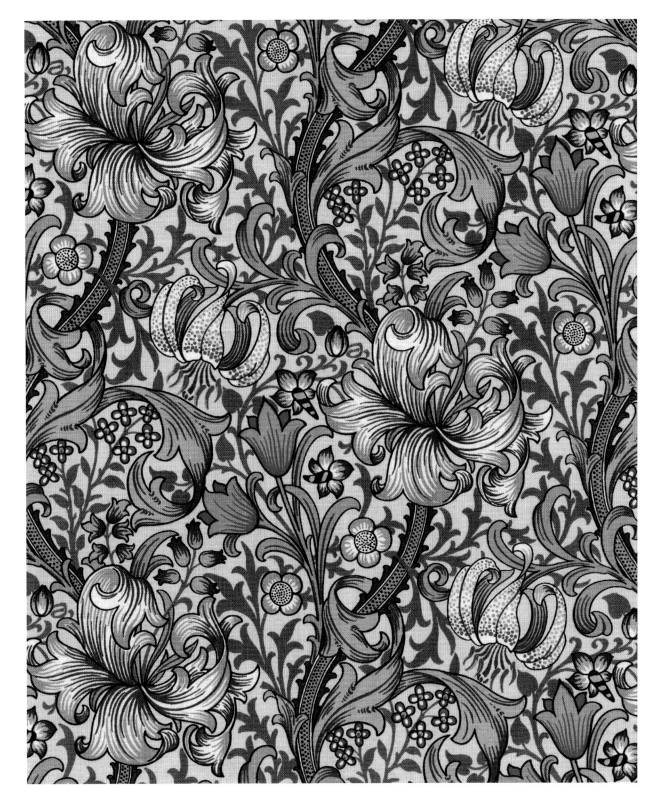

Charles Rennie Mackintosh (1868–1928)
High-backed chair for the Argyle Street Tea Rooms, 1897

The Scottish architect, designer and artist Charles Rennie Mackintosh was one of the earliest pioneers of Modernism in Britain and his impressive artistic output constituted an important and crucial link between the reforming ideals of the British Arts & Crafts Movement and the emergence of the Modern Movement in continental Europe.

Certainly, his architectural masterwork was the Glasgow School of Art (1897–99 and 1907–09), with its neo-baronial massing of red Glaswegian sandstone and its impressively large windows. However, in terms of his furniture design there is one model that stands above all others: the high-backed chair designed by Mackintosh for the luncheon room of the Argyle Street Tea Rooms in 1897.

This was the second project that Mackintosh had undertaken for Catherine Cranston, who owned a number of tearooms in Glasgow. A truly exceptional client, she allowed him creative as well as financial *carte blanche*. Commercial tea rooms had gained popularity in Glasgow from the 1870s onwards as part of the temperance movement's reaction to daytime drunkenness among the city's workforce. In sharp contrast to pubs, the tea rooms were designed to be not just havens of elegance and refinement, but also as fashionably novel as possible. Mackintosh's work was eminently suited for such a brief and his furniture for the Argyle Street Tea Rooms pushed the aesthetic boundaries of the British Arts & Crafts Movement to a new level of modernity.

His chair for the luncheon room revealed the influence of Japanese art, with its elemental construction and its high back which not only provided a modicum of privacy for its users by functioning as a screen, but also helped to spatially delineate the long and narrow room. The chair's distinctive elliptical backrail gave the impression that the sitter's head was haloed, especially if light was filtering through the pierced crescent-like motif.

Mackintosh incorporated this design in his highly influential Scottish Room installation at the 8th Secessionist Exhibition in Vienna (1900), as well as in his own apartment at 120 Main Street in Glasgow. Today, it has become known as "The Mackintosh Chair" and it certainly deserves recognition as a true masterpiece of British design.

As one of the founding fathers of modern design, Mackintosh also left another important legacy: a holistic approach to problem solving that was founded on the belief that it was as important to address spiritual needs as it was to fulfill functional ones. Through its carefully balanced composition of vertical and horizontal planes, this remarkable chair eloquently demonstrates the efficacy of this philosophy.

Below: design drawing of chairs and table for the dining room of Miss Cranston's Argyle Street Tea Rooms, c.1897

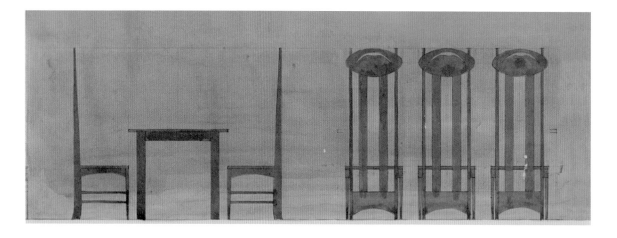

Charles Rennie Mackintosh (1868–1928)
High-backed chair for the Argyle Street Tea Rooms, 1897
Stained oak, textile-covered horsehair upholstery
No maker recorded, Scotland

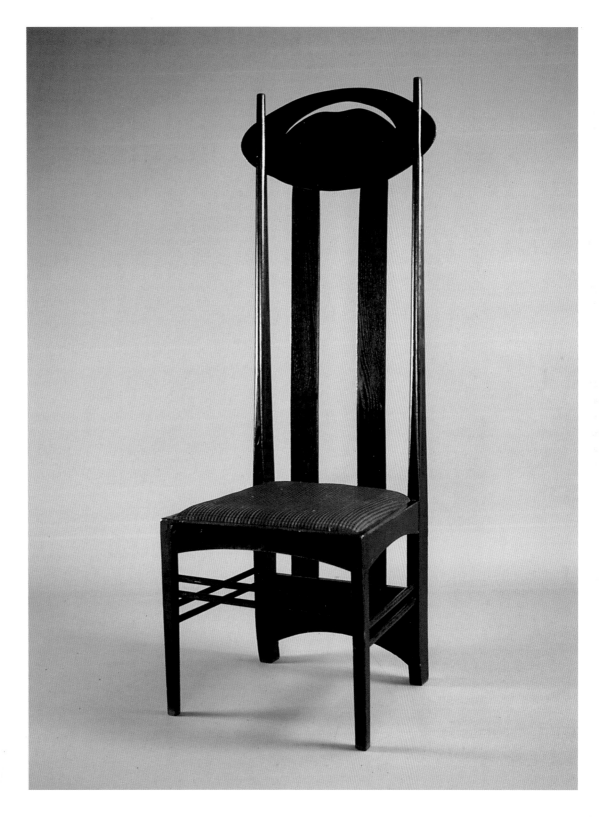

William De Morgan (1839–1917)
BBB tiles, 1898

One of the greatest British ceramicists, William De Morgan created patterns and motifs that reflected the desire among designers associated with the Arts & Crafts Movement to revitalize handicrafts and bring higher aesthetic integrity to what were known as "art manufactures". His work reflected an interest in historic precedents and foreign decorative influences, from shimmering Hispano-Moresque lustre-wares to colourful Iznik pottery.

De Morgan studied art at Cary's School in Bloomsbury, and went on to train at the Royal Academy Schools. It was while at the RA that he was introduced by his fellow student Henry Holiday to William Morris and the painter Edward Burne-Jones, a meeting that would have a hugely influential impact on his subsequent choice of career. De Morgan became a close associate of the Pre-Raphaelites and from 1863 designed stained glass, painted furniture and tiles for Morris, Marshall, Faulkner & Co.

Because Morris had experienced difficulties with tile production, De Morgan eventually took over this entire side of the business and soon began designing his own tiles as well. In 1869, he discovered that if paint containing silver was used for stained glass it created an attractive iridescence, and it was this discovery that led him to experiment with glazes and firing techniques in his pursuit of the perfect lustre finish for his ceramics.

In 1873 he established The Orange House Pottery located in Upper Cheyne Row, Chelsea, and six years later he was commissioned by Frederic, Lord Leighton to install the Turkish, Persian and Syrian tiles collected by Leighton on his travels into the Arab Hall of Leighton House. For this project, De Morgan also created his own Arabic-inspired tiles using a vibrant turquoise, and this formative introduction to the rich variety of ceramic patterns found in the Middle East was to have a profound influence on his work throughout the rest of his career – as exemplified in his Turkish-inspired charger with its brilliant saturated blues (below left), or his Moresque-style vase with its glistening red lustre surface (below right).

In the early 1880s, De Morgan moved his pottery to a new site adjacent to Morris's own factory/workshop in Merton Abbey, where he continued to produce tiles designed by Morris and his colleagues while at the same time manufacturing his own – including his beautiful *BBB* tiles – which were, confusingly, also retailed by "The Firm". Significantly, De Morgan raised the aesthetic bar not only of art pottery but also of serially hand-produced tiles, and it is difficult to imagine a fashionable Aesthetic Movement room or early Arts & Crafts interior without his ubiquitous sunflower tiles which brought such visual pleasure and homely warmth into any space.

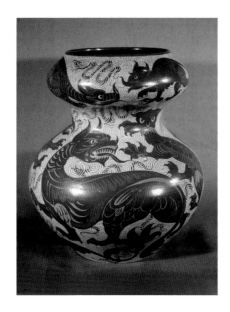

Far left: charger designed by William De Morgan, 1888–97 (painted by Charles Passenger)

Left: lustreware vase designed by William De Morgan, late nineteenth century

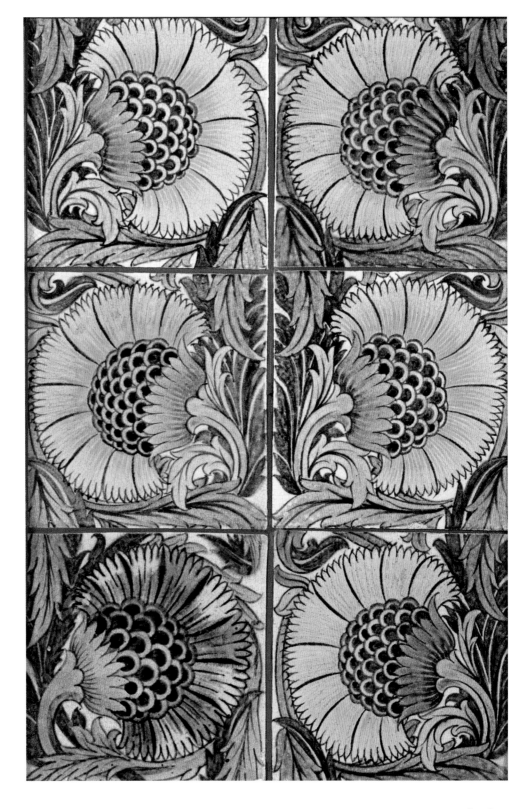

Charles Rennie Mackintosh (1868–1928)
Cabinet for 14 Kingsborough Gardens, 1901–02

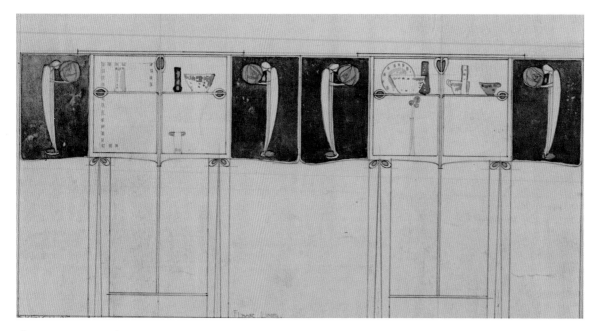

Above: Design drawing of two cabinets commissioned by Mrs Rowat for 14 Kingsborough Gardens, Glasgow, 1901–02

This remarkable cabinet was one of a pair that was specially designed for the home of Mr and Mrs Robert Rowat at 14 Kingsborough Gardens in Glasgow. Mackintosh's various interior schemes for the house's renovation in 1901 were notable for their airy lightness and startlingly modern white palette. Given the feminine delicacy of these interiors it is generally believed that Mackintosh's wife, the artist and textile designer Margaret Macdonald-Mackintosh, had a strong influence on the project.

As an integral part of the scheme for the terraced house's drawing room, this cabinet and its twin were decorated with painted panels showing stylized figures wearing Arabian cloaks and turbans, and holding highly abstracted Persian roses — a motif that was to become synonymous with the work of the Glasgow School and the Mackintoshes' designs in particular. As a relatively early piece within his oeuvre, the cabinet reflects Mackintosh's distinctive organic style with its rosebud-like insets of pink inlaid glass and the swelling curvilinear forms of its tapering supporting frame, with even the cabinet's doors having sweeping curved lines. Although relatively plain when closed, when its doors are opened the cabinet reveals its exquisitely painted and silvered panels, which have an almost otherworldly, fairytale quality. By painting the wooden carcasses of the cabinets white, Mackintosh was able to create a flawless surface that again heightened the room's overall sense of visual transcendence – and as such offered a glimpse of a different, more modern way of living.

In 1904, the German design reformer and critic Herman Muthesius, commenting on the ethereal quality of Charles Rennie Mackintosh's "white rooms", wrote in his influential book *Das Englische Haus* (The English House) that "Mackintosh's interiors achieve a level of sophistication which is way beyond the lives of even the aesthetically educated section of the population. The refinement and austerity of the artistic atmosphere... does not reflect the ordinariness that fills so much of our lives... At least for the time being, it is hard to imagine that aesthetic culture will prevail so much in our lives that interiors like these will become commonplace. But they are paragons created by a genius, to show humanity that there is something higher in the distance which transcends everyday reality."

Charles Rennie Mackintosh (1868–1928)
Cabinet for 14 Kingsborough Gardens, 1901–02
Painted oak, glass, silver-plated brass
No maker recorded, Scotland

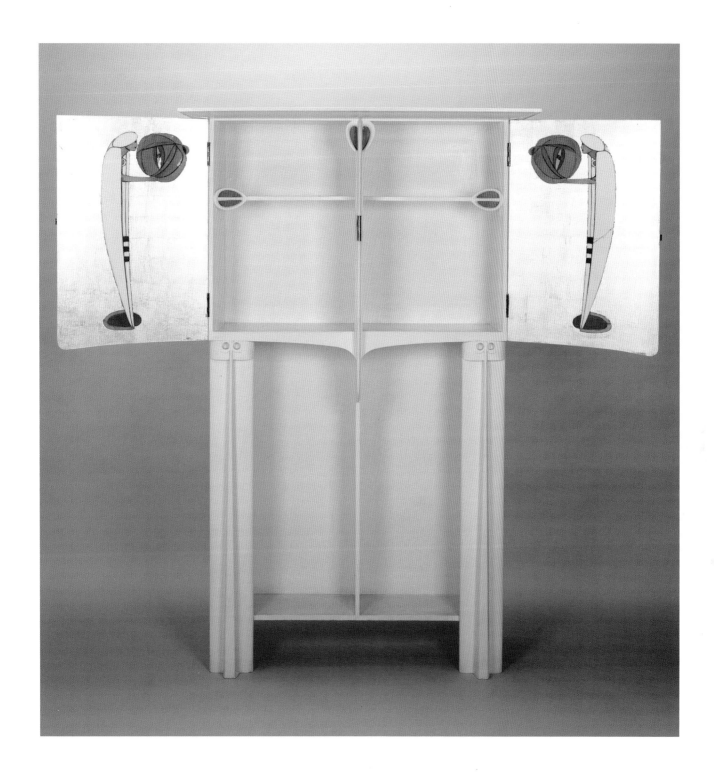

Frank Hornby (1863–1936)
Meccano constructional toy, 1901

Left: Meccano instruction booklet for *Outfit No. 4a*, 1930s

One of the twentieth century's most popular boys' toys, Meccano's origins can be traced back to around 1898–99 when Frank Hornby – the eventual creator of *Hornby* train sets and *Dinky* toys – while on a train journey passed the working docks in Liverpool, which inspired the decision to make a toy crane for his two young sons. He was frustrated to find that he was unable to source the necessary components to build it, and instead fabricated the parts himself in his home workshop by cutting them from sheet metal.

He subsequently built other toys, including models of bridges and trucks, but was irritated that each model required him to make special customized components. And then he had what can be described as a "eureka" moment, as he was to later recall: "I saw that only interchangeable pieces could remedy this state of affairs. This would require a new principle of standardization allowing for the assemblage of pieces in the system in multiple combinations."

By using a range of interchangeable parts with regularly spaced perforations that could be fastened together with nuts and bolts, virtually any model could be constructed using the same elements, just in different combinations. The holes of the sheet metal components also had another and absolutely crucial secondary function as support-bearing "journals" for shafts or axles, which meant that even quite complex mechanisms could be built with relative ease.

In 1901, having further refined his design, Hornby patented his "Mechanics Made Easy" constructional toy system and together with his then-employer, David Elliot, who provided the necessary capital, began production of this revolutionary new toy. The earliest sets comprised just 15 nickel-plated strips and some nuts and bolts, sold in a tin box.

Over the following years, new and larger sets were introduced, as were new components such as brass gears and wheels. In 1907, Hornby registered the Meccano trademark and in order to keep up with demand a new and much larger factory was built in 1914. In 1926, coloured sets were introduced, and by the mid-1930s ten different full sets were available, together with a number of accessory sets.

Meccano not only encouraged young enthusiasts to build the models in its manuals but also to experiment with models of their own design. It sponsored model competitions, and from 1916 published its own magazine, featuring new models to build and articles on subjects ranging from bridges and chemistry to famous engineers and aviation. But by the 1960s, Meccano was starting to face competition from other toy manufacturers, most notably Lego, and in 1979 the company was dissolved, but production continued – and still does – at the company's original subsidiary in France.

Meccano perpetuated a can-do, let's-make-it ethos among several generations of British boys, and by giving them a hands-on understanding of engineering principles, encouraged them to pursue careers in engineering later in life, which ultimately helped British industry retain its reputation as a centre of engineering excellence. Significantly, Meccano components embodied the central principles of successful mass-production: rationalization, standardization, prefabrication, interchangeability and adaptability.

Frank Hornby (1863–1936)
Meccano constructional toy, 1901
(This example is a rare top-of-the-line *Outfit No. 10*, 1938)
Enamelled tinplate, metal nuts and bolts
Meccano Ltd, Liverpool, England

Archibald Knox (1864–1933)
Cymric clock, 1903

Written on his gravestone on the Isle of Man, where he was also born, are the words "Archibald Knox, Artist, humble servant of God in the ministry of the beautiful."

It's no exaggeration to say that Knox was one of the most influential "New Art" designers of the late nineteenth/early twentieth centuries. A pioneer of the Celtic Revival style, he was also a proto-Modernist whose pewter and silver designs became synonymous with Liberty & Co.

He studied at the Douglas School of Art and worked with fellow Manx designer, Mackay Hugh Baillie Scott, before moving to London in 1897 where he worked for the progressive Silver Studio. Then from 1898 to 1912 Knox worked directly with Liberty, creating designs for metalware, textiles and carpets.

His beautiful *Cymric* range of silverware for Liberty – the name was derived from the Welsh word for Wales, to reflect the abstracted Celtic-inspired motifs and forms acknowledged in his wares – was launched in 1899, and comprised a wide variety of models. Among them were a number of exquisitely detailed, enamel-faced clocks such as the 1903 model shown here, with its beautiful mother of pearl inlays and turquoise cabochons. In 1900, Liberty launched a similarly influenced range of less expensive pewter wares under the *Tudric* brand, the majority of which were also designed by Knox. These were mass-produced, and with their simplified organic forms had an extremely modern look in comparison to most of what was being produced industrially at the time.

Knox's contemporary reinterpretation of age-old Celtic motifs should also be seen within the context of National Romanticism, which blossomed throughout Europe during this period as different countries sought to express their own national cultural identities, whether in design and architecture or music and poetry.

Apart from his work for Liberty, Knox also taught at various institutions (including Kingston School of Art); designed carpets for the Philadelphia-based manufacturer, Bromley & Co.; and established his own Knox Guild of Craft and Design.

Significantly, Knox's refined *Cymric* silverware and more utilitarian *Tudric* pewter were characterized by swirling, exaggerated and abstracted organic forms, which not only epitomized the second phase of the British Arts & Crafts Movement but were hugely influential on the development of the *fin-de-siècle* Art Nouveau style in Europe.

Left: *Cymric* silver and enamel chalice designed by Archibald Knox for Liberty & Co., c.1900

Charles Ashbee (1863–1942)
Decanter, 1901/1904-05

Charles Ashbee's decanter can be seen as a three-dimensional realization of the romantic utopian vision that lay at the very heart of the British Arts and Crafts Movement and its quest for social reform through design.

Ashbee studied architecture under the leading Gothic Revivalist, George Frederick Bodley, who was renowned for his ecclesiastical buildings as well as for his designs for textiles, wallpapers and stained glass. During this period he became so influenced by the writings and ideals of John Ruskin and Morris that in 1887 he founded the School of Handicraft, and the following year established the Guild of Handicraft in the East End of London at Toynbee Hall, a socially reforming institution that had been set up three years earlier. The initial aim was to provide handicraft training to the very poorest people living in the surrounding slums, thereby giving them a means to earn a livelihood.

The enterprise started with just five members, but soon expanded to include skilled cabinetmakers, silversmiths, metalworkers and woodcarvers. The wares that the guildsmen produced were displayed in shows put on by the Arts & Crafts Exhibition Society and were either sold through commissions or, later, in the guild-run shop in Brook Street. In 1891, the guild and school moved to larger premises at Essex House in Mile End Road, and there the community made furniture, fixtures and fittings that often related to Ashbee's architectural commissions.

In 1902, in an attempt to realize the Movement's guiding vision of a rural community of artistic craftspeople, Ashbee moved the guild *en masse* to the Old Silk Mill in Chipping Campden. The arrival of 150 East Enders had quite an impact on this small historic wool town set in the rolling Cotswold countryside, but the majority settled there happily, producing beautifully executed work such as the green glass and silver mounted decanter which was originally designed by Ashbee in 1901.

The form and colour of this decanter were inspired by three broken bottles unearthed during the excavations for the construction of Ashbee's own house, The Magpie and Stump. Located on Cheyne Walk in Chelsea, this fine riverside residence was built on the site of an earlier Elizabethan hostelry. The find certainly captured the historian Ashbee's romantic imagination and he is quoted as saying, "it was doubtless bottles of that shape, good solid glass, from which Falstaff and his worthies drank their sack".

The first example of this decanter incorporated a relatively thick bulbous glass bottle, but around 1904–05 James Powell & Sons began to manufacture a more refined and thinner-walled version, which was then encased in an exquisite silver mount of swirling, intertwining floral forms, topped with a domed stopper of a finial set and semi-precious stone. Sadly, the distance between Chipping Campden and London prevented the commercial success of the Guild of Handicraft and the enterprise eventually went into receivership in 1908, but many of the guild's craftspeople remained in Chipping Campden and managed to ply their creative trades in the years following.

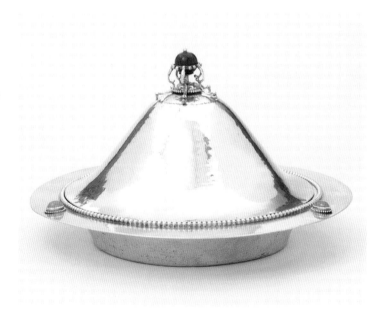

Above: muffin dish designed by C. R. Ashbee and executed by the Guild of Handicraft, c.1900

Charles Ashbee (1863–1942)
Decanter, 1901/1904–05
Silver, glass, chrysoprase
Guild of Handicraft, Chipping Campden, Gloucestershire, England
(Glass probably made by James Powell & Sons, London, England)

Edward Johnston (1872–1944)
Underground roundel design, c.1918 (redesigned c.1925)

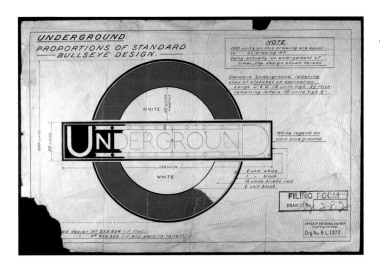

Left: diagram showing
the standard layout of the
"Registered Design" version of
the Johnston Underground
roundel, c.1925

Two people were responsible for the internationally recognized symbol that represents London Underground: Frank Pick, who was commercial manager for many years from 1908 and commissioned the famous underground map; and Edward Johnston, who married a typeface and a logo to create something extraordinary.

Pick believed that public transportation needed to be functional but that it should also provide an aesthetically pleasing experience for travellers. He introduced a holistically unified and standardized corporate graphic system that was based on a thoroughly modern "fitness for purpose" ethos. Edward Johnston was regarded as one of the greatest practitioners of modern calligraphy, and crucially brought a craft sensibility to typography and graphic design that imbued his work with an engaging humanist quality, reflecting a very British approach to Modernism in general.

Pick first commissioned Johnston to design a new house font for the Underground Group, which resulted in the easy-to-read yet highly distinctive sans serif *Johnston* typeface. He then asked Johnston to redesign the Underground roundel logo, which had been introduced in 1908 and comprised a solid red enamel disc with a horizontal blue bar running across which contained lettering.

Although this circle-and-bar device was perfectly serviceable – it could be easily distinguished from surrounding advertising billboards and gave prominence to the name of the station — it wasn't a particularly elegant solution. In contrast, Johnston's visually striking "bull's-eye" design, with its bold red circle targeting the eye into the horizontal blue text-holding stripe, was a work of genius.

The new standardized roundel symbol was first used on publicity material in 1919 and then introduced to station exteriors and platforms in the early 1920s. Around 1925, Johnston drafted exacting guidelines as to how the roundel should be reproduced and also slightly modified his design to better incorporate the standardized house font he had created for London Underground. This new version of the device, used in conjunction with Johnston's clean bold typeface, not only functioned better, but helped to establish a distinctively modern identity for London Underground.

Johnston further honed his roundel device between 1922 and 1933 by creating adapted variations of the logo for the additional rail and road divisions of the Underground Group.

As a key element of London Underground's corporate identity, from around 1924 the roundel symbol had the rare honour of being incorporated into the architecture of existing stations and the construction of new stations, as stained glass panels and flagpole-like devices. Today, the London Underground roundel is an integral symbol of London that can be seen just about everywhere you go in the city.

Edward Johnston (1872–1944)
Underground roundel design, c.1918 (redesigned c.1925)
(This example: "Underground" roundel from Westminster station,
signwritten onto painted plaster, c.1930)
Various materials
Underground Electric Railways Company of London Ltd, London,
England (known as the Underground Group and later becoming
London Underground)

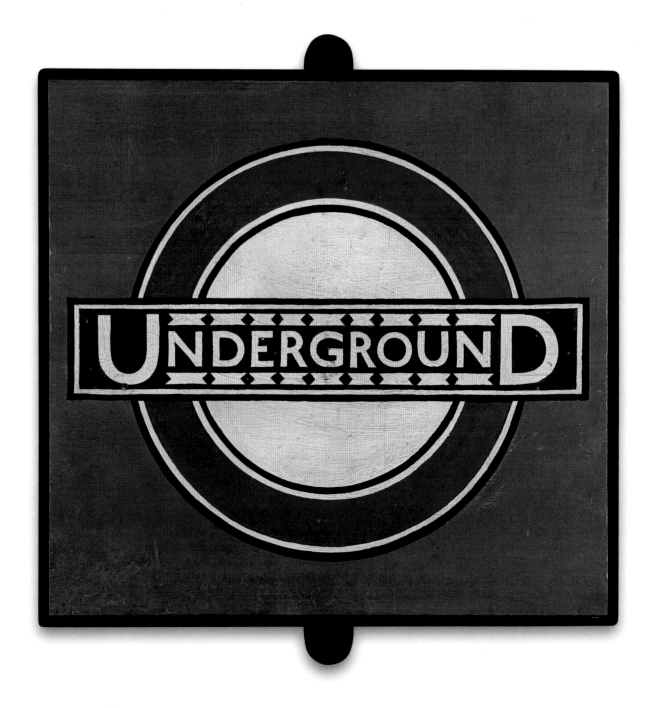

Sir Herbert Austin (1866–1941) & Stanley Edge (1903–1990)
Austin Seven motorcar, 1922

The *Austin Seven* was the British equivalent of the American Ford *Model T* or the German Volkswagen *Beetle*. It was the nation's first reliable and affordable automobile and was eventually to become known as "The Motor for the Millions".

Born in Buckinghamshire, at 16 Herbert Austin emigrated to Australia where he worked for a subsidiary of the Wolseley Sheep Shearing Machine Company. Austin enjoyed taking long journeys into the Australian outback, and it was these experiences that gave him a unique insight into the need for reliable petrol-powered vehicles. He built his own tiller-steered three-wheeler "autocar" in 1895, and continued to experiment with improved designs including a four-wheeler that won first prize in the 1,000 mile Great Britain Trial in 1900.

In 1901 the Wolseley Tool and Motor Car Company was founded in Adderley Park in Birmingham and Austin was appointed general manager. Four years later, he set up his own rival company in nearby Longbridge. Between 1906 and the outbreak of the First World War, the Austin Motor Company produced trucks and cars, including the *Endcliffe Phaeton*. In 1914, the company went from private to public ownership and for the duration of the war the factory was used for manufacturing munitions, trucks, armoured cars, ambulances, generators, searchlights and light fighter aircraft.

At the end of the war car production resumed but with a new one-model policy; however, sales of the *Austin 20* were unimpressive, and though a smaller version of the car was launched in 1921 – the *Austin 12*, which was far more popular especially among London taxi drivers – this was not enough to save the company, which was on the brink of bankruptcy. After tossing a coin to decide the fate of his business, Austin asked the workforce to forgo a month's wages in return for a guaranteed job for life. The company subsequently introduced in 1922 a new type of "baby" car, the *Austin Seven*. This was a joint effort by Herbert Austin and the talented young draftsman Stanley Edge, who convinced Austin that they should use a vertical water-cooled four-cylinder engine rather than a horizontal air-cooled twin cylinder engine – a revolutionary first in British car design, although it

had been used previously in France. Importantly, it was the young 18-year old who ensured that the *Austin Seven* incorporated all the most appropriate design features of the day to make it into a truly great little car, affordable to the masses. As *The Light Car and Cyclecar* noted, "What more could a man of moderate means want for his money?"

Demand for this revolutionary automobile was insatiable; by the time production ceased in 1939, around 300,000 had been made, enhancing the lives of huge numbers of British people for whom motoring had now become an affordable reality. The *Austin Seven* was also manufactured under licence by BMW in Germany, Rosengart in France, Datsun in Japan and by the American Austin Car Co. located in Butler, Pennsylvania – but nevertheless, at its heart, it was always a plucky little Brit.

Below: *Austin Seven* sales brochure showing the Austin prototype *OK 3537*, January 1922

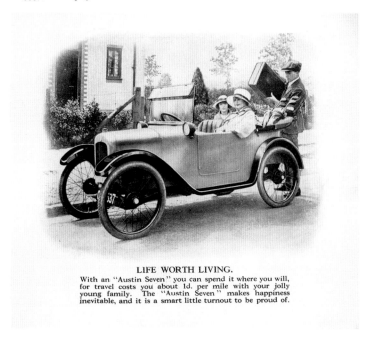

LIFE WORTH LIVING.

With an "Austin Seven" you can spend it where you will, for travel costs you about 1d. per mile with your jolly young family. The "Austin Seven" makes happiness inevitable, and it is a smart little turnout to be proud of.

Sir Herbert Austin (1866–1941) & **Stanley Edge** (1903–1990)
Austin Seven motorcar, 1922
Various materials
Austin Motor Co. Ltd, Longbridge, Birmingham, England

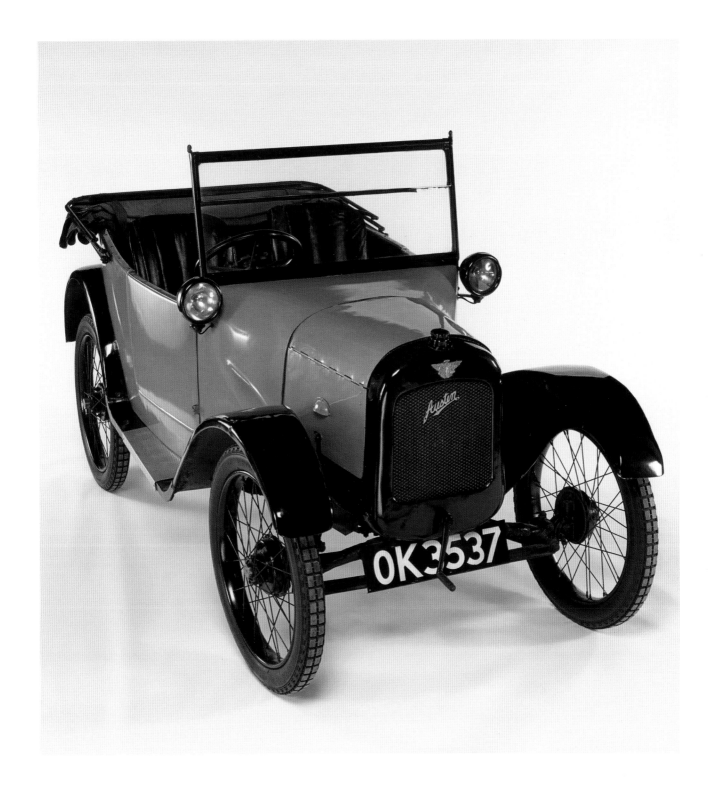

Edward McKnight Kauffer (1890–1954)

The Colne River at Uxbridge by Tram
poster for London Transport, 1924

Left: *Twickenham by Tram*
poster by Edward McKnight
Kauffer for London Transport,
1923

artwork. These early "painterly" landscape posters showed the enticing Arcadian delights of areas beyond the city – Watford, Oxhey Woods, Reigate and the North Downs – and were executed in the American Arts & Crafts woodblock style.

In 1920, Kauffer became a founding member of Group X, an artists' affiliation led by the Vorticist painter, Percy Wyndham Lewis; yet even before this, some of Kauffer's posters had begun to reveal the contemporary influence of Cubism and Vorticism. The following year, Kauffer decided to abandon the fine arts completely in order to concentrate his efforts on graphic design and what was then termed "commercial art". His posters for London Transport dating from that period were perhaps the most important works of his illustrious career; his poster *The Colne River at Uxbridge by Tram* (1924), with its abstracted landscape and bold, block-like colouring, is certainly the most striking of this group and was later included in the "Art for All" exhibition of London Transport artwork and posters held at the Victoria and Albert Museum in 1949. Its sweeping composition echoed the dynamism of the Vorticists' work, while its restricted palette of black, vibrant orange, lime green, leaf green, sage green and grey gave the poster a bold visual impact.

With its depiction of an arching bridge and the edge of a Modernist building, this poster is a celebration of the man-made environment, in sharp contrast with the rural idylls depicted in Kauffer's London Transport posters of the previous decade. He went on to design posters for, among others, the Great Western Railway, Shell-Mex, British Petroleum, the Orient Line, the General Post Office and American Airlines, and also worked as a book illustrator. It was, however, his Art Deco-style posters for London Transport from the 1920s – the Golden Age of the Railways – that were his masterworks, with their precisely balanced compositions of pictorial content and bold typography.

Born and educated in America, Edward Kauffer spent much of his graphic design career in Britain where he became one of the nation's leading poster artists. In 1913, his professor at Utah University, Joseph McKnight, loaned Kauffer the money to take a study trip to Paris to enable him to continue his artistic training at the Académie Moderne, and it was in acknowledgement of his benefactor's kind gesture that Kauffer adopted "McKnight" as his middle name. Before he got to Paris however, Kauffer visited Munich, where the attention-grabbing posters of Ludwig Hohlwein had a formative influence on the young artist.

He moved to England in 1914 and the following year received his first major design brief: four posters for London Underground from Frank Pick, who as the railway's publicity manager was responsible for commissioning all the company's graphic design

Edward McKnight Kauffer (1890–1954)
The Colne River at Uxbridge by Tram
poster for London Transport, 1924
Printed paper
Underground Electric Railways Company Ltd, London, England

George Brough (1890–1969)
Brough Superior SS100 motorcycle, 1924

The *Brough Superior* will be forever linked with Colonel T. E. Lawrence, or as he is better remembered, Lawrence of Arabia, who owned seven of them. He wrote letters to George Brough extolling their virtues, which Brough would then publish in his advertisements. As Lawrence noted in one of these communiqués, "They are the jolliest things on wheels".

The son of a pioneering British motorcycle manufacturer, George Brough decided to branch out and establish his own bike company after the First World War. The new venture specialized in the design and build of extremely expensive, high-performance models, which were dubbed by the journalist H. D. Teague as "the Rolls-Royce of motorcycles".

One of the company's first bikes was the *SS80*, so named because its top speed reached a then-impressive 80 mph. This model was subsequently adapted, its flathead engine being switched for an overhead valve, twin-cam engine. These air-cooled engines offered even better performance, and in 1924 the bike was consequently renamed the *SS100*, as it was guaranteed to achieve a top speed of 100 mph. In fact, it could easily top 110 mph, and Brough, who was a talented motorcycle racer as well as a consummate showman and canny marketeer, loved to break speed records and then let everyone know

about his achievements. One of the taglines in his advertisements declared the *SS100* "The Fastest Motorcycle in the World... 129 mph."

The legendary *Brough Superior SS100* certainly offered the ultimate in speed and luxury, and as Brough noted in another advertisement from 1925, "It is very satisfying to know that you are astride a machine which, if you wish, can leave behind anything on wheels." One of the main reasons for its performance success was the fact that its components were sourced from the best specialist sub-contractors Brough could find: its engines were made by J. A. Prestwich, the gearboxes were produced by Sturmey Archer and the speedometers were from Bonniksen, while its distinctive "Bulbous Nose Saddle Tank" was a proprietary design.

Sadly, it was a freak accident on a *Brough Superior* that famously cost Lawrence his life in 1935, though not through any fault of this famous machine. The example shown here is serial numbered "001" and was hand-built at the Brough Superior Works for the Olympia Motorcycle Show in 1924. Referred to as "The Shop Bike", it was subsequently kept by George Brough at the works until the 1930s and can be seen as the blueprint for all other *Brough Superior SS100* bikes ever made.

Below and right: Details of the *Brough Superior SS100* motorcycle showing gas tank and OHV twin-cam engine

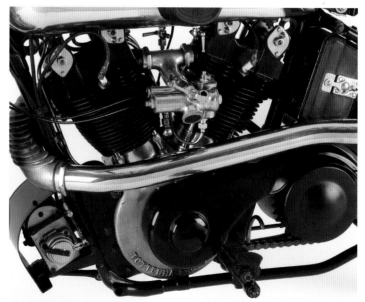

George Brough (1890–1969)
Brough Superior SS100 motorcycle, 1924
Various materials
Brough Superior Works, Nottingham, Nottinghamshire, England

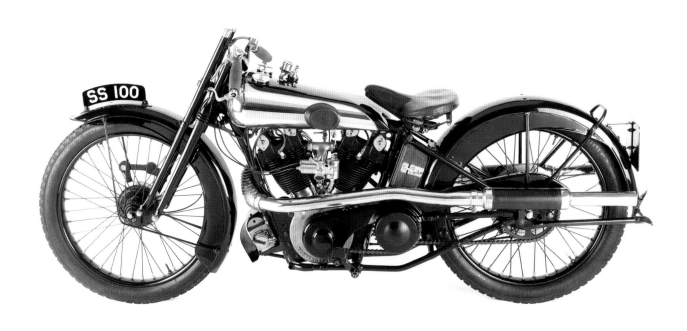

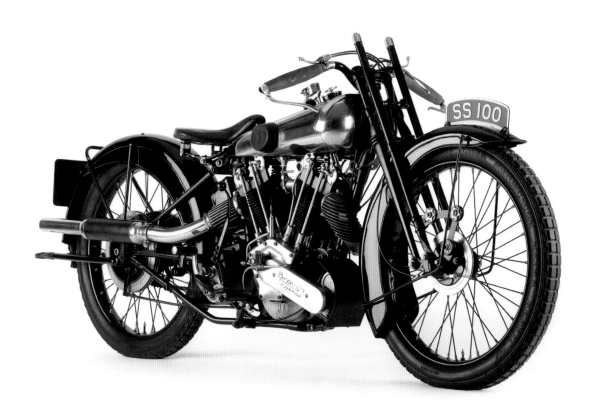

Eric Gill (1882–1940)
Gill Sans typeface, 1926

One of the greatest typographers of all time, Eric Gill was also an accomplished sculptor and printmaker, as well as an extremely controversial public figure whose strict religious faith (and many religiously-themed sculptural works) were at odds with the utterly scandalous sexual practices in which he indulged.

Born in Brighton, Gill studied at Chichester Technical and Art School prior to articling in the architectural office of W.D. Caroe in London, which specialized in ecclesiastical commissions. During this period, he also took evening classes in stonemasonry at Westminster Technical Institute while also studying calligraphy under Edward Johnston at the Central School of Arts & Crafts in London.

In 1903, he abandoned his architectural training and found employment as a letter-cutter, also designing several title pages for the Leipzig publishing house Insel Verlag. But after moving to Ditchling in Sussex in 1907, he began to receive considerable acclaim for his stone carvings. In 1913, he converted to Catholicism and five years later founded a quasi-religious craft community known as the Guild of St Joseph and St Dominic.

He became a founding member of the Society of Wood Engravers in 1920, and from 1924 began designing page layouts for the Golden Cockerel Press. This book artwork fell within the Arts & Crafts idiom, in that Gill carefully and stylistically integrated the typography with the illustrations. The same year he moved to Wales and set up a new workshop, and then in 1925, at the request of Stanley Morison (who was then working as Monotype Corporation's typographic adviser), he designed his first typeface, *Perpetua*.
He based this elegant serif typeface on the lettering found inscribed on ancient Roman monuments.

Perpetua was followed in 1926 by an elegant, modern typeface, *Gill Sans*, first used for the lettering on the fascia of a Bristol bookshop. Morison commissioned Gill to develop and hone this sans-serif typeface into a complete font family for Monotype, with the idea that it would compete with the modern sans-serif typefaces that were being released by different type foundries in Germany.

Monotype eventually released *Gill Sans* in 1928 and the following year it was adopted as the typeface for all posters and publicity material issued by the London and Northern Railway, which greatly helped to spur its popularity. With *Gill Sans*, its creator had attempted to devise the most legible sans-serif typeface possible, and it certainly functioned extremely well as a body text as well as for display purposes.

Gill Sans would not only become synonymous with British Rail's corporate identity, but was also used on the iconic covers of Penguin books from 1935 onwards. Modern and versatile, it is a typographic icon of British visual heritage. Although *Gill Sans* was utilitarian, it retained an engaging English Arts & Crafts sensibility that undoubtedly led to its enduring appeal, which was itself the reason it became one of the bestselling type families of the twentieth century.

Below: design drawing of the lower case "g" of the *Gill Sans* typeface, introduced by Monotype Corporation in 1928

Eric Gill (1882–1940)
Gill Sans typeface, 1926
Various applications
Monotype Corporation Ltd., Salfords, Surrey, England

aA bB cC dD eE

fF gG hH iI jJ kK

lL mM nN oO pP

qQ rR sS tT uU

vV wW xX yY zZ

1 2 3 4 5 6 7 8 9 0

. , ! ? & % $ £

Unattributed
Cottage Blue coffee pot, c.1926–30

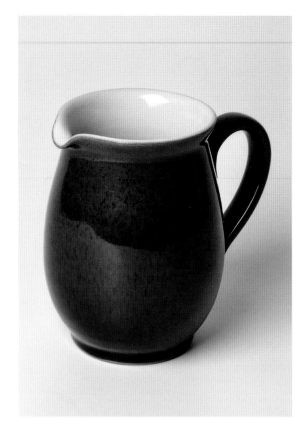

Denby's *Cottage Blue* tableware remained in production for over five decades, a remarkable testament to its position as one of the most important ranges of pottery ever produced. It perfectly captured the very British ability to evolve forms from vernacular paradigms and to translate them into practical, modern pieces with a soft-edged, tactile appeal, and a strong sense of usefulness and beauty.

In 1809, after a seam of fine clay had been discovered on the outskirts of Derby, local potter William Bourne moved his pottery there from nearby Belper. At first the newly founded Denby Pottery produced stoneware bottles but as the nineteenth century wore on, more decorative items were produced: standard stoneware models to which surface decoration was applied. By the 1870s, the firm had begun to manufacture "art pottery" and from 1886 this was sold under the

Danesby Ware name, including a range introduced in the 1930s that used a striking electric blue glaze. However, the majority of designs produced by the works were everyday items such as salt-glazed stoneware jugs and jelly moulds — practical household crockery produced in various shades of cream and brown.

In 1926, however, the pottery introduced a brand new mottled glaze, first applied to the traditional shapes already produced by the factory. *Cottage Blue*, as this new glaze was known, distinguished Denby's everyday wares from those of its competitors, and over the next few years more contemporary shapes were introduced to the range, such as this elegantly formed coffee pot and jug. The *Cottage Blue* range, though essentially utilitarian, had a strong craft sensibility with its smoothly flowing lines informed by functional requirements. The colouration of mid-blue mottled outer glaze contrasting with the warm buttercup-yellow internal glaze helped to heighten the sense of "art manufacture", despite the fact that the range was essentially mass-produced in a factory.

In 1931 the pottery revolutionized its production methods by installing high-capacity tunnel-kilns, which enabled it to introduce various new types of glazes. The designer Donald Gilbert, who joined the firm in 1934, helped to improve the range and quality of the company's decorative *Danesby Wares* and is sometimes credited with the design of the *Cottage Blue* range, even though it was launched before his arrival; however, he may well have been responsible for some of the new shapes introduced to the range in the 1930s.

Other differently coloured glazes, notably *Manor Green* and *Homestead Brown*, were also produced and the range was only finally discontinued in 1983. Denby stonewares could be said to be *the* quintessential British pottery, with their durable bodies, functional shapes and glistening glazes.

Unattributed
Cottage Blue coffee pot, c.1926–30
Glazed earthenware
Joseph Bourne & Sons Ltd, Denby, Derbyshire, England
(later became Denby Pottery Company)

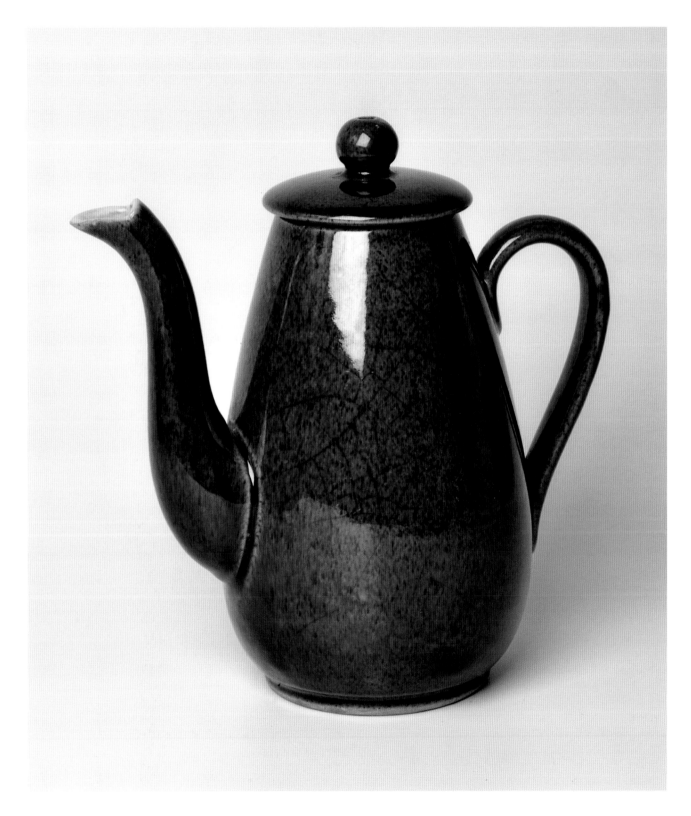

Unattributed
Cornish Kitchen Ware jars, 1926

Above: T. G. Green *Cornish Kitchen Ware* brochure showing range of items, 1958

Right: image from T. G. Green *Cornish Kitchen Ware* brochure, 1958

Thomas Goodwin Green founded the T. G. Green pottery in 1864, originally producing plain and rather dull earthenware designs for the home. In 1926, in response to worsening economic times, the pottery decided to introduce a more decorative range – a striped blue and white pattern, which was subsequently launched as *Cornish Kitchen Ware*. The name was reputedly inspired by a trip to the Cornish coast, with the blue and white colouring, according to a T. G. Green brochure, an homage to the "blue of the Atlantic, white of the Cornish clouds, glisten of the sea".

The distinctive banding of this classically British kitchenware range was achieved using an innovative lathe-turning process, which effectively cut precise and regular bands out of the "electric blue" slip to reveal the white clay below. Among the most successful items in the range were the distinctive storage jars, bearing black stencilled lettering which labelled their intended contents, in either a serif or sans-serif typeface. Significantly, this early *Cornishware*, though utilitarian and intended for everyday use, had a rather jolly seaside demeanour which reflected the British love of bold graphic forms and bright colours – which may well be a subconscious reaction to the predominant greyness of British weather. The public certainly responded well to this new mix-and-match kitchen- and tableware range and it became an instant commercial success.

Over the following years more and more items were added to the range, and by the 1950s it boasted "40 different items, but all with the same charming family likeness", and housewives were told, "It's so easy to build up your own 'Cornish' collection." The fact that it was sold as individual items — what was known as "open stock" – meant that it was more affordable for the average household, as it didn't have to be purchased as a full set all at once.

In 1966 it was decided that the design should be updated, and so Judith Onions, a recent graduate of design from the Royal College of Art in London, was given the task of enlivening the range. Her resulting more contemporary forms had a greater sense of geometric boldness, while still managing to retain the charming aesthetic quality of the original range. A classic British design, *Cornishware* is still in production today some 85 years after it was first introduced, and it is as popular as it ever was – there is just something so instantly recognisable and typically British about those bold blue stripes.

Unattributed
Cornish Kitchen Ware jars, 1926
Glazed earthenware
T.G. Green, Church Gresley, Derbyshire, England

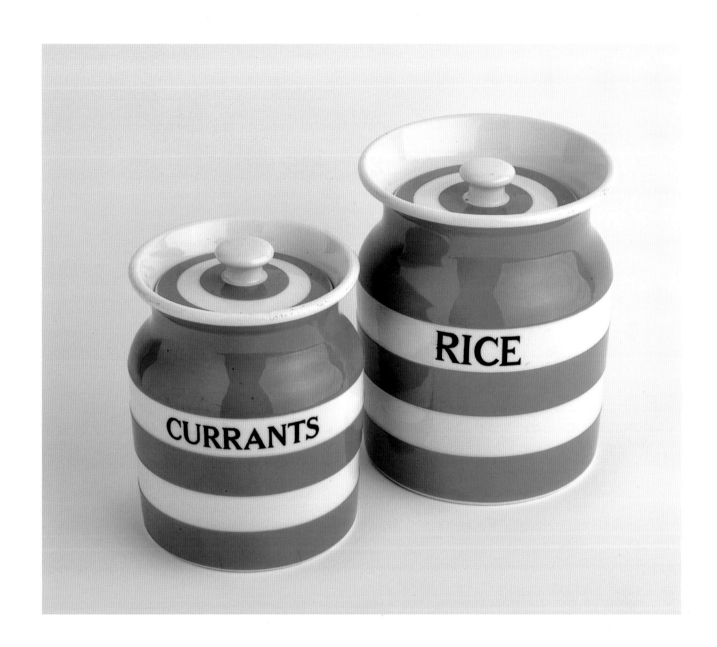

Stanley Morison (1889–1967) & Victor Lardent (1905–1968)
Times New Roman typeface, 1932

Having served a prison term as a conscientious objector during the First World War, Stanley Morison initially worked at The Pelican Press (which in 1919 published his first typographic survey linking calligraphy to typography) and then later briefly moved to the short-lived Cloister Press. In 1922 he was appointed as a typographic adviser to the Surrey-based Monotype Corporation, which had previously developed an innovative typesetting machine. For Monotype, Morison redesigned a number of typefaces including *Garamond* (1922), *Baskerville* (1923), and *Fournier* (1924), and he was also responsible for the commissioning of new typefaces, including those from the well-known artist Eric Gill which resulted in the highly successful *Gill Sans* (1926) font family.

During this period Morison was also actively involved with the Fleuron Society, which he had co-founded in 1922 with Holbrook Jackson, Francis Meynell, Bernard Newdigate and Oliver Simon. This venture, named after a typographic floral or leaf motif, was dedicated to all matters typographic and produced its own influential journal of typography. In 1931, as an acknowledged expert in typographic circles, Morison wrote an article that criticized *The Times* of London for its poor quality printing and its use of difficult-to-read, antiquated typography. As a direct result of this public criticism, in the same year the newspaper commissioned from the Monotype Corporation an entirely new newspaper typeface.

As Morison later noted: "*The Times* as a newspaper in a class by itself, needed not a general trade type, however good, but a face whose strength of line, firmness of contour, and economy of space fulfilled the specific editorial needs of *The Times*". Morison conducted extensive research into legibility and readability, which led to a completely new and unique newspaper typeface that had a greater visual contrast and was more condensed than previous broadsheet fonts. Based on various earlier and historic types, *Times New Roman* was developed by Morison in collaboration with Victor Lardent, a draftsman working in-house at *The Times* who was responsible for the new serif font's precise drafting, albeit under Morison's careful direction. Introduced on 3 October 1932, *Times New Roman* was a beautifully crafted and masterful example of modern British typography that went on to become one of the world's most widely used fonts thanks to its inherent clarity and exquisitely balanced harmonic lines that are still, even to this day, so easy on the eye.

Left: front page of *The Times* newspaper from 3 October 1932 – the day the *Times New Roman* typeface was introduced

Stanley Morison (1889–1967) & **Victor Lardent** (1905–1968)
Times New Roman typeface, 1932
Newsprint (and various other applications)
Monotype Corporation Ltd, Salfords, Surrey, England

aA bB cC dD eE

fF gG hH iI jJ kK

lL mM nN oO pP

qQ rR sS tT uU

vV wW xX yY zZ

1 2 3 4 5 6 7 8 9 0

. , ! ? & % $ £

George Carwardine (1887–1947)
Anglepoise Model No.1227 task light, 1934

During the 1920s, in response to the expansion of the automotive industry in Britain, the mechanical engineer and inventor George Carwardine established his own company specializing in the design and manufacture of car suspension systems. While working within this field, Carwardine developed an articulated mechanism that could be positioned and held in any place using what he termed "equiposing springs", which were based on the constant-tension principle of human limbs. In 1932, he patented the design of an articulated task light incorporating this pioneering mechanism, which the Patent Office referred to as "anglepoising". Subsequently christened the Anglepoise, this innovative lighting design allowed flexible re-positioning, with the light's springs acting in much the same way as human muscles. By balancing a weight against a spring through a linking mechanism, Carwardine was able to ensure that the light remained highly stable and could hold any position over three planes.

Carwardine's first *Anglepoise* light, known as the *Model 1208*, had a simple spun aluminium shade and was produced under licence by Herbert Terry & Sons, a manufacturer of springs based in Redditch. This early model, which used four anglepoising springs, was originally intended for purely industrial and institutional purposes, such as in hospitals and factories. Model 1208 became an instant success when it was first introduced in 1933 and it soon became apparent that Carwardine's useful task light could also potentially be marketed for use in homes and offices. To this end, the design was adapted to incorporate three rather than four coiled metal springs, which meant that it was less likely to trap fingers or long hair in its uppermost springs.

Launched in 1934, this more refined model, known as the *Anglepoise 1227* looked less utilitarian than its predecessor, but was no less functional. It went on to become an acknowledged masterpiece of British design, since the *1227* was widely used in offices, factories and hospitals as well as in domestic environments, and was produced in a number of variations including a ceiling fixture. The stepped base of the *1227* was slightly evolved during the late 1930s to reduce the amount of metal that was used in its production. Hugely influential, the Anglepoise was the blueprint for subsequent generations of task lighting and continues to be produced by its original manufacturer over 70 years after its original introduction, which is testament not only to its enduring visual appeal, but also to its astonishing functionality.

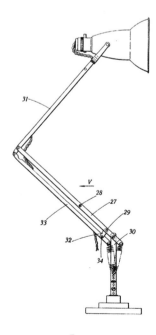

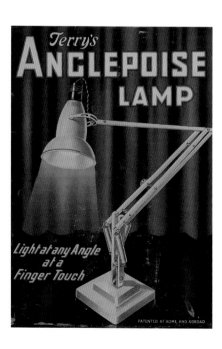

Far left: Patent drawing showing "anglepoising" mechanism of the *Anglepoise* light, 1932

Left: Herbert Terry & Sons Ltd advertisement for *Anglepoise* light, 1930s

George Carwardine (1887–1947)
Anglepoise Model No.1227 task light, 1934
Enamelled metal, metal springs
Herbert Terry & Son Ltd, Redditch, England

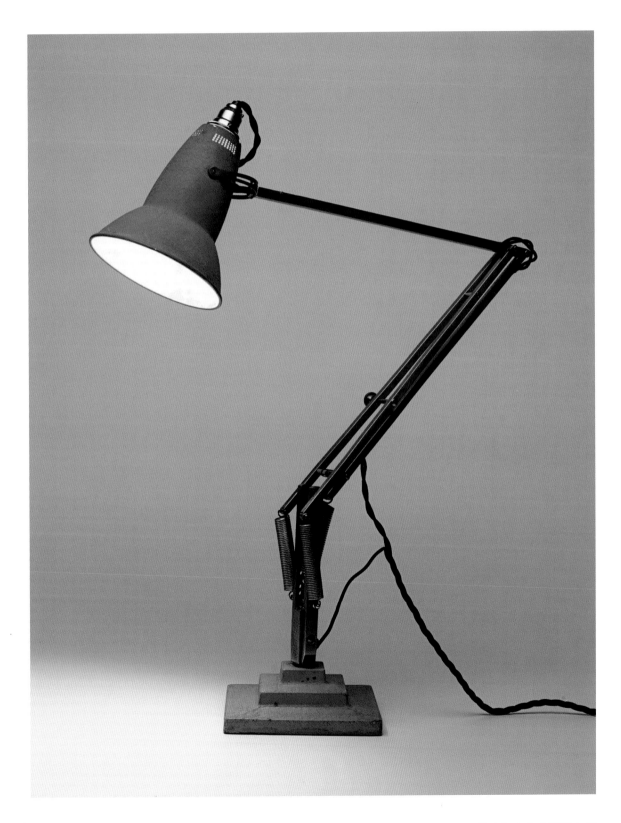

Wells Coates (1895–1958)
Desks, 1933

Wells Coates was an engineer, an architect, a soldier, a pilot, a journalist, an aesthete, an interior designer and a furniture designer. Along the way he became one of the leading protagonists of the Modern Movement in Britain during the 1930s, rallying against what he termed "ancestor-worship in design" and promoting instead a more scientific approach that was based on his engineering background.

He was born in Tokyo to Canadian missionary parents. His mother had trained as an architect under Louis Sullivan and Frank Lloyd Wright in Chicago before her marriage – which undoubtedly influenced Coates's later decision to become an architect and designer himself. His engineering studies at the University of British Columbia were interrupted by the outbreak of the First World War, where he was drafted as an infantryman and later served as a pilot, and it was only in 1921 that he finally graduated. In 1922, he moved to England to take up a two-year scholarship from the Department of Scientific Research and Industrial Research at London University, receiving his PhD in engineering in 1924.

His first job was as a journalist for the *Daily Express* and it was while working on an eight-month assignment as the newspaper's Paris correspondent that he became interested in the arts. In 1927, he decorated a flat for himself and his new wife, and designed and fabricated some its furniture and fittings. He was quite pleased with the result: "The

arrangement and decoration of our flat has afforded us great pleasure. It has furthermore demonstrated the fact that I have some talent in this field. All our friends say at once: 'You ought to go in for this sort of thing'."

It led to a commission to design shop fittings and advertisements for the fashionable textile company Crysede, and a year later, interiors for the firm's factory in Welwyn Garden City. That was followed by a number of interior design commissions including studios in London and Newcastle for the BBC. In 1933, he exhibited his design for the "Minimum Flat", a vision of contemporary living that was later built as Lawn Road Flats by the owner of Isokon, Jack Pritchard.

The same year, Coates created these elegant Modernist tubular steel desks (shown right) for Practical Equipment Limited (known as PEL), which with their curved sled-legs had no sharp edges that might damage wooden floors. Using the minimum of means for the maximum efficiency, these four tubular metal elements also functioned as the supports for the desktop and the drawer units. PEL produced a number of variants of these designs, which likewise conformed to Coates's belief that "the social characteristics of the age determine its art". Fashionably avant-garde yet also relatively affordable to buy, these desks and other functionalist tubular metal furniture designs industrially mass-produced by PEL reflected a new democratization in British design, which Coates described as "purpose related to purse".

Left: page from PEL catalogue showing *Typist's Desk* variation, 1930s

Wells Coates (1895–1958)
Desks, 1933
Chromed steel, chromed tubular steel, ebonized wood
Practical Equipment Ltd (PEL), Oldbury, Birmingham, England

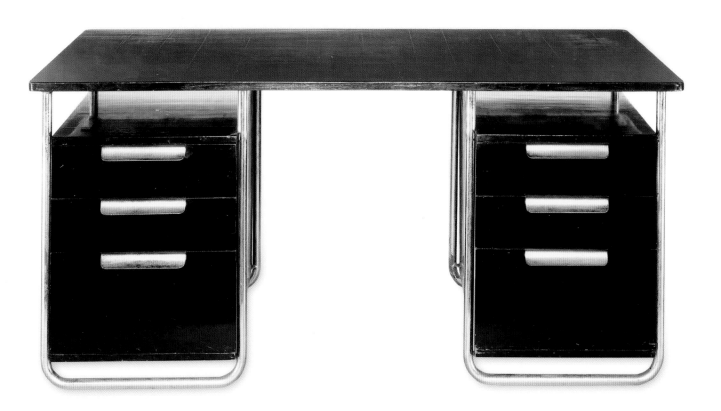

Henry Beck (1902–1974)
London Underground map, 1933

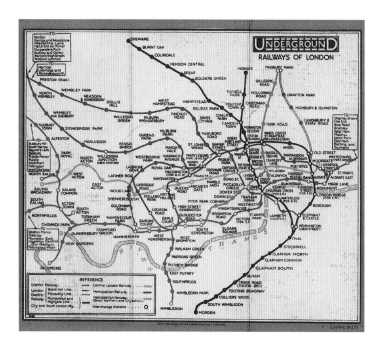

Above: London Underground map, 1927 – before Henry Beck's redesign

The London Underground's landmark schematic design has been a blueprint for railway and metro maps across the world; it is a true masterpiece of universal visual communications design.

The designer behind it was Henry Beck, an engineering draftsman appointed to the task by a man who had already been London Underground's commercial manager for 25 years. From 1908, Frank Pick had been in charge of all its publicity and corporate communications, and he commissioned many of the leading artists of the day to design posters and other printed materials for the company. He was also responsible for commissioning Edward Johnston to redesign the "Underground Roundel", itself an iconic symbol.

The mapping of the London Underground system was more complex; as more and more lines and stations had been added over the decades, so the maps had become more difficult to follow as they attempted to show the exact geographic location of each line and station. In his quest for something more user-friendly, Beck redesigned the map in 1933 using a diagrammatic approach which showed the spatial relationship of the stations to one another, rather than the relative distances between them. This ingenious approach to map-making also made use of colours as symbols: each line was given its own easy-to-distinguish colour, for example green for the District Line and blue for the Piccadilly Line.

The map was given even more visual clarity by being worked up from an octagonal grid, so that the lines and stations were "locked" at 180, 90 or 45 degrees to each other. The River Thames was shown as a symbolic, meandering blue line, which gave the map a strong and unmistakable London identity (while also helping users see which side of the river they were on or going to).

Henry Beck's London Underground map not only allowed passengers to navigate their way across the capital more easily, but also helped to contribute to London Underground's very clear and recognizably modern brand identity.

Henry Beck (1902–1974)
London Underground map, 1933
Printed paper
London Transport, London, England

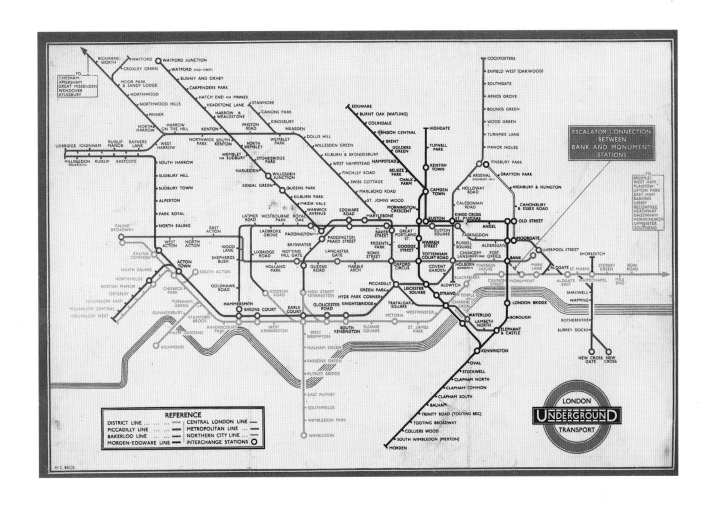

Gerald Summers (1899–1958)
Lounge chair, 1933–34

Gerald Summers left school, Eltham College, at 16, having studied among other things a little carpentry. He became apprenticed at a steam engine manufacturing firm, Ruston, Proctor & Co. in Lincoln, but enlisted in the army in 1916. It was during his service in France that he began to turn his mind to, as he put it, "dealing with wood and doing things with wood".

On his return to England after the First World War had ended, Summers worked as a manager at the Field and Air Division of Marconi's Wireless Telegraph Co. Ltd, and it was there that he met his future wife and colleague, Marjorie Amy Butcher. She needed new furniture and that led Summers to design and make a dressing table and wardrobe. This early project subsequently inspired the couple to start up their own furniture manufacturing company, Makers of Simple Furniture, in 1932.

Based in Fitzroy Street, London, the new venture produced "simple" modern furniture in sheets of cut and moulded plywood. The technical challenges of moulding plywood were considerably overcome with the help of Jack Pritchard, the visionary owner of Isokon, who was kind enough to share his production know-how with the couple.

In 1933 Summers began experimenting with thin sheets of aircraft plywood, which were extremely flexible and malleable and allowed him to create highly innovative constructions with engaging organic curves and free-following lines. Among these was his extraordinary lounge chair designed in 1933–34, which was originally conceived for use in the tropics. Because heat and humidity can have an adverse effect on traditional chair joinery, Summers constructed the design from a single piece of bent birch aircraft plywood to alleviate the problem. The curves of this single-form, single-material lightweight armchair also made it comfortable enough to use without upholstery, which was prone to insect infestation and rot, both common problems in the tropics.

The design was manufactured either in a natural finish, or painted white or black which gave it an even more overtly modern look. Like Alvar Aalto and Marcel Breuer, Gerald Summers pushed the physical limits of plywood in order to create chairs and other furniture that offered an alternative to the hard-edged and emotionally sterile aesthetic offered by bent tubular steel.

Although Makers of Simple Furniture operated for only nine short years until the outbreak of the Second World War, it produced some of the most innovative and influential furnishings of the 1930s. This lounge chair with its extraordinary undulating profile is a Modernist masterpiece, in that it pushed materials and processing technologies to a completely new level, resulting in a design that was both formally and functionally highly progressive.

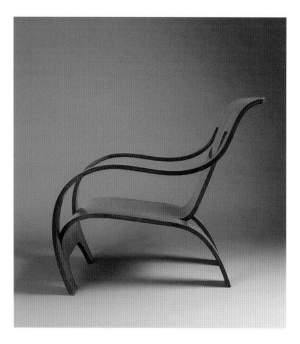

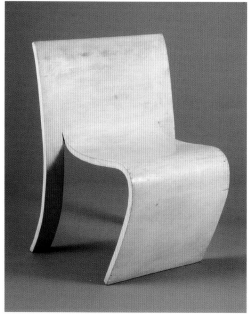

Far left: profile of lounge chair designed by Gerald Summers for Makers of Simple Furniture, 1933–34

Left: *SF/SC* dining chair designed by Gerald Summers for Makers of Simple Furniture, 1938

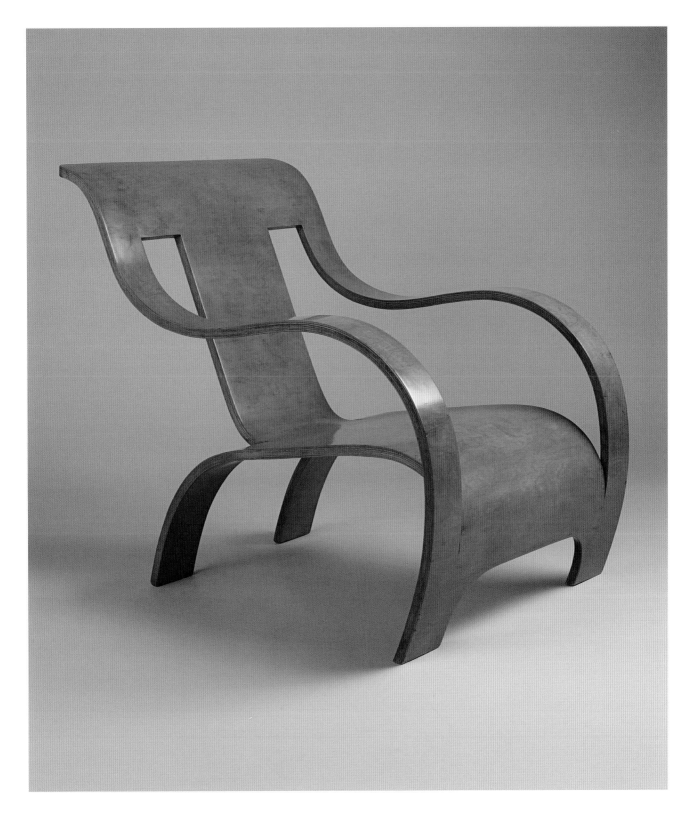

Keith Murray (1892–1981)
Globe vase, c.1934

The ceramic wares created by Keith Murray for the long-established Stoke-on-Trent potter Josiah Wedgwood typified the less doctrinal and softer-edged approach to Modernism taken by British designers during the 1930s, in comparison to their contemporaries working in Germany or France.

Using matt glazes and a restricted colour palette that included sage green, straw-yellow, pale turquoise, dove grey, warm cream, "Moonstone" and "Black Basalt", Murray created a large number of Art Deco-style models produced in plaster moulds, ranging from large globular vases and simple tankards to tea sets, ashtrays and bookends.

Born in New Zealand, Murray trained in London as an architect and in 1925 visited the landmark "Exposition Internationale des Arts Décoratifs et Industriels Modernes" in Paris, from which the term "Art Deco" was coined to describe the new style of the designs on display. In terms of modernity, the avant-garde glassware on show surpassed anything then currently being manufactured in Britain. Creatively emboldened by this experience, and also by his visit to the 1931 exhibition of "Swedish Design" held at Dorland Hall in London, he became increasingly interested in pure geometric forms and the functional aspects of design, and after trying and failing to interest Arthur Marriott Powell of Whitefriars Glass with various modern design proposals, Murray was taken on as a designer for the Stevens & Williams Glassworks.

It was this association that led to an introduction to Felton Wreford, manager of Wedgwood's London showroom, who subsequently arranged a visit to the company's Etruria factory in Stoke-on-Trent. Murray was encouraged to study the various production processes employed there. His simple yet bold volumetric shapes were eminently suited for mass-manufacture in moulded clay, and in 1932 he began a long and fruitful association with the company.

In 1933, Murray's functional designs were shown at the "British Industrial Art in Relation to the Home" exhibition in London and also at the fifth Milan Triennale, where they were awarded a prestigious gold medal. One of the most impressive vases designed by Murray for Wedgwood was the almost completely spherical model shown here, with its distinctive green matte glaze. Manufactured around 1934, the bulbous *Globe* vase with its concentric ribbed bands has an inherent visual dynamism that must have appeared startlingly modern in its day, the lack of superfluous decoration enhancing its striking geometric form. Interestingly, because of their structural simplicity many of Murray's designs were not subject to wartime restrictions and so were able to remain in production throughout the Second World War.

Apart from his designs for ceramics, Murray was – together with his architectural partner, Charles White – commissioned in 1936 by Wedgwood to design a new and much larger state-of-the-art factory for the firm at Barlaston (built 1938–40), the outcome of which was similarly determined by a stringently Modernist approach to both form and function.

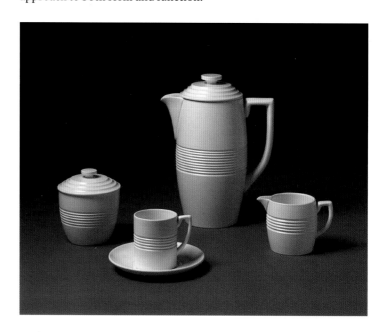

Above: Coffee set designed by Keith Murray for Josiah Wedgwood & Sons Ltd, 1933

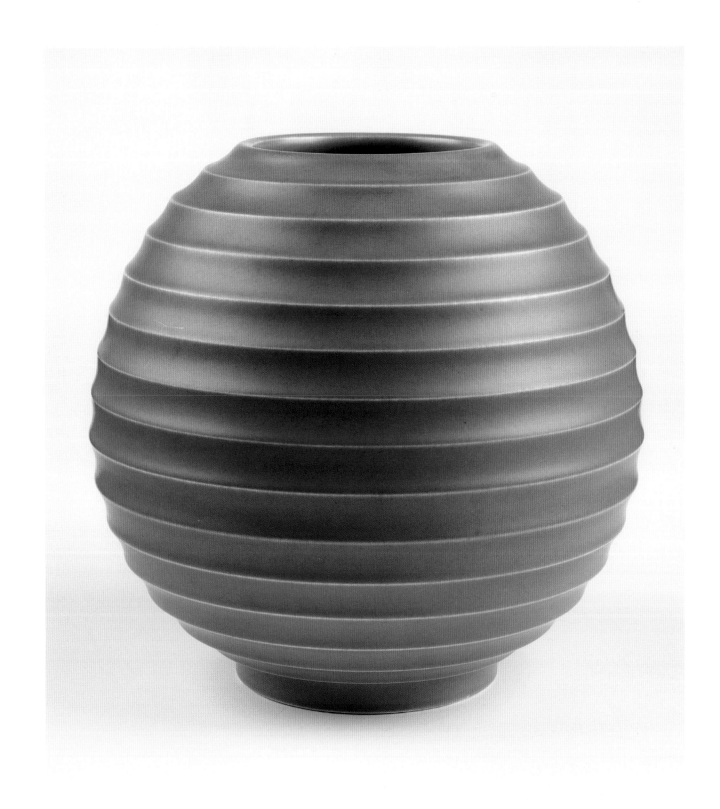

F. W. Alexander (active 1930s–40s)
Type A microphone, 1934

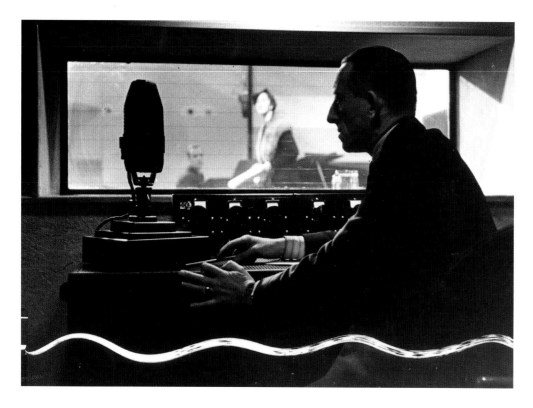

Left: a BBC staff member in the studio with a *Type A* microphone listening to an audition in Broadcasting House, London, 10 March 1936

As the "Voice of the Nation", the BBC (British Broadcasting Corporation) has had a huge influence on the development of cultural, social and political life in Britain since its establishment in 1922. Its broadcasting authority has also been felt around the globe, thanks to the BBC World Service or – as it was known when first introduced in 1932 – the Empire Service.

The iconic BBC-Marconi ribbon microphone that was used to make so many of these early historic radio broadcasts, was devised in 1934 by the BBC engineer F. W. Alexander. This landmark design was developed in response to RCA's *Model 44* ribbon microphone, which was in widespread use in Hollywood but which the BBC considered too expensive. At the time, the RCA microphone was priced at an exorbitant £130 per unit, whereas the microphone manufactured by Marconi for the BBC cost only £9 – about £500 per unit at today's prices, compared to £7,000.

Although it had a distinctive and authoritative presence, the *Type A* microphone – and subsequent, subtly improved versions – did have one major

drawback, in that it could only be used at around 20 degrees off vertical, because of its relatively large scale and the size of its aluminium ribbon. According to th BBC's principal engineer, Chris Chambers, when it first came out, its sound quality was also problematic, with "terrible peak of resonance" due to the material composition of the resonating ribbon. However, this problem was soon overcome by replacing the ribbon with thin aluminium foil, and the microphone was re-christened the *Type AX*.

The microphone was also modified internally in 1943 (as the *Type AXB*), and again in 1944 (as the *Type AXPT*); the iconic lozenge-shaped form, however, remained essentially unaltered. This classic microphone was used until 1959, and became as much a symbol of the BBC as the institution's famous logo. It reflected the expert hands-on expertise and can-do resourcefulness that is common among British engineers, which enables them, time and again, to come up with elegant yet inventive solutions to seemingly insurmountable problems.

F. W. Alexander (active 1930s–40s)
Type A microphone, 1934
Brass, aluminium, various other materials
Marconi's Wireless Telegraph Co. Ltd, London, England for the
British Broadcasting Corporation, London, England

Wells Coates (1895–1958)
Ekco *AD 65* radio, 1934

Left: EKCO *Model AD 75* valve radio designed by Wells Coates, 1940. A later evolution of the Ekco *AD 65*

E. K. Cole Ltd was set up by Eric Kirkham Cole and his wife in 1926 to manufacture radio sets they themselves had designed. With funding from local businessmen, the firm opened a factory the following year in Leigh-on-Sea to manufacture an "eliminator" model. This new radio receiver could be powered directly from AC current rather than from batteries – the term eliminator referred to the elimination of the heavy and bulky batteries that were the bane of early radio buffs.

By 1931, Cole's factory was employing 1,000 workers to mass-produce radios bearing the Ekco brand. That same year, the company acquired compression-moulding presses which were used for the introduction of its first Bakelite radio, the Ekco *M 25*, designed by J. K. White. This early model had a geometric Art Deco housing complete with landscape vignette and tree-like motifs, and as such did not look especially different from other cabinet-like models made of wood.

The following year, however, the company held a competition for the design of a new radio cabinet which would incorporate moulded plastic. The competition received submissions from some of the leading British Modernist architects and designers of the day, including Serge Chermayeff (1900–1996), Raymond McGrath (1903–1977) and Misha Black (1910–1977). It was, however, the innovative circular design submitted by Wells Coates that was named the overall winner.

Fully exploiting the mass-manufacturing potential of Bakelite – commonly advertised as "the material of a thousand uses" – his winning design revealed Coates's in-depth knowledge of the internal workings of a radio receiver and layout of its components. Importantly, it reflected his goal of reducing materials, components and manufacturing costs to make mass production easier and so undercut the competition. Coates described these democratizing methods as "purpose related to purse", and his radio – christened the *AD 65* and launched in 1934 – clearly embodied this mantra.

It quickly became a bestseller, and was available in two models: the standard version, manufactured in warm-toned, walnut Bakelite; and a slightly more expensive variant in stylish, black Bakelite with chromed metal fittings. Before the radio's launch, Coates wrote of his own role that "the most fundamental technique is the replacement of natural materials by scientific ones", something he certainly achieved with the *AD 65*'s phenolic plastic casing. Moreover, this landmark design's colour-coded waveband selector and three simple control knobs made it extremely simple to use.

Alongside its use of cutting-edge plastics technology, the *AD 65* was one of the first truly Modernist products that was generally available to British consumers, and as such it became a potent symbol of British Modernism of the 1930s.

Wells Coates (1895–1958)
Ekco *AD 65* radio, 1934
Bakelite (also Phenol-formaldhyde)
E. K. Cole Ltd, Southend-on-Sea, Essex, England

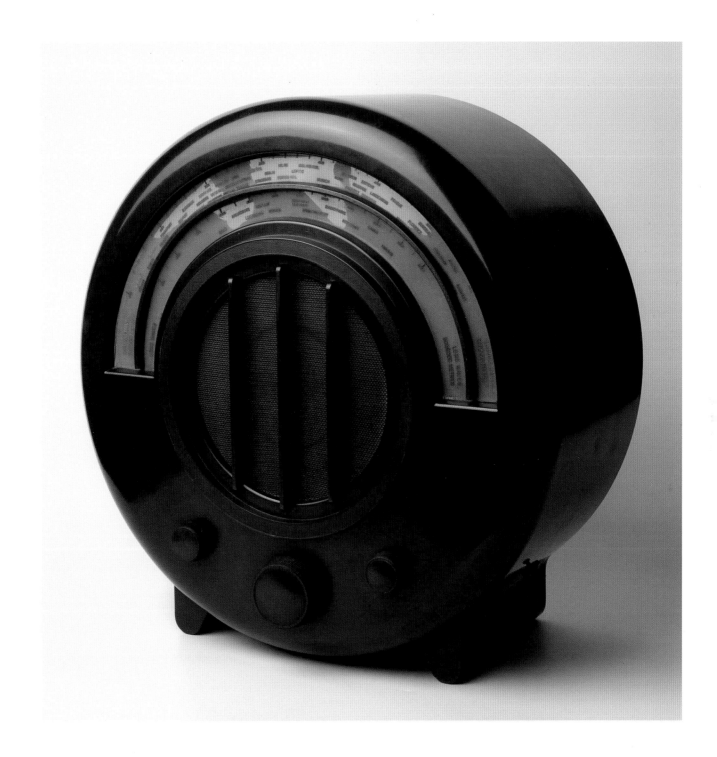

Herbert Nigel Gresley (1876–1941)
LNER *Class A4* locomotive, 1935

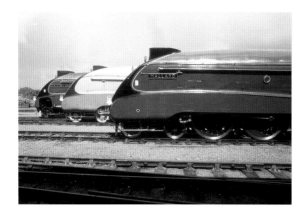

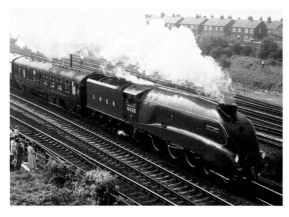

Above: Photographs showing LNER *Class A4* locomotives in use

The London and North Eastern Railway (LNER) was the second largest of the railway companies created under the aegis of Britain's Railways Act of 1921. Also known as the Grouping Act, it had been brought in by David Lloyd George's postwar government to rationalize the rail system and bring it under greater state control, as it was generally felt that the country had actually benefitted from its railways being run by the government during the Great War, rather than by a plethora of more than 100 small companies.

Edinburgh-born Herbert Nigel Gresley had worked for the London and North Western Railway, the Lancashire and Yorkshire Railway, and finally the Great Northern Railway as its Carriage and Wagon Superintendent, before his appointment in 1923 as chief mechanical engineer to the newly formed LNER, overseeing the design of its locomotives and rolling stock. One of Gresley's first steam locomotive designs for LNER was the iconic *Class A3 Flying Scotsman*, a Pacific locomotive with a 4-6-2 wheel arrangement that became the first train officially recorded to have reached 100 mph. The *Class A3* was followed in 1938 by what is undoubtedly the greatest British steam locomotive ever built at LNER's Doncaster works, the *Class A4 Mallard*.

Like the *Flying Scotsman*, the *Mallard* had a Pacific 4-6-2 wheel configuration, but there the comparison ends, thanks to its sweeping aerodynamic body which was the result of careful wind-tunnel studies. It was also the first of four *Class A4* locomotives designed by Gresley to incorporate a Kylchap double blast pipe, a steam exhaust system previously developed by the French engineer André Chapelon that gave better exhaust flow. By incorporating the exhaust stack into the actual body of the locomotive, Gresley not only improved its aerodynamic performance but the whole overall look of the *Mallard* was sleeker – a new modern train for a new modern age.

It was this more efficient steam exhaust system twinned with Gresley's bold streamlined form that gave the *Mallard* its edge when it came to speed. The *Mallard* – named because of Gresley's interest in duck breeding – became the fastest steam locomotive in the world, achieving an impressive 125.88 mph in 1938, a world speed record that it retains to this day.

Herbert Nigel Gresley (1876–1941)
LNER *Class A4* locomotive, 1935 (example shown is the famous record-breaking *Mallard*)
Various materials
LNER (London and North Eastern Railway) Doncaster Works, Doncaster, Yorkshire, England

Edward Young (1913–2003)
Book covers for Penguin Books, 1935

As British as strawberries and cream eaten at Wimbledon, the immortal Penguin paperback covers that were originally designed by Edward Young are a highly recognizable and much-loved classic of Britain's design and literary heritage.

In 1935 Allen Lane, a director of the well-known Bodley Head publishing house, began independently publishing paperback reprints. The following year he officially established his own imprint, Penguin Books, whose *raison d'être* was to put "into the hands of people like myself the books they would have read if they had gone to university".

Apart from reprinting acknowledged literary classics in affordable paperback form, Lane also published new titles priced at an inexpensive 6d (12 cents) – the same price as a packet of cigarettes. They were intended to be available not just in traditional bookshops, but also in railway stations, tobacconists and department stores. He even set up a vending machine for the purpose, in London's Charing Cross Road.

Many of these new titles had a self-improving educational remit, such as Anthony Bertram's *Design* (1938). The strong and coherent graphic visual identity achieved by Edward Young's boldly modern, three-banded cover design contributed hugely to the popular success of Penguin paperbacks. Using a different colour for each of the literary genres – orange for fiction, green for mystery and crime, dark blue for biography and pink for travel and adventure – the covers also had an added functional aspect.

The clear yet friendly penguin logo was also Young's creation, although it had been Allen's idea to have an animal logo – "something dignified but flippant" – for the new imprint: "It was the obvious answer, a stroke of genius", as Young was later to recall. "I went straight off to the zoo to spend the rest of the day drawing penguins in every pose."

The Swiss-born typographer and graphic designer Jan Tschichold, who was living in England between 1947 and 1949, amended Young's original cover system very subtly to incorporate a slightly more stylized penguin logo, and selected the modern (but not too scarily modern) *Gill Sans* typeface as the imprint's house font.

Described as having "the noblest list in the history of publishing," Penguin paperbacks, thanks to their affordable price and elegantly modern design, attracted a completely new type of middle-class readership. In so doing, it helped to educate a nation that avidly read both its fiction and non-fiction titles – democratic design at its very best.

Far left and left:
Mystery & Crime and Biography theme-coloured Penguin paperback covers

Edward Young (1913–2003)
Book covers for Penguin Books, 1935
Printed card
Penguin Books, London, England

Unattributed
Model No. 444 "People's Set" radio, 1936

The origins of the American manufacturer Philco can be traced back to the Helios Electric Company which was founded in 1892. In 1909, the company was renamed the Philadelphia Battery Storage Company (Philco) and in 1927 the firm began producing broadcast receivers, soon becoming, thanks to its early adoption of an assembly-line system of production, one of the big three radio manufacturers in the United States.

In 1932 Philco made its first foray into the British radio market by opening a state-of-the-art, custom-built manufacturing facility in the west London suburb of Perivale. Prior to this, British manufacturers had managed to restrict the import of foreign broadcast receivers, but Philco cleverly engineered a patent swap deal that enabled it to commence production in Britain. In 1935 the Ullswater Committee on Broadcasting investigated the high price of radios in Britain and implored the whole industry to produce higher-quality, but cheaper, models. The Committee was well aware that in Germany, through "co-operation between the broadcasting authority and the wireless trade", a new standardized receiver known as the *Volksempfänger* (People's Receiver) had been designed which was to be sold at a low fixed price and which was "constructed by the manufacturers on direct instructions from the German Ministry of Propaganda, the set being deliberately designed to receive only transmissions from the German National Station and 968 local transmitter". Although the committee did not "want that sort of thing in this country… [having] freedom and liberty here", it realized that there was a desperate need for better and more affordable radios in Britain, especially given the fact that another world war was looming and radio broadcasts were the best way of keeping a populace informed during hostilities.

Responding to this challenge, Philco launched the *Model No. 444* broadcast receiver in 1936 with its pioneering streamlined plastic housing made of gleaming black or brown Bakelite, "the material of a thousand uses." Rolling off the conveyor belt at Philco's Perivale factory, the *Model No. 444* radio was designed to be industrially mass-produced and as a result was relatively inexpensive to purchase, costing just £6 6s (six guineas). Unlike the majority of wooden-furniture-like radios produced in Britain around this time, the *Model No. 444*, with its attractively streamlined form and easy-to-use dials, had an alluring Art Deco/Moderne aesthetic, although when first launched it didn't sell particularly well. However, when the design was renamed the *"People's Set"* in 1937, sales took off and an astonishing 500,000 units were eventually sold. Using the same standardized arched plastic housing, Philco also produced the *B537*, which had four dials rather than three. As one of the great examples of British Art Deco, the *"People's Set"* was not only important in the new aesthetic direction it set for radio design, but also in the fact that it became a familiar and reliable conduit in homes across the country for the BBC's broadcasts during the war years.

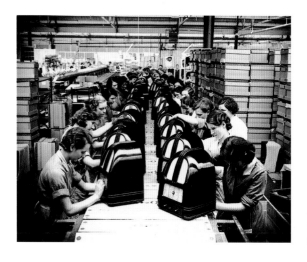

Left: workers at the Philco radio factory in Perivale, London, 1936 – showing the production of the *B537* radio

Anonymous
Model No. 444 'People's Set' radio, 1936
Bakelite, speaker cloth, plywood, various other materials
Philco Radio & Television Corporation of Great Britain,
Perivale, England

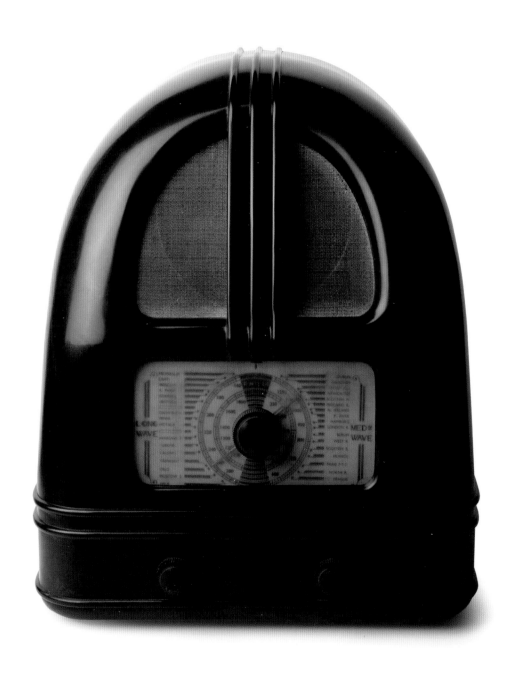

Percy Goodman (attributed) (d.1951)
Velocette MAC Sport motorcycle, 1936

For several years German-born John Taylor and his business partner William Gue tried and failed to manufacture a commercially successful motorcycle, despite developing innovative features such as a vane type oil pump and a two-speed pedal-operated drive gear. Then in 1913 they finally had a success with a bike designed by Taylor's son Percy: the *VMC*.

The lightweight *VMC* (an abbreviation of their company name, Veloce Motor Company) was more popular and much cheaper than its nearest rival, the Triumph, and significantly altered the company's fortunes. Over the next few years it was followed by other top-class two-stroke 250cc models, until some time around 1924/25 when Percy, realizing that the family firm's growth depended on developing a better-performing model with advanced specifications, designed a new 350cc overhead camshaft bike – the *Model K*.

By now Taylor had changed his name to Goodman, and Percy Goodman took the new bike and its *K Series* stablemates on to win numerous Isle of Man TT races and other competitions. But it was probably the company's *M Series* of bikes, first launched in 1933, that were the most important, especially the *Velocette*

MAC Sport motorcycle, launched in 1936.

A truly classic design, this hand-built 350cc model was one of the most beautiful British motorbikes ever made. It boasted an impressive level of performance that reflected Veloce's reputation for exceptional quality and innovative design. The bike's exquisite detailing epitomized the proud history of British engineering and bike-building, while its perfectly balanced form when set in motion, would prove to be a pure sensorial delight.

The slightly later, and higher-powered, 500cc *Velocette MSS* would also prove to be profitable for the company, but as with so many other British motorcycle firms, the outbreak of the Second World War interrupted Veloce's production and during the postwar years the company lost its manufacturing competiveness. As a result it struggled to compete with foreign imports, and was eventually forced to close its doors in the early 1970s. A sad end to a company that had produced some of the most exquisitely designed and built motorcycles of all time, which in their day set world records and had an enthusiastically loyal following among true bike aficionados.

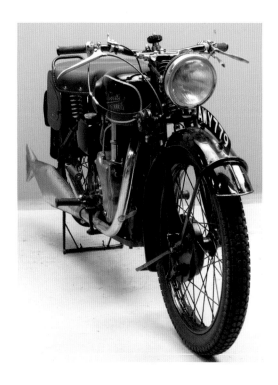

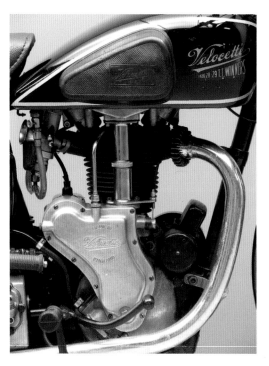

Far left: front view of the *Velocette MAC Sport* motorcycle

Left: detail showing *Velocette MAC Sport* motorcycle's 350cc engine

Percy Goodman (attributed) (d.1951)
Velocette MAC Sport motorcycle, 1936
Various materials
Veloce Ltd, Hall Green, Birmingham, England

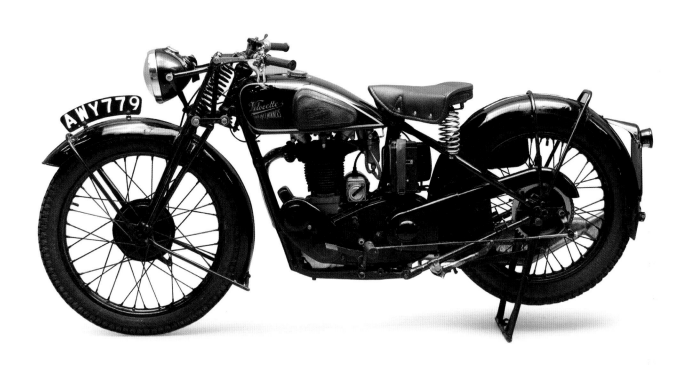

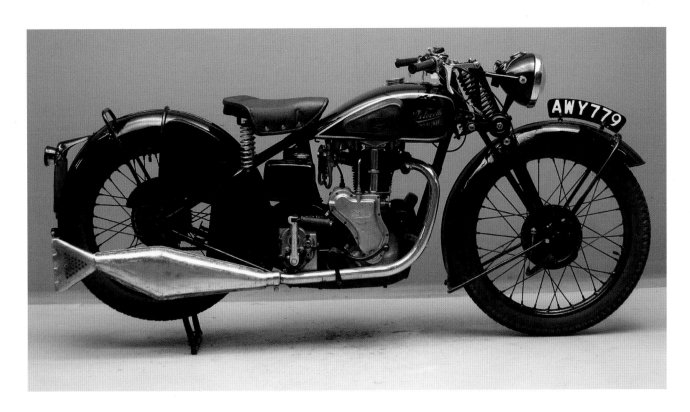

Giles Gilbert Scott (1880–1960)
Model No. K6 telephone box, 1936

Giles Gilbert Scott was the grandson of the Gothic Revivalist architect Sir George Gilbert Scott, who famously designed the jewel-like Albert Memorial in Kensington Gardens and the magnificent Midland Grand Hotel at St Pancras Railway Station in London. Following in his grandfather's footsteps, Gilbert Scott trained as an architect in the offices of Temple Lushington Moore, who had himself articled with Giles's grandfather and who similarly worked within the Gothic Revival style.

In 1904, as a youthful 24-year old, Giles Gilbert Scott won a competition to design Liverpool Cathedral, beating off a number of extremely strong contenders including the gifted Scottish architect, Charles Rennie Mackintosh. His design for this prestigious commission was notable for its bold Neo-Gothic form and monumental muscular massing, the latter being a strong characteristic of his later buildings such as Battersea Power Station (1932–34) and the colossal Bankside Power Station (1947–60), which now houses Tate Modern.

Apart from his towering brick-built edifices, Scott also designed two public telephone boxes for the G.P.O. (General Post Office): the *K2* in 1924, and the *K6* in 1936. The former was the first of Britain's telephone booths to be painted pillar-box red, but proved to be too large and too expensive to produce. Curiously, this box-like design with its arching canopy roof was inspired by the Neo-Classical mausoleum in the churchyard of St Pancras Old Church, designed by the architect Sir John Soane for himself and his wife.

The later, classic *Model K6* was essentially a refinement of the *K2* and it is sometimes referred to as the Jubilee Kiosk, because with its moulded (rather than pierced) royal crown motif, it was introduced to commemorate the silver jubilee of King George V's Coronation. Its domed roof ensured that water could drain properly, while slots beneath the illuminated sign allowed for much-needed ventilation. The three glazed side panels ensured that even when in use at night, there was usually sufficient light to see the telephone's dial.

Between 1936 and 1968 around 60,000 *K6* telephone boxes were installed across Britain,

making it by far the most ubiquitous of all of the eight kiosk types used by the G.P. O. Like the *Routemaster* bus and the famous black *FX4* Austin taxi, Scott's phone box has since become an iconic British design that is recognized throughout the world. As testament to its enduring place in national culture, when British Telecom decided to replace these well-loved telephone boxes with new kiosks in 1988 there was a public outcry, and as a result many examples were retained and are still in use across the country.

Below: earlier *K2* telephone kiosk designed by Giles Gilbert Scott for GPO, 1924

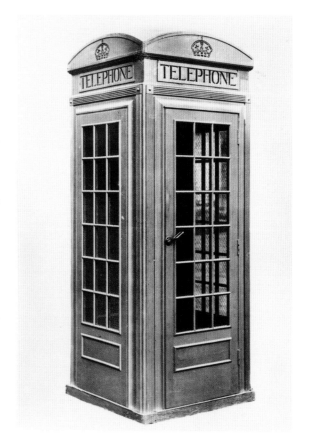

Giles Gilbert Scott (1880–1960)
Model No. K6 telephone box, 1936
Painted cast iron, painted teak, glass
GPO (General Post Office), London, England

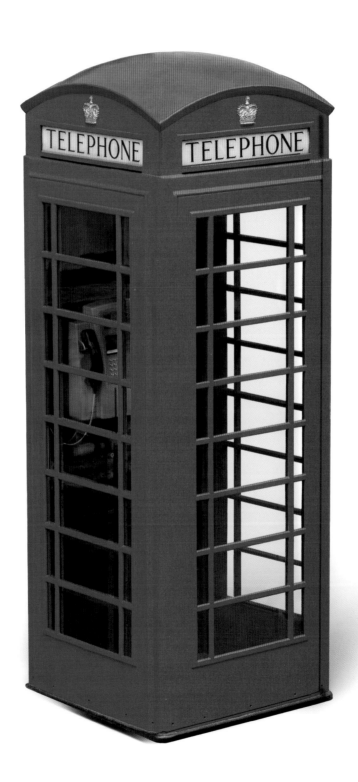

Reginald Joseph Mitchell (1895–1937)
Supermarine Spitfire, first flight 1936

No other aircraft that saw action during the Second World War embodies the attributes of British design better than the immortal *Supermarine Spitfire* with its extraordinary sense of purposeful elegance. Nor does any other warbird have quite the same emotional connection with the British people as this powerfully evocative symbol of the British fighting spirit.

Its designer, Reginald J. Mitchell, had trained as an engineer before joining the Supermarine Aviation Works in Southampton in 1916. Three years later, he became the company's chief designer and engineer, a position that he would retain for the rest of his all-too-short life. He initially designed high-speed seaplanes, which took part in the famous Scheidner Trophy contest and won the coveted trophy four times. Importantly, the design of these aircraft would later inform Mitchell's development of Supermarine warplanes.

The outstanding triumph of the *Supermarine S.6B* at the Scheidner Trophy in 1931 – winning the cup for Great Britain as well as setting a new speed record – prompted the Air Ministry to invite Mitchell to submit proposals for a new monoplane to replace its now-outmoded biplanes. This led to the development of an elegant, low-wing monoplane prototype with fixed landing gear, initially known as the *Supermarine Type 300* but rechristened the *Supermarine Spitfire* before it first flew on 5 March 1936.

The *Spitfire* prototype had a maximum top speed of 342 mph, making it the world's fastest military aeroplane at the time. It subsequently went into full-scale production with a few modifications, becoming Supermarine's first production landplane. A day fighter, a night fighter and an excellent reconnaissance plane, the *Spitfire* was fitted with a single Rolls-Royce *Merlin* engine and the first model to enter service, the *Spitfire Mk1*, had an impressive maximum speed of 360 mph; however, one of its later variants, the *Spitfire MK XIV*, had a top speed of an astonishing 440 mph.

With its distinctive elliptical wings and monocoque fuselage, this single-seat fighter underwent numerous evolutions throughout the war, yet as *Jane's All the World's Aircraft* noted in 1944, "The soundness of the basic design has been proved in six years of war, throughout which the Rolls-Royce-engined *Spitfire* has, in its many progressive developments, remained a first-line fighter." Renowned for its beautiful aerodynamic sleekness and its impressive high-altitude manoeuvrability, the *Spitfire* played a decisive role in the Battle of Britain as a superb defence interceptor and it was this that would forever forge the heartfelt affection for this extraordinary plane in Britain. The example shown here is the *Mk IXB Spitfire MH434* built by Vickers-Armstrong in 1943, and it is without question the most famous *Spitfire* that is still flying today. It saw impressive and decisive service during the Second World War and was subsequently owned by Ray Hanna, the legendary founding member of the RAF's aerobatic display team, the Red Arrows.

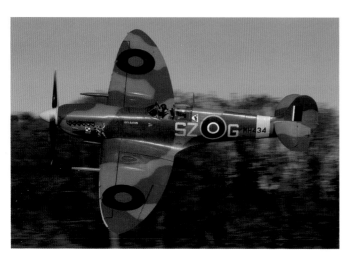

Far left: *Supermarine Spitfire Mk IXB MH434*, flown by Ray Hanna's son, Mark, in 1998.

Left: vector drawing of *Supermarine Spitfire Mk IX*

Reginald Joseph Mitchell (1895–1937)
Supermarine Spitfire, first flight 1936
(Example shown: *Spitfire Mk IXB MH434*, introduced 1942,
flown by Lee Proudfoot in 2010)
Various materials
Vickers-Armstrong Ltd, London, England (took over the
Supermarine Aviation Works in 1928)

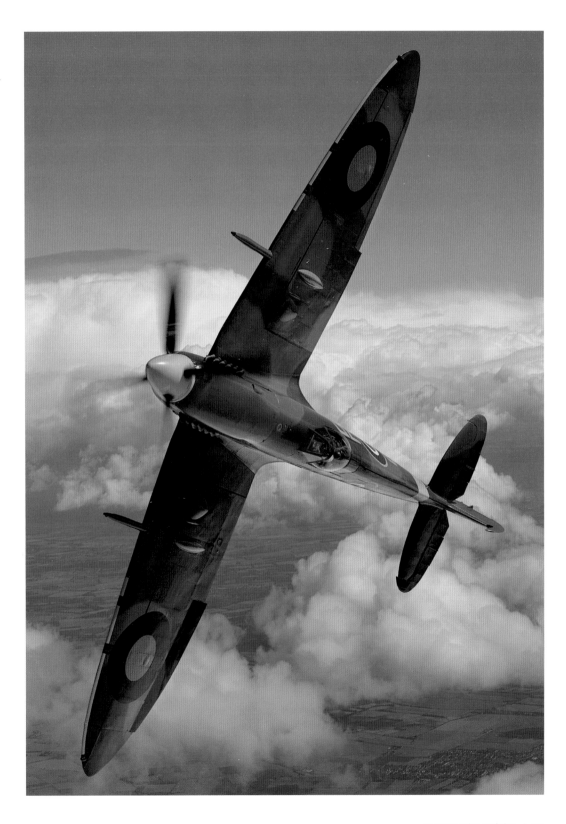

THE HENLEY COLLEGE LIBRARY

Enid Marx (1902–1998)
Chevron moquette textile, c.1938

Enid Marx is perhaps best known for the timeless textile designs she produced for the London Passenger Transport Board in the late 1930s, which are still in use on London Underground seating today. Bold but not too dazzling, her highly durable designs in hard-wearing cotton-velvets, including her well-known patterned Chevron moquette from around 1938, remain fresh-looking even after repeated hard use from travelling passengers day in and day out, year after year.

A distant cousin of the political philosopher Karl Marx, the young Enid was sent to board at Roedean School in Brighton, where she spent most of her last year in the art room doing life drawing and learning the basics of carpentry. She went on to study at the Central School of Arts & Crafts, followed by the Royal College of Art, but failed to achieve her diploma as her abstract modern artwork seemed to be beyond the understanding of her tutors. Her drawing was considered so poor, she was even refused permission to attend Sir Frank Short's wood-engraving class.

Unwilling to produce, as she put it, the "washed out William Morris stuff" that was so in vogue at the time, she turned instead to Picasso and Braque for inspiration. Her love of these artists, and her own talent for producing patterns (which she described as "second nature") soon put her on the textile-designing path. Working from a studio housed in a cowshed on Hampstead Hill in 1926, she designed and hand-block-printed textiles, which she sold through the Little Gallery in London to a discerning selection of fashionable customers who could not get enough of her ultramodern and unique designs.

Her gift for pattern making was recognized as a skill that could be turned to book jacket design, and work for publishers followed. Chatto & Windus began by commissioning two covers from her, but when they saw her submissions they went on to order a further ten.

In 1937 Frank Pick, developer of London Underground's iconic brand identity, spotted her talents and invited her to design a selection of cotton-velvets for the seating on the new tube trains. Attractive not only for their classic but unimposing pattern – the dark colours and tight patterns making them ideal for extremely heavy use – these textiles are a supreme example of Marx's ability to find perfect synchronicity between form and function and original off-cuts are now highly sought after by collectors.

Marx was also an avid collector of folk art, and published a book on the subject with her friend and collaborator Margaret Lambert (*When Victoria began to Reign, Faber & Faber, 1937*).

Far left: blue and red colourway of *Chevron* moquette textile, c.1938

Left: *Shield* moquette textile designed by Enid Marx for London Underground, c.1935

Enid Marx (1902–1998)
Chevron moquette textile, c.1938
Woven cotton velvet
London Passenger Transport Board, London, England

Ernest Race (1913–1964)
BA-3 chair, 1945

Far left: detail of BA-3 chair showing construction

Left: Race Furniture advertisement for BA chairs, 1957

Rationing in Britain during the Second World War was not limited to just food and clothes; shortages in raw materials of all kinds meant an entirely new approach to consumption was required, and it saw light in the form of the Utility Scheme. All available resources were to be used in the most sensible way, and furniture was a key part of the scheme not least because of the damage to homes from air raids. In her monograph on Ernest Race, Hazel Conway noted, "Of all wartime Utility schemes, that for furniture was an unparalleled example of total state control, not only of the supply, but also of the design, and it was the magnitude of the problem of rationing the almost non-existent supplies of timber that led to the application of such drastic measures."

Even after the cessation of hostilities the Utility Scheme remained in place, and it was against this background of stringent rationing that Ernest Race in 1945 founded a new furniture manufacturing company, Ernest Race Ltd (later to become Race Furniture). Around this time the Board of Trade was attempting to find new ways of expanding the range of furniture designs approved under the Utility Scheme, and because of this it gave a licence to Race's company that allowed it to manufacture unlimited amounts of furniture so long as those designs did not use any licensed materials (including all types of hardwoods) in their construction.

Essentially, the only materials that met this criterion were those used in aircraft manufacture: aluminium (in sheets or ingots) and steel rods. Ernest Race's landmark BA-3 side chair of 1945 made creative use of a lightweight frame made of recast aluminium derived from redundant British aircraft. Often even the upholstery used to cover the thin plywood seat was made from surplus parachute silk.

Yet precisely because of these materials, the BA-3 side chair and its matching armchair had a distinctively modern machine aesthetic that set them apart from the more Arts & Crafts-like cottage-style furnishings that were still being manufactured under the approval of the Utility Scheme. Furthermore, the frame of the BA-3 chair comprised just five interchangeable elements which could be readily dismantled and reassembled, so making it easy to transport. With its stove-enamelled die-cast frame of re-smelted wartime scrap, the chair was shown at the 1946 "Britain Can Make It" exhibition held at the Victoria and Albert Museum, and the following year was put into full-scale mass-production. Between 1947 and 1964 over 250,000 BA chairs were manufactured, using a total of 850 tons of recycled aluminium alloy. In 1951, this masterful and resourceful design was awarded a Gold Medal at the X Milan Triennale for its innovative construction and use of materials. Highly durable and virtually indestructible, the BA-3 chair fulfilled what can be only described as the holy trinity of chair design — strength, lightness and comfort, and in so doing was one of the most creative and commercially successful British furniture designs of all time.

Ernest Race (1913–1964)
BA-3 chair, 1945
Stove-enamelled die-cast aluminium alloy, plywood, textile-covered
latex-foam upholstery
Ernest Race Ltd, London, England (later to become Race Furniture)

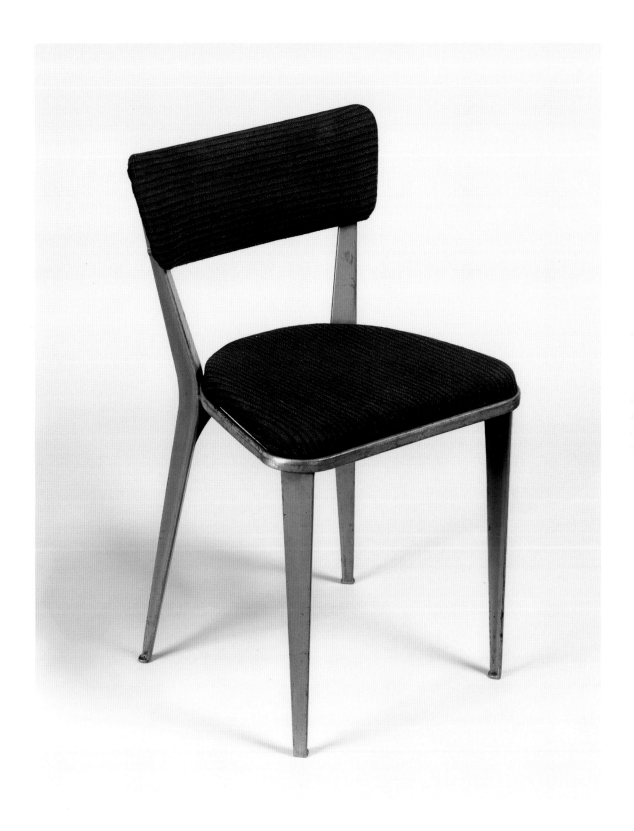

Clive Latimer (c.1916–?)
Plymet sideboard, 1945–46

Clive Latimer's elegant, yet futuristic aluminium sideboard was created in accord with the stringent and prescriptive guidelines of the Utility Scheme for the design and production of furniture, which was still in place in an exhausted postwar Britain; but it made use of the transfer of wartime technology to peacetime applications – in this case, from the aircraft industry to furniture production.

Heal's Plymet catalogue from 1947 describes the *Plymet* range of contemporary furniture as being constructed with "A new technique for bonding metal to wood developed during the war and employed in the construction of aircraft. The aluminium sheet is veneered on both sides to make a metal-cored plywood. The sheet is then curved to form the outer skin of the furniture and bonded to the structural frame of the steel. In this way, the best qualities of wood are combined with those of metal. The outer veneer displays the pleasing figure of the fine wood and gives warmth to the touch so lacking in other metal furniture, whilst the aluminium core and the metal framework contribute strength and rigidity. No rivets or bolts, which so often mar the appearance of metal furniture and give it an ugly engineering appearance."

Around this time, Clive Latimer and Robin Day – who he had previously met during the war while working as a fellow teacher at the Beckenham School of Art – also designed a system of tubular metal and plywood storage units that won first prize in the 1948 Museum of Modern Art's International Competition for Low-Cost Furniture Design, organized by Edgar Kauffman Jr. and judged by, among others, Gordon Russell and Ludwig Mies van der Rohe.

This group of case furniture conformed well with the aims of the competition as laid down by Rene d'Harcourt in the competition's catalogue: "To serve the needs of the vast majority of people we must have furniture that is adaptable to small apartments and houses, furniture that is comfortable but not too bulky, and that can be easily moved, stored and cared for; in other words, mass-produced furniture that is planned and executed to fit the needs of modern living, production and merchandising."

However, this award-winning storage system was not as revolutionary as Latimer's earlier and arguably more stylish Plymet range for Heal's.

Appearing with other furniture pieces from the Plymet range in the "Showcase" section of the "Britain Can Make It" exhibition held at the Victoria and Albert Museum in 1946, Clive Latimer's sideboard was totally innovative in form, function and manufacture. It is an unsung masterpiece of British postwar design.

Below and right: award-winning tubular metal and plywood storage units designed by Clive Latimer and Robin Day for the Museum of Modern Art's International Competition for Low-Cost Furniture Design, 1948

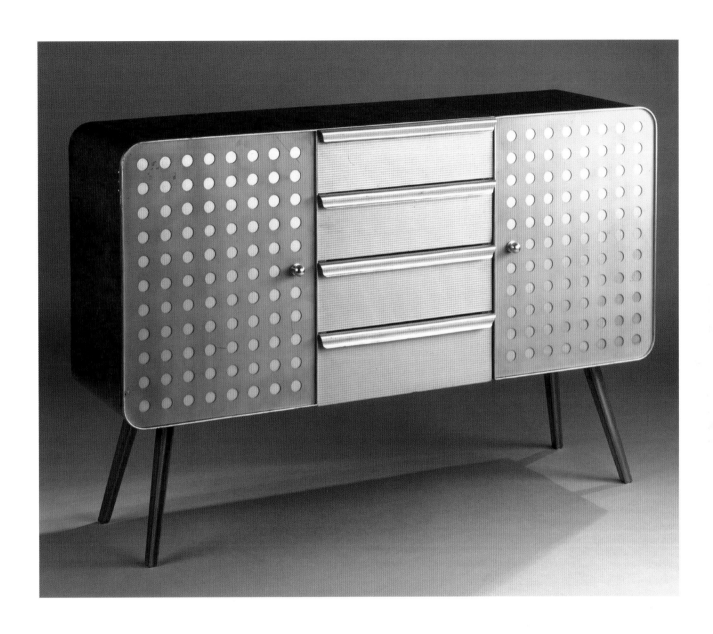

Benjamin Bowden (1906–1998)
Spacelander bicycle, 1946

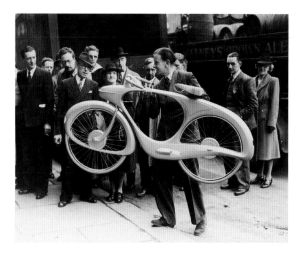

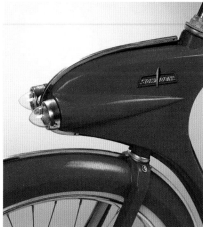

Far left: Benjamin Bowden taking his new bicycle to the offices of the Council of Industrial Design for inclusion in the "Britain Can Make It" exhibition, 1946

Left: detail of *Spacelander* bicycle showing its built-in twin headlights

After studying at the London Polytechnic on Regent Street, Benjamin G. Bowden took a job as a designer in the automotive industry. During the war years he was employed by Humber as a body engineer, designing its heavy-duty armoured vehicles, and it was while working there that Bowden met Donald Healey. Anticipating a massive postwar demand for fast cars, they designed, together with their fellow engineering colleague Achille Sampietro, what would become one of the fastest British cars of the immediate postwar years, the sublimely styled *Healey 2.4-litre* roadster (1946) with its curvaceous, lightweight aluminium body.

But just as streamlined was a remarkable prototype electric bicycle also designed by Bowden around this time. This futuristic vehicle was displayed at the "Britain Can Make It" exhibition organized by the Council of Industrial Design and staged at the Victoria and Albert Museum. Critics cynically dubbed this landmark show "Britain Can't Have It" because all the products on display were for export sale only and were not available to the home market.

Of the 6,000 designs on show, Bowden's "electric bike" was certainly the most futuristic; it had an aerodynamically-efficient, pressed-steel hollow body concealing a dynamo, which stored the energy produced when the bike was ridden downhill or on the flat so that it could be released as speed-powering kinetic energy on uphill runs. This extraordinary bicycle, intended "to show the developments likely to occur in the next 20 years", also boasted a shaft drive, an instrument panel, integral lights and horn, and even an optional built-in radio. Patented in 1946, it was, according to the application, intended to "provide a light but strong frame which can be inexpensively manufactured and assembled and will be of very pleasing appearance".

Regrettably, Bowden was unable to find a manufacturer in the United Kingdom for his "Bicycle of the Future", and in frustration he emigrated to the United States in 1949. Eventually, Bombard Industries of Kansas City contracted Bowden to create a slightly modified model suitable for mass-production, which was finally introduced in 1960 with a lighter-weight monocoque fibreglass body. Christened the *Spacelander* and sold under the auspices of Bowden as "The Newest Thing on Wheels", the production model had distinctive bullet-shaped, built-in twin headlights and tail-lights which added to its Buck Rogers aesthetic. The bike was offered in a range of five colours: Stop Sign Red, Outerspace Blue, Meadow Green, Charcoal Black and Cliffs of Dover White.

Unfortunately for Bowden, however, Bombard Industries went out of business thanks to a lawsuit over another product just three months after the *Spacelander*'s production had commenced. Ultimately, only 522 examples were produced, yet in its day Bowden's design had been a potent symbol of future hope in postwar Britain.

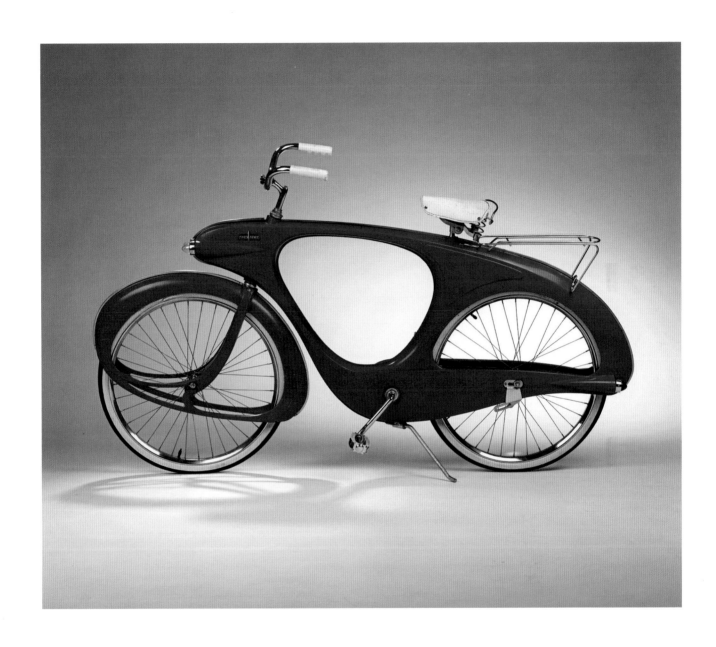

Max Gort-Barten (1914–2003)
Toaster, c.1946

Originally designed for use in commercial kitchens, Dualit's iconic toasters have always had an endearing low-tech robustness that has made them, alongside the trusty Aga, traditionally a much-loved part of many British kitchens.

Its inventor was Max Gort-Barten, a Jewish Swiss-German engineer who moved to London just before the outbreak of the Second World War having managed to flee Nazi Germany. After spending five years in the British army, Gore-Barten bought a factory in Camberwell and began manufacturing his own inventions including a stainless steel firescreen, a cocktail shaker and "shake-mixer" for puddings. His first successful product, however, was a flip-sided toaster which he patented in 1946.

Hot on the heels of this, however, was a new style of toaster that essentially had the same basic layout as the "classic" Dualit toaster of today. With its chunky no-nonsense cast aluminium and stainless steel construction and its manual eject lever, this new model saved time in commercial kitchens because up to three pieces of bread could be toasted at once without needing to be flipped halfway through the toasting process.

In 1952 a handy mechanical timer was added to the toasters, and a larger six-slot model was introduced. The winning combination of shiny stainless steel and enamelled aluminium in "utility cream", and a robust streamlined form that was visually accentuated with an indented vertical motif, gave Dualit toasters a distinctive "American Moderne" aesthetic.

In 1954, a new factory was built on the Old Kent Road and the company continued to prosper while the basic form of the toaster was refined and evolved. By the 1960s, the Dualit toaster had become a ubiquitous feature of commercial kitchens in Britain, but with the emergence of the industrial High-Tech style in the 1970s, John Lewis, Harrods and other leading department stores began retailing Dualit products for home use.

In the late 1970s the company hired a Royal College of Art design graduate to hone the toasters' design into what we now think of as the "classic" Dualit toaster. The following decade, there was a widespread revival of interest in 1950s styling with iconic designs from the period such as the Zippo lighter and Eames furniture enjoying a huge popular resurgence. Likewise, the classic Dualit toaster became a must-have piece of equipment in all style-conscious kitchens. Around this time, government export grants encouraged the company to find new foreign markets for its products and, coupled with the toasters' sudden popularity in the UK market, demand quadrupled. It is above all, however, the no-nonsense practicality and impressive durability of the Dualit toaster that has made it such an enduring classic of postwar British design.

Below left and right:
Six-slot Dualit toaster, introduced 1952, and two-slot toaster manufactured by Dualit Ltd, c.1952

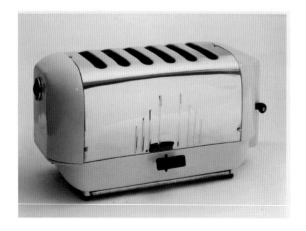
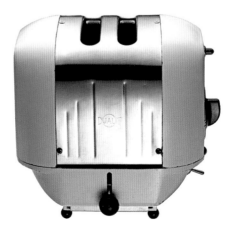

Max Gort-Barten (1914–2003)
Toaster, c.1946
(Example shown: restyled Dualit four-slot toaster introduced c.1980)
Stainless steel, aluminium, Bakelite
Dualit Ltd, London, England (later moved to Crawley, Sussex)

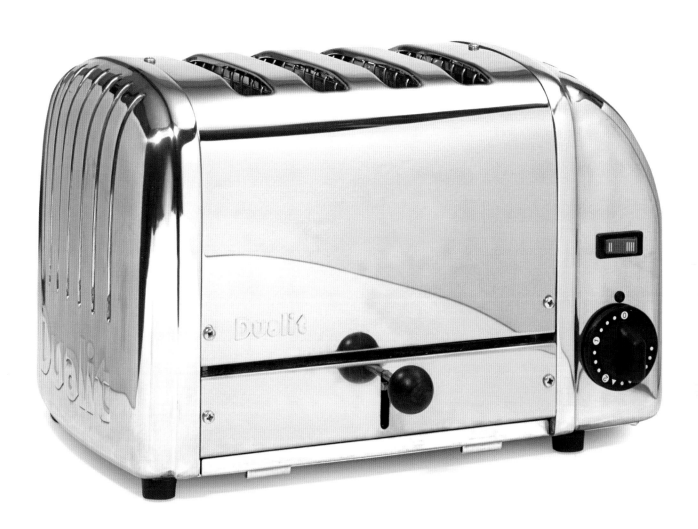

Andrew John Milne (active 1940s–50s)
Armchair, 1947

At first glance the finely sculpted rosewood frame of this remarkable chair looks as though it might have been designed by Carlo Mollino or Carlo Graffi or some other Italian postwar designer associated with the exuberant Turinese Baroque style. So it is somewhat surprising to learn that it was actually designed by A. J. Milne in Britain during the period of austerity immediately following the Second World War.

Finely constructed by the High-Wycombe based furniture manufacturer Mines & West, the example shown here still has its original chocolate brown moquette textile. Milne also designed a dining table to complement this remarkable armchair, with its graceful contours and richly grained wood.

Restrictions on materials were still in place in the United Kingdom during the late 1940s, and the chair would have been very expensive to buy because of high taxes on the use of a luxury material in its manufacture – in this case, rosewood. Costly, high-end products

such as these were mainly intended for overseas markets, and were seen by the British government as a crucial means of bringing about a design- and export-led economic recovery after the devastation of the war years.

Milne later designed more utilitarian seating, notably a perforated steel and steel-rod stacking chair for the Royal Festival Hall's outdoor terraces during the Festival of Britain. This practical outdoor seating design was manufactured by Heal & Sons, as were other furniture pieces that were created by Milne during the 1950s.

Significantly, Milne's earlier rosewood armchair of 1947 revealed a new postwar sculptural confidence within British design that would become more emphatic over the coming years, while while at the same time it also elegantly demonstrated that the long-held British tradition of superlative craftsmanship was still very much alive and kicking.

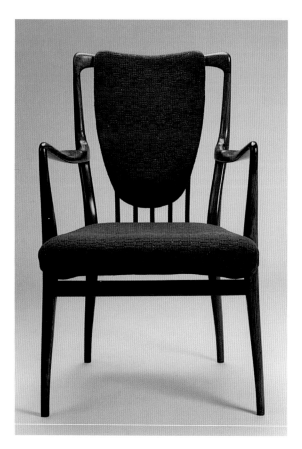
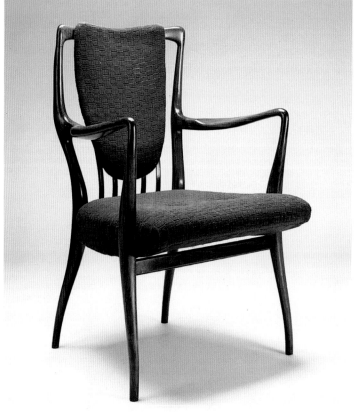

Andrew John Milne (active 1940s–50s)
Armchair, 1947
Rosewood, textile-covered upholstery
Mines & West, High Wycombe, England

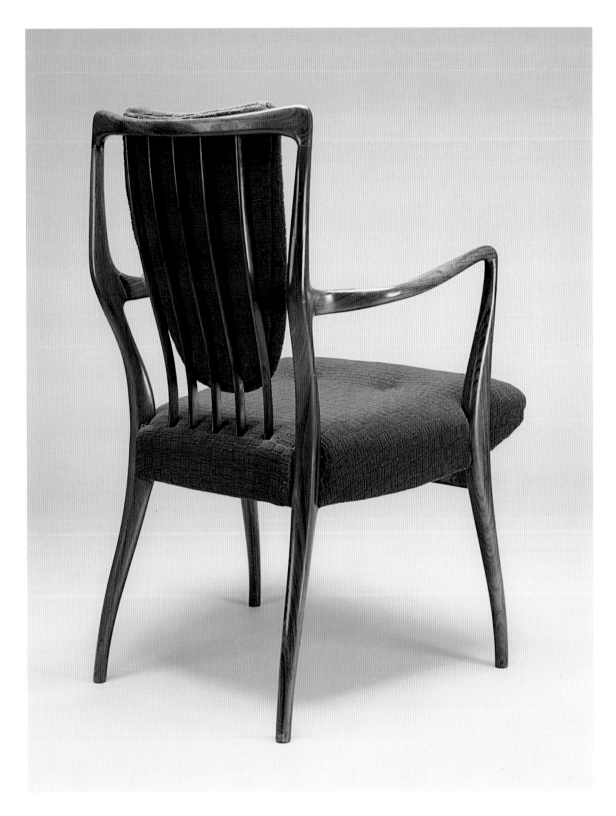

Frank Middleditch (active 1930s–50s) (attributed)
TV22 television, 1950

Bush Radio Limited was founded in Shepherd's Bush, London – hence its name – in 1932. A subsidiary of the Gaumont British Picture Company, Bush was formed from the remnants of the defunct Graham Amplion loudspeaker company, whose managing director had convinced his new bosses at Gaumont that sooner or later the cinema industry would have to become associated with the television industry. He proposed that the best first step into this potentially lucrative market would be to establish a radio design-and-manufacturing facility.

The firm was initially located in Woodger Road in Shepherd's Bush, and then around 1936 relocated to new and presumably larger premises in Power Road, Chiswick, and in 1949 moved to a newly built factory in Ernesettle, Plymouth. Although the company had produced a number of commercially successful radios during the early 1930s, it was not until after the end of the Second World War that its classic *DAC90* radio (1946) was launched. Designed by Frank Middleditch, this elegant radio had a housing of mahogany brown or creamy white Bakelite with simple yet robust flowing lines, a circular cloth grille, two easy-to-use dials and an easy-to-read, angled station display. It was included in the landmark "Britain Can Make It" exhibition (1946) and was subsequently adapted and relaunched as the *DAC90A* in 1950, going on to become one of the best-selling radios in Britain.

In March of the same year, Bush launched its *TV12AM* television, and in June (after a couple of slight modifications, most notably to the shape of the screen surround), the firm released its iconic *TV22* television. These models were most probably also designed by

Middleditch, given that their housings bear a striking similarity to that of his bestselling design.

Featuring a nine-inch screen, the *TV22* was the first British set that could be retuned by its user, as *Wireless World* magazine noted in July 1950: 'The most striking feature of the new Bush Radio sets is that they are provided with adjustable tuning so that they are suitable for any station in any band. The same model is, therefore, suitable for any district and in the areas of overlap between two stations, the choice between the two can be effected by a trial on site.' Although it is difficult to appreciate in our age of remote controls, this new feature was a huge breakthrough in television history.

Similarly, although the set's rather bold Art Deco styling might to our eyes seem a tad old-fashioned for its day, it was one of the best-selling models of the era and remained in production for several years, making it the television set that countless people across the nation used to watch the landmark live broadcast of Queen Elizabeth II's coronation in 1953.

In 1955, a Band III converter was also launched that could be fitted to existing *TV22* sets so that they could receive not only the two BBC channels, but also the newly launched ITV channels. The *TV22* set was also one of the cheapest models available, retailing at £35 10s, thanks to the use of plastic, rather than wood, for the cabinet, which allowed the model to be mass-produced on a large scale. Unquestionably an icon of early 1950s British design, the *TV22* television is also a much-loved piece of British television history, and as such is now a highly collectible item from the bygone era of black-and-white broadcasting.

Far left and left: Alternative views of *TV22* television showing moulded Bakelite housing

Frank Middleditch (active 1930s–50s)(attributed)
TV22 television, 1950
Bakelite, glass, other materials
Bush Radio Ltd, London, England

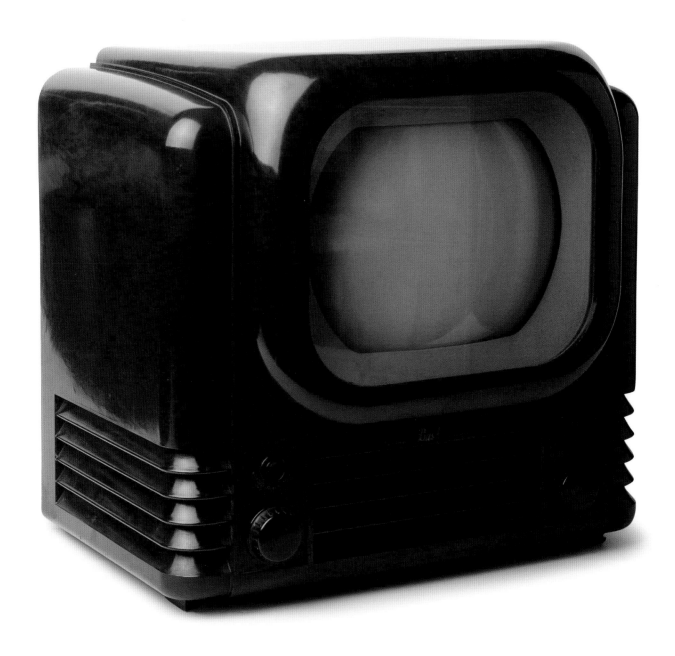

Lucienne Day (1917–2010)
Calyx textile, 1951

Lucienne Day studied at the Royal College of Art, where her tutor for printed textile design also happened to be the college's first Industrial Liaison Officer. In 1938 he arranged a two-month work placement at the Sanderson wallpaper design studio, an experience which had a formative impact on the young designer although her modern style approach was rather at odds with Sanderson's line of conservative floral patterns.

In 1948 Day and her furniture-designer husband Robin set up their own office. Because of continuing war restrictions on furnishing textiles, she concentrated mainly on the design of dress fabrics for – among others – Stevenson & Sons, Silkella and Argand, which were characterized by the use of highly abstracted floral motifs. But it was at the Festival of Britain exhibition in 1951 that the true extent of the couple's design vision was recognized.

The following year restrictions on furnishing fabrics were lifted and it was for this hugely influential showcase and celebration of British design and innovation that Day created her refreshingly contemporary *Calyx* pattern, which like her other textile designs was inspired by the work of abstract painters such as Kandinsky, Miró and Klee.

A large section of this screen-printed linen textile, with its free-floating pattern of abstracted cup-shaped mushroom-like motifs, was hung in a "contemporary" dining room designed by her husband for the Festival's Homes and Gardens pavilion. It brought her considerable recognition as a new, dynamic force within British textile design. Significantly, the *Calyx* pattern not only reflected Day's thoroughly modern re-interpretation of the geometry found in nature, but her rich selection of colour combinations which contrasted vibrant yellows and bright reds with muted earth tones also came to define the youthful "New Look" of contemporary 1950s interiors.

Calyx went on to win design awards in Milan and New York, was an instant success with the public and proved that radical design, mass production and popular appeal don't have to be mutually exclusive.

After the success of *Calyx*, Day established herself as Britain's leading textile designer, her name being particularly associated with Heal's furniture store. Her work combining organic forms, drawn from her love of plants, with the flourishing world of European abstract art, resulted in a highly individual, yet distinctively British style which was influential across the world. "For a conservative country like ours, the new designs were accepted extraordinarily quickly", she wrote in 1957. "Probably everyone's boredom with wartime dreariness and lack of variety helped the establishment of this new and gayer trend."

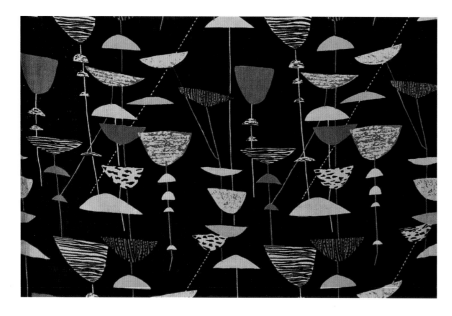

Left: Alternative colourway of *Calyx* textile, 1951

Lucienne Day (1917-2010)
Calyx textile, 1951
Screen-printed linen
Heal & Son Ltd, London, England

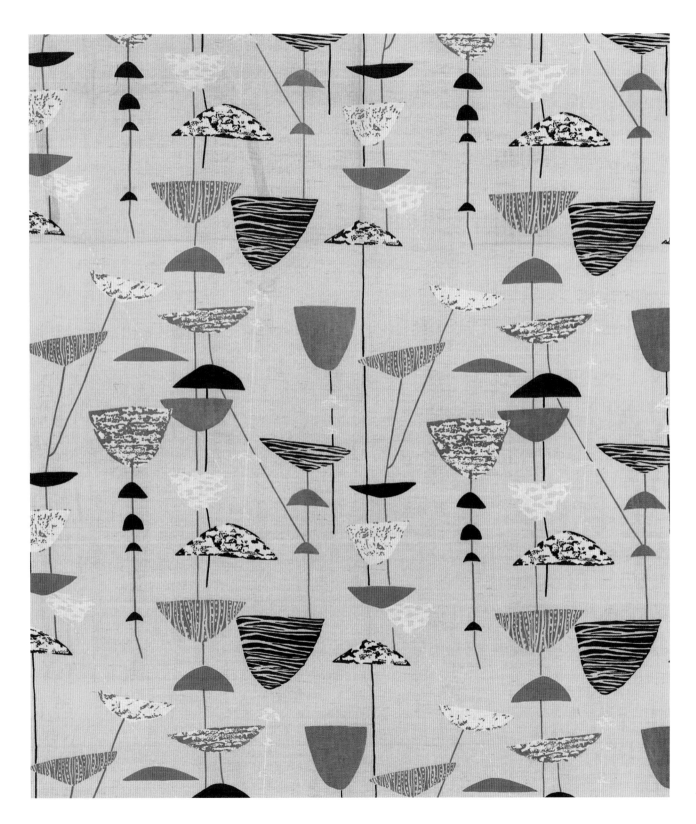

Abram Games (1914–1996)
Festival of Britain logo, 1951

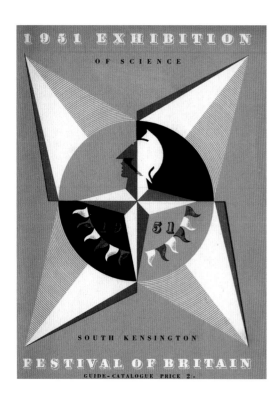

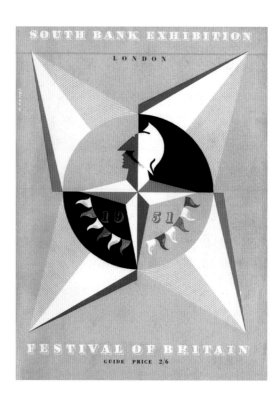

Far left and left: Festival of Britain exhibition catalogues, 1951 – incorporating the Festival of Britain "Britannia" logo

The 1951 Festival of Britain was a national morale-boosting celebration of British achievement in the fields of art, architecture, design, science and technology. Crucially, it was also an event that marked the end of postwar austerity and heralded a new and brighter future for the British nation. Alongside the specially commissioned buildings and exhibitions, one of the Festival of Britain's most important projections of this spirit of optimism was its distinctive emblem, designed by Abram Games.

This iconic symbol comprised a silhouetted profile of Britannia incorporated into a four-point compass device, from which was suspended a string of fluttering nautical bunting. With this winning combination, Games created an effective attention-grabbing logo, which had a light-hearted decorum about it that reflected British history and tradition. Although it featured the red, white and blue of the flag, the earthy background colours helped to soften the tone and it was the perfect symbol for a forward-looking Britain. The logo functioned beautifully as the public face of the Festival and helped to give the event not only a distinctively modern identity but also a visual and contextual coherence.

Abram Games was the British born son of Jewish immigrants, who had briefly studied commercial art at Central Saint Martins School of Art in London. Afterwards, while working for the renowned Askew-Young commercial art studio during the day, he took evening classes in life drawing. In 1936 he won a poster competition organized by London County Council, and around the same time established his own studio specializing in the creation of eye-catching posters that frequently used the chromolithographic printing process. Early clients included Shell, BP, London Transport and the G.P.O. (General Post Office), and during the Second World War he created over 100 memorable information and propaganda posters for the War Office.

One of the most talented poster artists of his generation, his work within this field has very high visual impact and powerfully expressed his guiding philosophy, "maximum meaning, minimum means". It was, however, his Festival of Britain emblem that was the creative pinnacle of Abram Games's illustrious career as one of the twentieth century's most influential British graphic designers.

Abram Games (1914–1996)
Festival of Britain logo, 1951
Various applications
Council of the Festival of Britain / Festival of Britain Office,
London, England

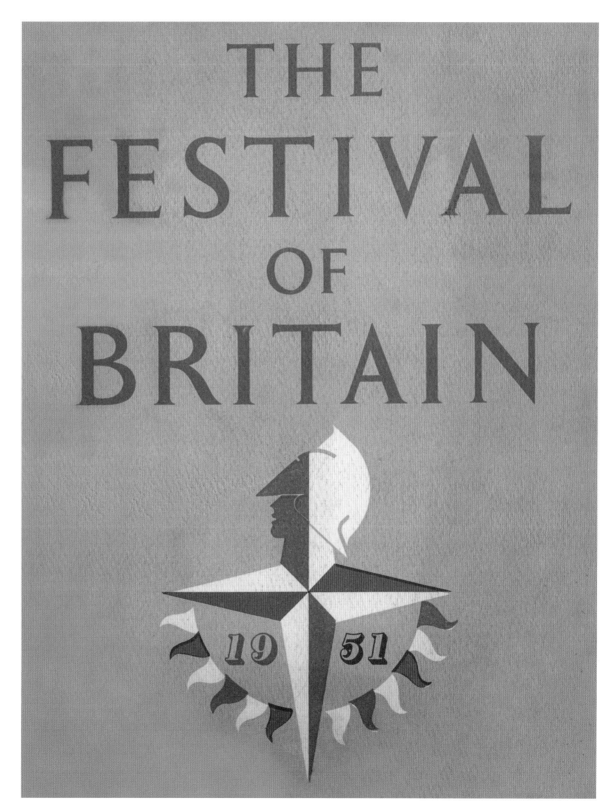

Ernest Race (1913–1964)
Antelope chair, 1951

Although Ernest Race's design of the *BA-3* chair in 1945 had received much critical acclaim at the 1946 "Britain Can Make It" exhibition, and had set his fledgling furniture company on the path to manufacturing success, it was the seating he designed specifically for the 1951 Festival of Britain that was to bring him the greatest recognition.

Hugely ambitious in its scope and highly popular among the great British public, the Festival of Britain was a much needed, morale-boosting national celebration of British achievement in the fields of science, technology, industrial design, architecture and the arts. The showcasing centerpiece of this yearlong event was the Festival's South Bank site overlooking the River Thames, which not only included the Royal Festival Hall but also the Dome of Discovery and the soaring Skylon tower – it was, quite simply, the epicentre of 1950s contemporary Britain.

For the outdoor terraces of the South Bank festival site, Ernest Race designed two stacking chairs, the *Antelope* and the *Springbok*, both of which were mainly constructed of bent steel rod. Thanks to this choice of material, both designs fell within the constraints of the Utility Scheme's restrictions relating to furniture production, which was only lifted in 1952.

Of the two designs, the Antelope chair had the more distinctively contemporary look with its splayed spindly legs terminating on ball feet, echoing the atomic imagery of nuclear physics and molecular chemistry. The bright primary colours used to paint its moulded plywood seat, which included drilled holes for rain-drainage, further enhanced the design's sense of cheerful modernity.

Ernest Race Ltd also produced a matching bench and side table, and today the *Antelope* chair is rightly regarded as a true icon of postwar British Design. The Festival of Britain's director, Gerald Barry, described this national exhibition as "a tonic for the nation" and certainly the spritely *Antelope* chair powerfully embodied the contagious postwar optimism of this landmark event.

Left and below: *Antelope* chairs in a café at the Festival of Britain, 1951, and *Antelope* bench designed by Ernest Race for Ernest Race Ltd, c.1951

Ernest Race (1913–1964)
Antelope chair, 1951
Painted steel rod, painted moulded plywood
Ernest Race Ltd., London, England (later to become Race
Furniture)

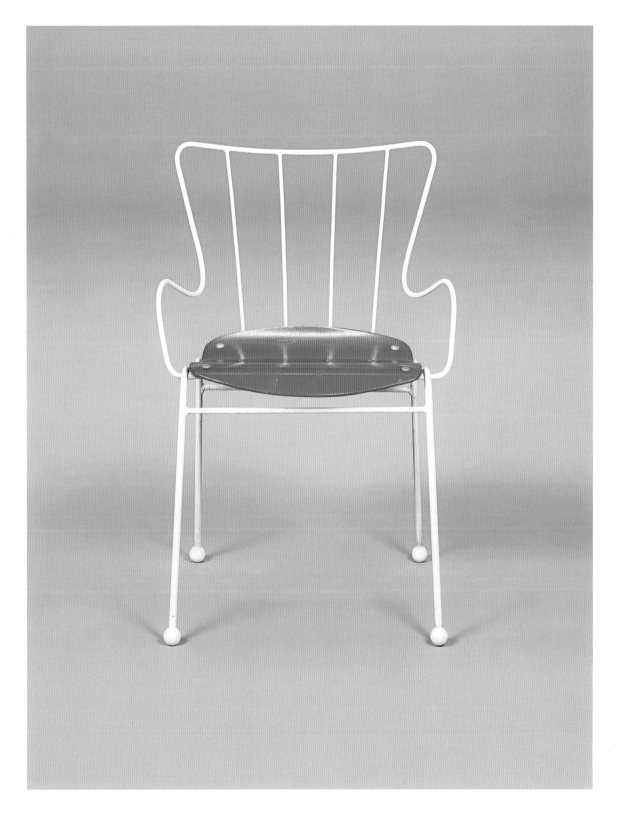

Roy Chadwick (1893–1947)
Vulcan bomber, first flight 1952

During the 1950s and 1960s, the Royal Air Force used the term "V Bombers" to describe a new class of jet-powered delta wing aircraft that were part of the United Kingdom's nuclear strike strategy. Officially known as the "V-force", it included three different bombers, all of which had names starting with the letter V: Vickers' *Valiant* (first flight 1951), Handley Page's *Victor* (first flight 1952) and Avro's *Vulcan* (first flight 1952). These three aircraft were commissioned in response to the Cold War development of nuclear weapons, which had altered the RAF's bombing requirements considerably; instead of mass bombing capability, the onus was now on strategic nuclear bombing. To this end the RAF drafted a specification in 1946 that sought a "medium-range bomber landplane, capable of carrying one 10,000 pound (4,535 kg) bomb to a target 1,500 nautical miles (2,775 km) from a base which may be anywhere in the world".

Of the three aircraft developed in response to this brief, it was the *Vulcan* that stood out as a truly exceptional aircraft design and perhaps one of the greatest aircraft ever produced. This striking-looking, high-speed, high-altitude strategic bomber was designed and developed by the British aircraft manufacturer, A. V. Roe & Co (Avro), which eventually became a subsidiary of Hawker Siddley. With its distinctive aerodynamic profile, created by Avro's chief designer Roy Chadwick, the *Vulcan B1* was first delivered to the RAF in 1956, and then four years later the *Vulcan B2*, which boasted even more powerful engines and a larger wingspan, succeeded it.

As a nuclear strike aircraft, it was intended to maintain the British nuclear deterrent during the Cold War years, and as such was armed with the Avro's *Blue Steel* rocket-propelled nuclear bomb. Despite its nuclear capability, however, this stalwart of the Cold War is best remembered for its epic conventional long-range bombing raid made during the Falklands War in 1982. Fittingly named after the god of fire, the *Vulcan* was retired from service in 1983; however, it is still remember by aircraft enthusiasts as an awesome and truly remarkable British aircraft that was way ahead of its time.

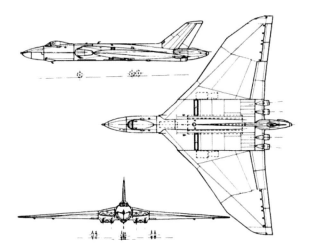

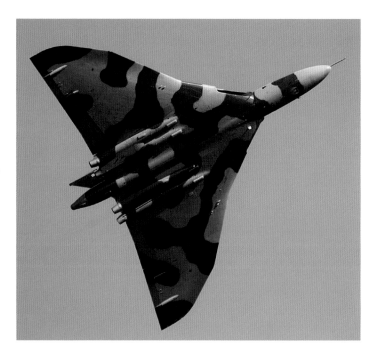

Top: vector drawings of an Avro *Vulcan B2*

Above: Avro *Vulcan B2 XH558* at the 2008 Farnborough Airshow – the last airworthy example

Roy Chadwick (1893–1947)
Vulcan B1 bomber, first flight 1952 (entered service 1956)
(Example shown: *Vulcan B2 XH558* bomber, entered service 1960)
Various materials
A V Roe & Co (Avro), Manchester, England

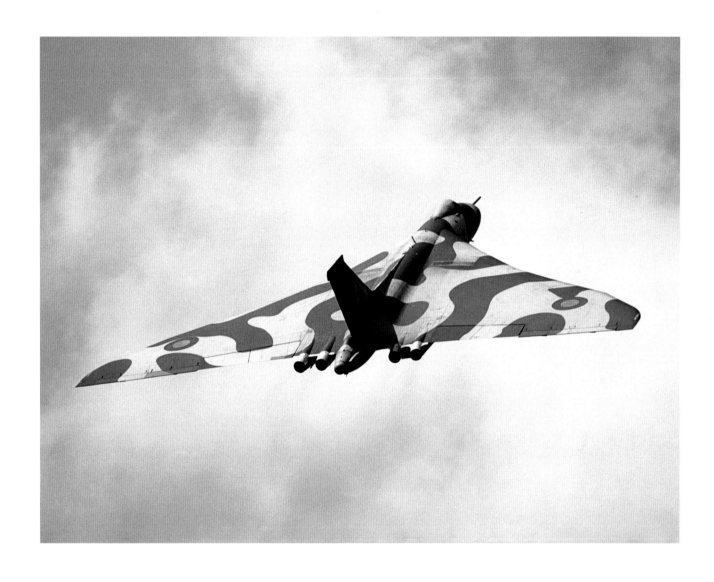

Robert Heritage (1927–2008) & Dorothy Heritage (1929–2005)
Sideboard, 1954

Above: detail of cityscape decoration on sideboard's door panels

Robert Heritage studied at Birmingham College of Art and the Royal College of Art, from where he graduated as a furniture designer in 1951. The same year, he began work as a designer for London-based furniture manufacturing company G.W. Evans. In 1953, Heritage left to establish his own design studio with his wife Dorothy (née Shaw), who had studied textile design at the RCA.

This elegant triple-door sideboard with its distinctive natural and lacquered birch construction was co-designed by the couple the following year, and manufactured by G. W. Evans. Dorothy, who collaborated with her husband on several other designs for the manufacturer, was responsible for the transfer-printed line drawing of a cityscape that embellished the door panels, beneath the sideboard's three drawers. The elegant lines of the sideboard with its indented drawer pulls and simple brass handles and supports reflected the stylish and rather sparse "New Look" of 1950s interiors. This simplicity provided the perfect canvas for the decorative printing of the door panels, giving the piece an eminently British character, with its jostling cityscape of buildings in many different architectural styles.

The pattern was also applied to another piece of case furniture that the Heritages designed for G. W. Evans: a smaller sideboard with a choice of either two or four sliding doors. Importantly, these sideboards expressed an optimistic and youthful direction in postwar British design, reflecting a growing national confidence within the design community that was kick-started by the Festival of Britain in 1951.

Robert Heritage subsequently designed furniture for various British manufacturers including Beaver & Tapley, Collins and Hayes, Gordon Russell, Shannon, Slumberland, Race Furniture and Archie Shine, as well as lighting for Concord Lighting, Merchant Adventurers, Rotaflex, Tecnolyte and GED. But without Dorothy's input, these later designs had a far more restrained quality and never matched the decorative cheer of this masterpiece of British postwar design.

Robert Heritage (1927–2008) & **Dorothy Heritage** (1929–2005)
Sideboard, 1954
Natural and lacquered birch, brass
G.W. Evans, London, England

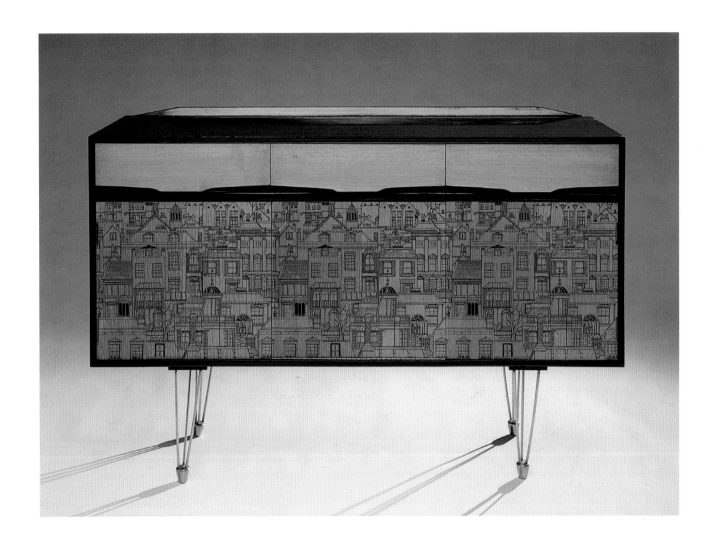

Douglas Scott (1913–1990), Colin Curtis (1926–), Albert Arthur Durrant (1899–1984)
Routemaster bus, 1954

Although London's first double-decker bus had been introduced as early as 1925, it was some thirty years later that the beloved *Routemaster* was launched, subsequently becoming one of the city's most evocative symbols.

Its designer, Douglas Scott, had studied silversmithing at the Central School of Art and Design in London, before going on to work in the London office of the American industrial design consultancy, Raymond Loewy Associates between 1936 and 1939. Around this time Loewy was developing a design for the streamlined Greyhound Lines *Scenicrusier* motorcoach and Scott would have been following this project closely. He certainly assisted with designs for streamlined vacuum cleaners and refrigerators which were commissioned by the Swedish manufacturer Electrolux, which must have had a strong formative influence on the young designer.

During the Second World War, Scott worked for the De Havilland aircraft company, where he gained valuable knowledge of production engineering, manufacturing processes and newly developed materials applications. Afterwards he set up his own office and in 1948 designed the Green Line coach for London Transport. Around this time London Transport also decided to standardize the buses used on its road services, as well as replace its large fleet of 70-seater electric trolley buses with a new diesel-powered bus, one that would be able to carry around the same number of passengers as these old-style trackless trams.

The design brief required this new vehicle to be compact, lightweight, easy-to-drive, fuel-efficient and comfortable for passengers, as well as to function as an attractive piece of "street furniture". Together with the engineers Colin Curtis and Albert Durrant, Scott was tasked with this colossal challenge, and the trio worked with a dedicated research and development team of designers and engineers. While its lightweight, rust-resistant aluminium body exploited processes derived from aircraft manufacturing technology, the new bus also incorporated some of the latest auto-engineering innovations including power steering,

automatic transmission, hydraulic-assisted brakes, independent suspension springs and heating controls. Intended for serial mass-production, the bus was constructed from standardized interchangeable parts so as to not only cut down on the costs of tooling and manufacturing, but also reduce the time needed for repairs and maintenance.

After years of development, the new *Routemaster* (or *RM-type*) was introduced in 1956. With its hop-on/hop-off open platform at the rear it looked very similar to the earlier *RT-type* double-decker bus, but it was functionally superior in every aspect of its design. Scott's *Routemaster* had a smoother, more streamlined form than its predecessor, and ultimately it is the vehicle's generously rounded curves that give it such an amiable presence.

Over 2,800 Routemasters were built between 1956 and 1968 and it is a tribute to the durability of its original design that they remained in regular service until 2005. As a much-loved icon of British design, *Routemasters* are still to this day operated on two heritage routes in central London.

Below: drawing showing plan view and seating arrangement for *Routemaster* bus, c.1960

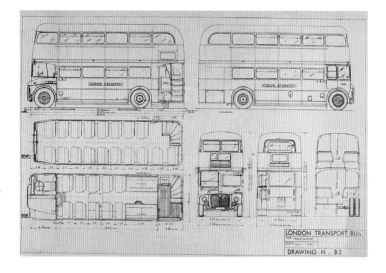

Douglas Scott (1913–1990), **Colin Curtis** (1926–),
Albert Arthur Durrant (1899–1984)
Routemaster bus, 1954
Painted aluminium, other materials
Associated Equipment Company (AEC), Southall,
London, England

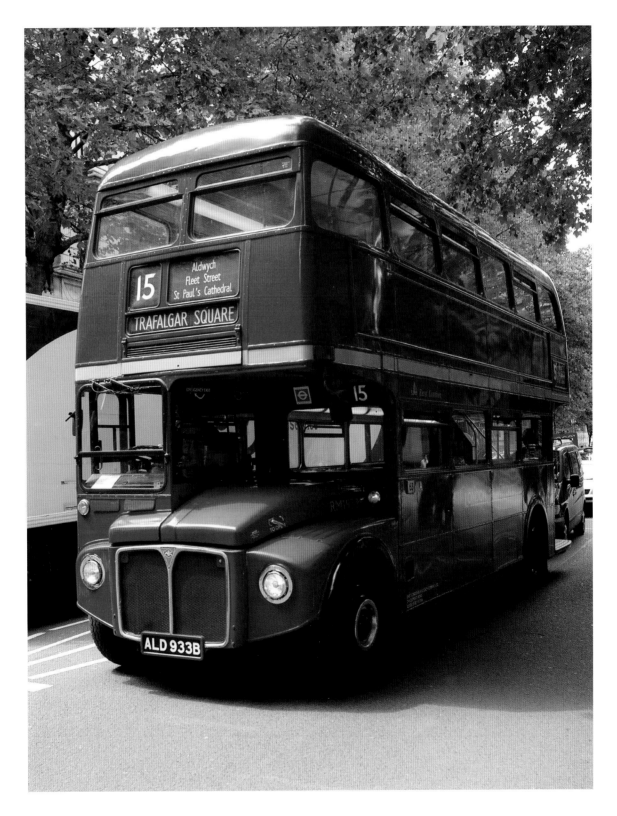

David Mellor (1930–2009)
Pride cutlery, 1954

David Mellor was a substantial figure in the evolution of modern British design and one of the greatest cutlery designers of all time. The son of a toolmaker, he was born in Sheffield, the historic centre of Britain's cutlery industry, and from the age of eleven attended the junior art department at Sheffield College of Art where he learned metalwork, pottery, woodwork, painting and decorating – all skills that would prove useful for his later chosen career. In 1950, he won a place at the Royal College of Art and the following year was awarded a travelling scholarship to Denmark and Sweden. The deeply rooted tradition in these countries of exquisitely designed and manufactured homewares, will undoubtedly have had a hugely formative impact on him. After completing his formal studies at the British School in Rome, he returned to Sheffield in 1954 and established a studio/workshop. Thanks to a resurgence of interest in contemporary silversmithing, he received various special one-off commissions, and that same year found himself hired by local firm Walker & Hall as a consultant designer. It was for them that he created his first flatware pattern, *Pride*.

Widely acknowledged as a modern classic, *Pride* became Mellor's most famous design. Though inspired by the elegant forms of eighteenth-century English cutlery, *Pride* had a graceful modernity that set it apart from the traditional patterns still being produced by Britain's cutlery manufacturers. Its refreshingly different, contemporary aesthetic captured the optimistic postwar spirit that had been joyfully released by the Festival of Britain three years earlier. *Pride* also reflected a cultural shift that saw the formality of the dinner party give way to the more informal entertaining preferred by a younger generation.

Mellor went on to design many other praiseworthy flatware patterns, which he sold together with his beautifully designed cookware through his shop in London's Sloane Square. During the early 1970s he began self-producing his cutlery at Broom Hall in Sheffield and eventually in 1990 he moved his design and manufacturing facility to a historic building in Haversage. The modernist architect Michael Hopkins skillfully adapted this former gas-works building into an elegant factory/studio/showroom, which subsequently won a BBC Design Award.

Unusually, Mellor was able to operate successfully as a designer, manufacturer and retailer, and he became known as "the cutlery king". He must also be credited with almost single-handedly revitalizing the long-established British cutlery industry with his beautifully balanced and timeless designs, which have proven to be so impervious to the whims of fashion.

Below: photograph showing manufacture of a *Pride* knife

Right: photograph of David Mellor working in his design studio, mid-1960s

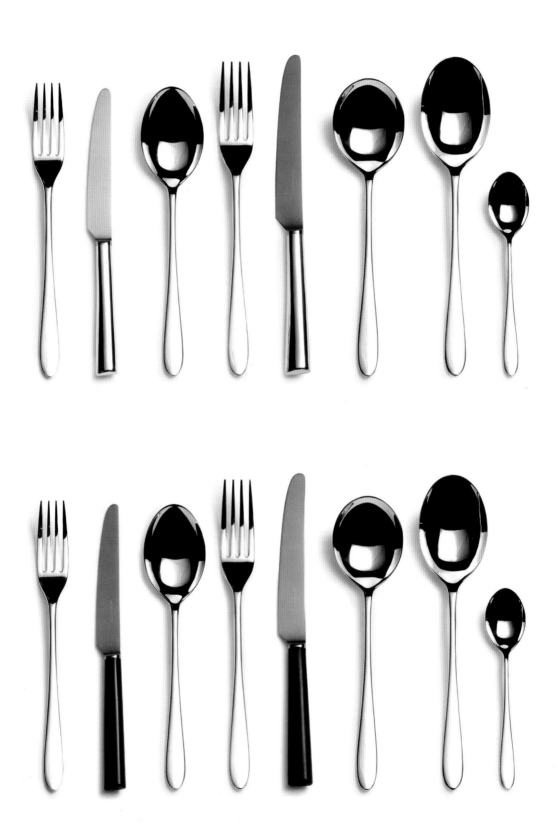

David Mellor (1930–2009)
Pride cutlery, 1954
Silver-plated metal, stainless steel or acetal
Walker & Hall, Sheffield, Yorkshire, England (later by David Mellor,
Sheffield, Yorkshire, England)

Jack Howe (1911–2003)
Electric wall clock, 1956

This clock, one of several Jack Howe designed for Gent & Co. and as avant-garde as it was at the time, can only give a flavour of the influence exercised by this great pioneer of Modernism in postwar Britain.

The son of a butcher, he studied architecture at the London Polytechnic on Regent Street. He was first an assistant to the architect Joseph Emberton, and then from 1934 until the outbreak of the Second World War worked in the architectural offices of the progressive British Modernist, Maxwell Fry. During this period the German émigré architect and former director of the Bauhaus, Walter Gropius, joined Maxwell Fry's partnership before he moved to the United States to take up a professorship at Harvard in 1937. This early contact with one of the towering figures of the Modern Movement was undoubtedly a hugely formative experience for the young British architect, especially as he worked on Gropius and Fry's most important joint commission, the rectilinear brick and glass Impington Village College (1939).

During the war years, Howe worked with the building firm Holland, Hannen & Cubitts on the construction of the Royal Ordnance Factories in Wrexham and Ranskill, and then in 1944 he became an associate partner of Arcon, which went on to become one of the most progressive architectural firms of its day. While he was at Arcon he worked on the design of the *Mark 4* prefabricated house, of which 41,000 units were later made and erected.

But aside from his architectural work, Howe was also an accomplished product designer. In the public field he designed litter bins, lampposts and bus shelters and famously also the *MD2* cash dispenser for Chubb, which was not only one of the first ATMs to be introduced in Britain, but was also awarded the Prince Philip Designers Prize in 1969 for being "an elegant solution to the problem of security for banks".

His first ever industrial design commission was from the Leicester-based clock manufacturer Gent in 1946. He went on to design several electric wall and table clock models for the firm, including this wall clock from 1956 with its visually striking face embellished with large Roman numerals. Apart from this black and white example the clock was also produced in a number of other versions, including one with a brass-coloured frame and stainless steel face.

Produced from 1957 to 1960, this model with its spun-aluminium frame and enamelled sunburst face was aesthetically way ahead of its time, and in fact looks much more like a design from the 1970s than from the 1950s – and as such, it should be regarded as a long-lost masterpiece of British design. Jack Howe never gained the recognition he deserved as an architect and industrial designer and is now almost a forgotten figure; however, his work was extremely progressive and deserves a reassessment.

Below: electric wall clock designed by Jack Howe for Gents of Leicester, 1949

Jack Howe (1911–2003)
Electric wall clock, 1956
Enamelled aluminium, glass, various other materials
Gent & Co Ltd, Leicester, Leicestershire, England

GENTS
OF LEICESTER

Lucian Ercolani (1888–1976)
Model No. 354 nest of tables, 1956

Above: detail of *Model No. 354* nesting tables

Born in Italy, Lucian Ercolani moved to London with his family as a child and subsequently studied drawing, design and furniture-making at the Shoreditch Technical College. In 1907, he made his first piece of furniture, a musical cabinet inlaid with mother-of-pearl, and from 1910 to 1920 he worked as a furniture designer for Frederick Parker & Sons (later to become Parker Knoll) and also for E. Gomme Ltd, eventual manufacturers of the *G-Plan* furniture range.

In 1920, the young Ercolani established his own furniture-manufacturing business in High Wycombe, a town which for centuries had been the chair-making capital of England thanks to the abundant supply of beech from the surrounding Buckinghamshire woodlands. This very beech wood was traditionally used to make the famous spoke-backed Windsor chair, as well as other lathe-turned vernacular models.

It was a fitting location for the new enterprise, known as Ercol. Here Ercolani perfected steam-bending techniques in order to create his own modern interpretations of the historic *Windsor* chair. He also discovered how to "tame" elm – a beautifully grained wood that was so hard, most furniture makers considered it impossible to work with.

Over the years, he continued to hone his manufacturing techniques and during the mid-1950s Ercol introduced more modern designs to its extensive range, most notably the *Model No. 354* nest of three tables. Beautifully made, these tables with their appealing curved tops made of richly hued elm supported on splayed tapering legs of solid beech, had a wonderful simplicity of design and marked a high point in 1950s British furniture manufacturing by being not only affordable and modern-looking, but also eminently practical.

Like other pieces in the Ercol range, they also stylistically complemented other models made by the company – an important innovation. A classic of mid-century British design, the *Model No. 354* tables have recently been reintroduced into the Ercol catalogue as part of the company's *Originals* range. They are part of a long-awaited re-assessment of Lucian Ercolani's contribution to the history of furniture, which changed the landscape of the average middle-class British home with the introduction of modern style designs with an engaging craft sensibility and high levels of quality despite being mass-produced.

Lucian Ercolani (1888–1976)
Model No. 354 nest of tables, 1956
Elm, beech
Ercol Furniture Ltd., High Wycombe, Buckinghamshire, England

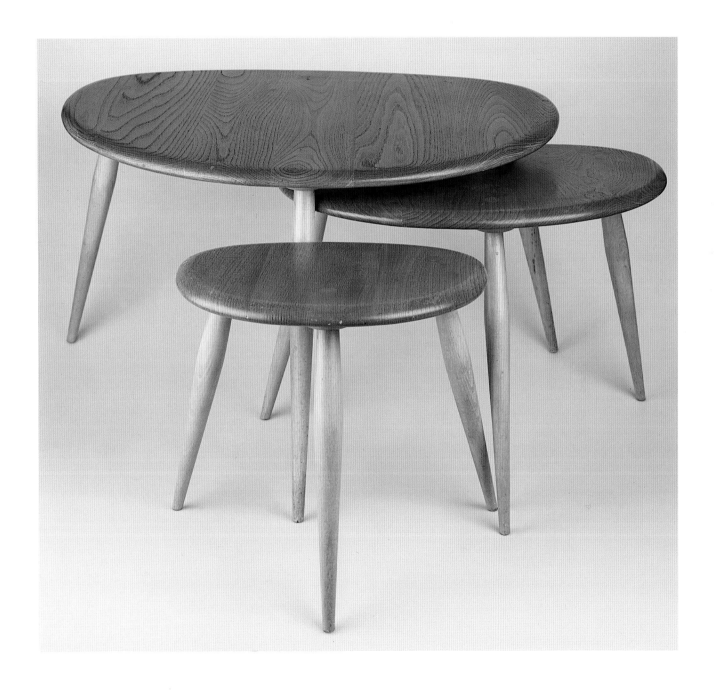

Austin, Mann & Overton & Carbodies
FX4 taxicab, 1956

THE AUSTIN TAXI

Left: Austin Motor Company brochure for the *FX4* taxicab, c.1959

Like the original red *Routemaster* bus, the classic black *FX4* taxicab has become a defining symbol of London, recognized across the world.

The first London taxis or "Hackney cabs" were hireable horse-drawn carriages, but by 1906 the Public Carriage Office had laid down its first Conditions of Fitness relating to petrol-driven motor cabs, including the stipulation of a minimum ten inch ground clearance, and a turning radius of no more than 25 feet.

In 1929 the largest taxi dealership in the country, Mann & Overton, commissioned the Austin Motor Company to design and build a new, improved and cost-efficient vehicle. Based on the existing *Austin 12/4*, the resulting *Austin Strachen High Top* taxi was seven feet high and boasted masses of legroom and luggage space. It remained a very serviceable workhorse until its replacement in 1934 by the more streamlined *LL Model* taxicab – known as the *Low Loader* – presumably because it was less lofty than its predecessor.

In 1947 a consortium made up of Austin, Mann & Overton and the coachbuilder Carbodies Ltd brought a new taxi to the streets of London, the sleekly styled *FX3*, which proceeded to dominate the market. The same consortium went on to develop a radically new and modern successor, initially styled by Austin designer Eric Bailey and then further honed by Carbodies' designer Jake Donaldson. At this early stage of its development the new design had an open-sided luggage area just like the *FX3*'s, and it was only after careful evaluation of its effect on the cab's luggage-carrying capacity that it was eventually decided to fit a fourth side door.

The new design differed from the *FX3* in that it had a fixed windscreen, but it kept its predecessor's outward opening "suicide doors", which were hinged on their rear edge.

One of the greatest innovations of this new cab was that its front and rear wing panels and outer sills were conceived as bolt-on items that could easily be replaced if damaged in the cut-and-thrust of London's chaotic, traffic-choked streets. Its doors were similarly constructed so as to make replacing their outer skins easier.

Despite difficulties getting the design from prototype stage to production model because of numerous problems encountered with the metal pressing tools used to make the cab's body, the diesel-powered *FX4* was eventually launched in 1958, and three years later a petrol option was introduced. Although it was offered in other colours, the *FX4* with its distinctive, softly curved body became the classic London black cab. It was the most perfectly configured vehicle for getting around London, with its roomy rear interior that comfortably accommodated five passengers and their luggage. In production for 40 years with over 43,000 units being built, the legendary *FX4* rightly became the best known and most loved taxi in history over its long and hard-working lifetime.

Austin, Mann & Overton & **Carbodies**
FX4 taxicab, 1956
Various
Austin Motor Company Ltd, Longbridge, Birmingham, England
(and later Carbodies Ltd, Coventry, England, and then LTI Ltd,
Coventry, England)

Jock Kinneir (1917–1974) & Margaret Calvert (1936–)
Road signage system, 1957–67

Left: "Children Crossing" sign, based on a childhood photograph of Margaret Calvert

Britain's motorway and road signage, designed by Jock Kinneir and Margaret Calvert during the late 1950s and 1960s, is probably the most effective and influential system of its kind. By utterly embodying the British design sensibility of graceful yet purposeful function, it has an unassailable visual logic that has made it one of Britain's greatest examples of modern graphic design.

Richard "Jock" Kinneir had studied at Chelsea School of Art before working as an exhibition designer for the Central Office of Information. In 1949 he joined the Design Research Unit (DRU), and he remained there until he set up his own office in 1956. His first significant commission was the design of signage for the new Gatwick Airport and for this project he was assisted by one of his students at Chelsea, Margaret Calvert.

Together they created an airport signage system that had a modern clarity and a formal consistency. Their work came to the attention of Sir Colin Anderson, who had recently been appointed chairman of a new Advisory Committee on Traffic Signs for Motorways by the Ministry of Transport in 1957. This working group was charged with overseeing the design of signage for the country's new motorway system and Kinneir, being the most obvious candidate, was commissioned to undertake it.

Using an in-depth research-led approach, Kinneir, assisted by Calvert, developed a new motorway signage system which was cleverly designed with letter tiles laid on a grid. By using this method, the overall size of specific signs could be determined by the amount of information they needed to contain, while the width of the signs' borders and other key elements were in relational proportion to the horizontal stroke of the capital letter "I".

To maximize clarity and legibility, the duo also created the rounded sans-serif typeface *Transport*, which could be easily read from a car travelling at high speed. Similarly, they used a combination of upper- and lower-case lettering to enhance readability, rather than purely capitals as used on British road signage until then.

By codifying the size and placement of the easy-to-read lettering, Kinneir and Calvert had developed a highly adaptable and functional signage system, which was first trialled on the Preston bypass in 1958 before being introduced the following year to the M1 motorway. After the new motorway signage had been installed the government set up the Worboys Committee to review the design of signage on all of the nation's other roads. This led to a new commission for Kinneir and Calvert, to design – over a period of several years – an exhaustive range of all-new traffic signs. They included the iconic "children crossing" sign, which was based on a childhood photograph of Calvert.

On 1 January 1965, Kinneir and Calvert's new signage system became law and as such the road-crossed landscape of Britain became a much more navigable place. Crucially, this thoughtfully conceived and gently refined signage family reflected a more modern and perhaps thoughtful nation, and as such became a potent symbol of the changing face of Britain.

Jock Kinneir (1917–1974) & **Margaret Calvert** (1936–)
Road signage system, 1957–67
Various applications
Ministry of Transport, London, England

David Bache (1926–1995)
Land Rover Series II, 1958

Left: photograph of *Land Rover Series II* being used off road, c.1960

The *Willys MB* US Army Jeep was a staunch workhorse during the Second World War II, and an inspiration to chief designer of the Rover Company, Maurice Wilks. In 1947, he set about designing his own off-road four-wheel drive utility vehicle, the first prototype being built on a Jeep chassis. Launched the following year at the Amsterdam Motor Show, the *Series I Land Rover* was originally intended for farmers and was marketed as such, with a 1950 advertisement using the following copy: "working for prosperity… Early morning: the *Land Rover* collects the milk, and comes back perhaps with a load of cattle feed from the town. Next, to the wood where they're cutting timber; the power-take-off, coupled to the circular saw, makes short work of a long job, and the four-wheel drive takes it over any sort of country. In the afternoon she's off to town again with a load of potatoes… the *Land Rover* certainly earns its keep on the farm. Wherever there's work to be done you'll find the *Land Rover*."

Initially the vehicle was only available in light green hues, postwar rationing limiting the choice to surplus military aircraft cockpit paint; but the army green shades suited the *Land Rover*'s air of quasi-military country ruggedness. In the early years, the *Land Rover* gained a well-deserved reputation as the superlative farm vehicle; it could carry "tough loads" and conquer "rough roads".

In 1954 the automotive industry designer David Bache moved to the Rover Company, having previously worked for Austin under Italian designer Riccardo Burzi. He was tasked with restyling the *Series I Land Rover* and the result of his endeavour, the more domesticated *Series II*, was introduced in 1958. Bache took the utilitarian farm workhorse and subtly transformed it into a truly classic British design by altering its proportions and cut-lines, by adding flash-gaps, widening its track and giving it an altogether boxier look with its distinctively curved barrel sides. In production from 1958 to 1961, the *Series II* and the slightly modified *Series IIA* – which had its headlights repositioned on the wings rather than between them and was produced from 1961 to 1971 – came with the option of a petrol or diesel engine and either a short or long-wheel base, as well as a host of other customizations that allowed them to be used in a huge variety of hostile terrains.

Eventually becoming the number one working vehicle in the world, the *Series II* has rightly been described as the archetypal *Land Rover*. Even today this instantly recognizable off-road vehicle has an almost mythic status among an enthusiastic following of collectors, who are dedicated to keeping this iconic British design both on and off the road.

David Bache (1926–1995)
Land Rover Series II, 1958
Aluminium, steel, various materials
The Rover Company Ltd, Solihull, Birmingham, England

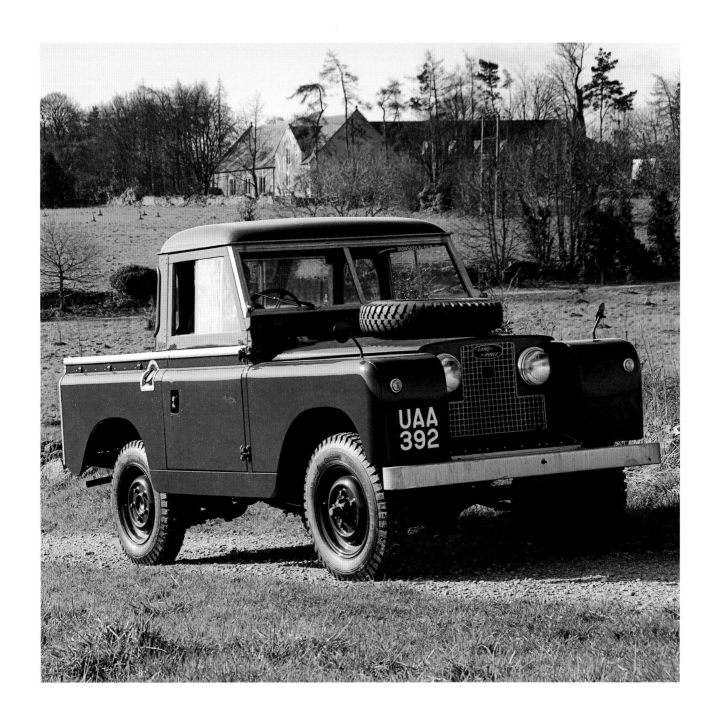

Abram Games (1914–1996)
Model C coffee maker, 1959

He was famous for his graphic design work, from his attention-grabbing wartime posters to his Festival of Britain emblem, but Abram Games also enjoyed tinkering with appliances around the home, and taught himself how to make castings from scrap aircraft aluminium. After telling a director of the Cona coffee company that although his wife Marianne's Cona coffee maker made excellent coffee, its design was too cumbersome, he was challenged to come up with an improvement. The result was Games's better-performing, streamlined model which he designed in 1947, but which wasn't actually put into production until 1949 because of postwar rationing. The first all-glass Cona coffee maker had originally been introduced as early as 1910 and like all subsequent models, including those designed by Games, used a vacuum-filtration process which ensured infusion at the correct temperature. The vacuum process, and the use of glass as opposed to metal or plastic, both of which could taint the taste, produced a smooth and crisp-tasting coffee.

A decade later, Games revisited his original design, and this time came up with an even more streamlined table model, with elegantly sweeping lines and better functionality. The arching aluminium and Bakelite stand of this version had a specially positioned holder for the glass filter when not in use, and beneath the holder was a handy drip-catching indentation.

In the 1950s Cona began selling its filter coffee makers to the catering industry, and even today its ubiquitous bulbous coffee jugs are still used in countless restaurants and cafes across Britain. Games's improved tabletop coffee maker, in contrast, was only ever intended for domestic use and yet it is still in production some 50 years after its introduction – an extremely elegant and still relevant mid-century British design, by one of the nation's most influential designers.

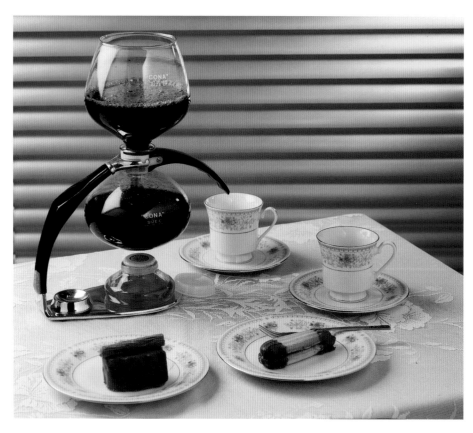

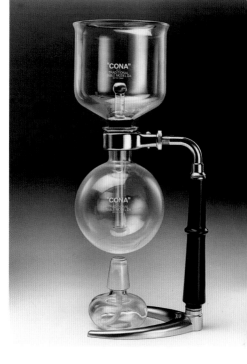

Abram Games (1914–1996)
Model C coffee maker, 1959
Heat-resistant glass, aluminium, Bakelite, cotton wadding
Cona Ltd, West Molesey, Surrey, England

Far left: Cona Limited publicity photograph showing the *Model C* coffee maker, 1960s

Left: early Cona coffee maker, 1940s – before Abram Games's redesign

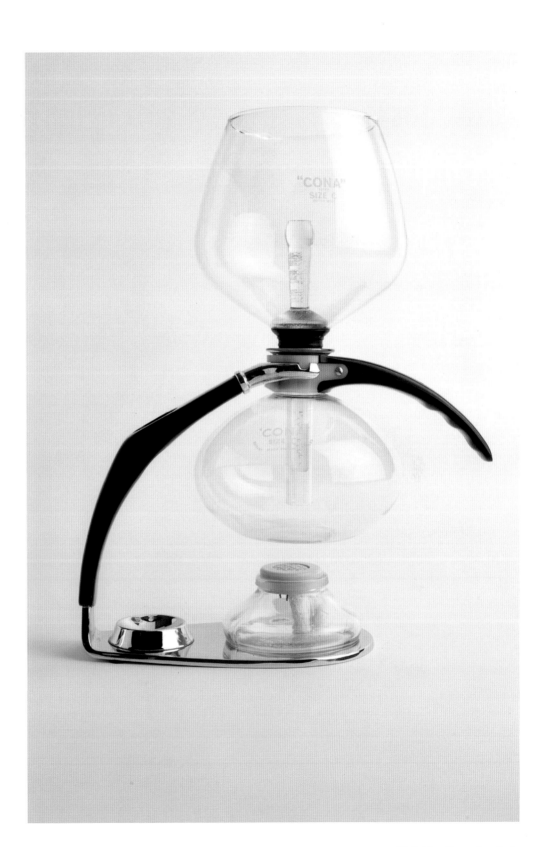

Alec Issigonis (1906–1988)
Morris Mini-Minor (Mark I), 1959

Not only was this little car hugely influential in terms of its design, it was also the first car to be truly "classless" – as likely to be driven by high-profile celebrities as by ordinary working men and women. In tune with the new liberal spirit emerging in Britain, the Mini became the car of the Swinging Sixties – young, fun and dynamic.

Its designer, Alec Issigonis, emigrated from Greece to Britain as a 16-year-old and in 1922 enrolled on a three-year engineering course at Battersea College of Technology. His first job was as a draftsman for Rootes Motors in Coventry, before becoming a suspension engineer for Morris Motors in Oxford in 1936.

Here Issigonis developed a small two-seater car in 1943, which was launched five years later as the much-loved *Morris Minor*. Influenced by American automotive styling from the 1930s and 1940s, this diminutive yet curvaceous vehicle had a unitary body construction that made it suitable for large-scale mass-production. Generally considered to be the first modern British car, the *Morris Minor* was extremely popular and was the first all-British car to exceed sales of one million.

In 1952, Morris Motors merged with the Austin Motor Company to form the British Motor Corporation (BMC) and Issigonis left to work at Alvis on a luxury car project which was subsequently cancelled.

Returning to BMC in 1955, he was tasked with developing a new small car in response to first, petrol shortages resulting from the Suez Crisis, and second, the increasing popularity of the Volkswagen *Beetle*, which had been introduced into the British market in 1953. The compact, fuel-efficient, inexpensive and boxy *Morris Mini-Minor* was launched in 1959.

Only three metres in length, this front-wheel-drive vehicle had a radically new layout that incorporated a space-saving transverse engine. This freed up 80 percent of the car's space to accommodate the driver and three passengers in relative comfort. The *Mini* was initially sold under both the Morris and Austin prefixes, and it was not until 1969 that Mini became a marque in its own right. Although in later years its safety record came under the spotlight, over five million *Minis* were sold between 1959 and 1986, reflecting not only its remarkably democratic design, but also the engaging emotional pull of this surprisingly charming vehicle.

The most significant car design of the 60s, the plucky little *Mini* powerfully embodied a new, more carefree Britain and became an iconic symbol of both the nation and the era. It is therefore unsurprising that in recent years, this landmark design has undergone something of a renaissance, albeit with a larger restyled body and better, more modern handling and performance.

Below left: finishing *Mini* front end sub-assemblies at the West Works in Longbridge, mid-1960s

Below right: sectional view of the original *Mini*

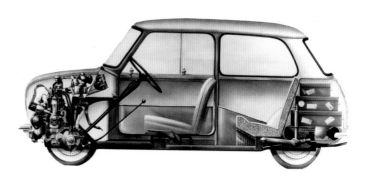

Alec Issigonis (1906–1988)
Morris Mini-Minor (Mark I), 1959
Various materials
British Motor Corporation, Cowley, Oxford, England (later
manufactured by British Leyland, Longbridge, Birmingham,
England – later becoming the Rover Group)

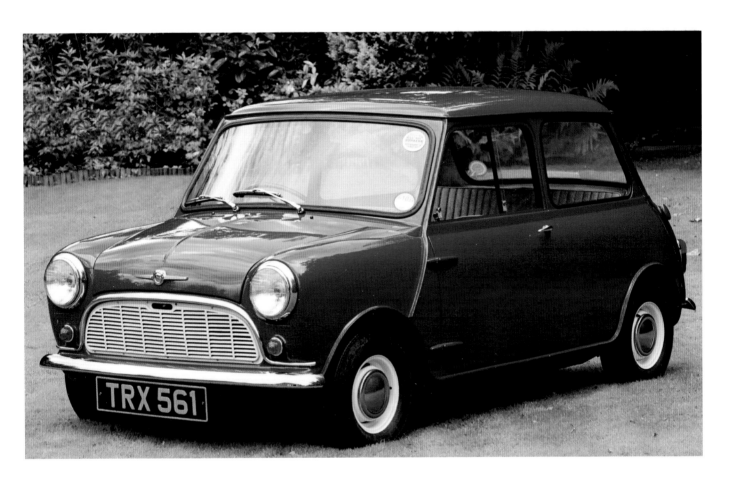

Kenneth Grange (1929–)
A701A Chef food mixer, 1960

Above: Kenwood advertisement for the new *Kenwood Chef*, c.1960

For 1950s housewives, the *Chef* was a labour-saving godsend in the kitchen, and it became the number one gift item on wedding lists across the nation. Understanding that looks were as important as function for commercial success, Ken Wood, whose motto was "Eye appeal is buy appeal", eventually decided to update the rather industrial-looking *A700*. He commissioned the highly talented industrial designer Kenneth Grange to redesign the mixer, which was now an international bestseller. Grange essentially took the earlier *A700* and created a new, sleeker plastic and enamelled metal housing for it, replacing the 1950s curves of the earlier model with more angular and dynamic lines. As well as the overall design being more visually cohesive, the product's gleaming wipe-down surfaces were much easier to keep clean.

Crucially, the high-tech clean styling of Grange's *A701* mixer distinguished it from other domestic appliances on the market, as did the choice of coloured trims (baby blue was by far the most popular). The newly redesigned *Chef* became a must-have aspirational product for the young 1960s housewife to create the perfect Victoria sponge or glamorous dinner party offerings. Despite the emergence of the Women's Lib movement at the same time, cooking was still very much the preserve of women and was seen as a rather fashionable pursuit, with television chefs such as Julia Child in America and Fanny Craddock in Britain extolling the virtues of foreign cuisine and demonstrating how to prepare it. Wartime food rationing was still a vivid memory for many in Britain, but now there was an exciting abundance of unimaginably exotic ingredients and recipes with which to experiment, and adventurous cooks needed tools that matched the sophistication of the cuisine.

Certainly the *Kenwood Chef* was without question "the world's most versatile mixer" with its potato peeling, juice extracting, mincing, slicing, shredding, liquidizing, shelling, whisking and kneading attachments, not to mention its distinctive K-shaped beater. With its sturdy, robust construction and sleek styling, the *Kenwood Chef* was a durable kitchen mainstay that not only transformed the food served on British plates, but also became an international bestseller, transforming the fortunes of the company that made it.

In 1947, Ken Maynard Wood founded the Kenwood appliance manufacturing business, initially to produce electric toasters designed by Wood, whose innovation was to find a way for slices of bread to be toasted on both sides without the user having to touch or turn them.

In the late 1940s the firm introduced its first electric food mixer: the streamlined *A200* had five different attachments, performing a variety of tasks from beating batter to mincing meat. But it was the *A700 Chef*, an evolution of the *A200*, that was to revolutionize the postwar British kitchen, with its more integrated body design and enhanced multi-functionality. Launched at the 1950 Ideal Home Exhibition in London, the *Kenwood Chef* was an instant commercial success, with department store Harrods selling out within a week.

Kenneth Grange (1929–)
A701A Chef food mixer, 1960
Enamelled metal, plastic, various other materials
Kenwood Manufacturing Ltd, Havant, England

Malcolm Sayer (1916–1970)
E-Type Series 1 roadster, 1961

Arguably the most sublimely beautiful British sports car ever made, the immortal *E-Type* encapsulates in its sensuous curves and flowing lines a very British approach to design that is shaped by function but not ruled by it, a Modernism tempered with a craft sensibility that ultimately imbues the end product with a deeply engaging emotive quality.

The designer Malcolm Sayer had studied at the Department of Aeronautical and Automotive Engineering at Loughborough University. During the Second World War he was employed at the Bristol Aeroplane Company and while working on aircraft improvements developed a unique expertise in aerodynamics as applied to mechanical engineering.

Sayer joined Jaguar in 1951 and began developing the first postwar British racing car capable of competing with models being produced by Ferrari and Mercedes. The body form of the *XK120C*, or *C-Type* as it became known, was determined by his unique methodology which combined complex logarithms and mathematical formulae to work out the precise three-dimensional shape of the most aerodynamic curves. Besides the sleek body, a triangulated tubular space frame chassis was adopted to reduce the weight of the car and enhance its top speed even further.

The *C-Type* and its successor the *D-Type* won Le Mans five times between 1951 and 1957, and around this time, Sayer began development of a new vehicle that would be a superlative roadster and racing car. With its sensuous styling and top speed of 150 mph,

the 3.8-litre *E-Type* set new standards in car refinement when it was first unveiled at the 1961 Geneva Motor Show, where it caused an utter sensation. Three years later a 4.2-litre version was launched; apart from its badge the car's external appearance remained unchanged, but beneath its body lay numerous tweaked improvements of the cooling and electrical systems plus improved gearbox and brakes. The interior of this upgraded *E-Type* now also featured a stylish matt-black dashboard and an improved seating arrangement. The top speed of the *E-Type* 4.2-litre, however, remained unchanged at around 150 mph. The main performance gain resulted from the larger engine having improved flexibility.

In 1968, the *E-Type Series 2* was launched with substantial revisions in order to comply with US legislation. This was followed in 1971 by the E-Type Series 3, which boasted a new 5.3-litre V12 engine. But of all the E-Type variants, it is the *Series 1* 4.2-litre roadster – as shown here –that is widely regarded by enthusiasts to be the most desirable. Costing £1,830 when first launched, the *E-Type* was half the price of an Aston Martin and a third that of a Ferrari. This comparative affordability stunningly embodied the value-for-money ethos that the marque's founder, William Lyons, had always tried to perpetuate at Jaguar. Ultimately, over 70,000 *E-Types* were sold as either soft tops or coupés from 1961 to 1974 – an accessible dream car that heralded a new modern sophistication within the world of British car design.

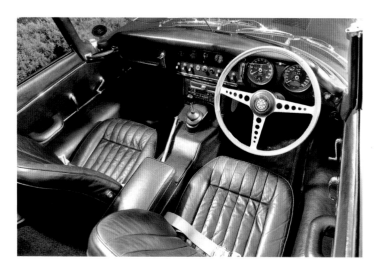

Left: detail showing interior of the *E-Type Series I* roadster

Malcolm Sayer (1916–1970)
E-Type Series 1 roadster, 1961
Steel body, various materials (aluminium body used for racing cars)
Jaguar Cars Ltd, Whitley, Coventry, West Midlands, England

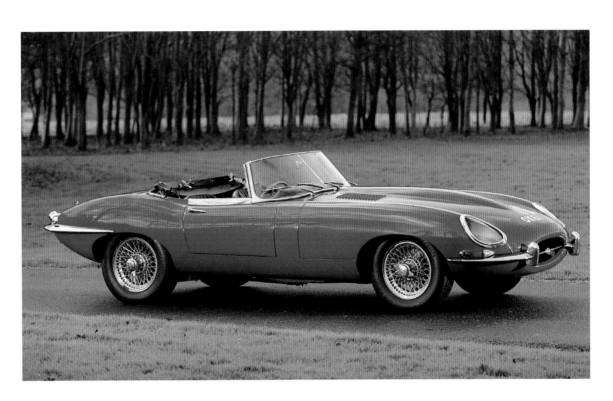

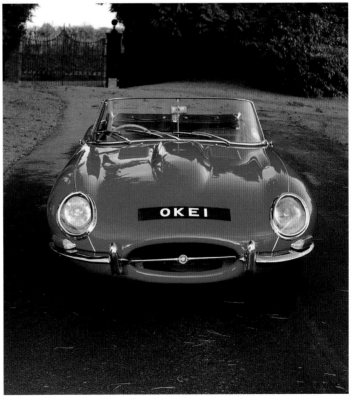

Christopher Cockerell (1910–1999)
SR.N2 hovercraft, first flight 1962

As long ago as 1716 the Swedish scientist and philosopher Emmanuel Swedenborg designed the first known "hovercraft", but the concept was almost immediately dismissed as impractical. In the 1870s, the British naval architect and engineer Sir John Thornycroft proposed a design for an air-cushioned seagoing craft, but despite the fact that he patented and built some early models, he was never able to overcome the fundamental problem of how to keep the cushion attached to the craft.

It wasn't until the 1960s that Christopher Cockerell overcame this drawback, by developing a "skirt" to contain the air cushion. Some years earlier he had built a two-foot prototype which scooted across water and over land. His patent was for a vehicle that he described as "neither an airplane, nor a boat, nor a wheeled land craft". Appropriately, he named his new invention a hovercraft.

Crucially, this early prototype proved the viability of the "air cushion effect" system; it creates a funnel of air under a craft, which in turn produces lift, thereby reducing drag. Although it was initially thought that the hovercraft would have a military application, there was a distinct lack of interest, as Cockerell later recalled: "The Navy said it was a plane not a boat; the Air Force said it was a boat not a plane; and the Army were 'plain not interested'."

Despite this, Cockerell went on to design the world's first practical hovercraft in 1959. Known as the *SR.N1* (standing for Saunders Roe, Nautical 1), this small amphibious vehicle could carry up to three passengers. But by going on to modify the *SR.N1* with a "skirt", the air cushion was effectively contained, so that it was more stable and its overall performance was enhanced.

The more important design, however, was Cockerell's later *SR.N2*. Launched in 1962, this was the world's first commercially viable hovercraft. Larger and with many improvements on the earlier craft, the *SR.N2* was designed around a spacious central cabin which, depending on its internal layout, could accommodate either 56 or 76 passengers. There was even additional space for their luggage.

The *SR.N2* heralded the advent of the widespread commercialization of hovercraft. It is the father of today's modern civilian and military hovercraft, which can carry hundreds of passengers and vehicles at impressively fast speeds.

Left: Westland Aircraft Ltd publicity photograph showing the *SR.N2* hovercraft on beach, 1960s

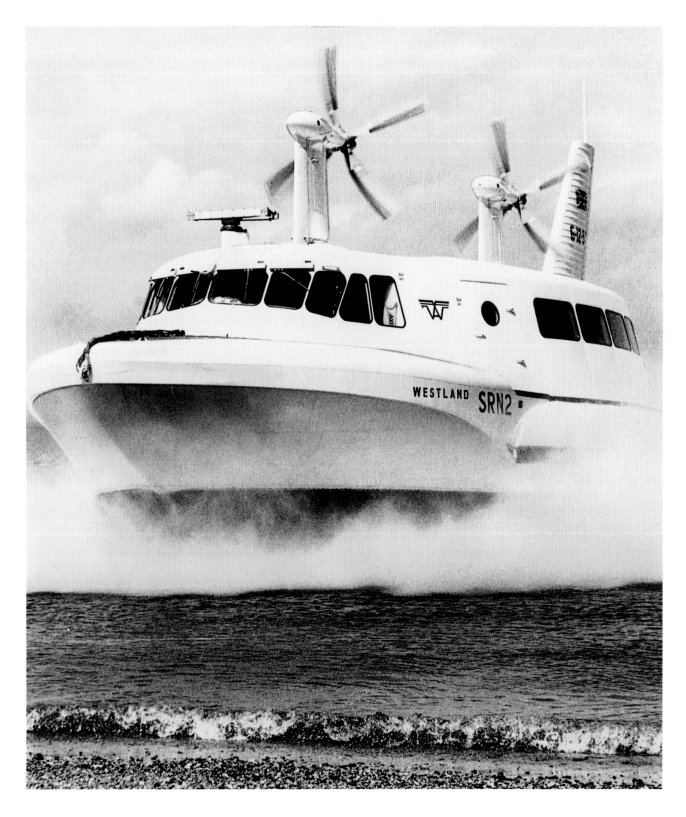

Christopher Cockerell (1910–1999)
SR.N2 hovercraft, first flight 1962
Various materials
Westland Aircraft Ltd, East Cowes, Isle of Wight

Robin Day (1915–2010)
Polypropylene side chair, 1960-63

The ever reliable "Polyprop" chair is a ubiquitous feature of everyday British life, having furnished school classrooms, hospitals and civic halls across the country for over half a century.

The chair's designer, Robin Day, came to prominence in 1948, when he won first prize at the International Competition for Low-Cost Furniture Design held by the Museum of Modern Art, New York, in 1948. This international success brought Day to the attention of Hille, an established British furniture manufacturer that was keen to modernize its product line. Hille subsequently commissioned him to design simple, pared-down furniture within the Modern idiom for the 1949 "British Industry Fair", and the following year he became the firm's chief designer.

In 1960, Day was asked to judge a design competition sponsored by Shell, which two years earlier had acquired the licence to manufacture polypropylene, a new type of thermoplastic invented by Guilio Natta in 1954. Having seen the success of Charles and Ray Eames's *Plastic Chair Group* (1948–50), Day decided to use this new plastic material for the design of his own seating system, similarly based on the idea of a standardized plastic seat shell that could be used with different bases.

The resulting *Polypropylene* chair with its universal seat shell made from injection-moulded polypropylene was developed between 1960 and 1963. According to Day in a press release, it arose from "the need for a multi-purpose side chair at a very low cost", while its form evolved from "considerations of posture and anatomy". Also referred to as the "Polychair", it was one of the first seating designs to fully exploit the high-volume manufacturing potential of thermoplastics, and as such was far more commercially successful than the Eames's earlier seating range because it could be produced at a much lower unit cost.

Strong and durable, polypropylene also had the added benefit of being a resilient yet malleable polymer, which meant that the seat shells had a degree of flexibility which ensured comfort without the need for upholstery. Developed as a seating system with two standard seat shells – side chair (1963) and armchair (1967) – and a wide variety of interchangeable bases, the *Polychair* had numerous applications, including airport beam seating and football stadium seating. Over the succeeding years, Day also designed other seat shells for the *Polychair* range, notably the *E-Series* (1972) for school children and the *Polo* (1973) for outdoor use. In Britain virtually every school, hospital and church hall has at some stage been furnished with the tough-but-light stackable *Polychair*, while Hille has also exported this landmark utilitarian design around the globe.

Since its debut in 1963, 14 million *Polychairs* have been sold worldwide – underlining the continuing demand for reasonably priced, durable, practical, multi-functional plastic chairs.

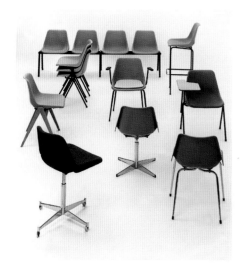

Far left: Hille promotional photograph showing the *Polypropylene* range of chairs, 1960s

Left: back view of the *Polypropylene* chair

Robin Day (1915–2010)
Polypropylene side chair, 1960–63
Polypropylene, enamelled tubular metal, rubber
Hille International Ltd, High Wycombe, United Kingdom

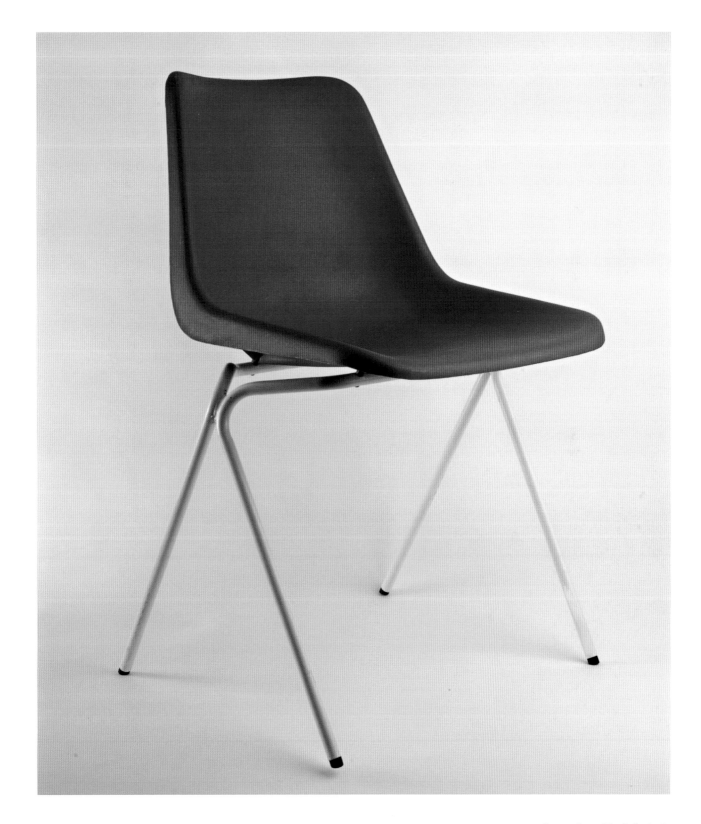

Joseph Cyril Bamford (1916–2001)
JCB *3C* backhoe loader, 1963

One of Britain's largest exporters, JCB is today a world-leading manufacturer of constructional, agricultural and defence equipment, from backhoe loaders and hydraulic excavators to industrial forklifts and telescopic handlers. Its origins, however, were exceedingly humble.

They can be traced back to 1945, when Joseph Cyril Bamford began producing agricultural tipping trailers in a rented lock-up garage in Uttoxeter, using war-surplus materials and a second-hand welding set. These trailers were designed by Bamford to be used with the new generation of petrol-driven tractors, and their popularity soon enabled him to move to larger premises and to hire some employees to cope with demand.

Around this time he also started to produce larger four-wheel tipping trailers. In 1948, having realized the potential of hydraulic mechanisms, Bamford launched the world's first four-wheeled hydraulically operated tipping trailer, and the following year he introduced a new model, the *Major Loader*. Designed to be used in conjunction with the Fordson *Major* tractor, this new trailer sold in its thousands and its success meant relocating to even larger manufacturing premises in Rocester.

The 1950s saw the development of a completely new generation of JCB heavy moving machines, which were inspired by a sales trip to Norway that Bamford made in 1952 on which he saw a very rudimentary backhoe being used. The resulting *MK 1* excavator was essentially a Fordson tractor with a hydraulic excavator at the rear, and a *Major Loader* at the front

with an optional cab to keep the operator protected from the weather. This was followed by the launch of the powerful *Hydra-Digger* in 1957 – which was the first JCB machine to have a comfortable cab – and the *Loadall* in 1958, with its innovative hydraulic shovel.

By combining these two designs in 1959, Bamford created the first truly recognizable backhoe loader, with its chassis, rather than the tractor skid, bearing the incredible pressure forces derived from loading and digging. The subsequent launch of the JCB *3C* backhoe loader in 1963 reinforced the company's position as market leader. Widely acknowledged as a design classic, the *3C* featured numerous innovations including an integrated chassis and a sideways-sliding excavator assembly, which gave the operator an uninterrupted view down the trench that was being dug.

In the year of its launch, JCB sold 3,000 *3C* backhoes and this landmark design continued to sell well over the coming years. In 1976, Bamford's son Anthony took over the helm at JCB and four years later the company successfully launched the *3CX*. This new generation of backhoe loaders was the result of what is believed to be the most intensive research and development programme for a single product line ever undertaken by a construction equipment manufacturer, with its development costs being an astonishing £24 million. Sleeker, and with enhanced performance, this new design replaced the trusted and iconic *3C* which had, during its 19-year production run, sold an astonishing 72,000 units – quite simply an earth-shaking design of a digger.

Left: JCB illustration of the *3C* backhoe loader

Joseph Cyril Bamford (1916–2001)
JCB *3C* backhoe loader, 1963
Various materials
J. C. Bamford Excavators Ltd, Rocester, Staffordshire, England

Peter Murdoch (1940–)
Spotty chair, 1963

A leading global supplier of paper and packaging, the International Paper Company rejected numerous designs for paper furniture over a period of five years until it came across a design for a simple origami-like child's chair by a young British designer.

Peter Murdoch had developed his idea while still a student at the Royal College of Art, London. He initially proposed to make his design out of sheet metal, but the International Paper Company had recently developed a new kind of paperboard, "Solid Fibre", using three types of paper to make up a five-layer lamination. It proved to be a far better choice of material as it allowed the chair to be lighter in weight, more colourful and – most importantly – much cheaper to manufacture. As an International Paper Co. advertisement from 1968 noted, "Solid Fibre can take the sharp curves that give this design strength and good looks, without cracking. The finished chair proved so durable that we added a polyethylene finish to make the surface washable. Hint: it's a great gift idea".

Because of the high strength-to-weight ratio possessed by the laminated paperboard, the *Spotty*, with its playful polka-dot patterning – inspired by contemporary Op Art – could be made large enough and strong enough for an adult to sit on. Although weighing just three pounds, it could support an impressive 500 pounds (according to its manufacturer) indefinitely. To produce this simple yet surprisingly resilient chair, a sheet of coated and printed laminated paperboard was die-cut into the required shape and then scored along the curvature

folds, finally being bent to create a tub-like seat form.

Murdoch patented the system of folded construction used to make the *Spotty* chair, which was suitable not only for paper seats, but also those made from sheets of plastic or aluminium. Unlike furniture from previous decades, the *Spotty* was a playful seating design with inherent disposability thanks to its low-cost material and production. A single machine could produce one every second, and transportation was easy and inexpensive.

The *Spotty* chair was sold in flatpack form, and as such could be bought literally off the shelf, taken home and assembled without any fuss and with very little financial outlay. It was a design icon of the Pop era, an ephemeral yet functional plaything that was totally in tune with the consumerist "use it today, sling it tomorrow" attitude. Later on, in 1967, Murdoch designed his similarly constructed *Those Things* range, manufactured by New Merton Board Mills for Perspective Designs, a company set up by Philip Bidwell to market the work of young designers. This range of children's self-assembly paperboard furniture in orange, navy blue, pink and turquoise, comprising a chair, table and stool, subsequently won a Council of Industrial Design Award in 1968.

Certainly disposable paper furniture was a potent symbol of the 1960s' consumer-led society and Murdoch's *Spotty* chair and *Those Things* range eloquently demonstrated that the design of furniture did not have to take itself too seriously. In fact, chairs could be fashionable, cheap, disposable and – perhaps most importantly – fun.

Left: International Paper Company advertisement showing the *Spotty* chair in use, 1968

Peter Murdoch (1940–)
Spotty chair, 1963
Polyethylene-coated, laminated paperboard
International Paper Co., New York (NY), USA

Martyn Rowlands (1923–2004)
Deltaphone (Trimphone), 1963

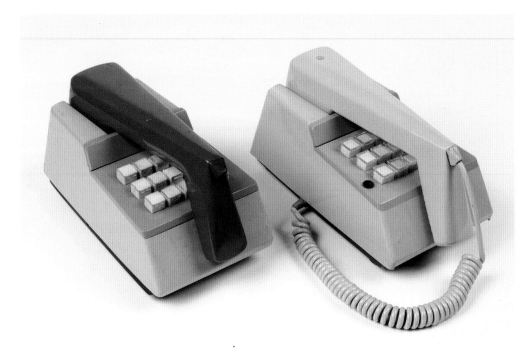

Left: *Deltaline* interoffice push button telephones designed by Martyn Rowlands for Standard Telephones and Cables Ltd, 1963

When it was launched in 1964 the *Trimphone*, as most people would have known it, could scarcely have looked more different from the standard GPO offering.

The original name given to this beautiful telephone by its makers, Standard Telephones and Cables Ltd (STC), was the *Deltaphone*. Manufactured in high-impact ABS and purple-tinted polycarbonate, it was elegant, slimline and not only more compact, but also considerably lighter than consumers had been used to, weighing less than 1kg. STC commissioned the industrial designer Martyn Rowlands to design it, after consultation with the Council for Industrial Design. Rowlands had previously worked as chief designer for Ekco's plastics division, and was one of the country's foremost experts on using plastics for mass-production.

The reason it was also called the *Trimphone* was not, as one might assume, because of its sleek appearance, but because TRIM was the acronym for "Tone Ringing Illuminated Model". The *Deltaphone* was convenient for use in the bedroom, being so lightweight, and for that reason it featured not only an integral handle, but also a dial which was permanently illuminated by a concealed tritium gas tube that did not require any power supply. It also incorporated a transistorized oscillator which meant it could have a "tone caller" (ie a ringtone), rather than the old bell used on earlier GPO models. This ringtone warbled relatively quietly to start with, but became louder with every ring.

The phone's compact layout was achieved by using what was known as the "horn principle" previously used for telephone operators' headsets. It allowed the distinctively shaped handset to lie vertically across the dial when not in use. The clean lines of its ABS housing also meant it was easy to wipe clean, as well as to manufacture. Over the years following its launch various performance-enhancing modifications were made to the original design, and new colour options were introduced. In 1979 it was redesigned to incorporate a press-button keypad, and in this guise it remained in production well into the 1980s.

Winning a Design Centre award in 1966, the *Deltaphone* was a masterpiece of 1960s plastics technology, and though it might not have been as radically styled as some telephones being produced in Italy during this period, it was the most beautifully engineered model that was not only highly functional and durable, but also pretty stylish.

Martyn Rowlands (1923–2004)
Deltaphone (Trimphone), 1963 (push button variant introduced 1979)
ABS, polycarbonate, rubber
Standard Telephones and Cables Ltd, London, England

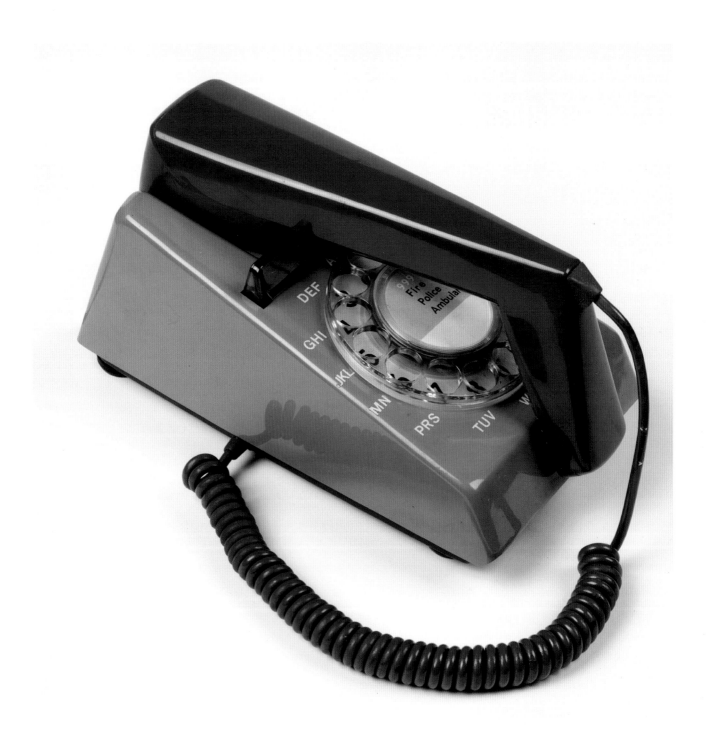

Robert Welch (1929–2000)
Alveston tea service, 1964

Left: *Campden* toast rack designed by Robert Welch for Old Hall, 1956

With its crisp precise lines, the *Alveston* tea set was personally selected by the then Minister of State for Technology, John Stonehouse, in 1967 to take with him on a trip to Moscow as a gift for the Russian government because it represented one of the finest examples of modern British craftsmanship.

Robert Welch was not only a gifted draftsman, but also a talented form-giver whose functional metalware designs had a distinctive modern flair. While studying silversmithing he made two trips to Scandinavia where he became, according to Fiona McCarthy, "excited by his discovery of Scandinavian modern stainless steel, as developed in neutral Sweden in the war years by the Gense factory. He began to see it as his mission to design an equivalent modern British range of stainless steel."

During his final year of study at the Royal College of Art, Welch made contact with Britain's only manufacturer of stainless steel wares, J. & J. Wiggin. This family-run firm had been established in 1893 and in the late 1920s had pioneered the development of tableware made from "Staybrite" stainless steel under the Old Hall brand. The outbreak of the Second World War meant the factory was converted to wartime production and in the immediate postwar period the firm struggled with material shortages and found it difficult to resume its prewar manufactures. There was, as Nigel Wiggins notes, "a need to build up export sales as quickly as possible because, by Government direction, supplies of stainless steel were only obtainable under licences directly proportional to the value of finished goods exported. Although the domestic markets overseas were difficult to break into, what did emerge was considerable interest from hotels, hospitals and other catering users. Accordingly, the company quickly developed new designs specifically for the catering trade."

Realizing it was having to compete for these crucial export markets with Scandinavian companies producing stylishly modern stainless steel wares, the company appointed the young but highly talented Welch as its consultant designer when he graduated in 1955. It was the beginning of a 40-year-long collaboration that resulted in numerous award-winning designs for supremely functional stainless steel tablewares. Although many of these designs had a rather utilitarian and institutional aspect, they were beautifully designed and possessed a distinctive pristine quality that reflected Welch's skilful understanding of the delicate relationship that exists between form and function. Among his many designs for Old Hall, the *Alveston* tea set stands out as being a superb example of his remarkable ability to give expression to the inherent qualities of the materials he was using, whether it was hard and shiny stainless steel or heavy cast-iron.

Named after the Gloucestershire village Welch was then living in, the *Alveston* tableware group (which included an award-winning cutlery range) comprised some of the finest stainless steel designs ever produced. It is not surprising that the *Alveston* tea set – unofficially known as the "Aladdin's Lamp" service because of the teapot's distinctive shape – is now the most sought after item among Old Hall collectors.

Robert Welch (1929–2000)
Alveston tea service, 1964
Stainless steel
J. & J. Wiggin, Bloxwich, Birmingham, England (later to become
Old Hall Tableware Ltd)

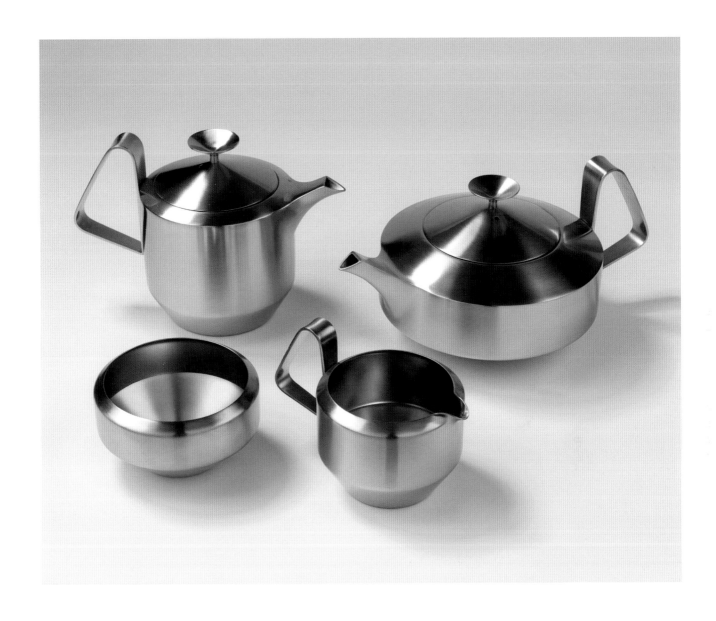

Design Research Unit (founded 1943)
British Rail identity, 1964

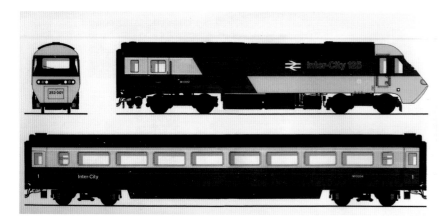

Left: British Rail livery for *InterCity 125* train, issued by British Rail in August 1977

Below: design of the "Double Arrow" symbol, issued by British Rail in April 1965

In 1942, the managing director of Stuart's Advertising Agency, Marcus Brumwell, and the design theorist Herbert Read, realizing that once the Second World War was over and wartime rationing had been lifted there would be a huge demand for consumer goods, proposed the idea of forming a collective of designers and architects who could create designs suitable for large-scale mass-production. They consulted Milner Gray, who had helped establish the Industrial Design Partnership before the war, on the formation and organization of such a group, and the Design Research Unit was subsequently founded in January 1943.

From the outset its stated intent was to "bring artists and designers into productive relation with scientists and technologists". It was the first multi-disciplinary design consultancy in Britain, with combined expertise in the three main areas of design practice – architecture, industrial design and graphic design. It offered its clients a truly comprehensive corporate design service.

DRU, as it became known, was responsible for the design of the "What Industrial Design Means" section at the landmark 1946 "Britain Can Make It" exhibition, which clearly demonstrated the design process by following the development of an egg cup from a designer's desk, through manufacture, to the breakfast table. The team also made a significant contribution to the Festival of Britain, and worked on a comprehensive corporate identity for the brewer Watney's.

In 1964 DRU was commissioned to reinvigorate the image of the nation's rather neglected rail industry, whose corporate identity had not changed significantly since the railway network's nationalization in 1948. The first noticeable changes were the shortening of the company name to British Rail, and the introduction of the famous double-arrow logo.

Launched in January 1965 at the Design Council in London as "The New Face of British Railways", DRU's integrated and extremely comprehensive corporate identity programme comprised four main elements: the new symbol, the British Rail logotype, the *Rail Alphabet* typeface and a codified system of house colours. The *Rail Alphabet*, devised as a bespoke sans serif typeface, was the lynchpin of the identity; this clear and simple font family was extremely easy-to-read and gave a distinctive modern identity to all of British Rail's graphic projections.

The "British Rail Corporate Identity Manual" was issued in 1969 and released across the country so that the new look could be implemented efficiently; the information came in a binder, so that it was able to be continually updated and expanded over the years. The longest lasting legacy of the Design Research Unit, this exceptional corporate identity programme has even outlived British Rail itself (which was wound up in 2000), by remaining in use in railway stations across the National Rail Network some 40 years after its launch.

Design Research Unit (founded 1943)
British Rail identity, 1964
Various applications
British Railways/British Rail, London, England

InterCity

Property Board

Railfreight

InterCity Sleepers

Sealink

Rail Express Services

Motorail

Europe

Travellers-Fare

British Railfreight

British Rail International

Owen Maclaren (1907–1978)
B-01 baby buggy, 1965

Far left: Maclaren publicity photograph showing *B-01* baby buggy in folded position

Left: Owen Maclaren's daughter demonstrating the use of the Maclaren buggy whilst travelling by plane.

The founder of Maclaren used the techniques he had developed and perfected as a Second World War aeronautical engineer to design and manufacture the world's bestselling baby pushchair.

In 1937, Owen Finlay Maclaren patented an invention for an aircraft undercarriage which allowed planes to land and take off in difficult crosswind conditions. He set up the Maclaren Undercarriage Company around 1940, and went on to develop and patent a new type of landing gear that was used on the renowned *Supermarine Spitfire*. In addition to this, the highly skilled engineer invented a special sealing device which allowed aircraft to survive even after receiving a bullet in their radiators – thereby saving the lives of many pilots during the Second World War.

In 1944 he established a new company, Andrews Maclaren, which specialized in the manufacture of aircraft components. He introduced the company's first consumer product 17 years later: the patented *Gadabout* picnic chair, which was made of lightweight tubular aluminium and canvas that folded down like an umbrella.

Once he became a grandfather in 1965, and after watching his daughter struggle with cumbersome and heavy traditional baby carriages, Maclaren set about designing a new kind of lightweight pushchair using a type of folding mechanism that was similar to the *Gadabout* chair. The development of this new design was undertaken in the converted stables of his house in Barby, Northamptonshire, as was its initial production run of 1,000 units. His baby buggy was described in its patent application as: "A baby carriage or the like having two frames which are inter-pivotally connected by means of a two-axes pivot joint and which are held in their unfolded position at a fixed angle with respect to each other by rigid brace members pivotally connected to the frames".

This utterly revolutionary design, using an X-frame of aluminium tubing and a durable woven textile sling seat, weighed just six pounds. It also had the competitive advantage of being extremely quick and easy to collapse, thanks to its five-second, one-hand folding mechanism; a parent just needed to push the bottom edge of the mechanism upwards with their foot and the buggy folded easily into an easily portable unit.

This new buggy liberated parents from unwieldy prams and burdensome pushchairs when it was first launched in 1967. The Ministry of Health commissioned a larger version of the Maclaren pushchair for older children with disabilities, and in 1976 the company also introduced a foldable pram. In 1991, the company launched the world's first car seat pushchair, the *Super Dreamer*, allowing a baby to be moved from house to car and into the pushchair without being removed from the car seat.

Owen Maclaren (1907–1978)
B-01 baby buggy, designed 1965, manufactured from 1967
Tubular aluminium, nylon moulded parts and Tygan fabric seat
Maclaren, Long Buckby, England

Patrick Rylands (1942–)
Playplax constructional toy, 1965–66

Above: *Fish* and *Bird* bath toys designed by Patrick Rylands for Trendon, 1970 – revealing a similarly child-centred approach to the design of toys

Playplax might look like a playful Pop interpretation of a Constructivist sculpture, but it was quite simply the plastic toy for a new generation of children born into the 1960s – the Plastics Age.

While he was still studying at the Royal College of Art in London, Patrick Rylands created various toys based on the concept of interlocking clay tiles, two of which were subsequently manufactured in wood by the Swiss maker, Spiel Naef. He also translated the concept into a prototype constructional toy made from hand-cut sheet polystyrene. He spent the summer holidays working at the Hornsea Pottery in his native Yorkshire, and showed the prototype to the proprietor of Trendon, a company that made moulded bungs for the pottery's salt pots.

Trendon immediately put this constructional toy into production and branded it *Playplax*. When it was launched in 1966, it became an instant commercial success, its interlocking squares and cylinders of brightly coloured acrylic expressing the almost magical optical qualities of this glass-like polymer. Beyond this, and as Rylands observed, *Playplax* was essentially "stuff" that was intended to stimulate playful interaction, with its simple elements ensuring a child "could build anything".

Playplax invited non-prescriptive play – absolutely in tune with the creative child-centred *Zeitgeist* of the mid-1960s, it was up to the child what they chose to build out of the pieces of clear, red, blue, yellow and green translucent plastic. They could also freely experiment with the colours themselves, by layering the component elements on top of each other to create a kaleidoscopic array of new shades. *Playplax* squares and cylinders could be endlessly and imaginatively joined together into different tower-like configurations.

In 1970, Rylands was awarded the Duke of Edinburgh's Prize for Elegant Design for his children's toys, which included not only *Playplax* but also his sculptural *Fish* and *Bird* bath toys made of hard, shiny ABS plastic. In the opinion of the judges he had demonstrated "how toys can be designed to amuse, to stimulate creative talent and to educate". They specifically commended *Playplax* for its abstract qualities which "encourage children to use their imagination and introduce them to ideas of structure, form, colour and balance".

Patrick Rylands (1942–)
Playplax constructional toy, 1965-66
Polystyrene
Trendon Ltd, Malton, Yorkshire, England; (later manufactured under license by James Galt & Company, Cheadle, Staffordshire, England & Portobello Games Ltd, Itchen Stoke, Hampshire, England)

Geoffrey Baxter (1922–1995)
Model No. 9681 Banjo vase, 1966

During the 25 years that Geoffrey Baxter worked for Whitefriars Glass he built up a reputation as the most gifted British glass designer of his era. Between 1954 and 1980 he was responsible for a wide range of innovative glass tableware as well as more flamboyant and heavily ornamented pieces.

Whitefriars itself went back as far as 1834, becoming the most respected glass-manufacturing works in the country under the management of Harry Powell, and supplying beautifully crafted glassware to among others, Morris & Co. and Liberty. During the 1920s and 1930s the company began to produce modern-style wares that reflected the socially-inspired, design-reforming *Zeitgeist* of the period, and after the Second World War it managed to maintain its reputation for manufacturing excellence.

In 1954 Whitefriars' managing director and chief designer, William Wilson, headhunted Geoffrey Baxter to be his new assistant, even though he had only just completed his studies at the newly established Department of Industrial Glass at the Royal College of Art. At the RCA, Baxter's glassware designs had attracted significant attention and he was the first industrial designer to be awarded a travelling scholarship to the British School in Rome.

At that time imported "Scandinavian Modern" glassware with its restrained, clean lines was especially fashionable, and to begin with Baxter designed glassware within the same purist idiom. It successfully competed with wares being produced by Nordic glassworks such as Iittala, Holmegaard and Kosta Boda. In 1966, however, a new range of chunky and heavily textured vases designed by Baxter was launched that was altogether more interesting. For this series Baxter was undoubtedly inspired by Timo Sarpaneva's *Finlandia* glassware range (1964) for Iittala, which used moulds made of charred slabs of wood. Baxter for his part was far more eclectic in his choice of materials used to create the deep relief moulds for this series of cased glass objects. Pieces of old wood, tree bark, tin tacks, nails and copper wire were all used to make up the moulds into which the molten glass would be blown. The resulting, almost collage-like, assemblages gave the final pieces an interesting textural quality, which was further heightened by the choice of three different smoky hues: Willow, Indigo and Cinnamon.

In 1969, brighter and more vibrant colours were added to the range: Tangerine, Kingfisher Blue, Meadow Green and Pewter. Among this group of thick-walled soda glass vases, the largest and most impressive model was the *Banjo* vase, so named because of its quasi-rounded form. Sadly however, the energy crisis of the early 1970s and the ensuing recession devastated the market for this type of handmade glass, and Whitefriars glassworks was eventually forced to close in 1980. Utterly revolutionary when first introduced, Baxter's textured vases are now being rediscovered by a new generation of collectors who have come to appreciate their boldly sculpted aesthetic bravado.

Above: *Cello, Sunburst* and *Bark* vases designed by Geoffrey Baxter for Whitefriars, 1966

Captiom

Geoffrey Baxter (1922–1995)
Model No. 9681 Banjo vase, 1966 (this example in Kingfisher Blue glass launched in 1969)
Mould-blown soda glass
Whitefriars Glass (James Powell & Sons), Wealdstone, London, England

Peter Blake (1932–) & Jann Haworth (1942–)

Sgt. Pepper's Lonely Hearts Club Band
record sleeve for The Beatles, 1967

Released by EMI Records in 1967, the Beatles' *Sgt. Pepper's Lonely Hearts Club Band* sleeve is surely the most famous album cover of all time. While this iconic image was art directed by Robert Fraser and photographed by Michael Copper, the overall concept and design was the brainchild of the leading British Pop artist, Peter Blake, and Jann Haworth, his wife and artistic partner.

The album cover image is a tightly-packed collage of celebrities fronted by John, Paul, Ringo and George, who are decked out in colourful satin military uniforms. Some 80, mainly historical figures (not including The Beatles themselves) are featured on the cover, including many of the band members' heroes, ranging from writers and musicians to film stars and Indian gurus.

Blake and Haworth painstakingly constructed the set using life-sized cardboard cutouts and waxworks of the young "Fab Four" which were borrowed from Madame Tussaud's. The band members were then photographed in person posing in front of a drum, on which was emblazoned the album's title, painted in fairground lettering. The curious municipal garden display in the immediate foreground – spelling out the word "Beatles" in red flowers – not only gave the composition an all-important sense of spatial depth, but also added to the overall quirkiness of the composition, while also referencing "flower power".

On top of this there were various objects such as cloth dolls, a Japanese stone-carved figure, a garden gnome, a Hindu goddess doll, a velvet snake, a hookah and a figure of Snow White, all of which added to the intrigue of the image as well as reflecting the diverse influences from which the Beatles drew musical inspiration.

The cost of the artwork, £2868 5s 3d, has been estimated to be around 100 times more than the average album cover cost at the time, but it was worth every penny. Not only was *Sgt Pepper's Lonely Hearts Club Band* an epoch defining concept album in terms of its musical content; it was also hugely influential thanks to its ground-breaking sleeve design, which demonstrated that music packaging could become high-concept art.

Left: John Lennon's caravan – decorated with the *Sgt. Pepper's Lonely Hearts Club Band* motif, 1967

Peter Blake (1932–) & **Jann Haworth** (1942–)
Sgt. Pepper's Lonely Hearts Club Band record sleeve for
The Beatles, 1967
Colour offset lithograph on card and paper
Garrod & Lofthouse Ltd, London, England for EMI Records,
London, England (publishers: The Gramophone Co Ltd and
Parlophone)

Colin Chapman (1928–1982) & Maurice Philippe (1932–1989)
Lotus 49 racing car, 1967

Above and right: details of *Lotus 49* racing car, showing rear suspension assembly and Ford Cosworth V8 engine

Grand Prix racing was utterly transformed in 1961 when the Formula One governing body limited engine capacity to 1.5 litres. This reduction in engine size meant that the teams and their constructors had to massively overhaul the design of their cars.

One of the most talented racing-car designers during this period was Colin Chapman. He had studied engineering at University College, London, and then set up the Lotus Engineering Company in 1952 where he developed a number of new designs for road racing and Formula One cars that were based on his experiments with wedge-shaped forms, new materials and aerodynamic "ground effects" for better downforce.

Among these was the *Lotus Mark VI* roadster (1952), which had an innovative lightweight, spaceframe chassis. In response to the new 1961 regulations, Chapman designed the *Lotus 25* (1962), thereby introducing the first fully-stressed lightweight monocoque chassis to F1. This aerodynamically engineered car famously took the British racing driver Jim Clark to a World Championship title in 1963, and enabled Lotus to win its first constructors' championship the same year. But it was the *Lotus 33*, designed by Chapman and built by Team Lotus using the design and engineering layout of the earlier *Lotus 25*, that became a supreme winning machine with a new suspension configured around wider tyres.

In 1966, Formula One hiked engine size regulations to a much more powerful three litres. This "return to

power" prompted Chapman to look for a new engine for the 1967 season. He contacted Mike Costin and Keith Duckworth, founders of the high-performance engine tuning company Cosworth, to develop and supply a suitable power plant. With development eventually sponsored by Ford, the new Cosworth three litre V8 engine, dubbed the DFV (Double Four Valve), was completely cast from aluminium and incorporated a Lucas fuel injection system.

This high-powered engine (400 brake horsepower at 9000 rpm) was then bolted directly onto the back of the aluminium monocoque chassis and took all of the rear suspension load, an innovation which was a much lighter and cleaner solution than using a rear subframe. Designed by Chapman and Maurice Philippe, this chassis configuration was utterly revolutionary and became the blueprint for virtually all Formula One cars, even to this day. The *Lotus 49* was lighter and more powerful than its competitors and famously enabled Graham Hill to clinch the World Championship title in 1968, albeit after his teammate Clark had been tragically killed earlier the same year at Hockenheim in a Formula 2 race.

In 1968, the *Lotus 49* was also the first F1 car to be liveried in the colours of the sponsor and to be equipped with wings for aerodynamic downforce. A British racing legend, the *Lotus 49* is widely regarded as one of the most influential F1 designs of all time, having introduced numerous ground-breaking firsts.

Colin Chapman (1928–1982) & **Maurice Philippe** (1932–1989)
Lotus 49 racing car, 1967
Aluminium, other materials
Team Lotus, Hethel, Norfolk, England

Kenneth Grange (1929–)
Instamatic 33 camera, 1968

Left: original *Instamatic 33* "colour outfit" box

Kenneth Grange's journey into the product design hall of fame almost happened by accident: "I couldn't yet make a living [from it], so I was working doing the displays for the Kodak pavilion at the World Trade Fair. I was arranging the products on the stand and someone overheard me say, 'It's a shame these are so ugly; I could make this [display] really good if they weren't.' The next day, the phone rang. It was the head of development at Kodak, and he said, 'I understand you're going to design a camera for us'. It was thrilling, but I was scared, too, because I didn't know cameras. But again, there was an element of luck involved. I just happened to be in the right place at the moment when Kodak decided to start selling cameras for profit. Up until this point, their cameras were sold at a loss in order to shift film."

The result was the Grange's *Brownie 44A*, whose well-conceived layout and clean modern aesthetic helped it win a Design Centre Award in 1960. He followed this in 1968 with the *Instamatic 33*, a compact camera that was far more ergonomically resolved than Kodak's earlier, boxy, *Instamatic 100* and *Instamatic 400* models, both of 1963. With its pared down aesthetic, which recalled the clean functional lines of electronic products designed by Dieter Rams for Braun, Grange's *Instamatic 33* had a less sterile, more humanistic quality. While its layout was dictated by functional requirements, this camera possessed a strong formal and operational clarity that made it extremely easy to use.

One of Britain's leading industrial designers, Kenneth Grange has created numerous celebrated designs that are seen as British archetypes: from his Morphy Richards' irons and *Parker 25* pens to the distinctive nose-cone of the *Intercity 125* high-speed train, his skillful redesigns of the classic London black cab and the famous *Anglepoise* task light.

The cameras he designed for Kodak were remarkably forward-looking and epitomized his user-centric approach to design, whereby the interaction between object and user is made as intuitively simple and pleasurable as possible. Produced in Britain by Kodak Ltd, this *Instamatic 33* shoot-and-go camera used easy-to-load 126 cartridges and would appear to have been made specifically for the British market. Later on, in 1972, Grange designed the bestselling *Pocket Instamatic 130, 230* and *330* cameras for Kodak, and so introduced a whole new generation of highly portable slimline models, all of which possessed the refined design sensibility that has defined Grange's work throughout his illustrious career.

Kenneth Grange (1929–)
Instamatic 33 camera, 1968
Plastic, metal, other materials
Kodak Ltd, Hemel Hempstead, Hertfordshire, England

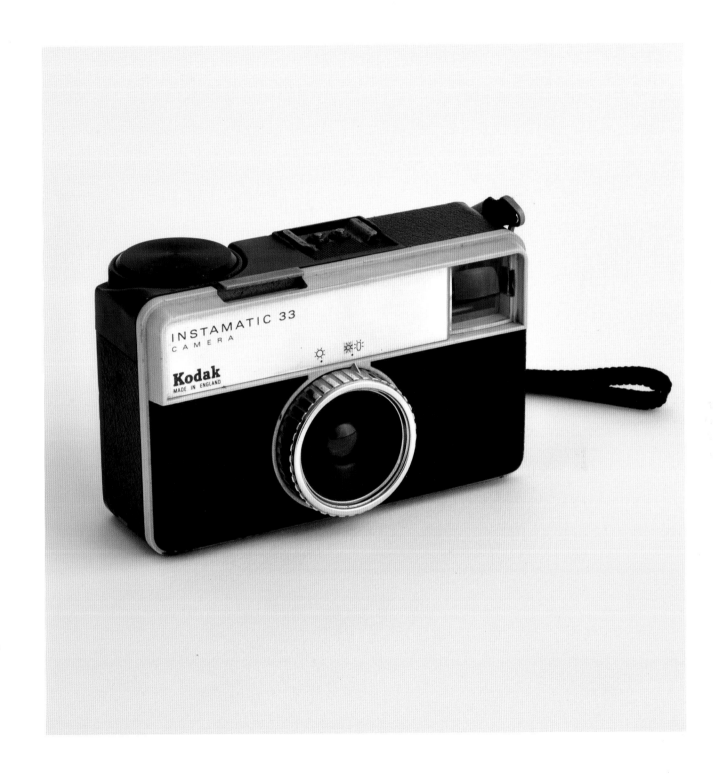

British Aircraft Corporation (founded 1960) with Sud-Aviation (Aérospatiale) (founded 1957/1970)
Concorde supersonic jet, first flight 1969

No passenger aircraft captured the imagination of the British public more than the streamlined, arrow-like *Concorde* as it pierced the sky. This remarkable plane promised a new age of supersonic passenger air travel, while the co-development programme between the British Aircraft Corporation in England and Sud-Aviation in France was a hugely symbolic event in the history of modern Britain, heralding a new era of European co-operation, or "concord". The concept for the *Concorde* goes back to the late 1950s, when Britain, France, America and the Soviet Union were all looking into the development of supersonic transport (SST). In Britain, the Bristol Aeroplane Company was working on a thin-winged, delta-shaped, transatlantic supersonic model, the *Type 223*, which was designed to carry around 100 passengers. In France, Sud-Aviation was developing its own medium-range supersonic *Super-Caravelle*. Both companies were largely state-sponsored and although both designs were sufficiently advanced to go onto the next prototyping stage, the development costs were so enormous that the British Government stipulated that for the ambitious project to go forward BAC had to find an international partner to co-fund it.

Eventually in 1962 a treaty was signed between the British and French Governments and development of the *Concorde* began, with two fully working prototypes being built concurrently by Aérospatiale in Toulouse and BAC in Bristol. The *Concorde 001* made its first test flight in Toulouse in March 1969,

while the first UK-built model, the *Concorde 002*, made its maiden flight from Fairford the following month. The delta-wing plane was powered by four Rolls-Royce *Snecma Olympus 593* afterburning turbojet engines that meant it could fly at Mach 2, a rate of travel well in excess of the speed of sound – hence "supersonic". The plane's distinctive drooping nose could be positionally adjusted straight, to achieve optimum aerodynamic efficiency while flying, or downward to give the pilot a non-obstructed view while taxiing, landing and taking off.

Although there was huge interest in *Concorde* at its launch, there were no firm orders on the books other than from the aircraft-developing countries' two state-owned airlines, British Airways and Air France – ostensibly because of perceived problems with its noise, pollution and sonic boom, but also possibly because the US lacked a competitor. Eventually only twenty *Concordes* were built between 1966 and 1979 and of these just sixteen were operational, the other four being prototypes.

Yet despite this, the elegant and slender *Concorde* with its distinctive British Airways livery was a source of national pride and also the transatlantic businessman's aircraft of choice; it was able to make the journey from Heathrow to JFK in New York City in only three hours and 20 minutes. Sadly, the tragic Air France crash in Paris in July 2000 prompted the removal of all *Concordes* from our skies, if not from our hearts – it was quite simply the most beautiful passenger jet ever to fly.

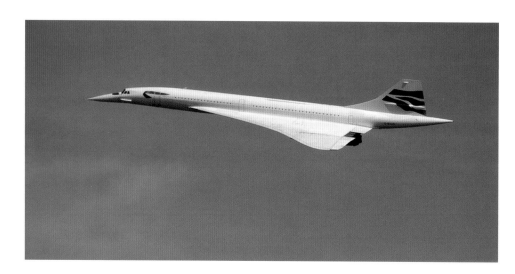

Left: image of *Concorde* in subsonic flight mode, c.2000

British Aircraft Corporation (founded 1960) with
Sud-Aviation (Aérospatiale) (founded 1957/1970)
Concorde supersonic jet, first flight 1969
Various materials
British Aircraft Corporation (BAC), London, England + Sud-
Aviation, Toulouse, France (later Aérospatiale, Paris, France)

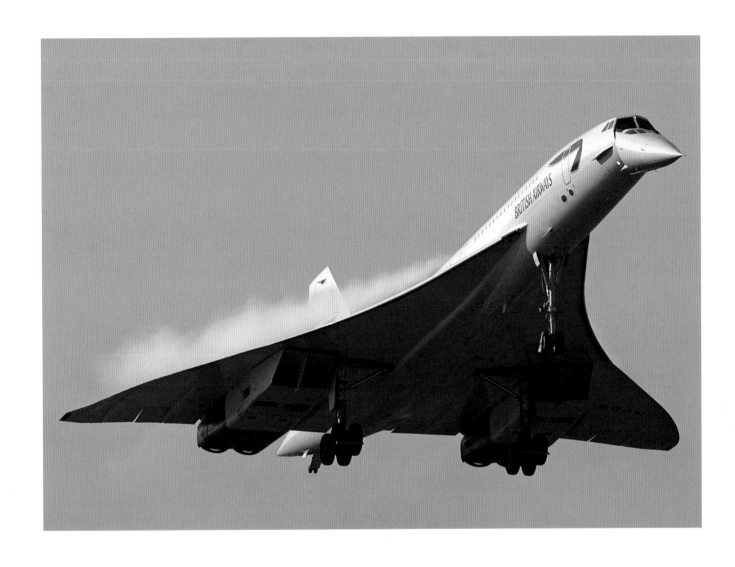

Susan Collier (1938–2011) & Sarah Campbell (1945–)
Bauhaus furnishing textile, 1972

Sisters Susan Collier and Sarah Campbell were responsible for some of the most dazzling textile designs produced in Britain during the 1970s and 1980s. Susan, the elder of the two, was influenced from a very early age by her "lifelong friend, Matisse" through a book of his work that captivated her creatively fertile imagination; but having decided she was no artist herself, she turned to textile design.

Unimpressed with the contemporary textiles on offer at department stores, she set about designing her own fabrics. Though self-taught, she had an eye for colour and composition and her painterly designs were initially used on scarves made by Richard Allen and Jacqmar. In 1961, she approached Liberty's with a portfolio of her colourful designs, promising herself that if they purchased just two of the patterns she would commit herself entirely to a textile-designing career; in the event they bought six and commissioned more. In 1968, she entered a more formal relationship with the department store, which retained her to design, for the most part, fresh floral prints for their range of fine cotton Tana lawns.

Meanwhile Susan's younger sister, Sarah, trained as her assistant and joined her at Liberty's. In 1971, Susan was appointed Liberty's design consultant and in 1972 the sisters, under the name Collier Campbell, designed what became their most famous textile, *Bauhaus*.

The pattern of this screen-printed furnishing textile was closely based on a tapestry executed by the master weaver Gunta Stölzl while teaching at the Dessau Bauhaus in around 1927. The brilliance of Collier Campbell's homage was their masterful ability to, as Susan put it, "cheat the repeat", enlivening the pattern with a brilliantly altered palette of different colours. The brightest of the colourways, with its visual symphony of royal blue, buttercup yellow, verdant green and vibrant red, became *the* British textile of the mid-to-late 1970s; its use of bold, pure colours and its suitably Modernistic ancestry meant that it was in stylistic accord with the industrial aesthetic of the High-Tech style. The textile was also produced in an earth-toned colourway of smoky greys, browns, and purples, which worked equally well in the more restrained Modernist-style interiors of the period.

In 1977 the sisters left Liberty's and set up their own company, where they continued to produce lavishly coloured fabrics under their own brand while also producing designs for Liberty's as well as for Habitat, Yves Saint Laurent, Cacharel, Marks & Spencer and Jaeger. Collier Campbell's vibrant patterns boldly mirrored the shifting decorating styles of the nation, from their Bauhaus-inspired textiles of the 1970s to their Matisse-influenced fabrics of 1980s, and in doing so can be seen as among the most influential and definitively British textile designs of the period.

Above: Alternative muted earth-tone colourway of *Bauhaus* textile

Susan Collier (1938–2011) & **Sarah Campbell** (1945–)
Bauhaus furnishing textile, 1972
Screen-printed cotton
Liberty & Co. Ltd, London, England

Rodney Kinsman (1943–)
Omkstak chair, 1971

The must-have British chair of the 1970s, the *Omkstak* was a robust, stackable model that had an all-steel construction, ensuring that it was light yet strong, not to mention fireproof. Its creator, Rodney Kinsman, trained at the Central School of Art and Design in London, and as soon as he graduated he established his own company, OMK Design, along with partners Jerzy Olejnik and Bryan Morrison. Initially the company concentrated on producing and marketing furniture designs for the domestic retail market, most notably for the newly opened Habitat stores which sold a number of the firm's designs, including the *T range* chair (1966).

In 1971 Kinsman began to create furnishings for the more lucrative contract market – as he himself noted, he found this new sector "more challenging in terms of design and mass production". Although in unfamiliar territory, his first product, the *Omkstak* – a pressed steel stacking chair – was an immediate commercial success, thanks to its striking industrial aesthetic and the array of boldly coloured finishes in which it was available. It was to become an omnipresent feature of 1970s interiors designed in the short-lived High-Tech style.

Just as importantly, the *Omkstak* was extremely strong and durable, and exceptionally functional. Over 25 units could be stacked on a purpose-designed mobile dolly for easy transportation and a linking device was also available, so that it could be used for public seating in, for example, institutional halls.

Kinsman understood that as well as being fashionable, a successful product had to have the right form/function balance so that there was less risk of the design becoming unfashionable later. He saw the designer as a marksman aiming at a target, with the first shot having to be a bull's-eye – a classic. The *Omkstak* would prove to be right on target in terms of sales appeal, and it was even manufactured under license in Italy by Bieffe. The *Omkstak* was included in the 1981 "The Way We Live Now" exhibition at the Victoria and Albert Museum, London. It is a tribute to its functional and aesthetic longevity that this practical steel chair remains in production some 40 years after its introduction and continues to enjoy a remarkable enduring popularity.

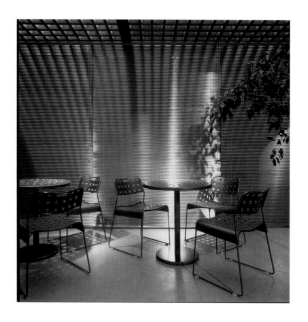

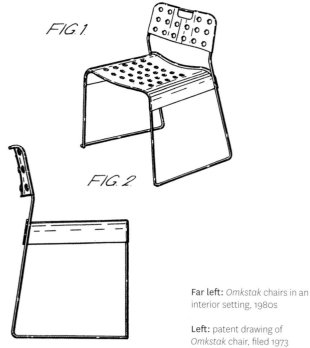

Far left: *Omkstak* chairs in an interior setting, 1980s

Left: patent drawing of *Omkstak* chair, filed 1973

Rodney Kinsman (1943–)
Omkstak chair, 1971
Pressed steel, tubular steel, epoxy coating
OMK Associates Ltd, London, UK

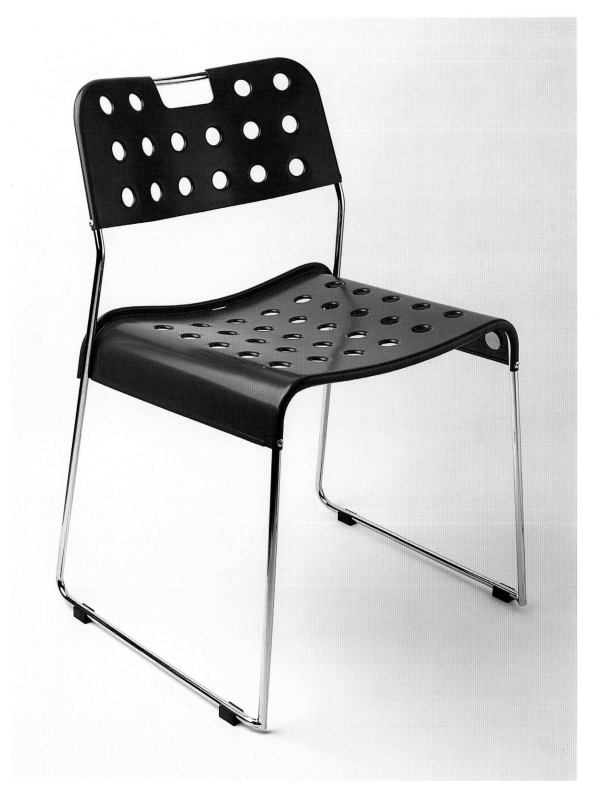

John Pemberton (1948–) & Sinclair Design Team
Sovereign pocket calculator, 1977

The controversial British inventor and entrepreneur Clive Sinclair left school at 17, in order to become a technical journalist. After several years of writing about other people's inventions, in 1957 he established his own consumer electronics manufacturing company.

Initially based in London, Sinclair Radionics Ltd moved to Cambridge five years later, selling its products through mail order advertisements. It was in August 1972 that Sinclair launched his ground-breaking *Sinclair Executive*, the world's first pocket calculator, costing £79.95 – about three weeks' wages for the average British worker. Unlike the bulky and more expensive desktop calculators produced by its larger and more established competitors, Sinclair Radionics's hand-held model was comparatively small and light, with one advertisement describing it as being "as thick as a cigarette packet", which reflected Sinclair's belief that "one must always bear a packet of cigarettes in mind as the ideal size".

The *Executive* calculator owed its miniaturized technology to the company's stirling efforts to develop a better and more energy-efficient type of circuitry, and Sinclair went on to produce other pocket calculators such as the *Cambridge* (1973) which also incorporated this pioneering technology. The *Cambridge* weighed only 99 g and was very

competitively priced at just £29.95. It cost even less (only £24.95) if you purchased it in kit form.

Despite the commercial success of the *Executive* (which earned a £1.8 million profit) and its successors, by 1975 the calculator market had begun to stagnate, and the firm tried to diversify, most notably with its launch of the *Black Watch* – a sleekly styled digital wristwatch.

Sharing this sophisticated aesthetic, the *Sovereign* was launched in 1977 and took its name from the occasion that year of the Queen's Silver Jubilee. This high-end, slimline calculator was created by Sinclair Radionics's in-house design team, under the supervision of John Pemberton. Pemberton went on to win a Design Council Award for the *Sovereign*'s progressive design, with its distinctive satin-chromed finished steel casing (more expensive silver- and gold-plated versions were also produced). But the *Sovereign* was far from the commercial success it was hoped it would be – largely because of the almost simultaneous introduction and subsequent market domination of better-performing LCD calculators. The *Sovereign*'s elegant design with its red LED display, however, marked a new, super-stylish sophistication within the electronics industry, and presaged the slender remote-control units later developed by companies like Bang & Olufsen during the mid-1980s.

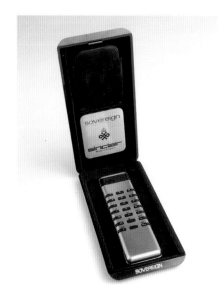

Far left: *Sovereign* calculator in original presentation case

Left: patent drawing of the *Sovereign* calculator, filed in 1977

John Pemberton (1948–) & **Sinclair Design Team**
Sovereign pocket calculator, 1977
Plastic, chrome-plated steel, LED display, other materials
Sinclair Radionics Ltd, Huntingdon, England

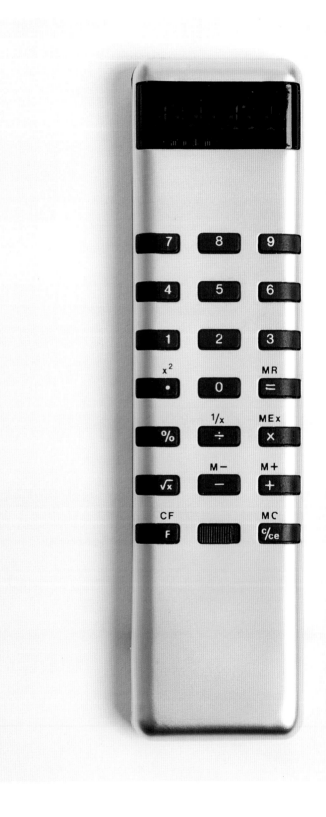

Fred Scott (1942–2001)
Supporto task chair, 1976

The Buckinghamshire-based furniture company Hille was one of the great manufacturing champions of postwar modern design in Britain, producing a number of progressive designs by Robin Day during the 1950s, and following these up with Day's groundbreaking *Polypropylene* chair – or *Polychair* – in the 1960s.

In the mid-1960s Hille began researching new ideas for flexible, open-plan office design. The German Quickborner team of management consultants had introduced a radical new concept known as *Bürolandschaft* (office landscape), and Hille's response to this was its modular *Hille Office System* (HOS) of the early 1970s. In 1979 it launched its more refined and rationalized *HOS/80* system, and in the same year, the *Supporto* task chair was designed by Fred Scott as a complementary product to be used in conjunction with this rigorously researched new system of office desking and partitioning.

Like the *HOS* system, the *Supporto* was designed from a scientific standpoint, informed by the very latest ergonomic data and equipped with a variety of adjustable features that enabled a wide range of human anatomies and postures to be accomodated comfortably.

It was among the first chairs to be designed with these considerations in mind, and went on to become one of the most commercially successful office chairs of the 1970s – a seemingly ubiquitous feature of every architectural office or design studio in the country thanks to its stridently industrial aesthetic which was perfectly in tune with the then-fashionable High-Tech style.

Over 30 years after it was first launched, the *Supporto* is still being manufactured, surely proving that the appeal of this true icon of British design was not fleeting. The chair was, and still is, offered as a low-backed or a high-backed model with arms, and as a narrow-backed armless model. Also available both then and now are armed and armless drafting stools. In 1991, the International Federation of Architects named this award-winning design as "the chair that most influenced modern office seating."

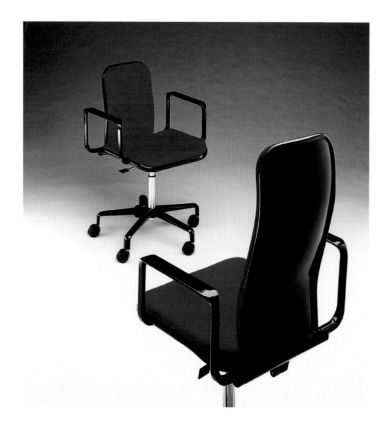

Left: Hille photograph showing both high-back and low-back variations of the *Supporto* chair, c.1979

Fred Scott (1942–2001)
Supporto task chair, 1976
Enamelled aluminium, polyurethane, textile-covered upholstery
Hille International Ltd, High Wycombe, Buckinghamshire,
England (later by Supporto, Bude, Cornwall, England)

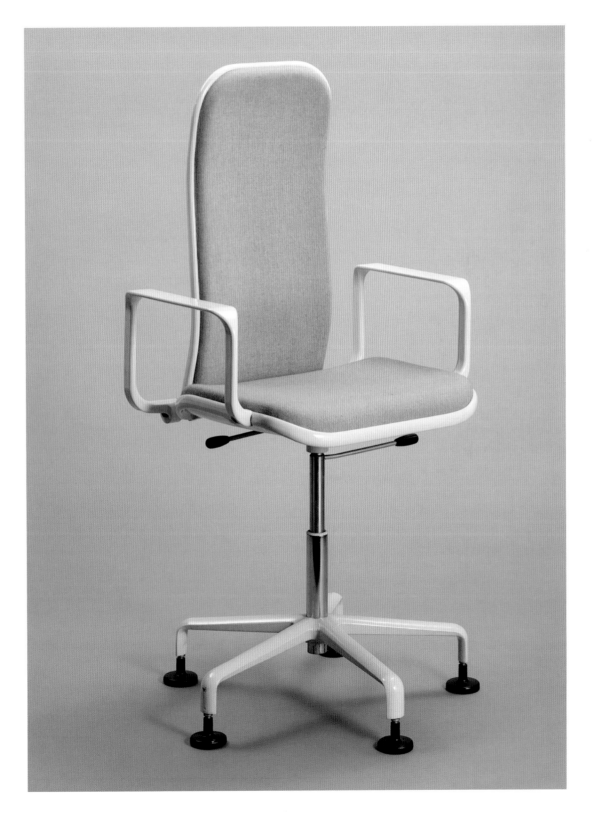

Jamie Reid (1947–)
God save the Queen record sleeve for the Sex Pistols, 1977

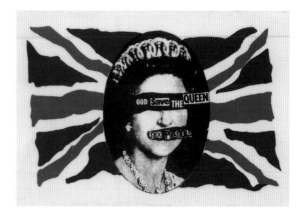

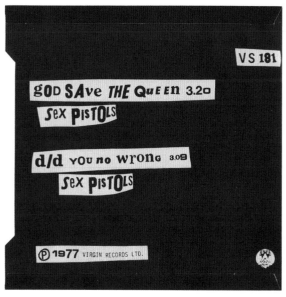

Above: *God Save the Queen* promotional sticker designed by Jamie Reid, 1977

Right: back of *God Save the Queen* record sleeve

The year of Queen Elizabeth II's Silver Jubilee was 1977, and the British nation was decked out in a royalist show of bunting and Union Jacks. Lurking beneath this patriotic outpouring, however, ran a virulent current of anarchic subversion: Punk and its musical personification, the Sex Pistols – a band seemingly intent on destroying the Establishment status quo.

The release in May 1977 of their *God Save the Queen* single – a seditious rendition of the national anthem – was fully intended to cause as much offence as possible both through its hard-hitting lyrics, its discordant tune and its subversive cover sleeve designed for the group by the artist, Jamie Reid. This striking screen-printed image was a blatant defacement of the official Silver Jubilee portrait of Queen Elizabeth taken by the royal photographer, Peter Grugeon. Some regarded this provocative gesture as a form of treason: on the record sleeve, the photographic image was reversed, and over the portrait's eyes and mouth a montage of roughly cut out newsprint was crudely stuck down, effectively gagging and blindfolding the Queen, the embodiment of the Sex Pistols' derided Establishment.

With its ransom-note appearance, this artwork had a menacing yet humorous charm, much like the music it was protecting. The rough-and-ready, do-it-yourself aesthetic of the imagery also perfectly captured Punk's rejection of what they regarded as manufactured, consumer-led "pap" then being churned out by the mainstream music industry.

Although banned by the BBC, this landmark single reached number one in the NME charts in June 1977 and even made the number two spot on the official UK singles chart – and its iconic sleeve design was utterly integral to the single's success. As the Sex Pistols' lead singer, John Lydon (aka Johnny Rotten) explained in the 2000 "rockumentary" *The Filth and The Fury*: "You don't write *God Save The Queen* because you hate the English race, you write a song like that because you love them; and you're fed up with them being mistreated." Jamie Reid's evocative artwork is a hard-hitting visual expression of this sentiment and this is the central reason why it was voted the greatest record sleeve of all time by Q magazine in 2001.

Jamie Reid (1947–)
God save the Queen record sleeve for the Sex Pistols, 1977
Printed card
Virgin Records, London, England

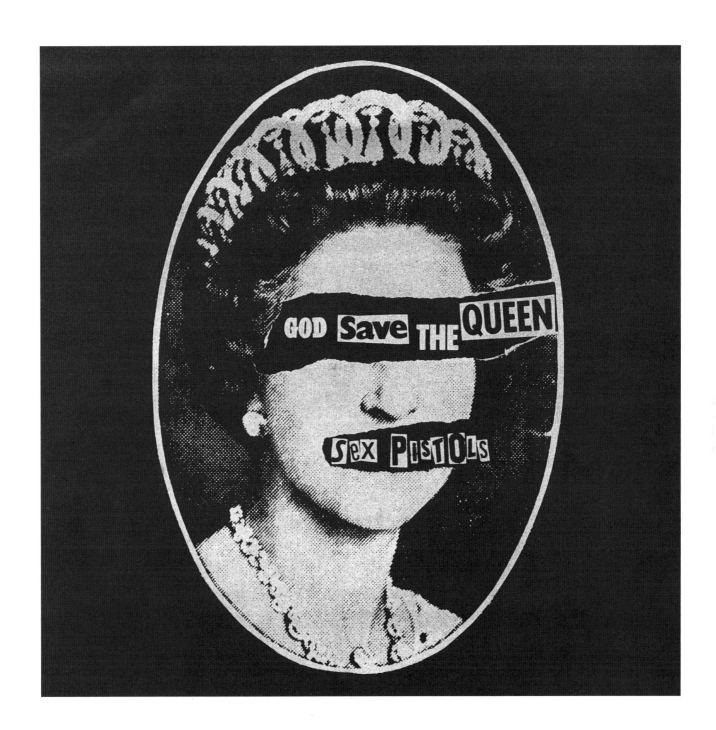

Nick Butler (1942–)
Durabeam flashlight, 1982

As a highly talented designer who believes that "design can make a real difference to how well a product is understood and therefore the efficiency of its usage," Nick Butler's design work is highly considered both in its approach to industrial manufacture, and in its end-user functionality.

After graduating from the Royal College of Art in London, Butler won an IBM scholarship to the United States where he worked under the mentorship of Elliot Noyes, the renowned industrial designer. On his return to England, Butler gained considerable recognition for his innovative yet practical designs for industry and in 1967 he founded his own office, BIB Design Consultants. He was elected Fellow of the Chartered Society of Designers (CDS) in 1975 and the same year he was also appointed a member of the judging panel for the Design Council Awards.

Butler's *Durabeam* flashlight itself won a Design Council Award. It was remarkable for its pioneering flip-top design and the bold simplicity of its layout, which enabled it to be used intuitively. Produced by Duracell, the battery manufacturer, the *Durabeam* used a distinctive combination of plastics for its housing, which were coloured black and yellow in accordance with Duracell's existing brand identity. The design's hinged upper section not only concealed and protected the bulb housing when not in use, but also activated the bulb when flipped open without the need for a conventional on-off switch. Also, unlike the majority of other flashlight designs, the rectangular *Durabeam* did not have to be held in the hand when being used, but could instead be rested on a flat surface and its angle of illumination adjusted for optimum performance, thereby freeing up both hands for the user.

There is unquestionably a very distinctive language of design to be found in many landmark British products which could best be described as "stylish utilitarianism", as reflected powerfully in this humble torch. It is no surprise that during the early 1980s, this landmark flashlight design was sold in the Design Centre's flagship store in London's Haymarket, which was a prominent export-led showcase of British design and innovation. With its simple form and minimalist aesthetic, the *Durabeam* was also a veritable icon of the relatively short-lived "Matt Black" style of the mid-1980s, and like the Zippo lighter – with which it shared its flip-top design – it became one of the must-have accessories of this "designer decade". The fact that *Durabeam* has been selected by New York's Museum of Modern Art as one of its "humble masterpieces" is testimony to the efficacy of Butler's long-held credo: "Making things better through intelligent design."

Below: *Durabeam* flashlight in closed position

Nick Butler (1942–)
Durabeam flashlight, 1982
Polypropylene, ABS, PMMA, metal
Duracell International Inc., Bethel, Connecticut, USA

Alex Moulton (1920–)
AM2 bicycle, 1983

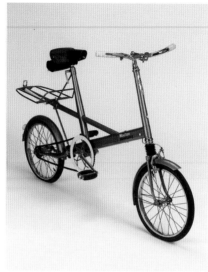

Far left: patent drawing for *Moulton* bicycle, filed 1960

Left: *Moulton Stowaway* bicycle designed by Alex Moulton for Moulton Bicycles Ltd, 1964

Alex Moulton studied mechanical engineering at King's College, Cambridge, and later worked as technical director of the family's rubber manufacturing company, Spencer Moulton, where he researched new methods of bonding rubber to metal which would have a bearing on his later bicycle designs.

In 1956 he founded Moulton Developments and for the next four years worked on developing "a better bicycle system", while at the same time working on an innovative "Hydrolastic" car suspension that would be incorporated into the iconic *Mini*. His first *Moulton* bicycle was launched at the Cycle & Motor Cycle Show in Earl's Court in 1962. It was a small-wheeled design featuring high-pressure tyres and, unusually for a bicycle, a full suspension system. Because it had smaller wheels than the average bike, its centre of gravity was much lower, which increased stability and ultimately made it easier to control and ride at faster speeds. The design of this F-framed mini-bike spectacularly proved its superiority to the classic safety bicycle configuration when in December 1962, John Woodburn broke the Cardiff to London record on a high-performance *Moulton Speed*.

Although Moulton had previously approached world-leaders Raleigh to produce his revolutionary bicycle, they declined and he reluctantly began manufacturing it himself. His new bike went on to win a Design Centre Award in 1964. However, Raleigh was watching the success of the five *Moulton* models

– *Standard, Deluxe, Speed, Stowaway* and *Safari* – and in 1965 launched a competing, though inferior bike: the *RSW16*. Like the *Moulton*, it featured a step-through frame and 16-inch wheels.

Under increasing competitive pressure, Moulton eventually found himself having to sell his company to Raleigh though he was retained by them as a consultant. In 1970, Raleigh introduced the *Moulton MKIII* alongside its own *Chopper*, but four years later this and other *Moulton* models were dropped in favour of the more commercially successful *Chopper*.

Later, Moulton managed to acquire back the rights to his designs and patents, and after continuing with the improvement and refinement of his revolutionary bicycle concept, the *AM Spaceframe* was launched in 1983. While the earlier "classic" *Moulton* had been a mass-market bicycle, this new design was an altogether more upmarket model intended for those who wanted the very best bike that money could buy. Originally released as the *AM2* "town" bicycle and the *AM7* sporting or touring model, it featured unique 17-inch wheels, front and rear suspension, and a super-light "spaceframe" construction.

The hand-built *AM* series marked a high point in bicycle design, manufacture and high performance, albeit with a pretty heavy price tag, and was a supreme demonstration of British engineering excellence at its best – which is probably why it still remains in production today, nearly 30 years later.

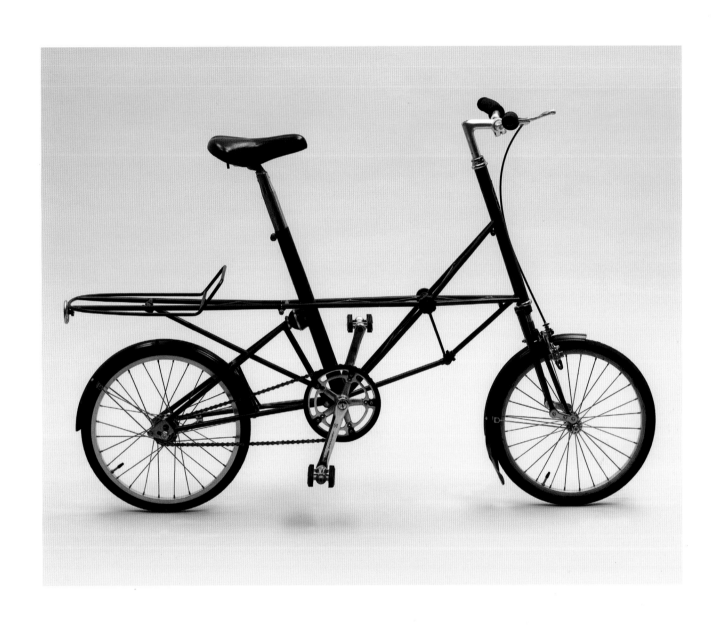

Seymourpowell (founded 1983)
Freeline cordless kettle, 1985

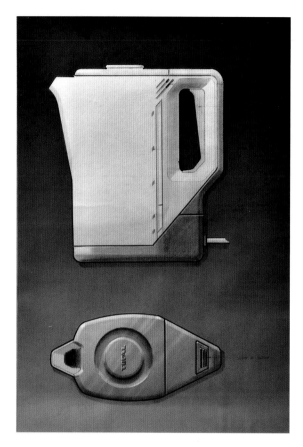

Both Richard Seymour and Dick Powell studied at the Royal College of Art in London, one in graphic and the other in industrial design. Seymour initially worked in the advertising industry while Powell set up as a freelance product designer, but the two teamed up in 1983 and together they established their own Fulham-based design consultancy, Seymourpowell.

Three years later they received widespread recognition for designing the world's very first cordless kettle, the *Freeline*, for the French company, Tefal. This was a paradigm-shifting product which epitomized the firm's hands-on, highly considered, user-centric "Super humanism" approach to design. Seymour's advertising background gave him an understanding of the importance of satisfying the consumer, and this contributed to their shared belief that "Form is function... the appearance of a product should give visual clues as to what it does and how to use it."

The new cordless kettle design reflected this belief, and demonstrated that it was possible to develop new solutions to age-old problems by thinking outside the conventional design box – an approach that typifies Seymour and Powell's design methodology. This was memorably captured when they were the subject of two television series, *Designs On...* (1998), and *Better by Design* (2000). *Better by Design*, which was produced by Channel 4 in association with the Design Council, sought to bring an insight into the design process by taking on six design challenges to improve everyday products. The *Freeline* kettle similarly demonstrated that British innovation was still alive and kicking in the mid-1980s, despite the fact that British manufacturing industries had become a shadow of their former selves.

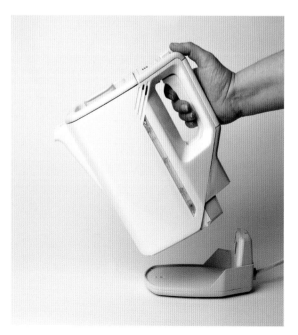

Above left: design drawing of *Freeline* cordless kettle by Dick Powell, 1985

Left: *Freeline* kettle shown removed from base unit

Seymourpowell (founded 1983)
Freeline cordless kettle, 1985
Polypropylene, Kemetal, other materials
Tefal S. A., Rumilly, France

Ron Arad (1951–)
Big Easy Volume II armchair, 1988

Tel Aviv-born Ron Arad studied at the Jerusalem Academy of Art before moving to London in 1973 to complete his studies at the Architectural Association, where he trained under the celebrated architects Peter Cook and Bernard Tschumi. In 1981, he co-founded – with his business partner Caroline Thorman – One-Off Ltd, a Covent Garden-based design studio, workshop and gallery that sold Arad's designs alongside work by other designers.

Kee Klamp scaffolding, salvaged Rover car seats, concrete and other "found" objects went into Arad's early furniture designs, which had a rough-and-ready industrial aesthetic and underlying poetic qualities, all of which were in accord with the post-punk nihilism of London's alternative scene in the 1980s. Later, Arad began exploring the sculptural potential of welded steel and in 1988 he created the *Big Easy* armchair – a cartoonish and abstracted representation of a traditional easy chair, made either from blackened mild steel or mirror-polished stainless steel.

As with so many other designs by Arad, the chair's name is a double entendre: it is a big easy chair (but not really in the traditional sense because it is neither upholstered nor particularly comfortable), but the title also makes reference to the nickname given to New Orleans, and the easy-going, laid-back attitude of the Louisiana city's local residents and jazz musicians.

To construct this chair, Arad would first draw roughly around a template directly onto a sheet of steel, then he and his assistants would cut the pieces out and weld them together to form the three-dimensional design. The piece would lastly be painstakingly polished into its finished form, removing all the welded seams. Significantly, by using this hands-on craft method of serial production, each example was slightly different and therefore absolutely unique.

Arad's series of "volume" chairs, which included the *Big Easy*, demonstrated that even the roughest of materials and most basic of welding methods could be used to create objects with a powerful sense of individualistic artistry, thanks to the use of bold forms and interesting surface treatments. The *Big Easy* was also translated into an upholstered model for the Italian manufacturer Moroso, and later was even produced as a rotationally moulded polyethylene chair. It is, however, the original hand-finished steel *Big Easy* that has become the archetypal "Arad chair", and as such must be considered his masterwork.

Left: mild steel version of the *Big Easy Volume II* armchair, 1988

Alan Fletcher (1931–2006) & Pentagram (founded 1972)
Victoria and Albert Museum logo, 1989

Left: *Palindrome* kinetic object designed by Troika, 2010 – incorporating the 1989 Alan Fletcher and Pentagram "V&A" logo, for the Victoria and Albert Museum, London, England

In 2011, the identity for the Victoria and Albert Museum was voted by readers of *Creative Review* – the inspirational bible of the graphic design and advertising community – one of the top ten logos of all time; in fact it was placed second, just behind Apple. The reason for this is not only its clarity, but also the beautifully crafted composition of the two capital letters joined by a scrolling ampersand.

Alan Fletcher designed this impactful yet graceful mark while he was working at Pentagram on an improved navigation system for the Victoria and Albert Museum, which was intended to help visitors find their way around its cavernous galleries and warren-like corridors. For this signage system, Fletcher devised a directional colour-coding scheme whereby if you were facing north the lettering colour was red, whereas if you were facing south it was blue.

Inspired by a facsimile edition of Giambattista Bodoni's 1798 serif typefaces that had recently been published in the Italian arts journal *FMR*, Fletcher decided to use this historic font as the typeface for the museum's signage. It was an inspired choice and one that was prompted, according to his then assistant Quentin Newark, by his desire to convey the feeling that "the typeface... was something from the collection."

Around the time of this project, the Victoria and Albert Museum's design manager Joe Earle was attempting to bring a visual coherence to the museum's identity and brand, as several different logos were being used at the time. Fletcher suggested that the institution should stop using a host of different typefaces for its various graphic projections and should opt for a single house font. For this he recommended the classical *Bodoni* typeface.

Fletcher and Newark set to work developing a logo for the museum based on its nickname, "the V&A", that also incorporated the eighteenth century typeface, but nothing seemed to quite work. On the morning of their presentation to the museum, Fletcher had a flash of inspiration; he realized that the bracketed serif on the upward sweep of the ampersand could form the crossbar of the letter A. By implementing this simple yet ingenious solution, the new logo was rendered with a satisfying tightness and clarity that conveyed a powerful sense of authority and authenticity – the perfect attributes for a world-class museum.

Described by *Creative Review* as "simple yet devilishly clever," this distinguished logo is a masterful piece of visual communication design that has since become an evocative emblem of the much loved Victoria and Albert Museum, itself established for the promotion of good design in 1852.

Alan Fletcher (1931–2006) & **Pentagram** (founded 1972)
Victoria and Albert Museum logo, 1989
Various applications
Victoria and Albert Museum, London, England

Gordon Murray (1946–) & Peter Stevens (1945–)
McLaren F1 road car, first unveiled 1992

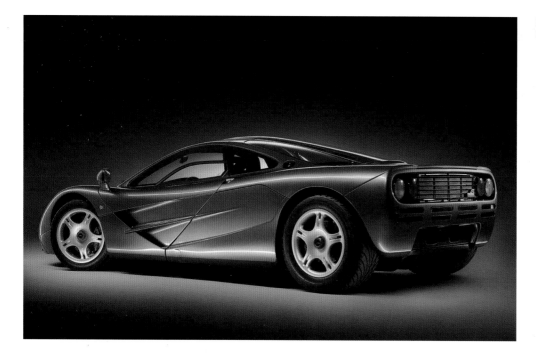

Left: angled rear view of *McLaren F1* road car

Although Britain's motor industry is thriving, the number of British-owned brands has dwindled to a handful yet the country remains at the very epicentre of Formula One research and development. McLaren is the nation's highest-profile constructor in this world of ultra high-performance engineering, as well as being one of the best and most famous Formula One teams in competition.

The company was founded in 1963 and the first 25 years were spent working on the development of superlative racing cars. But in 1988 McLaren decided to expand its remit and to design and build "the finest sports car the world had ever seen." The idea had originally come from the renowned car designer Gordon Murray, who managed to convince McLaren's team principal, Ron Dennis, that it was a viable project. Two years later the team tasked with the development of the company's very first road car came together, with the automotive designer Peter Stevens in charge of its exterior styling. Finally, in 1992, the *McLaren F1* was presented to the world.

It could be said that the DNA of Formula One runs through every cell of this highly seductive, aerodynamically styled car, from its full carbon-fibre monocoque body to its central driving position. It translated the phenomenal power of McLaren racing cars on the track to the street, being the fastest naturally-aspirated production road car ever built, a record that still stands today some 20 years after its introduction.

After calls from *McLaren F1* owners, a racing evolution of this awe-inspiring road car was begun in 1994. Despite having been developed in just three short months, an *F1 GTR* piloted by J. J. Lehto, Yannick Dalmas and Masanori Sekiya went on to win the Le Mans 24 Hour Race the following year – and in so doing made McLaren the only company in racing history to win the Formula One World Championship, the Indianapolis 500 and the Le Mans 24 Hours.

In the words of the legendary Ron Dennis, McLaren's chairman, "The *F1* is a technological tour-de-force and a real triumph in terms of packaging and design. Whether endurance racing or on road, it is supremely fast, agile and yet comfortable. Its styling is enduring and will never fade. I enjoy driving mine more today than ever before because I find its technical purity highly satisfying; the *F1* remains one of McLaren's proudest achievements."

Gordon Murray (1946–) & **Peter Stevens** (1945–)
McLaren F1 road car, first unveiled 1992
Carbon-fibre body, other materials
McLaren Automotive Limited, Woking, Surrey, England

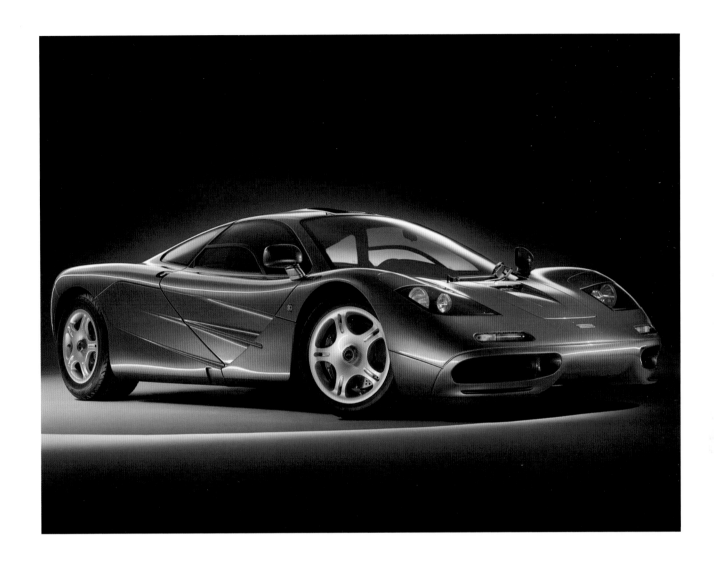

Tom Dixon (1959–)
Jack light, 1994

Rotational moulding was a process used in the manufacture of mundane, mostly hollow industrial objects such as trash containers, water tanks and plastic pallets – until Tom Dixon saw its potential for furniture production.

Throughout his career, Dixon has created innovative products which are functionally inspiring and visually delightful while simultaneously being materials-led solutions, from his earliest scrap-metal assemblages to his latest spun- and cast-metal designs. Very much the hands-on designer, Dixon has produced furniture and lighting concepts that are notable for their forms which are often unconventional and sculptural, and frequently possess a strong elemental quality.

In 1994, he established Eurolounge, a London-based manufacturing company, to produce his and other designers' lighting designs using rotational moulding technology. The firm's first product was his *Jack* light, its form inspired by the pieces used in the traditional game of the same name. It was intended to be a multifunctional object, described at its launch as a "sitting, stacking, lighting thing." With its playful three-dimensional X-shape, which enabled several lights to be stacked to create a tower, its pioneering use of rotational-moulded polyethylene and its single-form construction, it was strong enough to use as an illuminated stool.

The *Jack* light was manufactured in a variety of colours and epitomized its creator's experimental and light-hearted approach to design. This innovative design was one of the first successful so-called "designer" products to exploit the possibilities of both form and function offered by rotational-moulding.

It received widespread acclaim and within just a few years, virtually every leading manufacturer of modern furniture and lighting was exploring the potential of rotationally moulded thermoplastics, with their relatively low tooling and production costs, and impressive structural resilience and durability.

Far left: *Jack* lights in interior setting

Left: stack of *Jack* lights

Rolls-Royce (founded 1906)
Trent 700 turbofan engine, 1995

In 1884 the self-taught engineer Henry Royce founded Royce Limited to produce electric motors and generators, and in 1904 the company manufactured its first car. That same year, Royce met a successful London-based dealer of luxury cars called Charles Rolls, and the pair joined forces in 1906 to found Rolls-Royce Ltd with the aim of producing high-performance engines that could be used "on land or water or in the air." That same year they launched their first car, the *Silver Ghost*, at the Olympia car show; shortly afterwards *Autocar* declared it "the best car in the world."

It was around this time that Rolls met the great aviation pioneers, brothers Orville and Wilbur Wright. He became passionate about the potential of flight, while Royce was less enthusiastic until the First World War intervened. At the behest of the Royal Aircraft Establishment (RAE) located at Farnborough, Hampshire, in 1915 the company began developing its first aero-engines, the *Eagle* and the *Falcon*.

The diversion proved a success, and during the late 1920s Rolls-Royce developed the *R* engine for Britain's entry in the Schneider Trophy seaplane contest. This high-performance design established a new world air speed record of over 400 mph in 1931. It was from this technological base that the celebrated *Merlin* engine was developed, which went on to power both the *Supermarine Spitfire* and the *Hawker Hurricane* during the Second World War. It was Rolls-Royce who also manufactured Frank Whittle's

Welland engine, designed in 1943, which heralded the jet age. Over the succeeding decades, the company continued to refine and develop its aircraft engines, becoming a world-leader in this field of design, engineering and manufacturing.

In 1995, the company launched the *Trent 700*, which marked the birth of a new family of Rolls-Royce engines. Specifically designed for the *Airbus A330*, the *Trent 700* has a unique three-shaft design, meaning it is much easier to maintain than similar aircraft engines because it has fewer "stages". The three-shaft design also gives it a high strength-to-weight ratio and an excellent high thrust capability, as well as the lowest lifetime fuel burn, which ultimately means the lowest environmental impact.

With its precisely engineered fan of rotating titanium blades, the *Trent 700* demonstrates the beauty of pure functional form while also being one of the cleanest and quietest engines of its class – a market-leading masterpiece of British design and engineering excellence. The other members of the *Trent* engine family, designed for use on different aircraft, also use a three-spool design, which means that these engines are shorter and more robust than their competitors' more common two-spool configurations. The impressive sales success of the *Trent* engine family has led Rolls-Royce to become the world's second largest supplier of large turbofan engines for civilian use, while also making it one of Britain's leading manufacturing companies.

Below left: *Trent 700* turbofan engine being manufactured by Rolls-Royce

Below right: Cut-away drawing of *Trent 700* turbofan engine

Jonathan Ive (1967–) & the Apple Design Team
iMac computer, 1998

Undoubtedly the world's most influential industrial designer working today, Jonathan Ive has – through his work for Apple – changed the lives of millions across the globe with his intuitive electronic products that simplify the delivery of advanced communications technology.

Born in London, Ive studied art and design at Newcastle Polytechnic (now Northumbria University) before becoming a partner at Tangerine, a London-based design consultancy, in 1989. One of Tangerine's earliest clients was Apple, working with the design office on the Macintosh *Sketchpad* in 1990 and the *Powerbook* in 1991. On the back of these, Ive moved to join Apple in San Francisco in 1992, becoming Director of Design in 1996.

Working closely with the Apple Design Team and the company's co-founder, Steve Jobs, Ive began to develop a completely revolutionary new computer design that would not only become a game-changer for the fortunes of the then-struggling company, but also for the electronics industry as a whole. At the launch of the first *iMac* in 1998, Steve Jobs enthusiastically introduced this revolutionary

computer enthusiastically as follows: "the whole thing is translucent, you can see into it, it is so cool... this is incredible compared to anything else out there, it looks like it's from another planet, a good planet, a planet with better designers."

For once it was a product that lived up to the hype, and Jobs was absolutely correct in his assertion that Ive's design for the *iMac* marked an important paradigm shift in computer styling, with its seductive, unified gumdrop form. Before the *iMac*, computer housings were essentially boxes made of matt beige or pale grey plastic, both of which were visually dull and often became grubby after just a few months of use. In contrast, the sleek yet friendly *iMac*, with its bright, two-tone colour combination of gleaming opaque and translucent polycarbonate, had a visual freshness that massively distinguished itself from the stale aesthetic of virtually all other personal computers.

The success of the *iMac* not only dramatically rescued the declining fortunes of Apple, but heralded the departure of the computer industry as a whole from the prevailing aesthetic of the dull, lifeless box. Helped by a high-profile advertising campaign, which included the catchy slogan "Chic, not Geek", the *iMac* became the bestselling computer in America, with a then-astonishing 150,000 units being sold over the weekend following its launch. Ive's radical new design had managed to powerfully differentiate Macs from PCs and as people bought into its seductive looks, they subsequently came to appreciate the company's superior user-friendly operating system. Crucially for Apple, once the emotional connection had been forged between an *iMac* and its user, the latter was far more likely to buy other Apple products too. And the delectable *iMac* was just the first of a whole raft of revolutionary new products that Ive, working alongside Jobs, would carefully conceptualize, hone to the last exquisite detail and then bring to market to rapturous acclaim.

Left: overhead view of original *iMac* showing carry-handle component

Jonathan Ive (1967–) & **the Apple Design Team**
iMac computer, 1998
Polycarbonate, other materials
Apple, Inc., Cupertino (CA), USA

Jasper Morrison (1959–)
Air-Chair, 1999

Above: detail of *Air-Chairs* showing the graceful curving line of the back section

Jasper Morrison is one of the leading and most influential designers of his generation. His highly considered products typify many of the attributes that are often associated with the very best of British design – exquisite engineering, thoughtful innovation, practical functionality and a quiet, understated beauty.

His pioneering *Air-Chair* for instance, designed for the Italian manufacturer Magis, is an elegant and highly rational design, produced using state-of-the-art gas moulding technology. Formed entirely of polypropylene strengthened with glass fibres, the chair is made by injecting nitrogen at high pressure during the moulding process, which not only reduces the length of the production cycle but also introduces an internal air cavity so that less material is required.

The fact that it takes just three minutes to manufacture an *Air-Chair* demonstrates not only the impressive efficiency of gas-assisted injection moulding, but also Morrison's exceptional understanding of materials and processes, and his ability to translate them into an innovative product.

Initially, Morrison modelled the chair using CAD software, following which the design was carefully translated into a wooden prototype. As the manufacturer explains, "The mould was designed to be as simple as possible in order to prevent the formation of defects in the form of scratches produced by the movement of the chair within the mould. Much care was taken in the positioning of the impression and the injection and removal points to guarantee a perfect result and to simplify use."

After a year of intensive development Magis began mass-producing the *Air-Chair*, which became an instant critical and commercial success. Inexpensive and virtually indestructible, the *Air-Chair* is a coherent and structurally unified design, which stacks very efficiently and is totally recyclable.

The *Air-Chair* is intended for indoor and outdoor use, and is available in a range of colours – orange, fuchsia pink, sky blue, bright green, olive green, yellow and white. It features a cut-out in the middle of the seat which functions as a hand-hold, making the chair easier to move while also providing drainage for rainwater when it is being used outdoors. Achieving a total design unity through its adoption of a single material and a single form, Morrison's *Air-Chair* is a truly beautiful, durable, affordable and universal design solution – quite simply, it is a masterpiece of process-led, essentialist design.

Mark Farrow (1960–)
Let it Come Down CD packaging for Spiritualized, 2001

One of the most influential and talented graphic designers working anywhere in the world, Mark Farrow has a London-based studio that mainly specializes in packaging for the music industry and corporate identity work. Often, Farrow uses a purely typographic treatment, yet at other times he will explore a solely photographic means to fulfill a brief. The results are, however, almost always the same: an impactful graphic solution that has a precise, almost crystalline, visual clarity.

The first album designed by Farrow for Spiritualized, *Ladies and gentlemen we are floating in space* (1997), used a special-edition blister-pack pill package instead of a conventional CD jewel case. This unusual graphic and material treatment was inspired by Farrow's first meeting with Jason Pierce of Spiritualized (aka J.Spaceman), who had noted that "music is medication for the soul."

After the critical success of this first album both in terms of its musical content and for its outward appearance, Pierce asked BMG to ascertain that Farrow would be the designer of his next album and that a sufficient packaging design budget should be available to do something equally – if not more – interesting. For the sleeve design of this new album, *Let It Come Down* (2001), Farrow wanted to push vacuum-forming technology – used for the 1997 blister-pack case – to its limit and "do something completely different". Farrow's solution was to meld this plastic-moulding technique with the work of sculptor Don Brown. Farrow had seen Brown's exhibition of pure white plaster portrait sculptures of his wife Yoko at the Sadie Coles HQ gallery in the

autumn of 2000, where one of the artworks on show was a highly stylized bust. Farrow and Brown worked together to translate this portrait of Yoko into a vacuum-formed plastic case.

The decision to create a bas-relief of Yoko's face for the packaging had been prompted by Pierce, who had been reading about how the brain psychologically processes an image of a face; as he later recalled, "I got interested in the idea that when you see an image of a face that is concave, your brain is so used to seeing eyes and noses that stick out that it finds it impossible to read". The resulting CD protective cover was not only sublimely beautiful, but it also had a very precious quality that set it completely apart from anything that had gone before.

Sitting somewhere between graphic design and product design, this solution took packaging to a brand new aesthetic level and in so doing emphasized the innate value of the materials used, while also conveying the essence of the music it was protecting.

Far left: limited edition packaging for *Ladies and gentlemen we are floating in space* for Spiritualized, 1997

Left above and below: related single sleeves for Spiritualized, 2001

Mark Farrow (1960–)
Let it Come Down CD packaging for Spiritualized, 2001
Vacuum-formed plastic
BMG Records, London, England

Jonathan Ive (1967–) & the Apple Design Team
iPod, 2001

The first music-on-the-go product was Sony's cassette-playing *Walkman*, introduced in 1979. The next 20 years saw various platform changes and when digital music players appeared, from companies such as Creative, Sonic Blue and Sony, they were either big and chunky or small but useless; none had an effective user-friendly interface and they were often just plain frustrating to operate.

So it wasn't altogether surprising when Jonathan Ive and the Apple Design Team, having already transformed the desktop computer into the irresistably stylish *iMac* in 1998, turned their attention to the design and development of a better digital music player. Steve Jobs, whose idea it had been, presented the resulting small but beautifully formed white *iPod* on 23 October 2001. This ultra-portable, pocket-sized MP3 music player delivered CD-quality music and held a then almost unimaginable 1,000 songs, which was quite rightly described by Jobs as a "quantum leap". For most people, this number of songs constituted their entire music library. As Jobs enthusiastically observed at the *iPod*'s launch, "This is huge, how many times have you gone on the road with a CD player and said 'Oh God, I didn't bring the CD I wanted to listen to?' To have your whole music library with you at all times is a quantum leap in listening to music... your entire music library fits in your pocket."

This highly portable device had built-in FireWire for fast downloading, and an ultra-thin hard drive with a five-gigabyte capacity. That may sound minimal now, but at the time it was astonishing in comparison to other devices on the market. Not only was the *iPod* technologically advanced, but it was also wrapped in the most beautiful ergonomically attuned form, and possessed an intuitive user interface. Ive and his colleagues designed a mechanical scroll wheel with four navigational buttons that made the delivery of music completely effortless.

For many people this first generation *iPod* was their first encounter with an Apple product, and thanks to the clarity of its layout, its unassailable technological logic, purist aesthetic and tactile qualities, they connected with it emotionally and went on to "buy into" other Apple products.

Although the *iPod* is an iconic Apple design that expanded the technological capacity of the music-carrying device, there is a very British aesthetic within its overall form. It has a certain refinement, a definable functional elegance that was quite different from the chunky masculine aesthetic that so often identified American design. And it is undoubtedly Jonathan Ive's design sensibility that has infused this remarkably cutting-edge product with such an engagingly beautiful yet purposeful and functional form.

Left: Apple unveiled its new portable music player, the *iPod* MP3 music player on 23 October 2001 at an event in Cupertino, California. The device, seen here connected to a laptop could hold up to 1,000 songs in digital form.

Jonathan Ive (1967–) & **the Apple Design Team**
iPod, 2001
Polycarbonate, stainless steel, other materials
Apple Inc., Cupertino (CA), USA

Ross Lovegrove (1958–)
Water bottle, 1999–2001

Ross Lovegrove creates visually and functionally compelling forms that push the utmost boundaries of materials and technologies and he is a world leader in his field. He has described his role as being "a twenty-first century translator of technology into products that we use every day and relate beautifully and naturally with."

Lovegrove certainly possesses not only an in-depth and innate understanding of materials and process, but also a remarkable eye that allows him to create objects with a sublime aesthetic integrity. These useful observational skills were honed, he says, as a beach-combing child in his native Wales, and together with a deep love of the forms and processes found in the natural world, they directly inform his work.

Perhaps the best example of this is the water bottle he designed for the Welsh company, Ty Nant. The form of the bottle was inspired by Lovegrove's careful analysis of how water flows, and represents his attempt at capturing its essence: purity, fluidity and grace. From a few quick sketches taken from his notebook, the bottle was then three-dimensionally modelled on computer, and the resulting data used to

make a solid model milled from a block of acrylic.

At first there was a concern that the design might be impossible to produce because of its highly unusual asymmetrical form, but after months of development it was finally put into mass production. Lovegrove recalls that when the first bottle was received from the manufacturer, "it felt like nothing... [but] when I put water into it, I realized I'd put a skin on water itself."

Although the Ty Nant bottle is made of blow-moulded PET – exactly the same material that is used for other drinks bottles – Lovegrove's design exploits the material's plasticity when heated, to create an intelligent form that expresses the preciousness of water, and emphasizes its remarkable optical qualities. The Ty Nant bottle fits comfortably in the hand thanks to his understanding of ergonomics, and possesses a sculptural elegance that sets it apart from similar products. This inventive design demonstrates that even packaging can be given a sculptural and ergonomically refined form that is at the same time pleasurable to hold and to look at, while also emphasizing the utter preciousness of its contents.

Far left: milled stainless steel moulds used to mass-produce the Ty Nant bottle, 2001

Left: preliminary sketch of the Ty Nant bottle by Ross Lovegrove showing the flow of water, c.1999

Ross Lovegrove (1958–)
Water bottle, 1999–2001
Polyethylene terephthalate (PET)
Ty Nant Spring Water, Llanon, Ceredigion, Wales

James Dyson (1947–)
Airblade™ hand dryer, 2004–06

Having revolutionized the vacuum cleaner through the use of the cyclonic method of suction, James Dyson turned his attention to the washroom hand dryer, whose technology hadn't really changed over 60 years.

The traditional electric hand dryer blows heated air onto the user's wet hands, causing the moisture to evaporate. This method of drying, however, is frustratingly time-consuming and often people just give up, little realizing that still-damp hands are a thousand times more likely to attract and spread germs. To make matters worse, the bacteria-laden air blown out from a wall-mounted drier is swirled around a washroom and onto people and their clothes.

Over thousands of design hours, Dyson and his team painstakingly developed a totally innovative hand-drier that creates a high-speed sheet or "blade" of unheated air, which gently "squeegees" the hands completely dry in just 10 seconds. A powerful motor channels the air downwards at 400 mph through a 0.3mm gap into an ergonomic plastic trough-like receptacle. The user places his or her hands inside, without having to touch its sides or any operating button.

Importantly, a HEPA (High-Efficiency Particulate Air) filter, built into the dryer, then captures 99.9 percent of the bacteria from the air once the user's hands are dry, instead of circulating the bugs into the atmosphere like a conventional model would. The Dyson design is also a lot less costly than either warm-air hand dryers or paper towels, saving running costs of up to 80 percent and 97 percent respectively. The result is a much more efficient, effective and quite simply cleaner way to dry hands, and the Dyson dryer has received positive assessments from the medical technology academic establishment for its role in the fight against the spread of infections.

Throughout his career, Dyson has adopted a design methodology that is built on innovative thinking and an untiring commitment to trial-and-error research and development, which has often led to some spectacular results. With the introduction of the *Airblade™* he demonstrated that the efficacy of this approach was not just confined to the design of vacuum cleaners, but could be applied to other real-world problems in need of better design solutions.

Far left: computer-generated image showing the *Airblade™* hand dryer in use

Left: cut-away diagram of *Airblade™* hand dryer showing internal workings

James Dyson (1947–)
Airblade™ hand dryer, 2004–06
Polycarbonate, ABS, other materials
Dyson Ltd, Malmesbury, Wiltshire, England

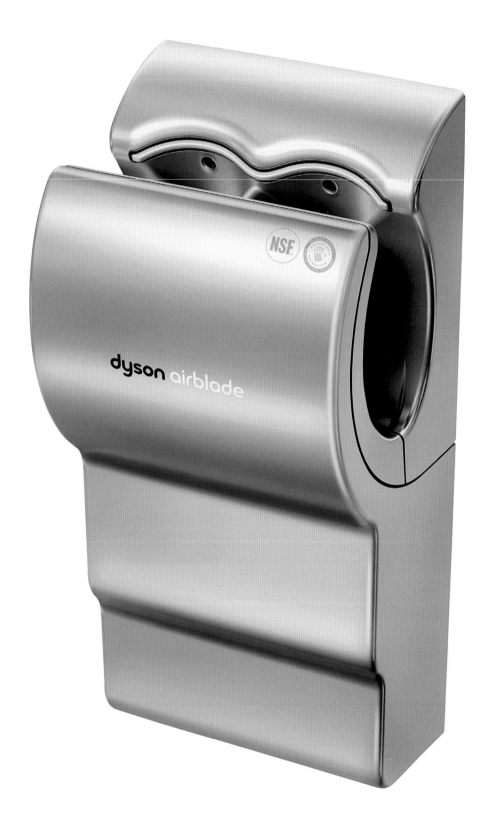

James Dyson (1947–)
DC15 vacuum cleaner, 2005

James Dyson is one of the greatest proponents of British design and engineering innovation, and has demonstrated that the dogged persistence of good design can eventually reap considerable rewards.

Having trained in furniture and interior design at the Royal College of Art, Dyson briefly worked as a designer in the marine division of Rotork, before leaving to develop his first invention, the *Barrowball*, which innovatively incorporated a ball instead of a wheel to assist its manoeuvrability. Although this improved barrow design was a huge commercial success, Dyson did not financially gain much from its sales, having previously sold his interest in it to fund his development of a bag-less vacuum cleaner.

Although Dyson first came up with the concept of a bag-less vacuum cleaner in 1978, it took from 1979 to 1984 to develop the design, and over 5,127 prototypes. The resulting revolutionary vacuum cleaner used centrifugal force to lift the dust and then separate it from the air, just like the much-larger cyclone towers used in sawmills and spray-paint shops to remove hazardous particles from the atmosphere. The Dyson cleaner used a cyclonic method of suction and therefore eliminated the need for a bag. In conventional vacuum cleaners with bags, the bag gets clogged with dirt and dust over time, which has the effect of reducing suction. The Dyson therefore had the added benefit of a contant high level of suction.

In 1986, the first production model of Dyson's bag-less vacuum cleaner was made and sold under licence in Japan. Known as the *G Force*, this early design was made in a combination of pink and lilac ABS plastic, presumably to attract the female consumer. However, Dyson found it impossible to find a UK manufacturer for his design, primarily because the sale of bags was just too lucrative to abandon. Eventually he concluded that the only way to penetrate the UK market was to manufacture the design himself, and after several refinements, the distinctive silver-grey and yellow *DC01* was finally launched in 1993. Unsurprisingly, less than two years after its launch the *DC01* had become the UK's best-selling vacuum cleaner despite its premium price.

Since then Dyson has implemented a rigorous and scientific approach to innovation that has led to numerous improvements to his vacuum cleaner. One of the most interesting of these was the addition of a ball mechanism, which harked back to his earlier *Barrowball* invention, and which also contained the motor. First fitted to the *DC15* model vacuum cleaner, the ball innovation provides dramatically increased manoeuvrability and thereby allows even better functional performance. As Dyson notes, "Our machines evolve as part of a holistic design process... there is no extraneous window-dressing, purpose prevails."

Far left: design drawing of *DC15* vacuum cleaner

Left: image of *DC15* vacuum cleaner showing articulation around ball mecahanism

James Dyson (1947–)
DC15 vacuum cleaner, 2005
ABS, PMMA, various materials
Dyson Ltd, Malmesbury, Wiltshire, England

Edward Barber (1969–) & Jay Osgerby (1969–)
De La Warr chair, 2005

Edward Barber and Jay Osgerby may today be internationally acclaimed for their design of the 2012 Olympic torch, but they first came to prominence with a design for a seaside chair.

The pair completed the postgraduate MA architecture programme at The Royal College of Art in London, and founded their own design studio in 1996. Their first notable design was the moulded plywood *Loop* table (1997) for Isokon, which like their later work was to reveal the strong influence of British Modernism from the 1930s. This was followed by a number of projects that involved the folding and shaping of sheet material, such as plywood and Perspex, which were inspired by the use of stiff card in architectural model making.

In 2005, the duo won a competition to design a chair for the newly renovated De La Warr Pavilion at Bexhill-On-Sea – a Modernist architectural masterpiece designed in 1935 by Erich Mendelsohn and Serge Chermayeff, overlooking the Sussex coastline. The resulting site-specific design, known as the *De La Warr* chair, has a fluid yet Modernistic form which was intended to contrast with the severe and uncompromising rectilinearity of the Art Deco building. An interesting feature of the design is its distinctive skid back leg, which was a response to the pair's observation that most chairs are mainly seen from the back, yet all too often designers do not overly concern themselves with the look of a chair's rear elevation.

The chair's Y-shaped frame is made of high-pressure, die-cast aluminium, while the continuous L-shaped elements that make up the front legs and arms are constructed of tubular steel and the seat and back sections are shaped from pressed special-ductile-grade aluminium. The punched holes in the seat and back not only allow rain drainage when the chair is being used outside, but also reduce the physical weight of the chair, as well as helping to lower wind-drag – this last being a fundamental consideration for seating destined to be used on the sweeping and exposed terraces of a British seaside pavilion.

Barber and Osgerby seem to be uniquely able to capture a very powerful sense of Britishness within their visually striking yet also rather understated designs, which possess a highly refined aesthetic and functional sensibility, as well as a slight tinge of nostalgia – contemporary modern designs for a contemporary modern Britain, that look back to the past with a certain sense of pride.

Below: components of the *De La Warr* chair in unassembled state

Right: *De La Warr* chairs in use on the terraces of the De La Warr Pavilion, Bexhill-on-Sea, 2005

Edward Barber (1969–) & **Jay Osgerby** (1969–)
De La Warr chair, 2005
Powder-coated aluminium, tubular steel (optional seat cushion)
Established & Sons, London, England

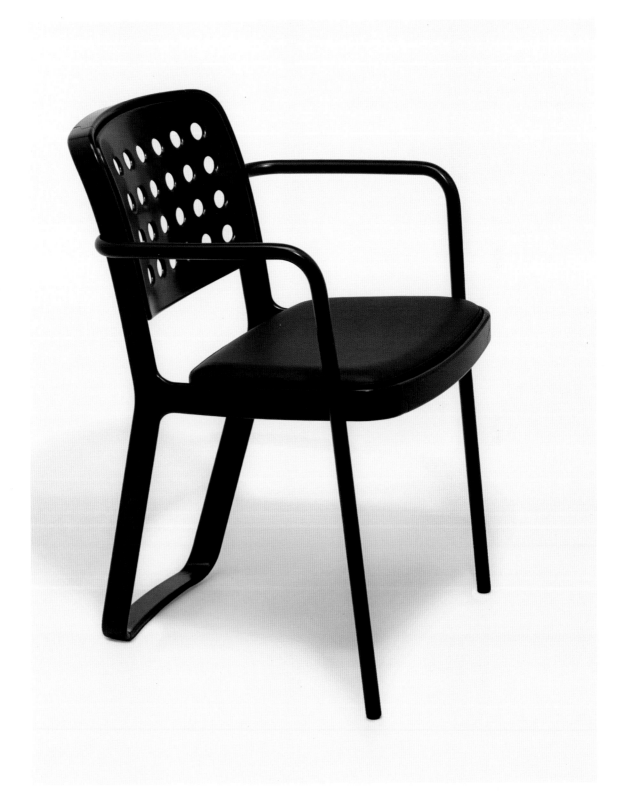

Tom Dixon (1959–)
Copper Shade hanging light, 2005

Above: clustered group of
Copper Shade hanging lights

Tom Dixon is one of Britain's most influential and enlightened contemporary designers, whose work continually surprises and delights. From being a leading *enfant terrible* of the 1980s Creative Salvage movement, Dixon has matured into a highly accomplished form-giver as well as a successful designer/maker. His more recent work has a strong elemental and sculptural quality, reminiscent of the earlier designs of Tapio Wirkkala, Robert Welch and Verner Panton; these are products with an inherent functional "rightness", as well as a refined aesthetic that expresses the innate qualities of the materials being used.

His *Copper Shade* pendant light is probably the most technically interesting as well as one of his most commercially successful designs. It uses a clear polycarbonate shade, to the interior of which is applied a thin layer of pure copper metal using a special vacuum-metallization process. This method involves vaporizing the pure metal at a very high temperature, and then getting it to attach itself permanently onto the polycarbonate surface by applying an electrical charge. This technique, also known as PVD (physical vapour deposition), is most commonly associated with the manufacture of solar cells, but Dixon has used it to make this lightweight, spherical diffuser which emits a wonderfully warm metallic glow.

He has also created a floor variant of the light, and another with a bronze-copper finish. A classic Tom Dixon design, the *Copper Shade* is seen on its own or grouped in clusters and has become a familiar feature of high-concept interior installations. Dixon's Design Research Studio, which was established in 2002, not only works on the development of furniture, lighting and accessories but is also known for complete design commissions. Since its foundation it has become widely acknowledged for its ingenious use of materials, and its ability to express a very British sense of eccentricity.

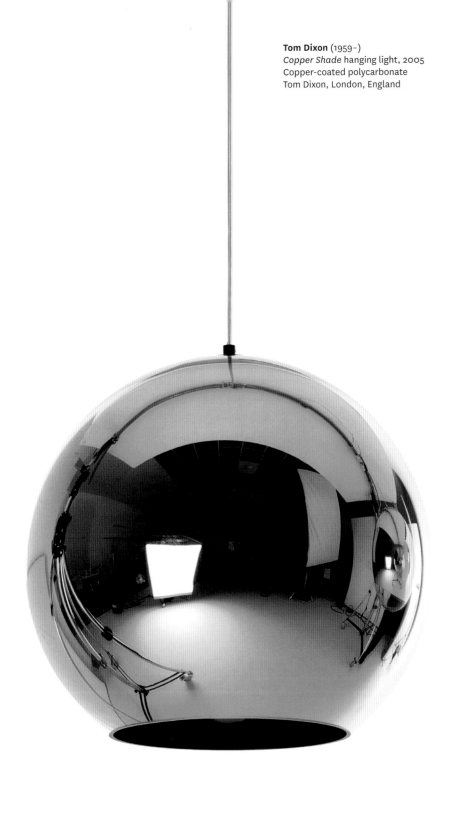

Tom Dixon (1959–)
Copper Shade hanging light, 2005
Copper-coated polycarbonate
Tom Dixon, London, England

Orla Kiely (1964–)
Multi Stem textile, 2007

The introduction of her iconic *Multi Stem* textile in 2007 brought Irish-born Orla Kiely widespread recognition. There is something so innately appealing about this repeating pattern of multi-coloured leaves in muted hues. It has a reassuringly childlike innocence and a retro "what-modern-was" quality that is a perfect counter to the vulgarity of bling culture, and is an appropriate companion for a difficult economic environment.

Kiely studied textile design at the National College of Art and Design in Dublin and worked briefly in New York. She later moved to London to work for the fashion manufacturer Esprit, while at the same time taking an MA at the Royal College of Art, graduating in 1993. She designed a range of hats for Harrods and worked as a consultant for Marks & Spencer, while also making handbags of her own design in her spare time. In 1997 she was asked by the department store Debenhams to develop a "capsule collection" – a set of fashion items that, when used together in different combinations, can produce about 20 different outfits – and this led to the formation of her own company with her husband and business partner, Dermot Rowan.

Inspired by textile designs from the 1950s, 60s and 70s, Kiely's colourful patterns, with their bold, engagingly cheerful and airy aesthetic, were an instant hit at home and abroad and were originally used as the basis for various fashion garments and accessories. In 2004, she launched her first homewares collection, which proved to be similarly popular, and in 2005 she began producing her first wallpapers.

It was, however, *Multi Stem* that really made her a household name. The design has been applied to literally hundreds of items ranging from bags and umbrellas to stationery, furnishings and even a digital radio. Like *Multi Stem*, Kiely's later *Striped Petal* textile and wallpaper pattern has a contemporary-retro quality, while its abstraction of flower motifs reflects a typically British love of bold floral patterns – from antique chintzes and Morris textiles to Liberty's Art Nouveau prints and Lucienne Day's postwar barkcloth designs.

Left: *Striped Petal* pattern for textile and wallpaper designed by Orla Kiely, 2008

Orla Kiely (1964–)
Multi Stem textile, 2007
Printed cotton
Orla Kiely, London, England

Jonathan Ive (1967–) & the Apple Design Team
iPhone, 2007

It was while he was conceptualizing a touch-screen computer monitor that Apple's visionary CEO Steve Jobs was struck by an even better idea. His original ideas was that without a mouse and a keyboard, the experience of using a computer could be made much more intuitive. When he saw the prototype created by Apple's R&D engineers, he realized that the technology might also be used to revolutionize mobile phones.

"Project Purple 2" was set in motion in 2005 and two years later, after months of rumours and speculation, the first generation *iPhone* was introduced to the world – a product that completely and utterly changed the landscape of mobile communications.

The design had been developed secretly in collaboration with Cingular Wireless (later to become AT&T Mobility), who were happy to allow Apple to develop the device's hardware and software in-house. As Jobs audaciously, yet so correctly, announced at the *iPhone*'s launch at the 2007 Macworld Conference & Expo held in San Francisco, Apple had quite simply reinvented the telephone.

Essentially, the *iPhone* brought together three different devices into a single, beautifully designed, slimline package. These were a widescreen music-playing and music-storing *iPod*, a technologically advanced mobile phone with camera function, and an Internet-accessing, web-browsing communicator. This was indeed an exceptionally smart smartphone, yet it was also very easy to use thanks to Jonathan Ive's sensitive ergonomic handling of the device's layout and his extraordinary attention to its precise and purposeful detailing. Enthusiastic consumers felt that they had a precious piece of the future in their hands, yet this first *iPhone* with its 3.5 inch multi-touch screen display and chrome-plated metal frame was not scarily difficult to understand; rather it invited playful interaction and discovery.

Despite a few minor glitches, it was named "Invention of the Year" by *Time* magazine in 2007 and over six million units were sold before it was superseded by the second-generation *iPhone* the following year. Thanks to the combination of Job's vision and Ive's design genius, the *iPhone* marked a beautiful and epoch-changing breakthrough in the development of mobile computing.

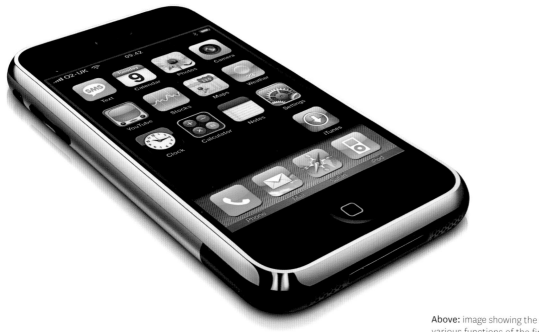

Above: image showing the various functions of the first-generation *iPhone*

Jonathan Ive (1967–) & **the Apple Design Team**
iPhone, 2007
Chromed metal, aluminium, glass, plastic, other materials
Apple Inc, Cupertino, California, USA

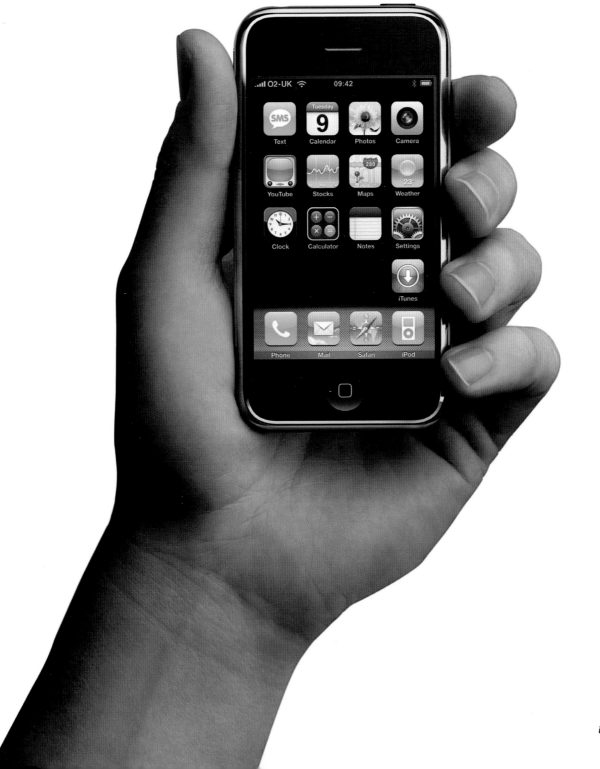

Ross Lovegrove (1958–)
Muon loudspeakers, 2007

A visionary creator whose work is informed by a remarkable and intuitive understanding of ergonomics, Ross Lovegrove has throughout his career pushed the aesthetic and technological limits of design to create products that pull the future into the present.

Among his most aesthetically refined and technically interesting products is the totemic *Muon* loudspeaker which he designed for KEF, the Maidstone–based company renowned for the superlative acoustic quality of its loudspeaker technology (as any serious audiophile would know).

In order to create the best speakers ever produced, Lovegrove approached the brief as "learning from the niche and applying higher aesthetics". By this he meant that he took on board the acoustic engineering constraints as they were determined by KEF's sound engineers and applied them to his own organic, essentialist approach to design, which he has carefully honed over the course of his career as a truly world-class industrial designer.

He initially came up with four different design solutions, but it was unanimously decided that the "monolith" option should be the one to undergo further development. The first prototype was essentially a rough mock-up by KEF's engineers to show the optimum positions for the four-way system of loudspeakers. Lovegrove and his studio then began to digitally "sandpaper" the prototypical 3D computer-generated model, creating planes that allowed the sound to move away from the embedded loudspeakers in order to "enhance both the performance and the intelligence of the technology" – in effect the design team were sculpting the sound by skinning the technology with purposeful form.

Ultimately, the final shape was created through an evolutionary process that ensured "it could only be the form it is". The large sculptural housing, measuring a towering two metres in height, was then fabricated in superformed aluminium – a vacuum-forming process of moulding, which uses malleable sheets of heated aluminium. The resulting *Muon* speaker design is the most extraordinary synergy of sound-engineering and cutting-edge design. Rarely in the world of product design does one find such a sublime marriage of form, function and manufacturing integrity – a remarkable achievement by a great British designer working with a great British manufacturing company.

Left: three-dimensional computer analysis of the *Muon* form by the Lovegrove Studio

Ross Lovegrove (1958–)
Muon loudspeakers, 2007
Superformed aluminium and other materials
KEF (GP Acoustics (UK) Ltd), Maidstone, Kent, England

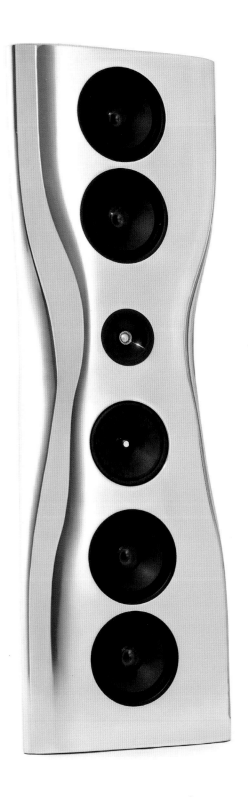

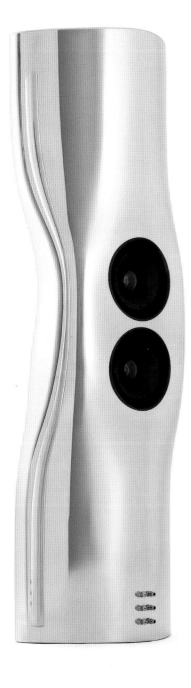

James Dyson (1947–)
Air Multiplier™ AM01 desk fan, 2009

It is probably no exaggeration to describe James Dyson as a genuine saviour of British industrial design and engineering. With his innovative thinking, and dogged determination to find solutions to sticky design problems, Dyson has been a massive inspiration to an entire generation of designers, engineers and would-be entrepreneurs. His tireless efforts to get across the message that "good design" is important have carried enormous weight because he has so evidently and successfully put theory into practice.

Having revolutionized the vacuum cleaner and the hand dryer, in 2009 Dyson transformed the conventional electric fan into a pioneering bladeless model that is better looking and more functionally efficient than any comparable product on the market. Speaking at its launch, Dyson said "I've always been disappointed by fans. Their spinning blades chop up the airflow, causing annoying buffeting. They're hard to clean. And children always want to poke their fingers through the grille. So we've developed a new type of fan that doesn't use blades." Instead, the *Air Multiplier™* uses a patented technology to amplify airflow up to 15 times, which allows an impressive 405 litres of cooling air to be expelled every second.

The air is accelerated through "an annular aperture set within the loop amplifier" to create a constant jet of air which then induces more air to be drawn into the airflow. The accelerated air then passes over a ramp-like element which channels the buffet-less airflow. The *Air Multiplier™* is less noisy than traditional bladed electric fans, and easier to adjust with its dimmer-type control as opposed to a conventional two or three-speed switch or dial. A touch-tilt mechanism allows effortless positioning adjustments. Because it doesn't have blades or a grille, it is also much safer and easier to clean.

This remarkably improved design with its strong and resilient ABS housing was the result of a long and painstaking programme of research and development that saw Dyson's fluid dynamic engineers run literally hundreds of simulations to precisely measure and map the airflow, and this data assisted their design-engineering colleagues to devise a fan that would provide the optimum results. Robustly built like all other Dyson appliances, the *AM01* is yet another example of how the application of British design and engineering ingenuity can lead to beautiful and often astonishing world-beating products.

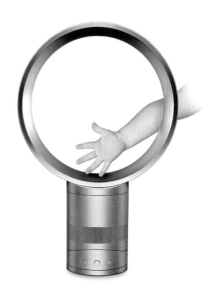

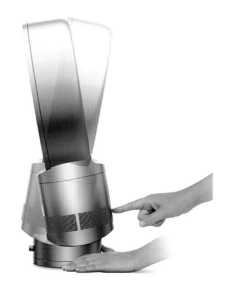

Left: Images showing the bladeless design of the *AM01* desk fan and its tilt mechanism for angling air-flow

James Dyson (1947–)
Air Multiplier™ AM01 desk fan, 2009
ABS, other materials
Dyson Ltd, Malmesbury, Wiltshire, England

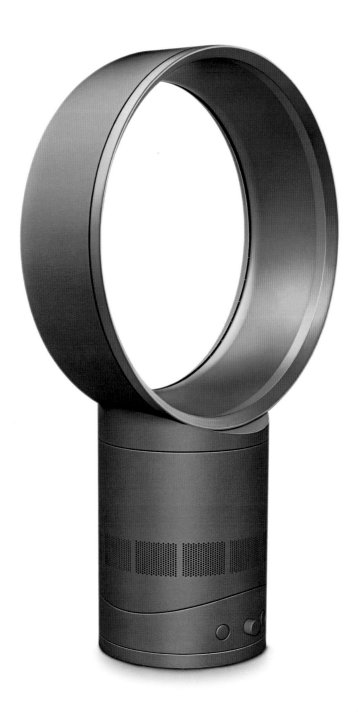

PearsonLloyd (founded 1997)
PARCS office furniture range, 2009

As the world's greatest postgraduate art and design teaching institution, the Royal College of Art and its illustrious alumni have been absolutely central to London remaining the design capital of the world, even if British manufacturing has itself declined over the decades. Importantly, the RCA has managed to inculcate into its design students a very British approach to problem-solving, which is based on a sound understanding of materials and processes as well as individual creative flair.

The founders of PearsonLloyd – one of Britain's most interesting industrial design consultancies – are both RCA graduates, and their work eloquently embodies this approach. Luke Pearson and Tom Lloyd studied furniture design and industrial design respectively, and after graduating Pearson worked as a senior designer in Ross Lovegrove's studio, while Lloyd joined the design consultancy Pentagram.

Using this valuable professional experience, the duo set up their own design office in 1997 and have since worked for an impressive international roster of clients, winning over 70 design awards for their extremely refined and purposeful work – from mobile office equipment for Knoll, to aircraft seating for Virgin Atlantic and Lufthansa. One of their main areas in which they specialize is the development of public seating and office furniture, and their in-depth understanding of the challenges posed by these means they can find ready solutions that function well and make these spaces much more pleasurable to be in.

One of their most recent projects in this field was developed in conjunction with the Austrian furniture manufacturer, Bene, and involves a pioneering collection of workplace furniture which addresses the rapidly changing landscape of today's offices. The *PARCS* range is a curious hybrid between architecture and furniture, and reflects the fact that in today's world of laptops and smartphones the need for traditional meeting rooms has been replaced with a more mobile way of working. It also addresses the need for effective communication between individuals and within teams, whereby productivity and user experience can be improved by making the office into a more social and functionally adaptable workplace environment.

The collection comprises six main elements: the *Causeway* range of benches and walls, which can be configured into "open rooms" for informal discussions; the *Wing* range of armchairs, sofas and booths, which offer individuals comfort and privacy; the *Toguna*, a semi-private meeting space for quick meetings and conversations; the *Phonebooth*, a free-standing acoustic booth for taking private calls; the *Club* series of chairs; and the *Idea Wall*, which provides IT presentation facilities.

As Luke Pearson himself says, "We don't consider *PARCS* to be a predefined product but rather something that evolves along with changing technologies." This holistic and culturally attuned approach to the workplace environment is a thoughtful response to our rapidly changing world.

Left: *Idea Wall* elements from the *PARCS* office furniture range, 2009

PearsonLloyd (founded 1997)
PARCS office furniture range, 2009
Various materials
Bene, Waidhofen an der Ybbs, Austria

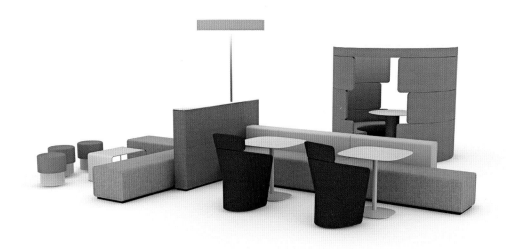

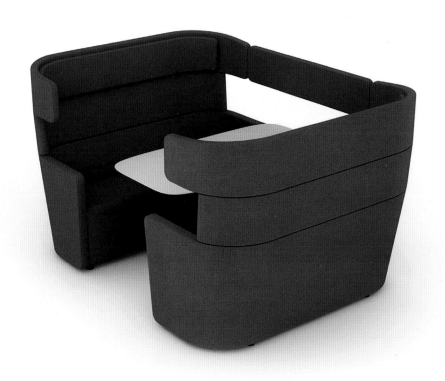

Thomas Heatherwick (1970–)
Spun chair, 2010

Looking like a giant spinning top, Thomas Heatherwick's *Spun* chair is an exceptional design that demands playful interaction. Made from moulded polypropylene, this lightweight sculptural chair can be gently rocked sideways, or more dramatically spun round in a complete circle. It is an extraordinary piece of process-led design.

One of the most interesting architect-designers working in Britain today, Heatherwick likes to challenge pre-conceived notions of how certain types of objects or buildings should be made or what they should look like – whether it is his new *Routemaster* bus, or the East Beach Café in Littlehampton.

The *Spun* chair was the result of research into the geometric simplification of seating, and Heatherwick's interest in whether it would be possible to make a comfortable chair from "a completely rotationally symmetrical form". It was developed using full-size test models which allowed Heatherwick to determine the optimum profile shape for ergonomic comfort. When placed in an upright position, the resulting plastic moulding looks like a sculptural vessel; but once it is tilted on its side, the scooped hollow form provides a relatively comfortable rocking-and-rolling seat.

The rotational-moulding manufacturing process used in making the *Spun* chair is not nearly as costly as some other plastic moulding technologies, and because the technique creates an internal cavity it is also materially efficient. Plastic pellets are heated in a spinning aluminium mould, and as the polymer melts, centrifugal force makes it flow around the mould to create a plastic wall of uniform thickness.

Heatherwick's chair actually uses the rippled surface texture that results from this spinning method, so that even when stationary the chair looks like it is in a state of movement. He also designed a limited-edition variant of the chair using spun steel and copper for the London gallery, Haunch of Venison. A truly gifted form giver, Heatherwick creates work with a typically Brtitish approah to design. It comes from his appreciation of cultural contexts, and a methodology that derives from an in-depth understanding of craft-techniques, engineering processes and the inherent qualities of the materials he chooses to use.

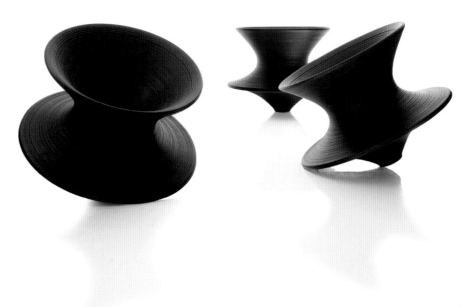

Above: Group of *Spun* chairs in various positions

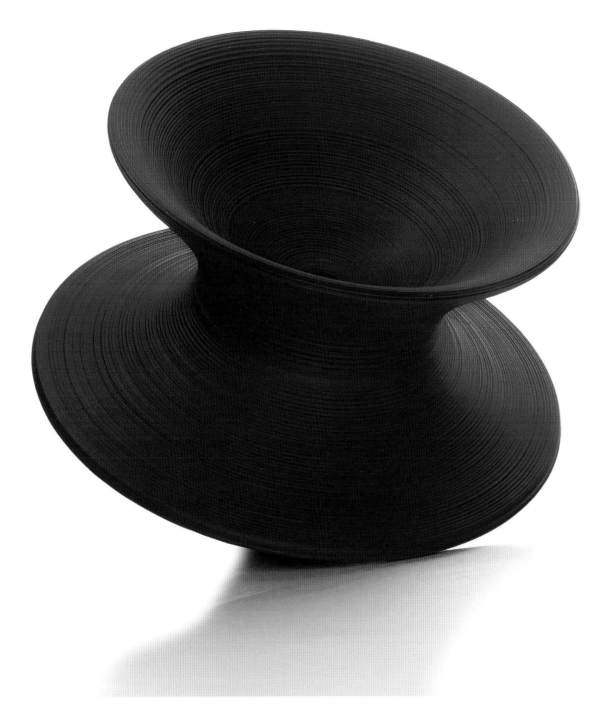

Timeline

1705 Thomas Newcomen's improved steam engine erected in Staffordshire

1714 Succession of House of Hanover to British monarchy

1771 "Factory Age" begins with the opening of Britain's first cotton mill

1776 American Declaration of Independence

1785 Treaty of Versailles ends American War of Independence

1792 France is declared a republic

1801 Act of Union creates the United Kingdom

1805 Battle of Trafalgar

1811–12 Luddite protesters attack industrial machinery in protest against unemployment

1815 Battle of Waterloo

1837 Accession of Queen Victoria

1849 Pre-Raphaelite Brotherhood established

1851 The Great Exhibition opens in Hyde Park, London

1854 The Crimean War begins

1861 American Civil War begins

1863 American Civil War ends

1878 First practical incandescent light bulb invented by Joseph Swan / electric street lighting introduced for the first time in London

1707
Abraham Darby I patents a method of casting iron cooking pots

1829
George Stephenson's *Rocket* locomotive wins the Rainhill Trials held in Rainhill, Lancashire

c.1849
A.W.N. Pugin designs his famous *Waste Not, Want Not* bread plate for Minton & Co.

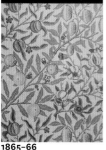

1865–66
William Morris designs his *Fruit* wallpaper, manufactured by Morris, Marshall, Faulkner & Co.

1879
Christopher Dresser designs a range of Anglo-Japanese teapots for James Dixon & Sons

1765
Josiah Wedgwood is given royal approval to rebrand his creamware as *Queen's Ware*

1830
Edwin Budding patents world's first lawn mower

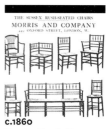

c.1860
Morris, Marshall, Faulkner & Co. introduces the *Sussex* chair as well as other rush-seated chairs

c.1867
E. W. Godwin designs his Anglo-Japanese sideboard, produced by William Watt & Co.

1885
John Kemp Starley designs his *Rover* "safety" bicycle

1885 Gottlieb Daimler and Wilhelm Maybach patent the high-speed internal combustion engine

1894 Karl Benz launched his first series production car – the *Benz Velo*

1901 Queen Victoria dies / Guglielmo Marconi transmits the first transatlantic telegraphic radio messages from Cornwall to Newfoundland

1903 The Wright brothers succeed in flying the first powered aircraft, the *Flyer No. 3*

1909 Leo Baekeland launches Bakelite – the world's first 100 percent synthetic plastic

1914 Outbreak of the First World War

1917 Russian Revolution

1918 End of the First World War

1918 British women (over the age of 25) are given the vote for the first time

1919 The Staatliches Bauhaus opens in Weimar

1900

1887
Arthur Silver of Silver Studio designs the *Hera* textile for Liberty & Co.

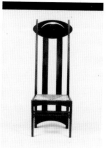

1897
C. R. Mackintosh designs the furniture for the Argyle Street Tearooms in Glasgow

1904–05
Charles Ashbee designs a silver and glass decanter, executed by the Guild of Handicraft

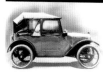

c.1918
Austin Seven car is launched, heralding the democratization of British motoring

1926
Eric Gill designs the *Gill Sans* typeface, it is subsequently developed into a full type family for the Monotype Corporation

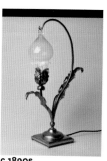

c.1890s
W. A. S. Benson designs various copper and brass "art manufactures" including the *Tulip* table lamp

1901
Frank Hornby patents a constructional toy system, later to become known as *Meccano*

c.1918
Edward Johnston redesigns the London Underground roundel

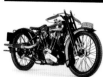

1924
George Brough launches the high-performance *Brough Superior SS100* motorcycle

1926
T. G. Green introduces its *Cornish Kitchen Ware* range

1925 The Bauhaus moves to Dessau / "Exposition Internationale des Arts Décoratifs et Industriels Modernes" staged in Paris

1927 British Broadcasting Corporation (BBC) is founded

1932 The atom is split for the first time

1936 Nikolaus Pevsner publishes *Pioneers of the Modern Movement*

1939 Outbreak of the Second World War

1941 Japanese bombing of Pearl Harbour

1942 First electric computer developed in the United States

1945 Germany unconditionally surrenders / first atomic bomb dropped on Hiroshima and Nagasaki

1947 The Cold War begins

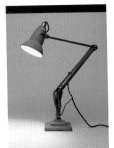

1933
George Carwardine introduces his first *Anglepoise* task light that uses "equiposing springs"

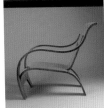

1933–34
Gerald Summers designs his single-form plywood lounge chair for use in the tropics

1935
Edward Young designs classic Penguin book covers

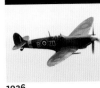

c.1936
Philco introduces the Bakelite *Model 444 "People's Set"* broadcast receiver

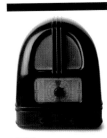

1936
First flight of the *Supermarine Spitfire* designed by Reginald J. Mitchell

c.1946
Max Gore-Barten designs the Dualit *Combi* toaster

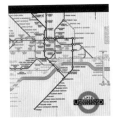

1933
Henry Beck redesigns the London Underground map using a diagrammatic system

1934
FW Alexander designs the iconic BBC microphone, known as the *Type A*

1935
Herbert Gresley designs the streamlined LNER *Class A4 Mallard* locomotive

1936
Giles Gilbert Scott designs the *Model K6* telephone box for the GPO

1945
Ernest Race designs the *BA-3* chair using re-smelted aircraft scrap

1946
Benjamin Bowden designs his *Bicycle of the Future*, which is exhibited in the "Britain Can Make It" exhibition

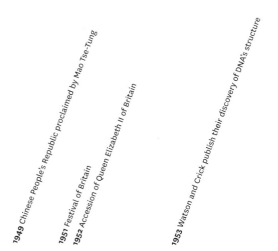

1949 Chinese People's Republic proclaimed by Mao Tse-Tung

1951 Festival of Britain

1952 Accession of Queen Elizabeth II of Britain

1953 Watson and Crick publish their discovery of DNA's structure

1956 Suez Crisis

1957 Launch of Sputnik satellite

1958 Britain's motorway system opens with the M6 Preston bypass

1958 Texas Instruments demonstrate the first integrated circuit

1951
Lucienne Day designs the *Calyx* textile for Heal's

1952
The first flight of the jet-powered delta-wing AVRO *Vulcan* bomber

1954
Douglas Scott designs the iconic red *Routemaster* bus

1957–67
Jock Kinneir & Margaret Calvert design a comprehensive motorway and road signage system

1959
The compact *Mini* is launched, Alex Issigonis's greatest car design

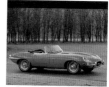

1961
The Jaguar *E-Type Series 1* is unveiled at the Geneva Motor Show

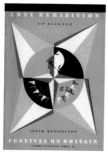

1951
Abram Games designs the Festival of Britain emblem

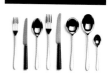

1954
David Mellor designs his first cutlery range, *Pride*

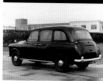

1956
The classic black London cab, the *FX4* is designed by Austin Motor Co., Mann & Overton and Carbodies Ltd

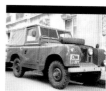

1958
David Bache's classic *Land Rover Series II* is launched

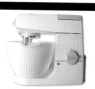

1960
Kenneth Grange designs the *A701 Kenwood Chef* food mixer

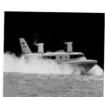

1962
Christopher Cockerell's *SR-N2* hovercraft makes its maiden flight

1961 Yuri Gagarin becomes first man in space

1967 Beatles release *Sgt. Pepper's Lonely Hearts Club Band*

1969 Neil Armstrong becomes the first man to walk on the moon

1971 Microprocessor invented by Intel

1973 Global Oil Crisis

1973 Britain joins the European Economic Community

1982 Falklands War

1983 Apple launches *Lisa* – the first personal computer to use a graphical user interface

1986 K. Alex Müller and Johannes Georg Bednorz discover the first high-temperature super-conductor

1989 Fall of the Berlin Wall

1989 Tim Berners-Lee invents the World Wide Web

1990 Reunification of Germany

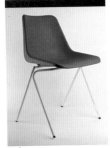

1962
Robin Day's *Polyprop* stacking chair for Hille is launched

1963
Joseph Cyril Bamford's revolutionary *3C* backhoe loader is launched by JCB

1967
The iconic *Sgt Pepper's Lonely Hearts Club Band* record sleeve is created by Peter Blake & Jann Haworth

1976
Fred Scott designs the ergonomic *Supporto* chair for Hille

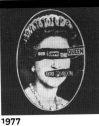

1977
Jamie Reid designs anarchic record sleeve for the Sex Pistols' *God Save the Queen* single

1989
Alan Fletcher and Pentagram devise the new logo for the Victoria and Albert Museum, London

1963
Peter Murdoch designs his *Spotty* chair, subsequently produced by International Paper Co. of New York

1964
Design Research Unit designs a new corporate identity for British Rail

1969
The supersonic *Concorde* makes its first flight, an Anglo-French design collaboration

1977
Sinclair Radionics launches its landmark *Sovereign* slimline pocket calculator

1988
Ron Arad designs the *Big Easy* chair heralding a new sculptural confidence in furniture design

1992
McLaren F1 road car is launched, becoming the fastest normally aspirated road car in the world

1991 First Gulf War / World Wide Web hypertext system used on the Internet for the first time / Cold War ends
1993 Eurotunnel opened between England and France / Pentium processor is invented

2000 Wireless Application Protocol (WAP) mobile telephone technology becomes widely available
2001 11 September attacks on New York City and Washington DC / war in Afghanistan begins
2003 Iraq War begins

2007 First complete genome of an individual human published
2008 Collapse of Lehman Brothers investment bank

2010 Arab Spring begins in the Middle East and North Africa

2012 Diamond Jubilee of Queen Elizabeth II

2000

1998
Jonathan Ive's *iMac* is launched by Apple, heralding a completely new type of personal computer

2001
Jonathan Ive's *iPod* is launched by Apple, revolutionizing the personal music player

2005
Tom Dixon designs his successful *Copper Shade* light

2007
Ross Lovegrove skins sound with his totemic *Muon* loadspeakers

2010
Thomas Heatherwick designs his playful *Spun* chair, and gets everyone in a spin

1999
Jasper Morrison designs the durable gas-assisted injection-moulded *Air-Chair* for Magis

2005
James Dyson launches the *DC15 Ball* vacuum cleaner, an evolution of his earlier *DC01*

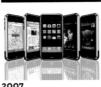

2007
The Apple *iPhone* is launched, revealing yet another revolutionary design by Jonathan Ive

2009
James Dyson redefines the electric table fan with the launch of the *AM01*

Index

Picture credits

The publishers would like to thank the following sources for their kind permission to reproduce the pictures in this book.

Key: t=Top, b=Bottom, c=Centre, l=Left and r=Right

Image courtesy of the Advertising Archive: 17b

Alamy: doti: 146, 245ct (Road sign), incamerastock: 147, Patrick Sahar: 109

Anglepoise Ltd (Farlington): 86lr, 87, 244tl

Apple Inc. (Cupertino): 18, 212, 213, 232, 233, 247tl, 247cbr

Cyril Barbaz: 245cbr (Land Rover)

Barber Osgerby (London): 226lr

Courtesy Ron Arad: 203, 246cbr

The-Blueprints.com: 110r, 132t

By kind permission of Bonhams: 131, 156, 157t, 157b, 245tr

The Bridgeman Art Library: © Cheltenham Art Gallery & Museums, Gloucestershire, UK: 49, 61, Photo © Christie's Images: 11t, 25, 43, 202, 243tl (chair), © The De Morgan Centre, London: 60l, 60r, Photo © The Fine Art Society, London, UK/Private Collection: 63, Freer Gallery of Art, Smithsonian Institution, USA/Gift of Charles Lang Freer: 42, Private Collection: 39

Carnegie Museum of Art, Pittsburgh; Women's Committee Acquisition Fund: 117

Gary Chedgy: www.minerslamp.co.uk: 26l, 26r, 27 © Cheltenham Art Gallery & Museum: 48

Sam Chui: SamChuiPhotos.com: 185

Cona Ltd (West Molesley): 150l, 150r

Cornishware.biz: 82l, 82r

Corbis: Auslöser: 247ctl, © Dave Povey/Loop Images: 137

David Mellor Design Ltd: 138l, 138r, 139t, 139b, 245cbl, © John Garner: 138r

Robin Day: 245tl

© John M Dibbs: 20-21, 110l, 111

Courtesy Tom Dixon: www.tomdixon.net: 208l, 208r, 228, 229, 247ct

Courtesy Dualit: 120l, 120r, 244tr

Dyson Ltd (Malmesbury): 222l, 222r, 223, 224l, 224r, 225, 236, 237, 247br

Alan Esplen/Alan's Meccano Pages: Charles Steadman: 65, 243bl (Meccano)

Established & Sons (London): Peter Guenzel: 227

Hans Ettema: 244bl (mic)

Mark Farrow (London): 216l, 216t, 216r, 217

Fears and Kahn (Epperstone): 89t

Fiell Archive (London): 6, 13, 14l, 17t, 23, 24, 28, 30, 52, 53, 57, 64, 78, 84, 88, 90, 91, 102l, 102r, 103, 116l, 116r, 122l, 122r, 123, 126, 128l, 128r, 129, 134, 135, 140, 142, 143, 144, 151, 152l, 152r, 154, 158, 160l, 160r, 164, 161, 165, 182, 183, 186, 187, 189, 190l, 191, 196, 197, 214, 215, 242tc, 242tc (Rocket), 242bl, 243tl, 243tr (car), 243tr, 244tc (Penguin), 244bl, 244bc (locomotive), 245tr (Mini), 245bl, 245bcl (taxi), 245br, 246tl, 246bl, 246bcr, 247bl, photographer Paul Chave: 14r, 23, 46, 47, 54r, 55, 80, 81, 83, 98, 242tl, 243bl, 243br, 244tc (radio), courtesy of Concrete Box/www.concretebox.co.uk: 141, 176, 177, courtesy of the collection of Roy Jones: 99, 105, 124l, 124r, 125: courtesy of Seymourpowell: 200l, 200r, 201

Michael FitzSimons: 76l, 76r, 77t, 77b, 243br (motorcycle)

Fotolibra: Graeme Newman: 145

Getty Images: 218, 219, AFP: 153, Hulton Archive: 108, 118l, 178, Marvin E. Newman: 184, Michael Ochs Archives: 195, 246ctr, Redferns: 179, 194l, 194r, 246ct (Sgt Pepper), SSPL: 72

GNU/GFDL: Franck Cabrol: 244tr (Spitfire)

Haslam & Whiteway (London): 11b, 36, 67, 242bc

Hille Educational Products Ltd (Ebbw Vale): 192,

246ct (chair)

James Humphreys (SalopianJames): 132
© The Hunterian, University of Glasgow 2012: 58, 59, 62

Courtesy of the Ironbridge Gorge Museum Trust: 22

Courtesy Jaguar Land Rover: 148, 149

JCB (J C Bamford Ltd)(Rocester): 162, 163, **246tl**

KEF (GP Acoustics (UK) Ltd)(Maidstone): Christopher Gammo-Felton: 234, 235, 247ctr

London Transport Museum: 70, 71, 74, 75, 112l, 112r, 113, 136

Lyon & Turnbull: Mike Bascombe: 44, 45, 242tr

Magis Spa: 240, 241, 247tr,

Wouter Melissen: 180l, 180r, 181

Courtesy Maclaren UK Ltd: 172l, 172r, 173

McLaren Automotive Ltd (Woking): 206, 207, courtesy of: 246br

The Millinery Works: 242tc (plate)

Sgt. David S. Nolan, US Air Force: 133, 245tl

The Old Flying Machine Company Ltd: John Dibbs: 20, 21,110l, 111

OMK Design Ltd (London): 188l

Orla Kiely (London): 230, 231

PearsonLloyd (London): 238, 239t, 239b

Peter Petrou/www.peterpetrou.com: 92l, 93, 244tl (chair),

PTG Dudva: 101

Patrick Rylands (London): 174t, 174b, 175

Private collection: 242bl (lawn mower), 242br (sideboard), 242br, 243bc, 244bc (telephone box), 245tl (Vulcan), 245tc (Routemaster), 246bcl, 246br
Race Furniture Ltd (Cheltenham): 114r, 130l, 244br

Rolls-Royce plc (London): 210l, 210r, 211

Ross Lovegrove Studio (London): 220r, John Ross: 211, 220l

Scala, Florence: Digital image, The Museum of Modern Art, New York: 199

Science & Society Picture Library: © NMPFT/Daily Herald Archive: 96, 104, 159, © National Railway Museum: 29, 100t, 100b, Science Museum: 31, 50, 51, 73, 97, 155

Superstock: Fine Art Images: 8t

Troika (London): 204

Ultimatecarpage.com: 180 (both images), 181

Michael Van Kleeff of Retrogoodies.co.uk: 245br (mixer)

Victoria & Albert Museum/V&A Images – All rights Reserved: 32l, 32r, 33, 34, 35, 37, 38, 40, 41, 54l, 56, 68, 69, 89b, 92r, 94, 95, 114l, 115, 127, 130r, 166, 167, 168, 169, 193, 198r, 204, 205, 243tc, 246tr, Dualit: 121

Bill Waltzer: 76l, 76r, 77t, 77b, 243cbr

Images courtesy of the Wedgwood Museum: 8b

Photo courtesy of Wright: 118r, 119, 244br

Yesterdays Antique Motorcycles/www.yesterdays. nl: 106l, 106r, 107t, 107b

Every effort has been made to acknowledge correctly and contact the source and/or copyright holder of each picture and Carlton Books Ltd apologises for any unintentional errors or omissions, which will be corrected in future editions of this book.

Bibliography

Bayley, S. & Conran, T., *Design: Intelligence Made Visible*, Conran Octopus, London 2007

Bayley, S., *The Conran Directory of Design*, Conran Octopus, London 1985

Bertram, A., *Design*, Penguin Books, London, 1938

Blake, A., *Misha Black*, The Design Council, London, 1984

Brightwell, C.L., *Heroes of the Laboratory and the Workshop*, George Routledge and Sons, London, 1859

Byars, M., *The Design Encyclopedia*, Museum of Modern Art, New York, 2004

Conway, H., *Ernest Race*, The Design Council, London, 1982

Crowther, L., *Award Winning British Design: 1957–1988*, V&A Publishing, London, 2012

Eastlake, C., *Hints on Household Taste in Furniture, Upholstery and Other Details*, Longmans, Green, and Co., London, 1878

Fiell, C. & Fiell, P., *Charles Rennie Mackintosh*, Taschen GmbH, Cologne, 1995

Fiell, C. & Fiell, P., *Design of the 20th Century*, Taschen GmbH, Cologne, 1999

Fiell, C. & Fiell, P., *Industrial Design A-Z*, Taschen GmbH, Cologne, 2000

Fiell, C. & Fiell, P., *Modern Furniture Classics Since 1945*, Thames and Hudson, London, 1991

Fiell, C. & Fiell, P., *Plastic Dreams: Synthetic Visions in Design*, Fiell Publishing, London, 2009

Fiell, C. & Fiell, P., *William Morris*, Taschen GmbH, Cologne, 1999

Gloag, J., *The English Tradition in Design*, King Penguin Books, London, 1947

Greenhalgh, P., *Quotations and Sources: on Design and the Decorative Arts*, Manchester University Press, Manchester, 1993

Hamerton, I., *W.A.S. Benson: Arts and Crafts Luminary and Pioneer of Modern Design*, Antique Collectors' Club, Old Martlesham, 2005

Heskett, J., *Industrial Design*, Thames and Hudson, London, 1980

Huygen, F., *British Design: Image & Identity*, Thames and Hudson, London, 1989

Levy, M., *Liberty Style – The Classic Years: 1898–1910*, Weidenfeld and Nicolson, London, 1986

MacCarthy, F., *British Design since 1880: A Visual History*, Lund Humphries, London, 1982

Martin, S.A., *Archibald Knox*, Academy Editions, London, 1995

Perris, G.H., *The Industrial History of Modern England*, Kegan Paul, London, 1914

Pevsner, N., *Pioneers of Modern Design: From William Morris to Walter Gropius*, Penguin Books, London, 1960

Sparke, P., *Did Britain Make It?: British Design in Context 1946–86*, The Design Council, London, 1986

Sudjic, D., *Design in Britain: Big Ideas (small Island)*, Conran Octopus, London 2009

Thomson, D., *England in the Twentieth Century*, Penguin Books, London, 1965

Exhibition Catalogues

Atterbury, P. & Wainwright, C., *Pugin: A Gothic Passion*, Yale University Press in association with the Victoria and Albert Museum, London, 1994

Breward, C. & Wood, G., *British Design from 1948: Innovation in the Modern Age*, V&A Publishing, London, 2012

Cox, I., *The South Bank Exhibition: A Guide to the Story it Tells*, H.M. Stationery Office on behalf of the Festival of Britain, London, 1951

Frayling, C. & Catterall, C., *Design of the Times: One Hundred Years of the Royal College of Art*, Richard Dennis Publications, Shepton Beauchamp, 1995

Lyall, S., *Hille: 75 Years of British Furniture*, Elron Press in association with The Victoria and Albert Museum, London 1981

Acknowledgements

This is a book that we've wanted to write for a very long time and we are especially pleased that it is our first "from the ground up" title for the new Goodman Fiell imprint. It has been a real pleasure working with everyone at Carlton Publishing Group and we would like to extend special thanks in particular to Gemma Maclagan-Ram, Isabel Wilkinson, Clare Baggaley, Alison Tutton, Lucy Coley, Jenny Meredith, Ben White, Maria Petalidou, Rachel Burgess and, of course, Jonathan Goodman. We would also like to thank Dominic Burr for his beautiful graphic design, Barry Goodman for his excellent copy-editing, Paul Chave for his superb new photography and also all the manufacturers, collectors, dealers, auction houses, museums and image libraries who have allowed us to use their images and/or shared their expertise.

Additional special thanks to:

Anglepoise Ltd

BarberOsgerby

Gary Chedgy of minerslamp.co.uk

Nigel Chell of JCB

Tom Dixon

Steve Dowling of Apple

Hans Ettema

Alan Esplen of Alan's Meccano Pages

Michael FitzSimons

Lily Grant Thorold and Charlie Stack of Dyson Ltd

Christopher Gammo-Felton of Buttaside up

Steve Halsall of KEF

Sarah Hanna of The Old Flying Machine Company Ltd

Thomas Heatherwick

Roy Jones of Radiochest

Sophie Kay of Established & Sons

Ross Lovegrove

John Mackie of Lyon & Turnbull

Lesley Malkin

PearsonLloyd

Leonora and Peter Petrou

Peter at Cornishware.biz

Pippa at Fears and Kahn

Ron Arad Associates

Derek Rothera of The Millinery Works

Patrick Rylands

Charles Steadman

Troika

Ultimatecarpage.com

Michael van Kleeff of Retrogoodies.co.uk

Geert Versleyen of Yesterdays Antique Motorcycles

Ray Wheeler of Concrete Box

Michael Whiteway of Haslam & Whiteway

Nigel Wiggin of The Old Hall Club

Philippa William of Orla Kiely

THE HENLEY COLLEGE LIBRARY

"It's very easy to be different,
but very difficult to be better"
Jonathan Ive

"Many people speak of good quality as if it were
made up of good workmanship and good materials
alone: but without good design it is impossible to
make the most of these qualities. Good design,
indeed, is an essential part of a standard of quality."
Gordon Russell